D0913100

MAYA FIGURINES

CHRISTINA T. HALPERIN

MAYA FIGURINES

Intersections between
State and Household

UNIVERSITY OF TEXAS PRESS

AUSTIN

THIS BOOK IS A PART OF THE LATIN AMERICAN
AND CARIBBEAN ARTS AND CULTURE PUBLICATION
INITIATIVE, FUNDED BY A GRANT FROM THE
ANDREW W. MELLON FOUNDATION.

Requests for permission to reproduce material from this work
should be sent to:
 Permissions
 University of Texas Press
 P.O. Box 7819
 Austin, TX 78713–7819
 http://utpress.utexas.edu/index.php/rp-form

♾ The paper used in this book meets the minimum requirements
of ANSI/NISO Z39.48–1992 (R1997) (Permanence of Paper).

Cataloging data on file with the Library of Congress

doi:10.7560/771307

For Eric

CONTENTS

PREFACE

This book explores the social complexity of Late Classic Maya states from the perspective of the inconspicuous ceramic figurine. It underscores the ways in which the practices and symbols of households are implicated in the making of states. Rather than viewing the contours of social life solely from the summits of towering temple pyramids or from the royal gaze inscribed in carved stone, this book takes as its vantage point a suite of small anthropomorphic, zoomorphic, and supernatural figurative remains, many of which were excavated from households. In juxtaposing the realms of the ordinary and the extraordinary, a lively, contradictory, and socially diverse understanding of Maya states emerges.

Ceramic figurines have long fascinated scholars, private collectors, and museum curators. The first scientific publications on the Maya included figurines in their regional and chronological reconstructions. Museum collections specializing in the Maya often house a large suite of ceramic figurines, especially those likely to have come from burials on the island of Jaina or along the Campeche coast. Yet there are relatively few systematic studies of Maya figurines, partly because so many of them are found as fragments in refuse deposits. This book attempts to make sense of both fragmentary and complete specimens, the large majority from archaeological contexts, and to think broadly about how they are implicated in the social tensions and relations of Late Classic Maya society. Research for this book developed from archaeological excavations and figurine analyses that I conducted at the site of Motul de San José, Guatemala, and its satellite sites for my doctoral dissertation. This work was complemented by research conducted both during and after the dissertation on collections from museums and the storage rooms of archaeological projects throughout Petén, Guatemala, and western Belize. I am grateful to many individuals and institutions that made this work possible.

I thank Antonia Foias and Kitty Emery for the opportunity to participate in the Proyecto Arqueológico Motul de San José and the Departamento de Monumentos Prehispánicos y Coloniales and the Instituto de Antropología e Historia (IDAEH) for their permission to conduct research in the Motul de San José region. Field research would not have been possible without Jeanette E. Castellanos, Jorge Cazali Guzmán, Gerson Martínez Salguero, Crorey Lawton, Suzanna Yorgey, Matt Moriarty, Elly Spensley Moriarty, Augustine Alonzo, Benedicto Alonzo Gutiérrez, Carlos Alonzo Ramos, Humberto Belice Melénez, Roberto Choch, Román Ek Tesucún, the Hernández González family, the Alonzo Ramos family, and the Zac family. I am grateful to Ron Bishop, James Blackman, and Erin Sears from the Smithsonian Center for Materials Research and Education (SMRCE) for conducting the Instrumental Neutron Activation Analysis (INAA) and to Elly Spensley Moriarty, who conducted the petrography analysis of the Motul de San José region figurines.

I am grateful to all the institutions and archaeological projects that allowed me to examine their collections. Lic. Fernando Muscoso and Monica Pérez graciously permitted me to look at the figurine collections from the Museo Nacional de Arqueología y Etnología. Jorge Mario Ortiz gave me permission to examine collections at the IDAEH Ceramoteca in Guatemala during the summer of 2003. I would like to thank Lic. José Sánchez for allowing me to look at the Tikal collections from the Parque Nacional Tikal *bodega*. Francisco Estrada Belli, Lic. Judith Valle, and Ryan Mongelluzzo graciously gave me access to the Holmul Archaeological Project figurine collections in 2004. I am grateful to Prudence Rice, Tim Pugh, and Mirim Salas for inviting me to examine figurines from the Proyecto Arqueológico Itzá del Petén (PAIP) and Proyecto Maya Colonial (PMC). I also thank Vilma Fialko, Daniel E. Aquino, and Walter Schwendener from the Instituto de Antropología e Historia en Guatemala (IDAEH), the Proyecto Protección de Sitios Arqueológicos en Petén (PROSIAPETEN), and the Proyecto Yaxhá Banco Internacional de Desarrollo (BID). Vilma Fialko kindly let me stay at the field camp at Yaxhá in 2008 while I analyzed the collections. I am grateful to Christophe Helmke for inviting me to look at the Pook's Hill collection in 2009 and to Ray Snaddon and the Pook's Hill lodge staff for making my stay on site so enjoyable. I thank Chelsea Blackmore, who accompanied me on this Belize trip and assisted me with both the photography and analysis. Reiko Ishihara-Brito, Paul Healy, Daniela Triadan, and Rhonda Taube kindly gave me permission to use their photographs.

Field and laboratory research for the dissertation was funded by Fulbright IIE, a National Science Foundation Dissertation Improvement Grant (No. 0524955), a Foundation for the Advancement of Mesoamerican Studies, Inc. (FAMSI) Research Grant (No. 05045), a Sigma Xi Grant-in-Aid of Research, a University of California, Riverside, Graduate Dissertation Research Grant, a Humanities Graduate Research Grant, and a Chancellor's Fellowship. Postdoctoral figurine research was supported by an American Philosophical Society Franklin Research Grant and a Wenner-Gren Hunt Postdoctoral Fellowship. The last half of the writing of the book was completed while in residence as a Cotsen Postdoctoral Fellow in the Society of Fellows at Princeton University. I thank the Society of Fellows (Mary Harper and Susan Stewart), the Program of Latin American Studies (Rubén Gallo), and the Department of Art and Archaeology (Thomas Leisten) for their support and intellectual stimulation. I am grateful to Bryan Just at the Princeton University Art Museum for his generosity in showing me the museum's collections and for his keen insights on all things Mesoamerican.

I would like to extend special thanks to Wendy Ashmore, Tom Patterson, and Karl Taube, who have provided sound guidance and comments on my research. They have been an inspiration and kind source of support. I also thank Simon Grote, Kata Faust, Antonia Foias, Julia Guernsey, Paul Healy, John Millhauser, and Shankari Patel for reading the manuscript (in whole or in part) and for their thoughtful comments. The late Jim Clark was a kind and helpful mentor on all press-related matters and also provided helpful comments on several of the manuscript chapters. I am forever grateful to Eric White, who has been a constant source of support.

INTRODUCTION

Inherent in the notion of the state is a contradiction. As Stuart Hall (2006: 363) remarks, "The state is both of and over society. It arises from society; but it also reflects, in its operations, the society over which it exercises authority and rule. It is both part of society, and yet separate from it." Seen from another perspective, households are both foundational components of all states and a social-economic domain disconnected from the production of state symbol and action.

Without completely eliminating or simplifying the contradictions of the state, how might we go about understanding it? In this book, I explore the Maya state from archaeological materials least suspected of illuminating state dynamics: ceramic figurines. These small figurative works are often dismissed as irrelevant to the topic at hand because they are frequently found within household refuse deposits. Furthermore, they are relatively enigmatic: scholars have had trouble assigning an unambiguous or single function (for example, as ritual objects, children's toys, or musical instruments) and meaning to the broad spectrum of small ceramic figurines known to the Maya area.[1] Nonetheless, I find that ceramic figurines—in their diverse and varied aesthetics, uses, and forms—draw out the contradictions of Late Classic period (ca. 600–900 CE) Maya state systems, helping to reveal the state as a series of relationships produced through both its interaction with and constitution from households. Thus, rather than examine the state and household as autonomous entities, I see state politics working on the microscale of everyday routines, localized rituals, and small-scale representations, such as ceramic figurines. At the same time, the more quotidian, commonplace, and smaller-scale elements of society influence and contribute to the representations and composition of the state.

Studies of ancient polities often privilege stone monuments, statements

in hieroglyphic texts, and large-scale or ceremonial architecture as both the means of constituting and the constituting features of the state. These material remains demonstrate asymmetric power relations in which the powerless is identified in the negative (Blanton et al. 1996; DeMarrais et al. 1996; Feinman and Marcus 1998). Household archaeology, however, is useful in identifying the everyday lives of members of states and in drawing attention to social groups (for example, common people, women, and children) who are often overlooked in most discussions of power, agency, and political systems (Ashmore and Wilk 1988; Gonlin and Lohse 2007; Hendon 1996, 2007; Hutson 2010; Joyce et al. 2001; McAnany 1995; Robin 2003).

This book helps bridge the household-state divide. From a largely synchronic perspective of the Late Classic period, I highlight ways in which households take on ideologies and symbolism espoused by the state as well as the ways in which states create their power from the ideas and practices of households. But households may also challenge state discourses by engaging with alternative representations, practices, and perspectives, and state strategies may likewise eschew such household representations, practices, and perspectives. Such dualistic state-household models of influence and interaction are simplistic: states and households are only two interrelated social formations of many that existed among complex societies in the past (such as lineages, neighborhoods, ethnic groups, class, gender, and age). Depending on particular social or historical contexts, the relations between state and household may have been downplayed as other social expressions were fronted. Nonetheless, these other forms of social relations were often played out as part and parcel of the tensions between and intersections of states and households. In this sense I see the state-household relationship as a central framework for thinking about how multiple identities were forged in ancient Maya society.

Ceramic figurines, in particular, showcase the contradictory relations of Maya states and households. Ceramic figurines were instrumental in disseminating state ideologies beyond the confines of public ceremonial spaces and into the visual culture repertoires of households. At the same time, they provide crucial perspectives on women, commoners, and ulterior supernatural beings, empowering more diverse social roles and spiritual practices than those highlighted in monumental media. Many figurine types or themes (e.g., as identified through paste categories, manufacturing types, imagery, and style) cross-cut site cores and settlement peripheries as well as elite and commoner contexts. But in other cases figurines reveal

more restricted social networks and privileges, underscoring divisions between rulers and the ruled as well as uneven political economies and forms of social and ritual expression across the Maya area.

Figurative representations, however, are more than a static by-product of cultural activity. In order to delve into the ways in which humans interact with their material surroundings and, more specifically, the ways in which Late Classic Maya peoples may have engaged with ceramic figurines, I draw on the interrelated theories of materiality and mimesis. Materiality points to the mutually constituting relationships between humans and their material world and underscores the importance of social and historical contexts in the interpretation of artifacts, landscapes, art, and architecture. As such, I contextualize figurine representations within the realm of social practices, whereby the interpretations of figurine meaning and symbolism inform and are informed by the social groups using these objects, the types of performances they were a part of, and the socially meaningful ways in which they were manufactured, exchanged, and discarded. In this sense iconographic analysis is not divorced from the more "materialist" focus on political economy. I adopt both analytical perspectives here to provide a more holistic understanding of these media and the society of which they were a part. Moreover, rather than treat figurines as isolated household finds as many previous analyses have done, I compare them with state-sponsored iconography and elite courtly material culture not only to provide interpretative depth but also to explore how different social realms relate to one another.

The concept of mimesis is particularly useful for the study of figurines in that, like theories of materiality, it has the potential to link durable representations conceptually with the practices that create and are influenced by them. Mimesis captures one of the most basic human behaviors: imitation or the process of imitation. Yet the varied ways in which such imitations are invoked, repeated, and interpreted expose the complexity and infinite possibilities of cultural experience. Figurative representations, as iconic symbols, may have been imitations of tangible human realities, of other iconographic media, or, alternatively, of intangible supernatural essences. In turn, human practices and beliefs may have been recursively realized as imitations of figurines. Mimesis also has implications for power relations, a critical part of understanding the articulation of state and households. Imitation need not always be the prerogative of a few elite leaders with authorized decision-making capacities. Whether as the sincerest form of flattery, as the reproduction of "tradition," or in

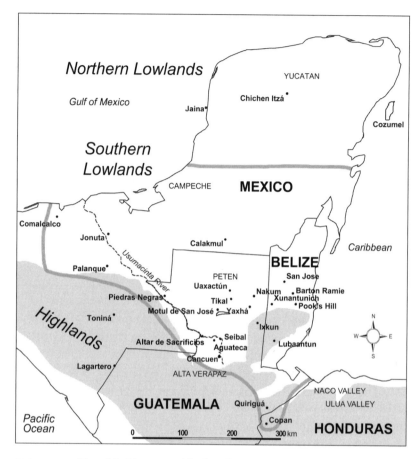

FIGURE 0.1. *Map of the Maya area with selected sites mentioned in text.*

mocking jest, mimesis highlights the creativity and agency of dominant and subordinate groups alike.

Ceramic figurines are some, if not the only, forms of iconic media found in both elite and commoner contexts in Classic period Maya society. As such, they provide a unique perspective for understanding social and political relations during the height of political power in the Southern Maya Lowlands (figure I.1). This study takes a broad regional approach, comparing datasets between households, sites, and regions. It focuses heavily on excavated figurines from Petén, Guatemala, where figurine traditions were especially prolific, but compares this region to sites in Belize, the northern highlands in Guatemala, centers along the Usumacinta River,

the Campeche coastal area, and Mesoamerican sites outside the Maya zone. These data are compared with published materials, particularly those from Jaina and other regions along the Campeche coast. Many of the Jaina examples were or are presumed to have been recovered from burials and are often complete and in excellently preserved condition. They have been actively collected by private individuals and public institutions and serve as a focus of published research and museum exhibitions, often to the exclusion of figurines from elsewhere in the Maya area. The Jaina and Campeche coast figurines, however, are the least understood in terms of archaeological context because the majority lack provenience, an important resource for exploring the sociality of Maya figurines.

Detailed contextual analyses in this book focus primarily on the Motul de San José region, where I conducted excavations and laboratory work for my dissertation as part of the Proyecto Arqueológico Motul de San José (PAMSJ) under the direction of Drs. Antonia Foias and Kitty Emery (appendix I.1).[2] Motul de San José is located on the northwestern side of Lake Petén Itzá in Central Petén, Guatemala, and was the capital (or one of the capitals) of the Ik' polity during the Late Classic period. Excavations centered at both the capital and several smaller satellite sites within an 8 km radius surrounding the site. Research also includes my systematic analyses of figurines from other sites on or near Lake Petén Itzá:[3] Nixtun Ch'ich', Ixlú, and Zacpetén excavated by the Proyecto Arqueológico Itzá del Petén (PAIP), directed by Dr. Prudence Rice, Lic. Rómulo Sánchez Polo, and Dr. Don Rice, and by the Proyecto Maya Colonial (PMC), directed by Don Rice, Prudence Rice, Rómulo Sánchez Polo, and Grant Jones. These investigations are complemented by my systematic figurine analysis of collections from Pook's Hill, Belize, excavated by the Belize Valley Archaeological Reconnaissance (BVAR) Project under the direction of Dr. Jaime Awe and led by Christophe Helmke as well as collections from the sites of Nakum, Naranjo, San Clemente, and Yaxhá, Guatemala. These collections were excavated by the Proyecto Triángulo and the Proyecto Protección de Sitios Arqueológicos en Petén (PROSIAPETEN) directed by Lic. Vilma Fialko of the Institute of Anthropology and History in Guatemala (IDAEH) and by the Proyecto Yaxhá Banco Internacional de Desarrollo (BID) directed by Lic. Daniel Aquino. This research is complemented by my investigations of museum collections from the Museo Nacional de Antropología e Historia in Guatemala (which include figurines excavated from the sites/regions of Seibal, Altar de Sacrificios, Poptún, Uaxactún, and Alta Verapaz); from the Princeton University Art Museum in Princeton, New Jersey; and Tikal

collections from the Parque Nacional Tikal excavated by the University of Pennsylvania.

In many ways my regional comparison of figurines from different households and sites and the comparison of figurines with other iconographic media (such as polychrome vessels, stone monuments and sculpture, and architectural façades) overshadow descriptions of other household material culture (e.g., grinding stones, spindle whorls, ceramic vessels, crafts production debris, and botanical and faunal remains). In this sense I do not make detailed interpretations of *all* the types of activities undertaken in and by households. Rather, the analytical focus allows for an exploration of how households related to one another, the types of symbols and narratives that different households deemed important, and the ways in which households were both part of and isolated from state discourses.

Although this book explores figurines from the Southern Maya Lowlands during the Late Classic period, it is important to note that figurines have been part of shifting social conditions since the Preclassic period. They have been found in household refuse, caches, and burials from some of the earliest settlements in Mesoamerica (Early and Middle Preclassic periods ca. 1800–500/300 BCE).[4] They often feature solid and hollow anthropomorphic, supernatural, and zoomorphic figures (and combinations of these forms) produced with modeled techniques (Blomster 2009; Cheetham 2009; Cyphers Guillén 1998; Joyce 2000a, 2003b; Lesure 2002, 2011; Marcus 1998b; Vaillant 1930, 1935). Anthropomorphic figurines, in particular, tend to be depicted nude or partly nude. Figurine producers emphasized details on the head, such as hairstyles, facial markings, and designs at the back of the head. Scholarly inquiry has often revolved around making sense of the high frequencies of female figurines during certain phases of the Preclassic period and of age-related iconographic indicators to underscore social transformations and stages over the course of the human life cycle, although these are just two of many varied patterns identified among such early collections.

In the Southern Maya Lowlands, ceramic figurines are especially common during the Middle Preclassic period (especially ca. 600–300 BCE) and come in slipped and unslipped modeled varieties (Laporte 2008; Moholy-Nagy 2003; Rands and Rands 1965; Willey 1972: 8–14). As elsewhere in Mesoamerica, they are recovered primarily from middens and household contexts. Interestingly, they are no longer produced, or greatly diminish in importance, during the Late Preclassic period (ca. 300 BCE–300 CE),

a period in which many centers became more urbanized, huge amounts of labor were devoted to the construction of monumental architecture, and state structures crystallized in form (see also Arroyo 2002; Guernsey 2012). Likewise, during the Early Classic period (ca. 300–600 CE), ceramic figurines continued as a relatively rare component of archaeological assemblages with both molded and modeled figurative techniques present. Slips were no longer applied. Figurines were either unslipped or decorated with paint on postfired unslipped surfaces, a pattern that continued throughout the Late Classic period.

The profusion of figurines, and especially figurine-ocarinas, that appeared during the Late Classic period coincided with a period of growing population, urbanization, and an increase in competitive political displays of power, an inverse pattern between figurines and state development found during the Late Preclassic period. Figurine production increased, in particular, during the middle of the Late Classic period. Because only subtle differences in figurine frequencies, types, and practices are noted between the middle of the Late Classic period (ca. 700–830 CE) and the end of the Late Classic period (the Terminal Classic, ca. 830–900/950 CE), I treat them collectively here (although such temporal variations are explored in more detail elsewhere: see Halperin 2011). Despite the synchronic focus of the book, when relevant I note similarities in iconographic or technical patterns between the Late Classic figurines and those of other periods.

After the Terminal Classic period, inhabitants of the Southern Maya Lowlands ceased to produce and use many of the types of ceramic figurines described in this book. During the Postclassic period, fewer figurines are produced. Many of those that appear differ in form, with emphases on female figures and slipped molded types without musical capabilities (Halperin 2010; Masson and Lope 2010: 85–91; Smith 1971). Thus the Late Classic ceramic figurines described herein do not emerge from a neat linear trajectory of figurine traditions but as a combination of earlier precedents and historically contingent circumstances. Changing relations between the state and households were a central component of such circumstances.

OUTLINE OF THE BOOK

This book examines the relationship between Maya states and households by considering how local dynamics were impacted by and affected broad

political and social spheres of life. To introduce the analytical framework of the book, the first chapter ("State and Household: Articulating Relations") discusses the basic contradiction of the state: its simultaneous incorporation and exclusion of the household. On the one hand, the state is the sum of its parts (such as an aggregate of households or communities); on the other hand, it includes only the political institutions and ruling elite of society. This contradiction is highlighted in particular in discussions of political economy and ideology, which consider multiple social actors and groups as contributing dynamically but not necessarily equally to what may be considered the "state." Thus, rather than viewing politics as inherent to a particular institutional body or to specific elite officials, monuments, or public buildings, I examine politics as a relation between individuals and/or social collectivities that emerge from and through historically contingent social practices. Importantly, material culture plays a pivotal role in the mediation of these social relations. Chapter 2, "Materiality and Mimesis," examines the ties that link social practices, meaning, and the material world, thus bridging notions of political economy and ideology, representation, and practice. These theoretical concepts are then discussed in relationship to other figurine studies beyond Mesoamerica.[5]

The remaining chapters relate specifically to Maya figurines. Chapter 3, "State Pomp and Ceremony Writ Small," examines the considerable overlap between small-scale and large-scale media and finds that many of the Classic Maya figurines represent a cast of characters from state ceremonies and public festivals. When possible, these images are further assessed through a fine-grained documentation of their social contexts. These distribution patterns indicate that small-scale state symbols were part of the visual culture of elite and commoner households as well as large urban centers and small peripheral sites. Arguably, imitations of state officials in the form of figurines were not just copies of particular personages or representational ideals of social categories but were also instrumental in molding how people thought about these identities and how these identities were performed.

While chapter 3 highlights the dissemination of state ideologies into the confines of domestic life, chapter 4, "From Oral Narrative to Festival and Back: Tricksters, Spirit Companions, Ritual Clowns, and Deities," helps complicate the seemingly unidirectional influence of state to household by documenting the role of household oral narratives and myths on the making of the state. In particular I examine concepts of social deviance, liminality, and ritual humor to investigate figurines depicting so-called

grotesques, animal-humans, and dwarves. Some of these supernatural figures imitate anthropomorphic social identities, while others may represent humans imitating supernatural beings. These figures show a more playful and in some cases subversive side of household and community practices. They contrast with the pantheon of formal Maya deities who were patronized by royal lineages and whose material manifestations were more rigidly controlled.

Chapter 5, "Figurine Political Economies," reveals the way in which these mimetic representations were produced and circulated, practices that helped carve out the contours of Late Classic Maya states in political economic terms. While figurines were intimately associated with households in their consumption and most likely in their production as well, I argue that festival-markets or large-scale state ceremonies were important mechanisms for their distribution. Centers were tied to peripheries in the making of broader state structures through participatory politics of spectacle and exchange as much as through the exclusionary tactics of political prestige. Not all figurines, however, were produced or used in the same fashion. Figurine-ocarinas, which relied heavily on molded productive techniques with the potential to produce numerous copies of the same image, were circulated more widely between social classes or status levels. In contrast, those figurines produced using elaborate modeling techniques, such as those without music-making capacities, were rare and related to more intimate forms of social relations and exchange. Moreover, not all regions of the Maya area engaged in the same modes of figurine production and distribution, underscoring the heterogeneity of political economic interactions and forms of cultural expression.

Chapter 6, "Figurative Performances," turns to the performative roles of ceramic figurines as a mechanism for the reenactment of social orders and the creative ways in which both household and state are experienced, reflected upon, and challenged. I explore the different types of social groups (adults and children; elite, middle-status, and commoner households; male and female) who used them as well as the varied ways in which ceramic figures were played, embodied, or "activated" for sound production. I find that figurines are best characterized by their informality, because they appear to have served many purposes, uses, and motivations. While their imagery and uses undoubtedly were shaped by cultural norms, their informal qualities remind us that material culture can be quite recalcitrant as it is resignified, reconceived, and appropriated in the context of human practice. In this sense the figurines highlight both the

taken-for-granted and creative qualities of ordinary things. Arguably, the ordinary is not a passive backdrop for the extraordinary but a different mechanism in which power and social life are enacted. It is the contradictory juxtaposition of the ordinary and extraordinary, however, that allows for a more refined understanding of state and household. I revisit this topic in the final chapter, "Comments on Maya State and Household," to reflect on how Maya states look different from the perspective of small, inconspicuous ceramic figurines.

STATE AND HOUSEHOLD

Articulating Relations

Previous scholarship on the state builds on two simplistic but contradictory models: *households as part of the state*, in which the state is an aggregate of households (or individuals, settlements, territories, and so forth), and *households as separate from the state*, in which the state exists and operates in isolation from the large majority of households. We may be better served, however, by a more complex perspective on the state in which the state and households are examined as a series of relations. A relational approach emphasizes how various social spheres intersect with one another and thus continuously create and reproduce each other. Thus, rather than deny the contradiction, a relational perspective attempts to identify how states and households managed such a contradictory status: how did households operate separately but remain influenced and regulated by centralized political ideas, institutions, and practices? How did political elites elevate themselves above society yet simultaneously draw on households (their own and others) for their basic needs, operating resources, legitimacy, and self-expression?

Different states may engage in various degrees and practices of household articulation, sometimes manifesting as city-states or territorial states, decentralized or centralized states, weak or strong states, and so forth. Nonetheless, the contradiction remains to some degree at the balance of all state dynamics. For the purposes of this book, this relational framework encourages a broader, comparative analysis of ceramic figurines and other visual media that moves beyond their treatment as isolated household finds, on the one hand, and as solely elite prestige goods, on the other hand. It simultaneously recognizes the divergent meanings, experiences, and social networks that figurines helped engender in Late Classic Maya society. Below I outline the two opposing poles of this basic contradiction and explore ways in which states and households articulate through

political economic and ideological strategies. In particular I look at state appropriation of household labor and symbols, household reproduction of state ideologies and practices, and the contestation of state discourses by the elite and nonelite alike.

THE HOUSEHOLD AS PART OF THE STATE

The conception of the state as a unified totality has two interrelated manifestations: an empirical perspective in which the totality consists of the sum of its parts (such as settlement sites, households, or individuals) and an ideological perspective in which the totality is an immaterial phenomenon (a metaphor, political ideology, or cultural concept). I explore the empirical and cultural totality perspectives in this section and return to the discussion of ideology and its links to human practice below.

The idea of the state as a totality, encompassing households, individuals, and various communities, is predicated on some type of internal homogeneity, whether it manifests in beliefs, practices, the material record, or all three. For example, eighteenth-century political philosopher Jean-Jacques Rousseau (2006: 6–7, 58–59) characterized the state as an aggregate of citizens united by their common interests and respect for the law as predicated on a social contract. While he recognized that the state often included many conflicting social groups and institutions, he conceived of an ideal state as one in which the will of its people (rulers and common people alike) was the same.

Anthony Smith's (1994) discussion of contemporary nation-states builds on this earlier perspective in promoting a civic-territorial model in which the nation-state consists of a grouping of people united by common laws and institutions and bounded within a single territory that can be measured and identified on the landscape. He also adds an opposing, "more traditional" ethnic-genealogical model, however, in which a nation is united by a common culture: myths of genealogical origin, ethnic descent, language, rituals, and customs. This latter model echoes early foundational perspectives in anthropology in which culture is that "complex whole," a bounded group sharing similar knowledge, beliefs, art, customs, and morals (Tylor 1958: 2). These approaches emphasize social homogeneity within a bounded "system" and downplay social differentiation, alliances, and tensions as both part of and reaching beyond it.

In some cases archaeological models of states have been implicitly

informed by such bounded and homogeneous concepts of nation and culture. Social boundaries, including political boundaries of the state, are often identified through similarities in artifact types, uniformity in stylistic attributes, and other material correlates. In this sense material remains are treated as either the conscious or unconscious reflections of a particular state, cultural unit, or social formation (Conkey and Hastorf 1993; Sackett 1982). As George Cowgill (1993: 555) points out, however, narrow applications of material culture as reflections of social groups can often ignore people and place the products of people at the forefront of analysis. As a result, human motivations and needs can be divorced from the production, use, and meanings of material remains.

Archaeologists have also taken on the state concept as an empirical totality incorporating its respective social organizing parts, such as population or settlement site hierarchies. In both cases archaeological reconstructions of these criteria are based on the survey of household architectural groups (or the clustering of household debris from surface collections and/or systematic test excavations) as the basic unit of analysis, with the assumption that households are "the smallest grouping with the maximum corporate function" (Hammel 1980: 251) and "the next bigger thing on the social map after an individual" (Hammel 1984: 40–41).

What these totalizing approaches have in common is that to understand a state one must consider its respective components. For some early archaeologists focusing on cultural evolution, the state was the ending stage or level of society that emerged after the formation of other social systems, such as bands, tribes, and chiefdoms. While such a linear and teleological trajectory of social systems has since been rejected, the idea of a state system with certain characteristics and qualities encompassing the whole remains. Likewise, for the study of households, the evolutionary assumption was that over the course of history households shifted from large extended families to smaller nuclear families, a simplistic narrative rejected with archaeological evidence. The boundedness of households as social units, however, is difficult to challenge. For example, the tensions between family and household, the co-residential household and multiresidential household, and the physicality of a house and the social or conceptual idea of the household are difficult to sort out with the material record alone. In the Maya area these tensions have recently played out in debates between "house society" and "lineage" models of Maya society that place different values on consanguineal and affinal relations

(Gillespie 2000; Houston and McAnany 2003; Joyce and Gillespie 2000; Watanabe 2004). Here I consider households to be corporate social units formed, in part, by their connections to residential architecture.

In addition to households, population size continues to play a defining role in identifying a state in the archaeological record, regardless of whether population is a prime mover or a resulting feature of state society (or both) (Brumfiel 1983; Carneiro 1967; Claessen and Skalník 1978: 17–18; Cohen 1978; H. Wright 1977). For example, John Clark (2007b: 26, 39–41), in his argument that San Lorenzo, Veracruz, Mexico, was the seat of Mesoamerica's first state, points to the site's dramatic rise in population to 13,644 people by 1300 BCE as one among other criteria of statehood. As Gary Feinman (1998) emphasizes, however, there is no clear cut-off in population size for identifying a state (e.g., 2,500, 10,000, 100,000 people); nor is population the only factor in understanding state dynamics (see also the discussion in Pauketat 2007: 143, 191–199).

Initial low population estimates of settlement centers in the Maya area led J. Eric Thompson (1950) to characterize Maya state systems as small and decentralized. Also influenced by what could then be deciphered from hieroglyphic texts, he asserted that Maya centers were relatively vacant, inhabited only by a small caste of peaceful priests and nobles who were surrounded by dispersed hinterland populations practicing land-extensive slash-and-burn agriculture. Since this early portrayal, settlement and agricultural data have challenged the vacant center models and revealed a network of urban zones (some with as many as 100,000 inhabitants) in interaction with complexly organized rural communities engaged in both extensive and intensive agricultural techniques (Ashmore 1981; Chase and Chase 1996b; Culbert and Rice 1990; Fedick 1996; Iannone and Connell 2002; Scarborough et al. 2003). Scholars have also turned to relative site sizes and hierarchies to identify state complexity. For example, Ronald Cohen (1978: 2–3), in emphasizing a bounded space on the landscape, defines a state as a hierarchically arranged "social system," a "polity," and a "human group that occupies or controls a territory." Joyce Marcus and Gary Feinman (1998: 4), in placing more emphasis on "tiers" of social organization, refer to archaic states as "societies with (minimally) two class-endogamous strata (a professional ruling class and a commoner class) and a government that was both highly centralized and internally specialized."

Marcus (1976, 1993, 1998a) argues that the Classic Maya state shifted temporally between four-tier and three-tier levels of political hierarchy. Stratification appears as a series of settlement categories of primary,

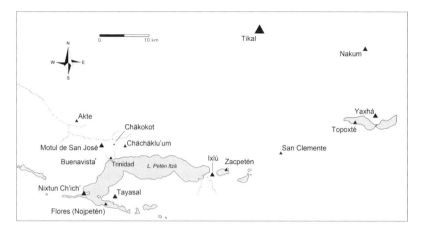

FIGURE 1.1. *Map of the Petén Lakes region, showing relative site hierarchies (size of triangle) based on monumental architecture, stone monuments, and settlement sizes.*

secondary, and tertiary centers that are identified quantitatively, such as by settlement size, number of courtyards, size and number of public buildings, and number of stela monuments. In addition to temporal dynamics, variability across the Maya area existed at any given time: a number of polities possessed three-tier settlement hierarchies but may have been relatively independent of strong, four-tier regional polities centered at primary or regional capitals, such as Tikal, Calakmul, and Caracol. Compared to the large regional capital of Tikal, for example, Motul de San José is considered a secondary capital because its ceremonial core area is only approximately 1.4 sq km, with a total of 230 structures. Its larger settlement has been designated as approximately 4.2 sq km, encompassing its site core and some of its smaller surrounding settlements (Foias and Emery 2012; Moriarty 2004: 30). While Motul's smaller surrounding settlements are considered secondary and tertiary centers in the Motul de San José settlement hierarchy, with Motul de San José as the primary center, such hierarchies would have shifted down once Tikal exerted political influence over Motul de San José (figure 1.1).

In turn, polities of different size may have been allied with one another then shifted alliances or dependencies within a generation or over several generations. These more subtle political changes are understood primarily through hieroglyphic texts, which document relative levels of political positions and their relations, such as references to some of the highest-ranking rulers, *k'uhul ajaw* (divine lords), and their relationship to *ajawob*

(expressed as *yajaw*, the lord of a higher ranking ruler), to *sajalob* (expressed as *usajal*, the noble of a higher-ranking ruler), to *lakam* (lower-level administrative officials), or to other noble and subordinate elites (Lacadena 2008; Martin and Grube 2000; Schele and Freidel 1990; Stuart 1993). For example, although Motul de San José rulers held the title of *k'uhul ajaw*, Motul de San José's Stela 1 records the accession of Ik' ruler Yeh Te' K'inich in 701 CE as occurring under the auspices of Tikal ruler Jasaw Chan K'awiil (Martin and Grube 2000: 45–46; Tokovinine and Zender 2012). As at Motul de San José, written texts reveal that other prominent centers along the chain of lakes just south of Tikal, such as Zacpetén and Ixlú, were also subordinate to Tikal at one point or another during the Late Classic period (ca. 600–900 CE) (Martin and Grube 2000: 49; Rice 2004: 144–167).

These demographic and settlement perspectives on the state marry well with "building-block" approaches to household archaeology (Pauketat 2000a). Like Aristotle's conception of *oikía*, the internally diverse Greek household as the minimal building block of the *pólis* (Weissleder 1978), archaeological reconstructions of households and kinship systems often consider these small social units to be the foundational components of archaic states. Similar to the culture totality approach taken from artifact styles as reflections of polities, building-block approaches often suffer from the portrayal of households as static, homogeneous segments of society that lack influence or agency (Binford 1964; Clark 1972, 1977; Marcus 1983, 2000). That is, their diversity in terms of age and gender, kin and nonkin relations, and large and small household sizes is of no consequence. Furthermore, their basic composition and cultural traditions are conceived as existing relatively unchanged despite political developments or crises (Iannone 2002).

With the growth of household archaeology, however, scholars have underscored the tremendous complexity of social and economic life centered around the physical remains of residential architecture (Ashmore and Wilk 1988; Hendon 1996; Robin 2003; Wattenmaker 1998; Wilk 1989; Wilk and Rathje 1982). Households are not just places where activities and labor are coordinated. They serve as a foundational social realm for the production of gendered, age, ethnic, and class identities. They can be the foci for linking ancestors with their descendants and, in turn, connecting descendants with land and material possessions (McAnany 1995). Households form the material embodiments of localized memory-making, anchoring family histories and social ties in time and space (Hendon 2000,

2010; Lucero 2008; Waterson 2000). Yet household studies can create a sense of disconnect if the analytical focus dwells on only a small sample of households in which broader patterns within and between households and other forms of social organization are not examined (although see Ashmore et al. 2004; D'Altroy and Hastorf 2001; Pauketat 2000a, 2003; Robin 2003; Yaeger and Canuto 2000). This problem of disconnect occurs equally in formulations of the state when the analytical focus dwells exclusively on ceremonial and administrative site cores and the material culture and written texts deriving from these realms.

THE STATE AND HOUSEHOLD DIVIDE

Looking at the other side of the state's contradictory nature, one may also refer to the state as quite separate from kin relations, domestic life, and the household. As Timothy Mitchell (2006 [1999]: 173) notes, "State-centered approaches to political explanation presented the state as an autonomous entity whose actions were not reducible to or determined by forces in society." Rather, the workings of the state can be seen in terms of political officials and institutions, regardless of whether they are the highly formalized bureaucracies described by Max Weber or the non-Western political formations documented by twentieth-century ethnographers. In early modern Europe, for example, the state was equated with royalty and exemplified in King Louis XIV's remark "l'état, c'est moi" (I am the state) (A. Smith 2003: 85). In describing the nineteenth-century Balinese theater state, Clifford Geertz remarks that its royal court and political capital is "not just the nucleus, the engine, or the pivot of the state, it *is* the state" (Geertz 1980: 13, emphasis in the original). In turn, village life was quite separate from the state: "Though dynasties, kings, courts and capitals came and went, a procession of distant spectacles, the unpretentious villager, hardly conscious of changing masters, went on, exploited but unchanged" (Geertz 1980: 45).

Geertz's description of the Balinese state parallels what Robert Redfield, among others, has termed "Great and Little Traditions" to describe cultural divisions in contemporary societies (Redfield 1952, 1956). The Great Tradition represented the culture of "the reflective few": the refined, socially complex, educated, and civilized individuals living in cities. It is the political core and the center of state life. In contrast, the Little Tradition was characteristic of "primitive," "peasant," or "folk" society, consisting of the "unreflective many": the unrefined, homogeneous, and

uneducated peasants living in the countryside (Redfield 1952, 1956: 68–71). The Little Tradition was seen as bounded, isolated, and static. When culture change occurred (in the form of technological innovation, economic growth, artistic creation, and political development), it emerged from the Great Tradition and eventually trickled down to the Little Tradition.

Similarly, the identification of the state in archaeology often centers on the material manifestations of political institutions, rulers, royalty, and political officials, such as stone monuments, royal tombs and elite burials, prestige goods, monumental architecture, and collective labor projects (Flannery 1999). Like the claim of King Louis XIV, ancient rulers also manifested a "body politic" in their statements of an all-encompassing status: as embodying their political territories, the universe, and the members of the larger community (Gillespie 2008; Kristan-Graham 1989). Narmer's palette (a carved stone piece dating to the 31st century BCE), perhaps one of the most commonly cited examples of an ancient body politic, portrays Egypt's first pharaoh with the white crown of Upper Egypt and the red crown of Lower Egypt, demonstrating in a single body his succession and control over both territories.

Stone monuments were the embodiments of historic rulers in the Maya area, and their construction and dedication marked their accessions and claims to power (Clark and Colman 2008; Gillespie 2008; Houston et al. 2006). They also signified the ebbs and flows of entire political systems: political instability is inferred from a pause or cessation in monument carving and erection (Demarest et al. 2004). On a more intimate level, stone monuments were more than just durable signifiers of political power; arguably, they formed extensions of royal personhood. As Stephen Houston and David Stuart (1998: 90) remark, "Such representations operated not only as memorials of matters of record and of participants in them but as embodiments or individual presences of the ruler, who thereby effected the extraordinary trick of being in several places at the same time."

Beyond iconic representations of political leaders, state power is also commonly equated with public architecture, palace complexes, large-scale agricultural and road systems, and objects produced with large sums of labor (DeMarrais et al. 1996; Flannery 1999). Political leaders and institutions are deemed responsible for the knowledge behind and mobilization of such elaborate works. It is the people of high office who receive recognition in building the city, the palace, and the pyramid, not the contributing laborers, artisans, engineers, and supporting families (who

pay tribute and house and feed laborers) (Helms 1993: 77–87). In this sense, spectacle and grandness are often seen as a *result* of particular types of political power rather than the making of it (cf. Grove and Gillespie 1992; Patterson 1999b; Pauketat 2000b).

On another level, the contradiction of a strict state and household divide is evident in the palace itself. Sometimes seen as the seat of political authority, royal or governing palatial complexes combined residential household activities, such as sleeping, eating, cooking, raising children, and engaging in crafts production, with ceremonial and administrative functions (Evans 1998; Gilchrist 1999). In the Maya area, palatial complexes possess labor-intensive stone vaulted architecture, multiple courtyards, and diverse degrees of accessibility (e.g., open halls or rooms with large doorways and more secluded rooms entered only through several passageways). For example, the royal palace at Motul de San José, Group C, was a complex of vaulted masonry buildings formed around seven interconnected courtyards. Building construction was over 65,740 m³ in volume, towering over the other elite residential complexes at the site (between 10,600 and 6,796 m³) (figure 1.2). These data in combination with iconography and textual sources indicate that Late Classic Maya palaces were heterogeneous households, likely incorporating both kin and nonkin (such as servants, visiting nobles, court officials, and entertainers) (Inomata 2001a; Inomata and Houston 2001; Jackson 2009). The social diversity of royal courts and their ability to engage in larger-scale and more diverse types of activities than other households underscore the variable political tensions and sources of competition that underwrote social change (Halperin and Foias 2010; McAnany 2008).

Nonetheless, ancient written texts can also reinforce state and household divides in their emphasis on the exploits of ruling lineages, warfare and political conquests, and the cosmological and sacred sanctions of rulership. Classic period Maya hieroglyphic texts have generated a wealth of knowledge regarding royal and noble participants of political life. Chronological ordering of rulers from each polity reveals microhistories rarely glimpsed among state systems in the Americas. These decipherments have been instrumental in identifying the networking relations between polities and in substantiating both decentralized and centralized political models of the Maya state as predicated on particular regions and periods. The resulting picture is a shifting network of multiple competing centers of varying scales of power and size whose ties fragmented and formed over time. Not all sites, however, have yielded textual data; large swaths

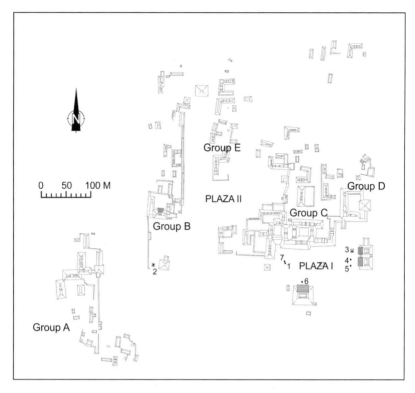

FIGURE 1.2. *Map of Motul de San José's Site Core, showing elite residential groups in relation to public plaza spaces, ceremonial architecture, and stela monuments (identified by numbered dots) (courtesy of Proyecto Arqueológico Motul de San José).*

of sociopolitical groups of varying degrees of political prominence lack textual voices. As I reveal throughout the book, ceramic figurines help fill in these silent spaces by revealing economic and social networks forged not just between elite royal households but between elite and commoner households and between settlement site centers and peripheries.

The problem with a strict state-household divide is that the state is either given too much power, as all agency derives from the top, or not enough power, as too much of a separation of state and society would suggest that the state could not produce any real effects (Mitchell 2006 [1999]). For example, the cultural model of Great and Little Traditions has been critiqued for its treatment of peripheries or folk culture as passive, for its basic assumption that economic "progress" stems only from the cultural elite, for its perspective on culture as bounded, and for its

reliance on a simplistic dual model of society (McAnany 2002; Mintz 1953). The approach taken here is to consider the types, degrees, and points of their articulation.

ARTICULATING STATE AND HOUSEHOLDS:
RELATIONAL APPROACHES

A relational approach to exploring the state is by no means novel within the social sciences. At its core is the idea that sociality emerges at the points of interaction. It follows anthropological emphases in articulating the global economy with local developments, resistance, and ethnogenesis (Kearney 1995; Lederman 1998; Nash 1981; Ong 1987; Vélez-Ibáñez 2004). In feminist and postcolonial studies, social identities are formulated at the articulations of social groups. Borders and peripheries are places of culture creation and innovation, rather than places where traditions are passively handed down (Joyce 2004; Nonini and Ong 1997; Patterson 1999a: 177–180). As Homi Bhabha (1994/2004: 2) writes, "It is in the emergence of the interstices—the overlap and displacement of domains of difference—that the intersubjective and collective experiences of nationness, community interest, or cultural value are negotiated." In archaeology, a new turn to state interactions, culture contact, and core-periphery relations challenges isolationist perspectives (Jennings 2010; Lightfoot and Martinez 1995; Parkinson and Galaty 2009; Smith and Berdan 2003; Stein 1999). In addition, there is growing interest in relationships of authority that are played out in the inscription of, experience, and performance in political landscapes, such that states are seen less as teleological and absolutist categories and more as a series of networks that are continuously produced and contested (A. Smith 2003; M. Smith 2005).

It is not my intention to explore broad regional or "world system" state interactions in this book, however; nor is it my intention to focus solely on political relationships created and experienced through the imposing constructions of the palace, road, or monument. Instead I focus on more ordinary material culture and on closely configured social relations among elite, noble, and commoner households, between genders and ages, among different urban and rural communities within a polity, and among closely located polities. My analysis skirts between what may and may not be considered political to highlight the elusiveness of such boundaries. As I outline below, discussions of these articulations have grown out of intellectual scholarship on political economy and ideology.

Political Economy

Political economy includes the political tensions and negotiations of social groups in relation to production, exchange, and consumption—a process that creates and reconfigures the materiality of representations (Patterson 2009; Roseberry 1988; Wilk and Cliggett 2007: 94–113). I take "political" in the term "political economy" to encompass historically contingent relations of power that shape and are shaped by the activities of making a living and other material-focused pursuits. In classical Marxist analyses, class is not a quality of an individual or group (e.g., how much wealth one possesses) but of groups of people identified *in relation* to the means of production (Marx 1990; Wolf 1982).

Similarly, for Christine Gailey and Thomas Patterson (Gailey 1987a, 1987b; Gailey and Patterson 1987; Patterson 1985, 1986, 1991, 1995; Patterson and Gailey 1987), the state is never a static entity but a process formulated through the relationship of its members. While state formation is often explained in terms of class (the emergence of class as the origins of the state, the nature of class relations as defining the typologies of state organization), it also encompasses other relations, such as between genders, with peripheral kin-organized groups "outside" the margins of the state, with other states, and among elite and nonelite factions. In this sense politics is not inherent to a particular ruler, state official, institution, or class of people but manifests from the contradictions, tensions, and collaborations among various individuals and collectivities.

Archaeological investigations of political economy have often revolved around the identification of highly or poorly integrated economies (Blanton et al. 1996; Claessen and van de Velde 1991; D'Altroy and Earle 1985; Earle 1997; Feinman and Marcus 1998; Foias and Emery 2012; Smith 2004; Trigger 2003). For example, some have suggested that relatively stronger and more expansive states (e.g., territorial or regional states rather than city-states or segmentary states) rely more heavily on wealth finance (currency or goods that can be converted into staples) than on staple finance (utilitarian items, foodstuffs). Wealth is storable, more efficiently transportable, and thus can support administrative hierarchies over larger areas (D'Altroy and Earle 1985). Likewise, centralized states possess high levels of integration, organized around a complex, hierarchical bureaucracy (reflected in infrastructure and settlement scales and hierarchies) as well as highly coordinated distribution systems such as markets and redistributive networks. In decentralized states, political elites play less of

a role in coordinating production and distribution, because the political structure is often highly redundant (e.g., with multiple coexisting polities) (Claessen and van de Velde 1991; D'Altroy and Earle 1985; Earle 1997, 2002; Johnson and Earle 2000). Clearly, these models are typological ideals that resonate with notions of the household as part of the state in the former case and a more divisive state and household separation in the latter case.

Early conceptions of the Maya state have often teetered back and forth between a centralized model with households as intimately part of state action or decentralized with the large majority of households as peripheral to state action (Fox et al. 1996; Lucero 1999; Potter and King 1995). Interpretations of the Classic Maya state as decentralized often view Maya society as consisting of a two-part economic system (Ball 1993; Foias and Bishop 2007; Masson 2002; McAnany 1989, 1993; Rice 1987). On the one hand, elites controlled luxury goods networks in a "prestige economy" or "political economy." Prestige goods were critical for legitimizing political power and reinforcing ties between elites. Control was facilitated by the monopoly of particular nodes of exchange or the knowledge and labor related to prestige goods production (through "attached production," the patronage of goods by elites, or the production of goods by elites themselves). Most households, however, are thought to have engaged in a subsistence economy that was relatively decentralized in nature and autonomous from political elites. These economic pursuits are often described as motivated by efficiency and security, following models of "independent" specialization, in which producers procure goods for an unspecified demand crowd (Brumfiel and Earle 1987; Costin 1991; cf. McAnany 2010).

Alternatively, archaeologists cite evidence of complex settlement hierarchies, road networks, and regional markets as support for centralizing tendencies (Chase and Chase 1996a, 1996b, 2001a; Folan 1992; Folan et al. 2001). The capitals of these "regional" states include some of the largest Maya settlement sites, such as Calakmul, Tikal, and Caracol, whose broad political influence over and incorporation of other smaller polities is corroborated in statements in hieroglyphic texts. The implication is that social experiences and networks of even humbler households and peripheral settlements were tied to broader political, social, and economic formations. These connections, however, need to be tested at the household level.

As scholarship has grown, research on political economies has shifted to dynamic models in which Maya polities ebbed and flowed between

centralized and decentralized states (Iannone 2002; Marcus 1993, 1998a) as well as to the variability of political economic integration across space, with some centralized networks from Petén and the Usumacinta region working in tandem with decentralized political economies, such as in western (LeCount and Yaeger 2010; McAnany 1993) and northern Belize (Scarborough et al. 2003; Scarborough and Valdez 2009). These different political economic systems may have been loosely linked or operated largely in isolation from one another. As detailed in chapter 5, "Figurine Political Economies," figurine data also underscore variable and uneven political economies across the Maya area.

More specifically, however, how do household economies and compositions change with the development or disintegration of states? Although a diachronic analysis of Maya figurine political economies is beyond the scope of this book, these shifting forms of state and household relations are essential to consider. One of the most common ways in which many ancient states are seen to articulate with households is in the extraction of taxes, tribute, or labor, a process that has the potential to reconfigure kin-based relations of power, household labor contributions, and local community relationships (Elson and Covey 2006; Gailey 1987a, 1987b; Patterson 1985, 1995). For example, archaeologists have suggested that increasing state demands correlate with increasing household economic specialization (Brumfiel and Earle 1987; Childe 1951; Costin 2001). Tribute and market activities can be seen as interactive, feeding off one another in their mutual expansion (Brumfiel 1991a; Morehart and Eisenberg 2010). These correlations are not always universal (Smith 2004; Spielmann 2002; Wailes 1996), and different households or household members may contribute to and benefit from household specialization unevenly (Brumfiel 1991b; Halperin 2008a, 2008b).

For example, Christine Hastorf's (2001) paleoethnobotanical and stable isotope research in the Montaro Valley of Peru reveals that Inca state incorporation of local Xauxa peoples was accompanied by an increase in household maize production due to tribute demands. In turn, the increased agricultural labor requirements of Xauxa households during Inca rule served as a leveling mechanism, impeding local elites from promoting their political positions through feasting. In an earlier study, Hastorf also noted that Xauxa males and females experienced these changes differently, with greater participation of males than females in maize consumption during Inca rule. Because maize consumption (mostly through drinking *chicha*) was a central component of Andean feasting, Xauxa females had

become increasingly estranged from the political processes tied to food consumption (but not necessarily food production) (Hastorf 1991).

In contrast to the leveling mechanisms documented by Hastorf, socio-economic differences between households within a local community can also increase as state tribute or labor demands increase. In the U.S. American Bottom, "nodal" Mississippian farmsteads emerged and disappeared alongside the rise and fall of the large center of Cahokia (AD 1050–1200) (Emerson 1997). These nodal farmsteads were located alongside other rural floodplain farmsteads but differed from them in their physical proximity to public buildings and access to types of goods and symbolism similar to those found at Cahokia. Patricia McAnany (1995: 119, 2010: 136) argues that because larger Maya households could draw from larger labor pools, they could buffer state demands better than smaller households. As a result, these households and their architecture grew over time, whereby their status became recursively linked with their physicality.

Alternatively, local leaders could also gain a foothold within their communities by resisting state expansion, such as in the Ocotlán-Zimatlán subregion of Oaxaca, where early resistance strategies resulted in political autonomy from Monte Albán in the short term. Such resistance contributed to changes in Monte Albán's military and administrative strategies, which ultimately led to Monte Albán's conquest of the Ocotlán-Zimatlán subregion (Spencer and Redmond 2006). Another type of resistance includes "voting with their feet." Commoner Maya households abandoned their plots of land for better conditions elsewhere and arguably could force different political leaders to compete for their loyalties (Inomata 2004; Pohl and Pohl 1994). Their power to do so, however, was partly dependent on the availability of land and the types of ties that families had to their existing landscapes and communities. Small commoner households were the first to leave some areas of the Belize Valley at the end of the Classic period, while slightly larger and more established commoner households held on longer (Ashmore et al. 2004). These state and household relationships not only manifest as a series of demographic and materialist pursuits but are simultaneously intertwined with the performance and politics of ideology.

Ideology

As noted earlier, the conception of the state as an ideological project often denotes the existence of a cohesive totality (Abercrombie et al. 1980; Abrams 1977/1988). For example, as Henri Claessen and Peter Skalník

(1978: 21) note, "a common ideology exists [among early states], on which the legitimacy of the ruling stratum (the rulers) is based." Dominant groups legitimate their economic, social, and political positions by promoting a belief system that naturalizes such differentiation and renders such domination self-evident (Eagleton 1991: 5; Marx and Engels 1970: 64–66). This may occur through claims of divine sanction, juridical implementation of laws, the charisma of particular leaders, or the promotion of specific "traditions" that favor some groups over others (Weber 1964). Nonetheless, the ideology of social stratification, on the one hand, or of a bounded system, on the other, is better viewed as a process: the making and unmaking of social rules, traditions, and boundaries. In addition, claims of state legitimacy are not restricted to the agency of rulers but manifest as a negotiation or tension among multiple parties.

Antonio Gramsci referred to the consent to a dominant social and political order as hegemony. He was careful, however, to stress that this phenomenon emerges and is reproduced within particular historical contexts, rather than as an inherent or permanent condition (Adamson 1980: 170–172; Gramsci 1973: 235). He also saw the idea of a cohesive state as promoted through education, the church, and other activities in which ruling and nonruling classes alike participate (see also Althusser 1971). Thus, for him, the state was not just the government or the workings of an elite few but was also equated with civil society itself.

Michel Foucault also viewed modern power relations and the dissemination of state ideologies as diffuse, although he placed more emphasis on bodily performances (Foucault 1977, 1980). The state is embodied in the workings of everyday life, practices structured by the spatial arrangements of prisons, schools, and hospitals and by the timetables of modern industrial life. In contrast, Foucault finds state disciplinary tactics in eighteenth- to mid-nineteenth-century Europe to have been employed through the public spectacle of the scaffold: experienced by the masses as a large-scale political ritual. Nevertheless, Foucault's ancient and modern forms of state discipline are not strictly dichotomous: elements of both processes can be found in various societies past and present (Kertzer 1988; Valverde 2007). As argued in chapters 3 and 4, Classic Maya disciplinary practices permeated both public spectacles and household contexts.

State ideologies, however, are not always unconsciously inscribed onto the body, molding subjectivities and forming what Foucault calls the matrices of power/knowledge. James Scott (1976, 1985, 1990) questioned whether hegemony could ever really exist in its purest form; for him,

subordinate groups do not blindly follow an ideology of their subordination. Rather, they know when they are being exploited and when possible resist this exploitation through both overt actions, such as open revolt, boycotts, strikes, and demonstrations, and covert behaviors, such as sabotage, foot-dragging, clandestine tax evasion, pilfering, hidden rituals of aggression, humor, gossiping, and the engendering of their own subculture through myths and folk traditions. These covert forms of resistance are sometimes part of "hidden transcripts," operating in households, in forests, behind closed doors, and away from "public transcripts" where power relations between ruler and ruled are performed openly, such as parades, accession ceremonies, and state celebrations of religious or calendar events (Scott 1990). These covert forms of resistance have the appearance of ideological consent and business as usual for the underclasses, but they serve as an important means to demarcate their own sense of selves.

Archaeologists have explored the possibility of both overt and covert resistance by subordinated peoples, discussing the various ways in which commoners and other social groups participate in the reproduction of social relations (Brumfiel 1996a, 1996b; Joyce et al. 2001; Joyce and Weller 2007; Paynter and McGuire 1991; Schackel 2000; Silliman 2001). Elizabeth Brumfiel (1996a), for instance, has suggested that Central Mexican peoples contested Aztec state ideologies of male dominance through the production and use of female figurines, items often recovered from domestic spaces. Arguably, these ceramic figures offered an alternative and more positive commentary on gender relations from the context of household reproduction. Similarly, as Patterson (2004: 293) notes, while Ica nobility began to imitate Inca pottery styles during the fifteenth- and sixteenth-century Inca occupation of the Ica Valley, Ica commoners actively reproduced local Ica pottery styles in the face of such political changes. After the dissolution of Inca political control, Ica peoples, noble and common alike, revived the traditional Ica pottery styles and abolished Inca versions. As in the Ica case, the appropriation and reinvention of "tradition" is not specific to one particular group but is an active field of contestation, negotiation, and forgetting (Hobsbawm 1983; Mills and Walker 2008).

Susan Kus and Victor Raharijaona's research in central Madagascar emphasizes the complexities of such political tensions that emerge from what they call "the poetics of human practice" (Kus and Raharijaona 2001: 114). In relation to the sixteenth- to nineteenth-century Imerina state, they assert that "state ideology is neither an issue of facile appropriation of local symbols nor a straightforward imposition on local knowledge"

(Kus and Raharijaona 2000: 98). Using a combination of ethnohistoric, ethnographic, and archaeological evidence, they document the subtle ways in which state sovereigns interwove collective worldviews and local symbols with claims to their royal singularity. These practices occur through the durable media of stone monuments, tombs, and royal house construction, which seemingly possess a vitality of permanence. For example, the singularity of Imerina rulership is reinforced in the physical centering of the palace at the highest central point of the capital center, Antananarivo, and the location of this capital in the geographical center of Imerina in the same way that the central wooden pillar (*andry*) of Malagasy houses centers the activities and spatial arrangements of domestic life. The palace also possessed an *andry* of monumental proportion, 50 m high: it required the labor of 10,000 men to cut down, transport, and erect this immense log of wood. Processes of state co-optation, however, were juxtaposed against the resilience of local ritual specialists and common peoples who continuously reinterpreted state ideologies as part of ritual performances and everyday lived experience in the construction of their own homes, mortuary ritual linking them to their ancestors, and children's play and other quotidian activities conducted on top of stone monuments (Kus and Raharijaona 1998, 2000, 2001).

The Maya state also drew from both the house form and household practices for basic metaphors of state power. Temples for gods were modeled after the singular house form, and palaces consisted of multiple houses. As Stephen Houston (1998: 521) remarks in reference to the common house, "their familiarity makes them especially suitable for 'structural' replication, which acquires force through repetition and by its intelligibility to a large number of people." In terms of household practices, Lisa Lucero (2003: 544) argues that Maya rulers were able to "build and maintain an unequal relationship of sanctified rights and obligations" by adopting and expanding on ancestor rites and household dedication and termination rituals that were in place as early as the Preclassic period. She notes that while temple caches from the urban capital of Tikal contained greater quantities and more exotic caching items (e.g., jade instead of chert, obsidian eccentrics instead of obsidian blades) than those from both commoner and elite residences at the small hinterland center of Saturday Creek, Belize, structural patterns of the rituals were the same in both contexts. Buildings were animated through caching, lip-to-lip ceramic containers held cached contents of items that together may have represented a microcosm of the universe, and buildings were deanimated by

breaking and scattering objects over the structure. Indeed, archaeologists have documented similar symbolic expressions and rituals in a range of social contexts and temporal periods, in some cases documenting continuity that stretches from the Preclassic period to the present (Bozarth and Guderjan 2004; Lucero 2008; Mock 1998; Robin 2002: 255).

Yet despite these spatial and temporal commonalities, differences existed between elite and commoner rituals as well as between large public celebrations and more intimate household practices. It is important to examine these contradictions as possible points of contention and not only as the passive inheritance of "tradition." McAnany (1995), for instance, explores the appropriation of lineage-based Preclassic period ancestor veneration by Classic period rulers. Rather than representing household or lineage ritual writ large, however, she contends that kingship- and kinship-based ancestor rites were qualitatively different. Such differences were a prominent source of Classic period political tensions, as some of their burials were integrated into public pyramidal structures and glorified through iconography and the written word. She contends that kingship forces resulted in the centralization of power, a process involving the co-option and transformation of kinship practices and structures (McAnany 1995: 133).

Another example of the reworking of household practices for state ceremony can be seen in changes in sweat bath practices at some political centers in the Maya area. Architectural evidence of sweat baths dates as far back as the Preclassic period (Alcina Franch et al. 1982; Hammond and Bauer 2001). During the Classic period, as in earlier times, they are most commonly found within the confines of residential architectural groups, whether large palatial complexes or small rural households (Child 2007; Helmke 2006b; Sheets 2002). Ethnographic, ethnohistoric, iconographic, and epigraphic data indicate that sweat baths were used for curing ailments, giving birth, and ritual cleansing related to rites of passage. As such, they were an important domain of midwives.

Yet during the Classic period some sweat baths took on new meanings and purposes: at the site of Piedras Negras, Rulers A, 2, and 4 commissioned monumental sweat baths adjacent to other ceremonial architecture, ball courts, and dance platforms overlooking large open plazas (Child 2006; Houston 1996). At Palenque, monumental sweat baths were built in temples of the ceremonial Cross Group buildings but were symbolic in that they did not house actual fires or possess water drainage systems. Hieroglyphic texts indicate that the Palenque ruler K'inich Kan Bahlam II

commissioned the sweat baths and that they served as the sacred natal loci of the site's patron deities.[1] These monumental commissions, like those of royal tombs, privileged different values and authority structures than those built and used by typical households. Less clear, however, is if and how the authority and practices of midwives were reconceived with the appearance of monumental sweat baths. In order to complement some of the dominant perspectives deriving from monumental forms, the following chapters tease apart state and household relations from the vantage point of household media.

SUMMARY

On the one hand, the state is the sum of its parts, such as an aggregate of households or communities. On the other hand, the state consists of the political institutions and ruling elite of society. This contradiction underscores the dialectical relations by which states and households produce and redefine each other. Although they are manifested differently from one state to the next, all state formations involve some sort of interplay of this basic contradiction. How does this interplay appear, in what forms, and to what extent for the Late Classic Maya? In drawing on ceramic figurines as the primary body of evidence, I explore (1) the extent to which state-sanctioned religious practices and symbols were present within households, (2) the ways in which household media may have expressed alternative meanings and symbols than those of the state, (3) the diversity of political economic networks that included but also moved beyond elite-elite exchanges, and (4) the significance of informal, marginalized performances in the making of state and household.

MATERIALITY AND MIMESIS

I recognize that the concepts of state and household have no inherent fixity of meaning, organization, or composition but rather are socially and historically constitutive through a series of practices and their effects (Hendon 1996, 2010; Patterson and Gailey 1987; Pauketat 2000a; Sharma and Gupta 2006; Trouillot 2001). While boundaries among various social realms are sometimes arbitrary and porous, they are also drawn and redrawn through both habitual behaviors that are taken for granted and purposeful, strategic actions. These practices have effects in that they create representations (e.g., architecture, artifacts, iconography): material references for socialization, interpretation, and critique that feed into the production of further practices. In this sense physical objects and landscapes are not merely backdrops for the workings of state power and everyday household affairs but are the media through which these social entities and their participants take on meaning and crystallize in form.

In this chapter I explore concepts of materiality and mimesis as interpretative frameworks for thinking about the production of social relations. More specifically, how do material objects play a role in reflecting and defining states, households, and other social formations? Materiality highlights the social as emerging from human-object relations such that a study of an artifact or art object's meaning ultimately derives from an understanding of its context. At the same time, I would not like to lose sight of the object itself and its signifying capacity embedded in its form (its raw material, imagery, shape, and so forth), which influences where, how, and by whom it was produced, viewed, and experienced. Particularly helpful in thinking through this relationship between people and things is the concept of mimesis. Mimesis stresses imitation, emulation, and reproduction as ways in which social identities are formulated on previous models, but it also allows for deviations and creative "plays" on

those models that reconfigure and comment on power relations. I draw upon ethnographic and archaeological materials from various cultural regions and time periods to help illustrate these ideas below.

MATERIALITY

Critical to the concept of materiality are two underlying premises. First, the material world recursively influences social experience and, as such, mediates social relations. Second (and related to the first point), meaning is not automatically attached to material objects or landscapes but is produced from the context-dependent interactions between people and things. While the use of the word "materiality" is relatively new (DeMarrais et al. 2004; Meskell 2005; Miller 1998, 2005), the idea of a recursive relationship between humans and the material world has roots in early scholarly thinking deriving from both economic and semiotic formulations.

In Karl Marx's (1973, 1990) political economic treatises, for example, he explores the recursive relationship between humans and nature through the process of production. In making things, we make ourselves. Through labor humans engage with and change the natural world and, in turn, simultaneously change themselves (objectification). Labor thus is an embodied process in which humans realize their own existence. It also creates new material conditions, however, such as the presence of monumental architecture or the installation of agricultural irrigation systems that affect subsequent productive processes and other human-nature, human-human engagements (Patterson 2003: 13–16, 2009: 57–63).

Although Marx was particularly interested in production as a critical component in the making of class relations, we can also appreciate how different forms of production are integral in identifying other types of social formations. For Jeanne Lopiparo and Julia Hendon, household-based crafting of ceramic figurines, whistles, and vessels was a way of reproducing household identities within the politically decentralized political landscape of the Ulúa Valley in Honduras during the Terminal Classic period (Hendon 2010; Lopiparo 2003, 2006; Lopiparo and Hendon 2009). Households at sites CR-80, CR-103, CR-132, and CR-381, for instance, engaged in molding ceramic figurines and firing the figurines at the last three of these sites. These productive activities were part of a larger cycle of domestic activities that included the use of these items in household rituals and the ritual destruction of both figurines and figurine molds.

The destruction of these items and the production tools to make them coincided with the interment of existing occupational surfaces over which new domestic buildings were constructed. Despite the use of molds for production, the types of figurine imagery created by each household were quite varied. As Lopiparo (2006: 146) states, "the creation of figurines at the household level—and the unique association of certain figures with specific households—indicates that the production of these figurines in particular was an essential practice in the re-creation of that house."[1]

In shifting from production to exchange, the work of Marcel Mauss (1990) engages with the concept of materiality in his emphasis on the ways in which material objects tie people together through webs of giving. Upon receiving a gift, a recipient has the obligation to return a gift. The obligations involved with giving, accepting, and receiving gifts derive from the intimate connections between people and things. For the Maori, gifted things were imbued with the *hau* or spirit of the owner. This embodied aspect of material things compelled the receiver to accept the object and return a gift. In this sense personhood can extend beyond the physical body and be embedded in the material world with which people interact (see, for example, Houston et al. 2006; Strathern 1988; Weiner 1992). Gifting creates alliances but can also produce hierarchical social relations, as relations of social superiority and inferiority accrue through cycles of debt. John Chapman (2000) incorporates this idea of gifting in his study of Balkan Neolithic figurine fragments (and other material culture). He argues that Neolithic personhood was constituted through social relations, which were created and marked in some cases by broken figurine fragments. These fragments, he contends, were purposefully broken and carried away by different parties as embodied parts of a large whole (the relationship itself). It is unclear, however, if these relations were reinforced with other material exchanges or activities.

Annette Weiner (1985, 1992), in building on the work of Mauss, asserts that it is not the giving of objects that creates such strong connections between people and things. Rather, it is the keeping of an object that embeds some element of its owner into the material world. This is the process of making inalienable possessions: socially valued goods tied to people as a result of their intimate social histories (goods "consumption"). Inalienable possessions serve as forms of social memory, marking previous social histories while simultaneously producing the identities and relations of the people who engage with them. As Barbara Mills (2004) points out, inalienable possessions may help reinforce communal, heterarchical

relations as much as they may produce exclusive, hierarchical relations. For example, among Pueblo peoples in the U.S. Southwest, eleventh- to fourteenth-century altarpieces in the form of carved wooden masks, flowers, cones, and birds were collectively owned by ritual sodalities. She asserts that these altarpieces aided in the creation and legitimization of the prestige of sodality members, especially their leaders, who handled these items during rituals. Such hierarchical relations, however, could be subverted with an emphasis on the collective ownership of ritual objects or if they were cached, lost, or discarded, thereby breaking "their chains of authenticity" (Mills 2004: 248).

The studies of Marx, Mauss, and Weiner emphasize that the value of objects is produced in part through the historical relations between people and things enacted in the process of production, exchange, and consumption. In this sense economic value is not only the amount of skill or labor involved in production (labor value) or the amount of material return received in exchange for the object (exchange value) (Clark 2007a; Robb 1999). Changes in value can just as easily be created through the forgetting or severing of human-object histories in the process of alienation. Object history approaches, such as those by Arjun Appadurai (1986), attempt to chart some of these shifts in sociality and subjective desires surrounding commodities, items typically conceived of as immune from social influence.

One way in which recent archaeological research has engaged with materiality studies is in challenging the static dichotomy of prestige and utilitarian goods. Prestige items are typically considered to have been produced in centers (by attached specialists or elite producers themselves), to have served as markers of status and rank, and to have been restricted to elites who kept them for social and political display or exchanged them horizontally between elites to build alliances and expand territories (Brumfiel and Earle 1987; Friedman and Rowlands 1977: 220–224; McAnany 1989: 359). In contrast, utilitarian or subsistence goods, such as household tools and foodstuffs, served the basic functionalist goals of survival. Status as a "prestige" or "utilitarian" good, however, is produced through the social practices surrounding its production, distribution, use, symbolism, and aesthetics—in short, its social context. In turn, the identities and relations of those who acquire and use these items are changed in the process.

In some cases archaeologists have adopted the concept of social valuable to incorporate the shifting valuation of goods based on their social

contexts (Bayman 2002; Spielmann 2002). Kevin Vaughn (2004, 2005), for instance, finds that Early Nasca (ca. 1–750 CE) polychrome pottery was centrally produced at a regional center (Cahuachi) and may have been distributed by elites in the context of ceremonial feasts. Nonetheless, most polychrome pots could not be considered prestige goods in the traditional sense because they were widely consumed by outlying villages and by both high- and low-status households within these sites (approximately 55–60 percent of vessels from outlying village assemblages were polychrome pots) (Vaughn 2004: table 7.2). These data indicate that polychrome pottery helped build sociopolitical affiliations between Cahuachi and rural settlements that were reinforced on a daily basis in their residences and patio spaces.

Furthermore, the production of value does not always necessitate elite involvement, as is the case with prestige goods. John Janusek (1999) investigates the production of Tiwanaku social valuables in relation to what he calls embedded production. He documents the corporate organization of panpipe and serving vessel production and consumption during the Late IV and Early V periods (700–1000 CE). Janusek argues that their production and distribution were relatively autonomous from the Tiwanaku state and therefore could not be considered a form of elite-sponsored production typical of the manufacture of prestige goods. Nonetheless, neither could their manufacture be identified as fully independent, because producers were organized within specialized corporate compounds headed by local leaders. The products of these specialists were not available for anyone who wanted to barter, trade, or acquire them through gifting. They were distributed primarily within each corporate group and marked localized corporate relations—albeit still embedded within a broader Tiwanaku style (Janusek 1999: 124). Because Late Classic figurines do not fit neatly into prestige or subsistence goods categories, I turn to these contextual approaches in the following chapters to understand their social significance.

In addition to materiality's roots in economics, it has also grown out of semiotic studies that examine the effects of objects as part of a greater sign-producing system. These studies often react to or move beyond static sign-signifier relations espoused by Saussurean linguistics. For example, Charles Sanders Peirce's (1958) notion of semiotics took into consideration sign-making as a process (Preucel 2006). As a pragmatist, Peirce judged the meanings of signs through effects, and, as such, the relations between objects and people were critical in understanding meaning. Rather than

seeing a static and arbitrary relationship between a sign and its signifier determined by rule or custom, Peirce considered sign-making to be a web of interaction among a Sign, an Object, and an Interpretant. "Signs have the capacity to generate new signs since the Interpretant of one sign relation can become the Object for another sign relation and so on in a process of endless semiosis" (Preucel 2006: 55). In this sense the sign can be said to have agency: it influences the other components of the interactive web, not unlike the human and nonhuman networks of relations espoused by Actor Network Theory (Latour 2005).

Signs produce effects through resemblance (icon), through inference or causation (index), or through convention (symbol). These different ways of signification, however, can intermix. For example, the Statue of Liberty in general resembles a woman holding a torch but more specifically resembles other depictions of woman-torch figures in French and Italian paintings and sculptures that were symbols of liberty and freedom. The statue is indexical of France's relationship with the United States. France gave the United States the statue to commemorate the American Revolution. It has come to symbolize (although not necessarily in an arbitrary sense) many things since its erection in 1886, including the United States as a nation-state.

Alfred Gell (1998) draws from Peirce's work in suggesting that art, and material culture more generally, possesses agency as a result of its relation within a larger field of action consisting of people and things. Gell takes on Peirce's concept of the index (for example, smoke is an index of fire, a ceramic pot is an index of the ceramist who manufactured it, a weapon is an index of a soldier) to suggest that all elements of material culture work as indices because they are extensions of people. Art does not possess agency (the ability to affect and influence) as a result of any inherent quality. Rather, art's agency manifests as an "emergent quality produced from human-material relations" (Gell 1998: 21). For instance, a work of art takes on meaning within the context of social action, such as its production by an artist with particular skills, fame, and character; in turn, that work of art can create a response such as fear or awe in its recipient. The interaction of the recipient (whom Gell calls "the patient") with the piece further conditions new practices and meanings in subsequent human-object networks.

In an example from Neolithic, Copper, and Bronze Age Europe, John Robb (2008) considers the roles (or in Gell's terminology the "agency") of figural images in influencing further practices. Neolithic figurines from

the Mediterranean and Alps regions of Europe were infrequently and informally used in small-scale quotidian settings. Figurine iconography was extremely heterogeneous and did not derive from a particular prototype. Rather, Robb contends that figurine *practices* (their localized production alongside other ceramic items, their possible use within coming of age rites, and their discard with domestic debris) structured the repeated production and use of figurines rather than a desire to replicate a particular idea, person, or identity embedded in their imagery. In contrast to the heterogeneous and informal modes of expression among Neolithic social groups, the Copper and Bronze Age stelae from the same region were part of public gatherings. They possessed more formal attributes than the figurines, such as similar body proportions and the consistent depiction of weapons and sexual attributes. The monument's stylistic features served as the prototype, influencing other statue constructions and in turn the standardization of collective values, such as the memory related to particular ancestors. These two examples of human-object relations highlight two different forms of mimesis in the making.

MIMESIS

Mimesis complements our understanding of materiality by playing with linkages between material culture and practice, past and present, and reality and its appearances. Simply stated, mimesis is an imitation or the process of imitating. As such, it is a broad concept with widespread appeal in anthropology, aesthetics, biology, history, literature, music, philosophy, and the visual arts (Halliwell 2002; Ming Dong 2005; Potolsky 2006; Smith 2006; Taussig 1993). I find the concept of mimesis especially useful for the study of visual media and social relations in its consideration of both representation and practice and in its implications for power relations, with its emphasis on expressive creativity and agency deriving from both dominant and subordinate groups.

Representation and Practice

Mimesis dances between a tension of representation and the process of representing. It is a copy, an imitation, and thus a representation of something else. It draws on some form of similitude to make a connection between a copy and its template. While likeness can be visual, as in Peirce's icon, mimesis is broader in that it can encompass fleeting behaviors or performances, linguistic prose, sound, and even the metaphysical

(e.g., the Pythagorean notion that the material world is an imitation of the world of numbers or the material imitation of an intangible spirit or deity) (Halliwell 2002: 15). Analysis of mimesis from this perspective is often semiotic (in the traditional sense of "reading" a text), an attempt to understand the truly "real" behind its representation. In figurine studies, this often entails the identification of the identities and activities of anthropomorphic, supernatural, and zoomorphic figures depicted, on the assumption that these figures had real-world or spiritual counterparts (e.g., goddesses, gods) in the society and/or religion under investigation.

Copies, however, are never exact replicas. As Michael Taussig (1993: 52) phrases it, mimesis is "a copy that is not a copy." In this sense, the copy is simultaneously like and unlike the original. Early philosophical thinkers mused over this paradox, taking different stances on the extent to which mimetic forms resembled or needed to resemble their model. For example, Plato is known for his emphasis on the visual arts as a mirror of reality and as a form of searching for the representation's underlying truth. Nonetheless, even Plato recognized that some attempts of imitation were *phantasmas*, mere appearances (Halliwell 2002: 37–71; Ricoeur 2004: 16–20). Alternatively, the copy may be an interpretation of and commentary on its template rather than an attempt at perfect similitude. For Aristotle (2011: 15–19), for example, the meanings of the mimetic representation could shift, depending on the manner of imitating and changes in the sentiments of both artist and audience.

In this sense mimesis is also a process of emulating and therefore takes on a behavioral perspective of action and a phenomenological perspective on living experience. Aristotle viewed mimesis both as a representation (a product of intentional human artistry) and as a type of *techne* (craft, artistry) or *poiesis* (making) and thus included the process of producing mimetic forms as central to the understanding of mimesis (Halliwell 2002: 152–154). This aspect of mimesis is similar to Peirce's index in its emphasis on meaning-making, although it differs in its specific reference to a previous template or model rather than as an inference or causal deduction. Hence mimesis is a form of history-making. According to Paul Ricoeur (1998, 2004), historical inscription emerges as a dialectic between remembering and forgetting. That which is recalled or privileged in the form of a text or representation is a mimesis of previous action. The experience (via reading, listening, or seeing) of historical representations molds subjectivities and, in turn, informs further action. Judith Butler's (1993) version of this process, citationality, works largely unconsciously,

with bodily performances serving simultaneously as text and mode of experience in repetitive linked forms of mimesis.

Rosemary Joyce (2000b, 2003b) draws on Butler's notion of citationality to suggest that Preclassic period figurines from northwest Honduras were media used to objectify age-related identities through visual cues of figurine postures, dress, ornamentation, and hairstyles. The figurines served as embodied precedents, helping mold subjectivities that were actualized through everyday lived experience. The performance of these identities is inferred from skeletal remains and body ornaments identified in burials. Using these two lines of evidence, Joyce is able to highlight the interplay between representational forms and lived experience.

A number of other figurine studies have suggested that small figurative representations served as idealizations of social identities that were privileged and emulated as part of a larger social discourse (Bailey 1996, 2005; Blomster 2009; Brumfiel and Overholtzer 2009; Cook 1992; Joyce 1993, 1998, 2000a; Lesure 1997).[2] For example, Jeffrey Blomster (2009) finds that differences in figurine styles from Etlatongo, Oaxaca, Mexico, both reflected and promoted gender and ethnic identities that were integral in legitimizing increasing social and political hierarchies during the Early Preclassic period. Some of the principal forms were solid male and female figurines produced with local stylistic conventions and hollow, ambiguously gendered figurines produced using foreign stylistic conventions. In comparison with an earlier phase in which figurines were depicted predominately as females, a new visual distinction among male, female, and ambiguously gendered figures brought new social discourses to the fore at the end of the Early Preclassic period. In this sense they provide some insights into how early Oaxacan peoples negotiated and made sense of changing gender roles as well as of their relationships with ethnic groups from distant regions. I also consider the role of Late Classic Maya figurines as social ideals which were instrumental in both reflecting and constructing the complex social relations of rank, status, gender, and age.

In the case of the Classic Maya, written texts provide some clues to their own conceptions of mimesis. A common hieroglyphic phrase was "U-ba-hi" or *u-ba(h)* (Houston and Stuart 1998). While epigraphers have provided many interpretations of this phrase, it has been most commonly recognized as identifying an expression of selfhood or personhood, "his self" or "his person." What is most interesting is that these phrases often reference images or portraits of historic figures, such as carved stone diadems or monuments, wherein the textual caption functions as a type of

"name tag" for the mimetic image and links a person's sense of self with his or her representation (Houston and Stuart 1998: 81). This also appears to be the case for deities and their relationship to artistic renderings of them. Rather than presenting a "false" representation of the self, these mimetic forms are thought to share the very essence of the person or deity represented. As such, they are extensions of the self beyond either the confines of the human skin or the metaphysical manifestations of supernatural beings.

Royal figures also expressed their own sense of selves in relation to deities and other supernatural beings. In their impersonation of deities, a process sometimes undertaken through masking, they created tangible manifestations of the supernatural (Houston and Stuart 1996: 298–299). It is unclear, however, to what extent the ceramic figurines shared in the essence of their representations, because textual sources do not mention or label these objects. In the following chapters, I consider their relationship to social and spiritual essences by exploring conventions of their representational forms (for example, modeling and molding) and their treatment (such as use, discard, and destruction).

Mimesis, however, does not always reflect or create intimate human-object, human-human relations. Rather, mimesis may leapfrog through space and time, defying contextualization and linear development (Nagel and Wood 2010; Taussig 1993). The female bodily features emphasized in some Paleolithic and Neolithic figurines from one culture area may not have the same meanings (such as fertility) despite similarities in their forms (for example, pendulous breasts, large hips and buttocks) (Conkey and Tringham 1995; Lesure 2011; Meskell 1995). While some of the variations in the emulation of artifact styles occur as an unconscious replication of tradition within closely spaced time scales (the basis of evolutionary typologies with long linear sequences), much older artifact and art styles may be evoked as an archaism of a distant past. Likewise, artisans not under the political control of an empire may copy imperial styles, inadvertently making the imperial domain seem more powerful from an archaeological perspective (Patterson 2004; Pauketat 2001; Robb 2008).

Mimesis as process also has an emotive, affective dimension for both mimetic producer and audience. These effects can take many forms. Both Plato and Aristotle, for example, wrote about literary and theatrical tragedies of their day and the ways in which these works (as representations) reflected human perspectives on suffering while also arousing in their spectators sentiments of sadness, pity, and helplessness. In this sense

mimesis draws on and produces culturally specific aesthetic systems. While it is difficult if not impossible to recover emotive responses in the archaeological past, durable mimetic productions such as figurines undoubtedly conditioned aesthetic dispositions. In an example from Early Postclassic Nicaragua, Geoffrey McCafferty and Sharisse McCafferty (2009) argue that figurines promoted local ideals of beauty, which included particular patterns of dental modification, tonsured hairstyles, bulbous legs, and headbands of various local significance. These bodily aesthetics continued, at least in the depictions of the figurines, despite the migration to this region of Central Mexican peoples whose aesthetic understandings of beauty were quite different.

In some cases the simultaneous merging of likeness and difference in mimesis promotes new ways of perceiving the world. For Aristotle (2011: 17), the emotive experience of mimesis is a form of learning: "the reason why men enjoy seeing a likeness is, that in contemplating it they find themselves learning or inferring, and saying 'Ah, that is he.'" For Michael Taussig (1993: 13) it is an "embodied way of knowing." Walter Benjamin (1969 [1936]) finds that photography and film, unlike sculpture or painting, create a profane illumination, an alternative version of the world that allows the viewer to see reality differently. This is a form of disembodiment, in which a mimetic connection with such common and everyday reality makes viewers momentarily step outside themselves and see themselves and their world anew. Douglas Bailey's study of Neolithic figurines (2005), for instance, examines the psychological effects of seeing and handling mimetic versions of the human body through an analysis of size reduction (miniaturization), abstraction, and compression. Despite the inability to verify such emotive responses in the archaeological record, these matters of scale, along with other lines of evidence, not only help us recognize the phenomenological import of material engagements but provide points of comparison for assessing how different types of media (e.g., reduced scale vs. life-sized) were treated and manipulated in the past.

Power Relations

Mimesis is implicated in power relations because the making of representations is a way to order and define the world. Mimetic representations assert a particular way of thinking, feeling, and enacting. In some cases, as discussed above, mimetic forms can help unlock what Benjamin (1969 [1936]) calls the "optical unconscious," allowing people to see the structures that shape their lives. At the same time, power may be enacted through

a politics of representation in which some representations are controlled and privileged above others, giving conceptual weight to particular social groups and their associated practices. Importantly, however, mimesis also resists containment, providing space for appropriation, reinterpretation, and revision. This flexibility underscores some of the nuances in which social groups may play off one another in forging a place in the world. While archaeological discussions tend to focus on power as inherent to leaders and dominant social classes, mimetic power plays are enacted by both the dominant and the subaltern.

Taussig highlights some of the ways in which the Kuna of Panama reinterpret and subvert dominant Western discourses through mimesis. One of his case studies centers on Kuna *nuchus*, wooden curing figurines. They are kept in boxes within the household to protect the household members from spirit intrusions (Salvador 1997: 44) and employed in rituals to cure illness. Larger versions may be used in community rituals to remedy spiritual disturbances of large numbers of people. They are carved in the form of "European types," in the guise of white males outfitted with top hats and Western clothing. In some cases, they may even reference particular historical figures, such as U.S. general Douglas MacArthur. Despite their external appearance, it is the balsa wood itself from which the spirit or soul of the figure derives (Taussig 1993: 8). In this sense the figure exhibits a dual force of external alterity and internal familiarity. Taussig argues that the process of copying the image of a European male is a form of Othering, creating and defining distance between Kuna and non-Kuna. At the same time, the ulterior power of the European male is tapped through physical likeness and subverted to meet the needs of Kuna healing and spiritual assistance. Thus not only do we see agency of the Kuna, but a traditional politics of representation is turned on its head. Furthermore, the imitation has the power to affect its template, as Taussig points out: why else would he (and other Westerners) be fascinated with his own illumination in a Kuna figurine?

Another way in which mimesis shakes the foundations of dominant ideologies is through the imitation of dominant groups through humor, clowning, and ridicule, as I discuss further in relation to Maya trickster and grotesque figurines in chapter 4. The mockery of social and cosmic orders creates a temporary disordering of structure through which dominant relations are produced. These forms of mimesis serve as social commentary, as in medieval carnivals in Europe in which the social fabric of order was mocked as royalty and clergy mimicked beggars, the

poor mimicked the rich, and common people threw excrement at church officials and nobles (Bakhtin 1984). Likewise, during Maidu ceremonies in California, Native American ritual clowns continuously interrupt the proceedings of the shaman's performance by parodying his speech and gestures (Tedlock 1975). The excesses of carnival and ritual clowning are often critical for social and cosmic renewal. Such ritualized imitation and joking allows the "hidden transcripts" of common peoples to surface, in which normally oppressed behaviors, speech, and aggression are permitted (Scott 1990: 162–182). Emulation, in this sense, is not necessarily a form of social mobility: an attempt to go from poor to rich, from fool to shaman. It is a way of disrupting the social categories and orders that confine us.

The politics of mimesis is also about controlling the mimetic faculty (see the discussion in chapter 4 in relation to certain Maya deities). Dominant groups feel the need to repress the mimetic faculty, which speaks to the subversive power that it unleashes as well as the ability of the copy to affect its template. One often-cited example of such repression is the attempted banning of the Hauka movement in Ghana during the nineteenth century (Stoller 1995; Taussig 1993: 240–243). This movement emerged in West Africa during French colonial rule. It consisted of public spirit possession rituals in which West Africans mimicked and embodied French colonial officials during trance. Through this performative process, the Hauka tapped into and parodied the horrific and cruel power of the French, with their ability to inflict pain and to regulate everyday lives. Colonial (and later postcolonial) officials fervently tried to extirpate these spirit possession practices, which were seen as a threat to French authorities. As Paul Stoller (1995: 119) notes, "the Hauka became outlaws who make outlaws of those who outlawed them." Again, dominant groups do not hold a monopoly on esoteric representations and restricted mimetic forms, and the interplay between restriction and appropriation is enacted as a complex web of emulations that define and redefine social boundaries. In exploring these mimetic engagements, I first turn to the emulation of state symbols in small-scale form as one of the ways in which Maya conceptions of state power were disseminated and negotiated.

STATE POMP AND CEREMONY WRIT SMALL

State pomp and ceremony does not completely disappear at the exits of large plaza areas or at the end of the calendar cycle framing key religious, political, and ceremonial events. Landscape studies underscore the enduring presence of temple pyramids and other monumental landmarks that tower into the vistas and consciousnesses of local peoples as they go about their everyday activities (Brady and Ashmore 1999; Delle 1999; Kus and Raharijaona 2000; Robin 2002: 260–261). Economic analyses reveal how ceremonial occasions help mediate goods production and circulation, such that objects move into and out of the domains of household and public spectacle (Halperin et al. 2009; Rappaport 1984; Vaughn 2004; see chapters 5 and 6).

This chapter examines the ways in which figurine images from sites throughout the Maya area portray aspects of state pomp and ceremony with a particular focus on anthropomorphic figures (appendix 3.1).[1] I interpret these mimetic representations as idealized social categories, which reflected and reinforced some (but by no means all) of the social identities that Late Classic Maya peoples experienced personally, interacted with, or understood through oral narrative and other visual media. I also document distribution analyses of the figurines, particularly at the site of Motul de San José and environs, where detailed contextual data are recorded, to explore how state symbols and other images evoking ceremony and spectacle penetrated into elite and commoner households.[2] In this sense I explore the possible contexts in which figurines and their associated meanings were consumed and interpreted. These distributional data suggest that state ideologies and symbols were part of the everyday discourses of and ritual implements used within households.

Large-scale imagery, particularly stone monuments, however, depicts a rather narrow view of state pomp and ceremony. As Takeshi Inomata

states (2006a: 818), "the strong emphasis on rulers found in stelae indicates that, symbolically and often physically, at the center of public gatherings was the body of the sovereign. Rulers were at once the sponsors, organizers, and protagonists of many of the large theatrical events." In commenting on the gendered aspect of performance, Matthew Looper (2009: 49; emphasis in the original) remarks: "In Maya art, masks are exclusively worn by men, suggesting a strongly gendered aspect of their use. In fact, *all* of the specialized dance costumes and attributes are linked to male performance." In some senses figurines reinforce these class and gendered ideals by replicating gendered social divisions and specialized performative roles in small-scale form. At the same time and as a source of contradiction, figurines also challenge these more formal representations of Classic Maya ceremonial participation and social expression by offsetting them with a wider diversity of gendered, age, and status identities (Joyce 2000a). In following a strict state-household analytical separation (as discussed in chapter 1), these figures can be interpreted in two ways: as external to state ceremony and office or as marginalized but essential participants in the workings of royal courtly life, state ceremony, and political rule. As I demonstrate below, however, they often lie at the intersection of these dichotomies.

Because of their tendency to focus on single figures, figurine media lack the narrative scenes and contextualizing imagery present in polychrome pottery, lintels, murals, carved stone panels, monuments, and altars. Nonetheless, they possess a series of visual cues that can be used to infer social identities, relations, and contexts. I pay particular attention to headdresses, clothing, and other ornamental features. The focus on headdresses is useful because figurines (particularly molded figurines) do not portray individualizing facial characteristics; nor do they take on the fluid and expressive poses seen in painted media. Figurines are often recovered as fragmentary specimens, so an entire ensemble of clothing, footwear, ornamentation, accoutrements, pose, and headdress is not always available for identification (heads can also indicate the minimum number of specimens). Moreover, in Mesoamerica as in other parts of the world, the head was a focal point in distinguishing social and personal identities (Houston et al. 2006: 60–72; Houston and Stuart 1998; Joyce 2003b). Headgear was a central locus for embedding personal names and signifying rank, title, and social affinity (Bassie et al. n.d.; Coe and Kerr 1998: 92; Martin and Grube 2000: 77; Reents-Budet 2001: 217; Van Stone 1996).

As a form of embodied mimesis, the act of wearing headdresses, clothing, adornments, masks, and body painting/tattooing was a form of becoming: facilitating spiritual transformations, states of being, and the acquisition of political office (Guernsey 2006; Houston et al. 2006; Houston and Stuart 1996, 1998; Schele and Miller 1986: 66–69).[3] Not only symbols of social position, they also served as the conduits and mode of negotiating power, spiritual forces, and identity.

RULER FIGURINES

One of the most common iconographic themes that depict state ceremony shows rulers with fan-shaped feathered headdresses.[4] In figurine media, these headdresses are miniature, simplified versions of more elaborate feather headdresses worn by ruling elites with titles such as k'inich, k'uhul ajaw, and kaloomte' found on stone stela monuments, sculpture, lintels, large effigy incensarios, and other media (Halperin 2004b, 2009c; Taube 1992b, 2000b; Willey 1972). While perhaps inspired by these monumental versions as well as by real-life historical figures and their headdresses, ceramic figurines could produce and perpetuate a notion of rulership both outside the confines of civic-ceremonial site cores and beyond ethnic and political boundaries.

The ruler figurines with fan-shaped feather headdresses often possess a supernatural or zoomorphic mask at the center of the feathered sprays. In addition to these two features, other headdress accoutrements were present but were often depicted in a relatively compressed, simplified form. In their monumental counterparts, these accoutrements include braided mats or cloth knots, scrolls, serpent wings, venus symbols, glyphic inscriptions, beaded jewels, shells, jester god heads, and other motifs, some of which symbolized the personal names, family affiliations, titles, and other identities of the headdress owner. Because many of these nuances were not present among the figurines, it is likely that ruler figurines were not individual portraits but broad references to rulers, royalty, and rulership more generally.

A common central face or mask among these figurines is the War Serpent (waxaklahun ubah chan, "18 its image serpent"), which is identified by platelet skin, an upturned snout (sometimes with a conch shell "breath" or feathers emanating from it), and large reptilian eyes. War Serpent imagery is closely associated with individuals possessing the highest-ranking royal titles (k'inich, k'uhul ajaw) and those that hold accoutrements for war

(figures 3.1, 3.2, 3.3c, 4.2a).[5] Arguably, one of the earliest manifestations of the War Serpent is as a zoomorphic platelet headdress on the sculptured façade of the Temple of Quetzalcoatl (Taube 1992b, 2000b; cf. Sugiyama 1989, 1993: 114–116, 2000) as well as among figurines from Teotihuacan and Oaxaca dating to the beginning of the Classic period (Caso and Bernal 1952; Linné 1942; Martínez López and Winter 1994). Such widespread patterns indicate that symbolic canons of state power were similarly produced

a b

FIGURE 3.1. *Monuments depicting male rulers with War Serpent headdresses: (a) Chan Muwan, Bonampak Stela 3 (after Mathews 1980: fig. 4); (b) K'inich Yo'nal Ahk II, Piedras Negras Stela 7 (courtesy of the Peabody Museum of Archaeology and Ethnology, Harvard University [04.15.6.19.20]).*

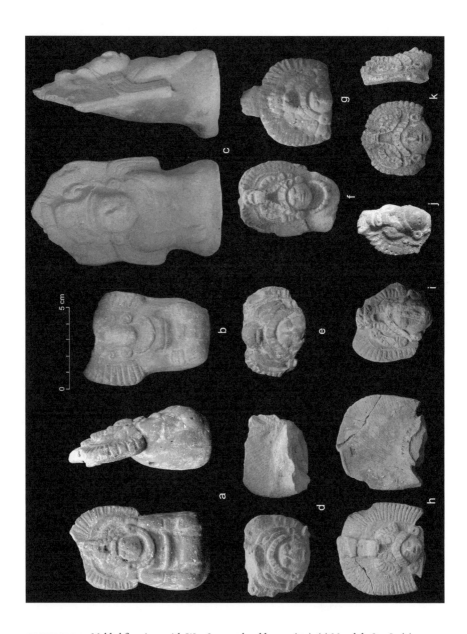

FIGURE 3.2. *Molded figurines with War Serpent headdresses (H9): (a) Motul de San José (MSJ2A-3-11-1d); (b) Altar de Sacrificios (Museo Nacional de Arqueología e Etnografía, MUNAE7890); (c) San Clemente (SCFC010); (d) Nixtun Ch'ich' (NC003); (e) Motul de San José (MSJ15A-34-2-3a); (f) Nixtun Ch'ich' (NC006); (g) Nixtun Ch'ich' (NC119); (h) Trinidad (TRI10D-3-4b); (i) Uaxactún (MUNAE4584 X9); (j) Tikal (290-2); (k) Motul de San José (MSJ45C-1-1-1a) (note: the scale bar applies to all; d and e are eroded but identical; all photos by author).*

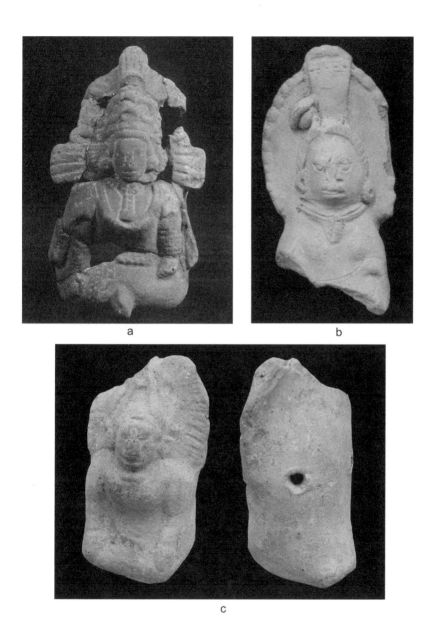

FIGURE 3.3. *Molded female figurines with fan-shaped feathered headdresses* (H9):
*(a) Aguateca (FG1223; 01-20A-39-3-1; photo courtesy of D. Triadan); (b) Altar de Sacrificios
(MUNAE9560; photo by author); (c) unprovenienced, Museo de Uaxactún, Guatemala
(photo by author).*

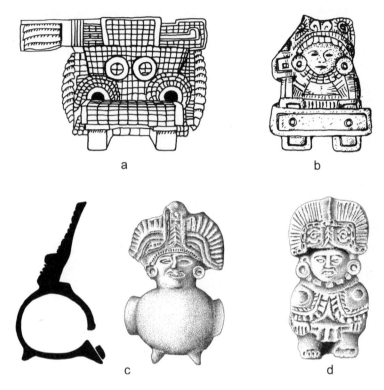

a

b

c

d

FIGURE 3.4. *War Serpent imagery from other regions of Mesoamerica: (a) detail of sculpted façade from the Temple of Quetzalcoatl, Teotihuacan, Mexico (drawing by author after Caso and Bernal 1952: fig. 184A); (b) Classic period molded figurine, Teotihuacan (drawing by author after Seler 1961: 476, fig. 87); (c) Classic period molded figurine-whistle, Monte Albán, Mexico (drawing by Luis F. Luin after Martínez López and Winter 1994: fig. 49b); (d) Classic period molded figurine-whistle, Monte Albán, Mexico (drawing by Luis F. Luin after Martínez López and Winter 1994: fig. 51f).*

throughout many regions of Mesoamerica (figure 3.4). During the Classic period in the Maya area, they were worn by Maya rulers portrayed in stone monuments, stone pillars, and wooden lintels from widely spaced sites in Yucatán and Chiapas, Mexico, Guatemala, and Belize (Clancy 2009; Schele and Freidel 1990: 159–161, fig. 4–25; Taube 1992b, 2000b). These rulers are often accompanied by other Teotihuacan-derived symbols, such as the Mexican year sign and goggle-eye imagery. After the decline of Teotihuacan during the Late Classic period, these representations were likely local Maya interpretations of rulership that incorporated foreign elements of power (Stone 1989).

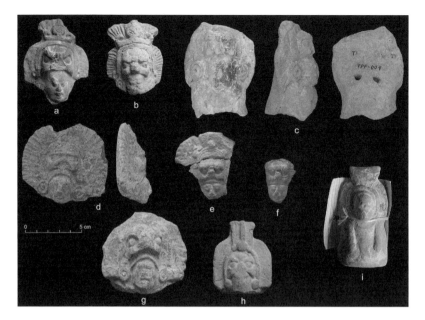

FIGURE 3.5. *Molded figurines with fan-shaped feather headdresses with deity/zoomorphic masks (H9): (a) Uaxactún (IDAEH Ceramoteca 3185 X1); (b) Uaxactún (IDAEH Ceramoteca 1712 X1); (c) Topoxté (TPFC004) (note: a, b, and c are likely identical but in varying states of preservation); (d) Motul de San José (MSJ2A-40-5-4b); (e) Nixtun Ch'ich' (NC009); (f) Zacpetén (ZP014); (g) Trinidad (TRI10D-3-3a); (h) Uaxactún (IDAEH Ceramoteca 4511 X1); (i) Tikal (20B-229) (scale bar applies to all; photos by author).*

Other fan-shaped headdress figurines contain a variety of supernatural masks.[6] They often possess large "god-eyes" and vary in terms of their associated headdress accoutrements (figs. 3.3a, 3.5, 5.27). God-eyes are large and square-shaped and appear on highly codified deities (Coe and Van Stone 2001: 109; Miller and Taube 1993; Schellhas 1904; Taube 1992a). Some may depict supernatural birds, identified by "serpent wings" at the sides of the face of the headdress (Schele and Miller 1986: 67–69). In Mesoamerica, the transformation into and impersonation of bird deities as a way to legitimize rulership have roots dating back to the Middle Pre-classic period and were especially prominent in the iconography of Late Preclassic period stela monuments from the Highlands and Pacific coast of Guatemala and Chiapas, Mexico (Guernsey 2006). One of the most famous of the Classic period bird deities is the Principal Bird Deity, the zoomorphic manifestation of Itzamnaaj, an elderly creator deity (Bassie 2008; Taube 1992a). Other variants include stacked versions of supernatural/

FIGURE 3.6. *Molded ruler headdresses with stacked deity masks (H9: figurine versions may be similar or identical to each other): (a) detail from Bonampak Stela 2 (after Mathews 1980: fig. 2); (b) Yaxhá (YXFC062); (c) Nakum (NKFC250); (d) Tikal; (e) Tikal (97A-147-57); (f) Zacpetén (ZP014) (photos by author).*

zoomorphic faces,[7] similar to headdresses seen on monuments from Motul de San José (Stela 2), Bonampak (Stela 2), and Yaxhá (Stela 31) among other sites (fig. 3.6). These follow symbolic conventions of multilayered cosmic and spiritual zones that interfaced with each other through vertical links (Freidel et al. 1991).

While some ruler figurines are depicted standing and holding shields, axes, and/or other war implements (e.g., Rands and Rands 1965: fig. 34; Schele 1997: plates 9, 11, 12; Willey 1972: fig. 27b), most are seated in stiff poses with both hands resting on their knees or legs (Halperin 2004b). This pose in combination with their large feathered headdress parallels large-scale sculpted roof-combs where rulers, seated on thrones, peer down into plaza spaces below as well as sculpted versions housed in the buildings themselves, such as Yaxchilán Structure 33 (fig. 3.7c). Such poses are also seen on rulers seated in palanquins (discussed below) or on perishable scaffolds (fig. 3.7b). Scaffold scenes likely took place on small platforms in the middle of large plazas and were tied to themes of kingly ascension, sacrifice, and the hunt (Clancy 2009: 29–32; Taube 1988). These Late Classic period poses recall Preclassic Olmec carved stone sculptures and figurines of rulers in similar poses (e.g., Río Pesquero greenstone figurine, La Venta Monument 77). They differ from royal court scenes, in

seated ruler

a

b

c

FIGURE 3.7. *Frontally faced, seated rulers with hands on lap: (a) molded figurine, Comalcalco periphery (drawing by Luis F. Luin after Gallegos Gómora n.d.: fig. 2); (b) accession scene of Ruler 4, Piedras Negras Stela 11 (courtesy of the Peabody Museum of Archaeology and Ethnology, Harvard University [04.15.6.19.35]); (c) reconstruction drawing of Yaxchilán, Str. 33, with seated ruler in roof comb (drawing by Luis F. Luin after Miller 1986: fig. 8).*

which the seated ruler's arm is often bent in front of the body, perhaps denoting his presence in front of a more intimate courtly audience (Stone and Zender 2011: 58–59).

Like their monumental counterparts, the ceramic figures are adorned with heavy jewelry, such as thick beaded necklaces (usually two or three strands thick and some with diadems or ornamental bars), thick beaded bracelets, and ear spools, although the iconography of ornament is reduced to its most simplified forms. Also in parallel with the monumental versions, ceramic ruler figurines predominately depict male-gendered figures with loincloths and bare, flat chests. Nonetheless, examples from both large-scale and small-scale imagery do depict ruler headdresses on named females with royal titles, such as *ajaw* and *kaloomte'*, and on figurines with female attributes such as breasts and/or female attire, such as *huipiles* (fig. 3.3) (Josserand 2002; Proskouriakoff 1961; Reese-Taylor et al. 2009; Triadan 2007: fig. 10a). Thus the figurine examples further reinforce what we have known from monumental media: that some royal women held prominent political roles.

Ruler figures are recovered from a wide range of archaeological contexts, including both site capitals and peripheral settlements as well as elite, middle, and commoner architectural groups (appendices 3.2, 3.3) (Halperin 2009c). For example, at Motul de San José, they were excavated from elite-, middle-, and lower-status architectural groups from the site's epicenter as well as from middle- and lower-status groups in its northern periphery. They were also recovered from secondary (Trinidad de Nosotros, hereafter referred to as Trinidad) and tertiary (Chäkokot, Buenavista) settlement sites surrounding Motul de San José (figs. 3.8, 5.20, 5.21). At Tikal, they derive from elite residential and civic-ceremonial groups (e.g., 5D-2, 5D-10, 5D-11, 5C-1; Mundo Perdido, Zona Norte) and small residential groups both near and beyond the site's epicenter (e.g., 4F-1, 4F-4, 4H-1, 5G-2, residential groups south of Mundo Perdido) (personal observation 2006; Laporte 2008: 951). Similarly, at Comalcalco they are recovered from the site's North Plaza, from the Grand Acropolis, and in small residential contexts (Gallegos Gómora 2008, 2009). Some of the Comalcalco versions, like unprovenienced specimens attributed to Jaina and its environs, sit on thrones or benches.

Furthermore, ruler figures occur at widely dispersed sites with varying degrees of inferred political power: the elite epicenter of Aguateca (Triadan 2007) and a commoner settlement near Aguateca (Eberl 2007: fig. 10.27b), Altar de Sacrificios (Willey 1972: fig. 22k, l, o, q, 27b), Calzada

FIGURE 3.8. *Distribution of ruler figurines in Motul de San José's site core and northern periphery (left) and among settlements at the western edge of Lake Petén Itzá (upper right). H9 headdress = fan-shaped feathered ruler headdress with deity or zoomorphic mask at the center. (Note: only the MSJ Site Core and northern periphery were subject to intensive test-pitting with multiple test pits placed in each group; the East Transect test-pitting program was less intensive [half of eastern periphery and CHT] with a single 1.0 × 1.0 m unit per group; see chapter 1 notes for more details on sampling.)*

Mopan, Ixkun, Ixtonton, and Sacul in southeastern Petén (Laporte et al. 2004), Chama (Rands and Rands 1965: fig. 34), El Zotz (Lukach and Garrido 2009: 363, see also 408, 429), Jaina (Corson 1976; Pina Chán 1968, 1996), Jonuta (Alvarez and Casasola 1985: plate 20, 21, 23b; Corson 1976: fig. 24c, d), Lubaantun (Joyce 1933; Wegars 1977: fig. 6e, 10, 12f), Nakum and San Clemente (Halperin 2009b), Nixtun Ch'ich', Ixlú, and Zacpetén (Halperin 2010), Palenque (Butler 1935: fig. 3c; Goldstein 1980: fig. 6a), Piedras Negras (Nelson 2003; Taube 2006), Quiriguá (Ashmore n.d.), Seibal (Willey 1978), Toniná (Becquelin and Baudez 1982: fig. 256g, 262b, d, e), Topoxté (Hermes 2000: fig. 62–1), Uaxactún (personal observation 2004), Xunantunich (LeCount 1996: fig. E.35), and sites in Yucatán (Brainerd 1958: fig. 54a; Butler 1935: fig. 1h, 3g).

These fan-shaped headdresses, however, not only reference rulership but underscore the public nature of political performances. Their bulky sizes would have been inappropriate for more intimate interactions and

contrast with polychrome vessel scenes in which simpler head wraps and other headdresses were worn by ruling elites within palaces (Reents-Budet 2001). Thus it is not surprising that accompanying hieroglyphic data make reference to their participation in period-ending ceremonies, accessions to office, ball games, warfare and celebrations of warfare, and the witnessing of ceremonies by political officials and deities (Martin and Grube 2000; Proskouriakoff 1960; Schele and Miller 1986). The narrative sequences of such events are most comprehensively portrayed on the murals at Bonampak, which even include a dressing scene in which subordinate figures help a Bonampak lord put on his jewelry and feathered backrack (fig. 3.17) (Miller 1986, 2002). Notably, in the mural scenes of tribute presentations, dances with musical accompaniment, sacrifice, and warfare, subordinate officials, musicians, and performers do not wear the fan-shaped quetzal feathered headdresses with deity masks; they wear simpler headgear, as described below.

PALANQUIN FIGURINES

Palanquins also explicitly convey processional and display episodes of large-scale performances (fig. 3.9). Figurine versions of palanquins consist of a ruler seated on a portable platform outfitted with pillars and a roof. The most well-known examples appear to derive from Jaina and the Campeche coastal region, although the large majority are unprovenienced (fig. 3.10) (Gallegos Gómora n.d.; Pina Chán 1968, 1996: fig. 10; Schele 1997: 110–111).[8] Palanquin figurines, however, are not restricted to the western Maya coast; fragmentary versions have been excavated from multiple sites in Petén, Guatemala, and western Belize. For example, they appear in fragmentary conditions in both residential and civic-ceremonial contexts: on-floor middens in elite residences (Strs. 1, 3, 4, 7) at San Clemente (n = 12), in the ball court (Str. A-V) and in royal administrative and residential architectural contexts (Str. A-I) at Altar de Sacrificios (n = 4) (Willey 1972: 54), in a residential zone at the site of Calzada Mopan (Group 25) (Laporte et al. 2004: 331), in royal elite residences from Tikal's Central Acropolis (Group 5D-11) and civic-ceremonial and elite residential groups nearby (Groups 5D-2, 5D-10, 5D-19; at least six are noted from University of Pennsylvania investigations, of which two did not have labeled proveniences: personal observation 2006; Tikal Bodega collections, Parque Nacional Tikal), in structure collapse from Group CC at Nixtun Ch'ich' (Halperin 2010), and from Burial C12 in an elite architectural group at San

FIGURE 3.9. *Tikal ruler, Yik'in Chan K'awiil, seated in palanquin decorated with Naranjo emblem on steps, Tikal Lintel 2, Temple IV, Str. 5C-4 (after Jones and Satterthwaite 1982: fig. 73; courtesy of University of Pennsylvania).*

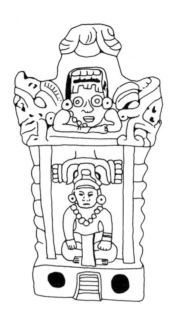

FIGURE 3.10. *Figurine of ruler seated in effigy palanquin (drawing by author after Piña Chán 1968: plate 21).*

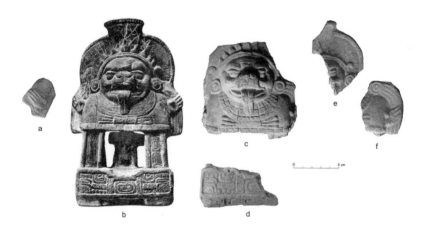

FIGURE 3.11. *Identical molded palanquin figurines from multiple sites: (a) San Clemente (SCFC085); (b) San José, Belize (after Thompson 1939a: plate 23a); (c) Tikal (47A/50); (d) Yaxhá (YXFC079); (e) San Clemente (SCFC198); (f) San Clemente (SCFC178) (all photographs by author).*

FIGURE 3.12. *Palanquin figurines: (a) effigy palanquin roof, Tikal (12H-30); (b) palanquin base with quatrefoil motif, Tikal (42F-61); (c) profile and front of ruler seated in palanquin (now missing), Yaxhá (YXFC072); (d–e) Uaxactún; (f) profile, front, and back of palanquin base showing mouthpiece for use as an ocarina, Nakum (NKFC088); (g) palanquin base (Tikal 1087-18) (scale bar applies to all).*

Jose (Thompson 1939a: plate 23a). Other examples are noted from the sites of Uaxactún (personal observation 2004, Cerámotequa, IDAEH), Nakum (n = 7), and Yaxhá (n = 2) (figs. 3.11, 3.12) (Halperin 2009b).

A number of these figurines are quite homogeneous, showing a hieroglyphic platform with half quatrefoil, a four-petal shape used to signify a flower, sun, and/or earthly openings, such as caves. The seated ruler sits just above the half quatrefoil opening as if perched at the edge of cosmic divides, a long-standing theme in Mesoamerican iconography (Bassie-Sweet 1991; Stone 1995). The roof above consists of the upper portion of a large supernatural figure whose hands, in human form, appear on either side of the ears. Profile representations of palanquins in other media indicate that these hands extend out from the effigy figure's body, holding up the frontal pillars of the palanquin. The striking similarity of some of the figurines indicates that they were made from the same mold or set of molds even if recovered archaeologically from widely distant sites, as discussed further in chapter 5 (fig. 3.11).

The figurines share attributes with depictions of palanquin scenes on monuments and lintels, such as (1) roofs composed of supernatural effigies,

(2) platforms containing text and imagery (in these examples they detail political locations and sacred geographies) (Freidel and Guenter 2003; Martin and Grube 2000: 79; Taube 1992b: 68–72), and in some cases (3) the seated poses of the enclosed rulers. The accompanying texts on the large-scale versions indicate that these devices were used for royal visits, large-scale celebrations, accessions, and military campaigns (Clancy 2009: 120–122, fig. 6.3; Freidel et al. 1993: 310–317; Freidel and Guenter 2003; Jones and Satterthwaite 1982). Simpler versions of palanquins appear in polychrome vessel scenes (e.g., K767, K3412, K7716),[9] some without roofs or with supernatural figures perched on top (K5456).

Palanquins were not only vehicles to prop up and transport a polity's ruler. They were indexical of a ruler, his or her polity as a whole, its mythical/historic origins (Taube 1992b: 68–74), and its military might (Freidel et al. 1993: 314; Martin and Grube 2000: 79). Tikal Lintel 2 from Temple 4, for example, documents the defeat of Naranjo and depicts a ruler from Tikal, Yik'in Chan K'awiil, seated in a palanquin captured from Naranjo (identified by the Naranjo emblem glyph on its stepped platform) (fig. 3.9). Such text and imagery were powerful embodiments of Tikal's victory over Naranjo. Furthermore, the effigy supernatural figures forming the palanquin roofs were analogous to the rulers' headdresses and were likely integral in the spiritual affiliations and transformations of rulers themselves. Their larger-than-life size, however, could visually project beyond the range of a headdress, aided by porters who carried and elevated the palanquin. The presence of porters is all but absent save for "nonofficial" examples, such as the graffiti at Tikal or figurines from Lubaantun (fig. 3.13) (Hammond 1972: 224; Joyce 1933: plate VI-11; Trik and Kampen 1983: fig. 72).

Looper (2009: 53–54) suggests that the processions of palanquins were not only a part of ceremonial war celebrations and period-ending rites but were related to dance performances. He points out that Lintel 3 from Tikal Temple 4, which commemorates a victory over El Perú, mentions dancing in its associated texts. Fray Antonio de Ciudad Real, in a visit to a Yucatecan village in 1588, vividly discusses the central role of a palanquin in a dance performance:

> the Indians brought out to welcome him a strange device and it was: litter-like frames and upon them a tower round and narrow, in the manner of a pulpit . . . in this pulpit, visible from the waist up, was an Indian very well and nicely dressed, who with rattles of the country in

one hand, and with a feather fan in the other, facing the Father Commissary, without ceasing made gestures and whistles to the beat of the *teponastle* [log drum] that another Indian near the litter was playing among many who sang to the same sound, making much noise and giving shrill whistles; six Indians carried this litter and tower on their shoulders, and even these also went dancing and singing, doing steps and the same dancing tricks as the others, to the sound of the same *teponastle*; it was very sightly that tower, very tall and was visible from afar by being so tall and painted. This dance and device in that language is called *zono* and is what was used in ancient times. (Clendinnen 2003: 159–160)

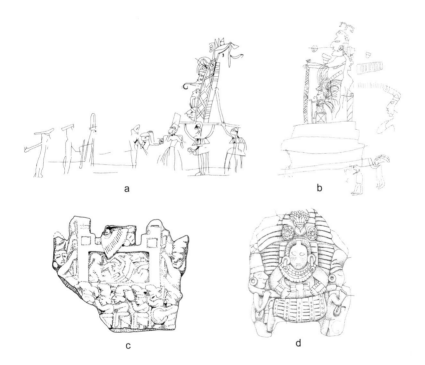

a

b

c

d

FIGURE 3.13. *Porters carrying palanquins and litters from "nonofficial" media: (a) effigy palanquin with seated ruler, graffiti, Caracol, Str. B-20-2nd (drawing by Luis F. Luin after Chase and Chase 2001b: fig. 4.12); (b) effigy palanquin with seated ruler, graffiti, Tikal Str. 5D-65 (drawing by Luis F. Luin after Trik and Kampen 1983: fig. 72); (c) base of palanquin with porters and drum player, molded figurine, Lubaantun (drawing by author after Wegars 1977: fig. 18d); (d) litter of ruler carried by porters, molded figurine, Lubaantun (drawing by Luis F. Luin after Wegars 1977: fig. 18d).*

Figurines also depict simpler carrying devices, such as cloth and pole litters (fig. 3.13d) (Joyce 1933: plate VI-5). While these lack the grandeur of palanquins, they too would have been on public display as transport devices. In several polychrome vessels, scenes with cloth and pole litters are part of a procession of figures carrying musical instruments (such as trumpets and conch shells); in some cases they hold circular fans and wear broad-brimmed hats (K594, K5534, K6317, K7613). These scenes likely represent state visits, in which music was an important part (Houston et al. 2006: 260–262). Seventeenth-century Spanish accounts of official visits between Spanish and Itzá Maya leaders, for example, indicate that the welcoming and departure formalities of the Itzá were accompanied by music (Jones 1992: 258, 1998: 194, 272, 282). It may not be coincidental that many figurines themselves functioned as music instruments, as explored further in chapters 5 and 6.

BALLPLAYERS

Architectural evidence of ball courts indicates that they were located within the central precincts of site centers within or as passageways between major plazas and ceremonial foci (Ashmore 1991). While the rules and meanings of the ball game undoubtedly shifted depending on the contexts of play (for example, whether as part of formal games in masonry or "official" courts or as more informal games, inside plaza areas or outside settlement precincts), over its long history, spanning more than 2,500 years, the game has been intimately associated with public festivities, politically charged events, ritual sacrifices, and important calendrical moments of cosmic renewal (fig. 3.14) (Fash and Fash 2007; Fox 1996; Scarborough and Wilcox 1991). Boxing, a relatively understudied sport, also appears to have been related to ceremonial sacrifice (for example,

FIGURE 3.14. *Ballplayer scene in public plaza area; inscribed as graffiti on Tikal St. 5D-43, Room 1 (drawing by Luis F. Luin after Trik and Kampen 1983: fig. 46a [Trik version]).*

some combatants wear cloth ear pendants of captives), petitions for rain, and festive occasions (such as dancing, drinking alcoholic beverages, and smoking). Boxing may have been performed in ball courts as well (Orr 1997; Taube and Zender 2009). While some named royal figures and supernatural figures are clearly depicted as ballplayers, participation probably was not limited to the royal elite.

Figurines commonly feature ballplayers and boxers who are identified by bodily accoutrements: thick yokes around the waist, arm bands (usually found on the right arm), knee pads (usually found on the right leg), round balls held in hands or arms, and striking poses (fig. 3.15). They often possess plain animal headdresses without feather sprays (Corson 1976: fig. 22d; Kidder and Samayoa Chinchilla 1959: fig. 77) or other simple headdress types (Miller and Martin 2004: 88; Schele 1997: 121–127). Boxers may also wear yokes or thick padding, helmets with eye slits or holes, or hand mitts; hold round hand-sized balls (some with hand holes, rope suspensions, or cloth/leather saps); and engage in poses of combat (Orr 1997; Taube and Zender 2009).

Ballplayer figurines are found widely throughout the Maya area during the Classic period (Ekholm 1991; Folan et al. 2001: 245; Rands and Rands 1965: 543, fig. 30; Schele 1997: 120–126),[10] but they do not appear to be as numerous as ruler figurines. Among the figurine collection from Motul de San José and its environs, for example, four anthropomorphic male figurines (fragmentary body pieces, with no head) possess ballplayer paraphernalia. They were found in a large secondary midden near the site's royal palace (Group C) and within a midden from a medium-sized residential group (Op. 19, Group H) at the secondary site of Trinidad. Ballplayer figurines are recovered from the Central Acropolis at Tikal (e.g., Group 5D-11) as well as in small residential groups (such as Groups 4F-1 and Group 6C-XV) (personal observation 2006; Tikal Bodega collections, Parque Nacional Tikal; Laporte and León 1990: fig. 7). Other sites that report ballplayer figurines include Aguateca (n = 1) (Triadan 2007: 277), Altar de Sacrificios (Willey 1972: 30, fig. 23), El Perú (Freidel et al. 2010), Holmul (n = 1) (fig. 6.5), Ixtonton (n = 2) (Laporte et al. 2004: 299), Nakum (n = 16) and San Clemente (n = 4) (Halperin 2009b), Nixtun Ch'ich' (n = 1) (Halperin 2010: fig. 10), Piedras Negras (Schlosser 1978: 134; Taube 2006), and San Jose (n = 1) (Thompson 1939a: fig. 92d).

In contrast, figurines of boxers appear to be highly regionalized (fig. 3.16). As Karl Taube and Marc Zender (2009) note, some Teotihuacan figurines with helmets and thick padding may depict boxers. Maya boxer

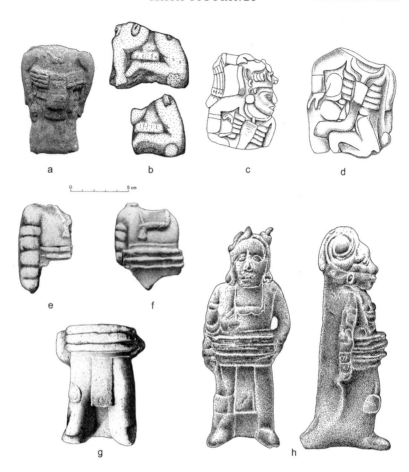

FIGURE 3.15. *Molded ballplayer figurines: (a) Motul de San José (MSJ2A-40-5-2a; photo by author); (b) matching ballplayers, Motul de San José and Trinidad (MSJ2A-40-4-1d [appliqué ball broken off] and TRI19B-4-3-1a); (c) Lubaantun (drawing by Luis F. Luin after Wegars 1977: fig. 7c); (d) Lubaantun (drawing by Luis F. Luin after Wegars 1977: fig. 7d); (e) Nakum (NKFC213; drawing by Luis F. Luin); (f) Nixtun Ch'ich' (NC022; drawing by Luis F. Luin); (g) Nakum (NKFC210; drawing by Luis F. Luin); (h) Tikal (drawing by Luis F. Luin after Laporte and Ponce de León 1990: fig. 7) (note: scale bar applies to all except c and d).*

figurines appear with great frequency at the site of Lubaantun, Belize (Joyce 1933; Wegars 1977) during the Late Classic period and are identified among only a few unprovenienced "Jaina-style" figurines (Taube and Zender 2009: figs. 7.11b, 7.23; but see Finamore and Houston 2010: 285; Goldstein 1980: fig. 7b; Triadan 2007: 287, fig. 9a).

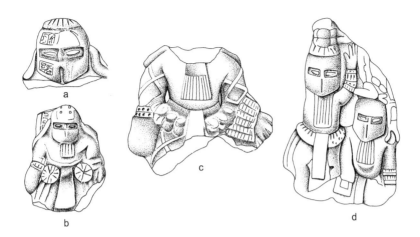

FIGURE 3.16. *Molded boxer figurines from Lubaantun: (a) (drawing by Luis F. Luin after Wegars 1977: fig. 5a); (b) (drawing by Luis F. Luin after Wegars 1977: fig. 5d); (c) (drawing by Luis F. Luin after Wegars 1977: fig. 5b); (d) (drawing by Luis F. Luin after Wegars 1977: fig. 17d).*

MUSICIANS, DANCERS, AND PERFORMERS

While stela monuments tend to downplay the role of secondary and accompanying performing figures at major accessions, period-ending celebrations, battles, and other momentous events, murals, carved stone panels, and polychrome vessels do highlight a suite of secondary and supporting figures who played integral roles within state spectacles. Likewise, ceramic figurines reference many of these other performers. One class of performer is identified by a simpler version of the fan-shaped feathered headdress consisting of two feathered sprays or "wings" that emerge from the lateral sides of the head (fig. 3.17).[11] The feathers are paired with various types of ornamented headbands and cloth wraps. As in the more elaborate feathered headdresses, the impracticality of wearing the horizontal feather sprays during everyday activities indicates that they were visual expressions of pomp and performance (figs. 3.18, 3.20d, 4.29a, c, e, f, 5.24). In addition, some of the figures wear masks, hold musical instruments, and/or are posed in the midst of dancing (fig. 3.17d). As discussed further in chapter 4, Wind god figurines, who were often musicians themselves, also don this headdress.

When portrayed in narrative scenes, the simpler feather headdresses tend to be associated with subordinate or secondary performers when

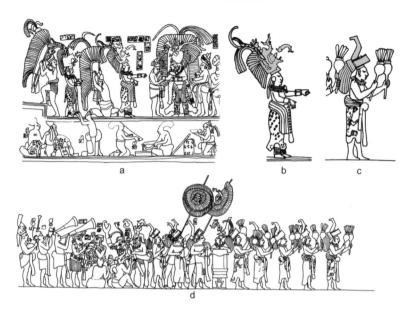

FIGURE 3.17. *Comparison of fan-shaped and winged feathered headdresses from Bonampak murals: (a) dressing scene of young lords in preparation for ceremonial performance, upper register, North Wall, Room 1; (b) detail of North Wall, Room 1 showing young lord wearing fan-shaped deity mask headdress without backrack; (c) detail of rattle player showing winged feather headdress, lower register, Room 1; (d) procession of musicians, parasol carriers, and impersonators, lower register, Room 1 (L. Schele drawings from www.famsi.org [accessed April 2, 2010]).*

compared to the *k'uhul ajaw*. For example, musicians on the Bonampak murals wear the winged feather elements in their headdresses but lack the full-fledged fan-shaped sprays of royal princes, who are the principal performers (Miller 1988). Stone sculptures of nobles adorning the roof of Structure 22A at Copan, a *popol nah* or council house, also wear headdresses with winged feather elements drooping on each side of the head (Fash 1992: 93–95, figs. 8 to 11). While the central elements of the headdresses are unique to each noble, perhaps denoting their lineage affiliations, the winged feathers unite them as a group and set them apart from a larger figure, one of the divine rulers of Copan. This sculpture is eroded, but the ruler's more elaborate, fan-shaped feathered headdress can be reconstructed from the stone fragments. Notably, Barbara Fash (1992) identifies a dance platform next to the *popol nah*; during the colonial period, *popol nah* platforms were stages for dances, feasting, and festivities, even if not on the scale of larger plaza-based performances (Inomata 2006b: 196).

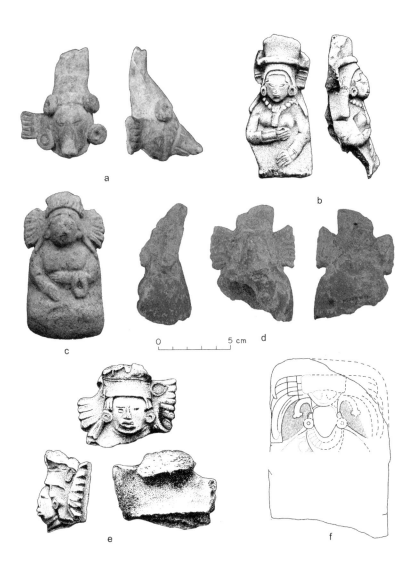

FIGURE 3.18. *Molded figures with stiff paper headdresses containing winged feathered elements (H4): (a) anthropomorphic face with animal snout mask, figurine, Altar de Sacrificios (Museo Nacional de Arqueología e Etnografía, MUNAE10089a, photo by author); (b) seated female with feathers broken at their tips, figurine, Trinidad (TRI10D-7-2-4b; drawing by Luis F. Luin); (c) female wearing* huipil, *figurine, Trinidad (TRI10D-1-2-4b; photo by author); (d) female head and torso, figurine, Motul de San José (MSJ2A-40-5-9c; photo by author); (e) anthropomorphic head with stepped-cut hair style typical of females, figurine, Motul de San José (MSJ2A-5-6-15l; drawing by Luis F. Luin); (f) "Lady of Tikal," Tikal Stela 23 (after Jones and Satterthwaite 1982: fig. 35; courtesy of University of Pennsylvania).*

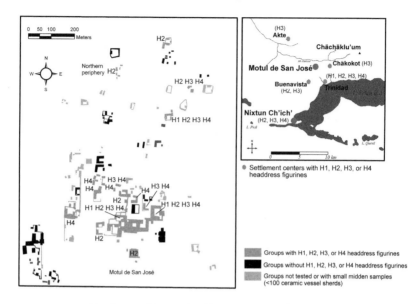

FIGURE 3.19. *Distribution of figurine headdress types in the Motul de San José site core and northern periphery (left) as well as among settlements at the western edge of Lake Petén Itzá (upper right). H1 = simple cloth head wrap with decorated band (see fig. 3.31); H2 = simple cloth or paper head wrap with tie in front (see figs. 3.29, 3.30, and porters in 4.13); H3 = broad-brimmed hat (see figs. 3.33–3.35); H4 = winged feather headdress (see fig. 3.18).*

Although in many cases ceramic figurines are too fragmentary to identify gender, a number of specimens from the Motul de San José region reveal both males (or male-gendered supernatural figures; n = 4) and females (n = 3) with this headdress (fig. 3.18). These figurines were excavated from elite residential contexts in Motul de San José's epicenter, in middle- and lower-status household contexts in its northern periphery, and at the secondary site of Trinidad (fig. 3.19). A variant of this headdress can also been seen on identical female figurines from Tikal and Pacbitun (fig. 5.24) (Healy 1988: 31). The emphasis on both genders in the figurines contrasts with the marginalized roles of women on the Bonampak murals and many polychrome vessels, indicating that performative recognitions between different forms of media were sometimes at odds with one another.

Nonetheless, strict gendered roles of musicians were not challenged in the figurines: females are never found holding instruments. In addition to the winged feathered headdresses, musicians donned a range of costuming and headgear (fig. 3.20) (Hammond 1972: 223; Joyce 1933: plate V-14;

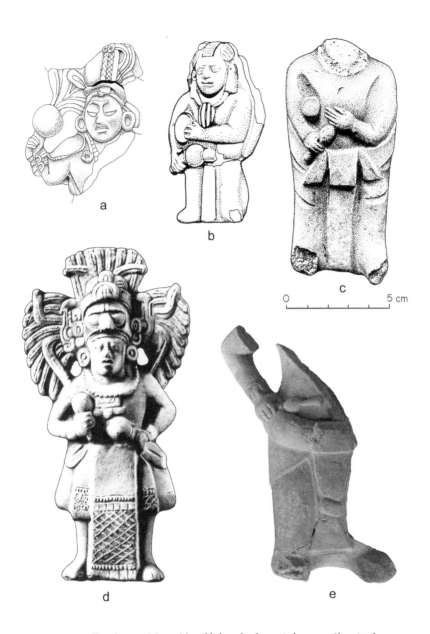

FIGURE 3.20. *Figurine musicians: (a) molded rattle player, Lubaantun (drawing by Luis F. Luin after Wegars 1977: fig. 8d); (b) molded male rattle and drum player, Lubaantun (drawing by author after Hammond 1972: 223); (c) molded male rattle and drum player, Motul de San José (MSJ2A-5-7-2d; drawing by Luis F. Luin); (d) molded male rattle player, Nebaj (drawing by Luis F. Luin after Kidder and Chinchilla 1959: fig. 54); (e) molded male rattle player, Tikal (97A-81; photo by author).*

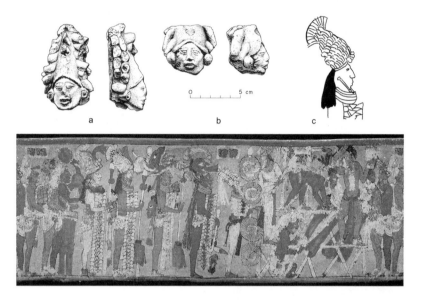

FIGURE 3.21. *Conical headdress with multiple tassels/plumes (H7): (a) Motul de San José figurine (MSJ2A-5-6-17a); (b) Motul de San José figurine (MSJ15A-12-1-1a) (drawings by Luis F. Luin); (c) detail of polychrome vase K2781; (below) procession and public scaffold scene, polychrome vase (K2781 © Justin Kerr).*

Miller and Martin 2004: plate 19; Taube and Taube 2009: figs. 9.10, 9.11). An example from Lubaantun (Hammond 1972: 223) sports a three-part "Mohawk" hairstyle often worn by Fat Men. He holds both a rattle and drum. Paul Healy (1988: 31) and Norman Hammond (1972: 227) suggest that these two instruments made up a formal musical combination: they are repeatedly played together, such as in the Dresden Codex (34a), the murals of Bonampak, polychrome pottery (K3051), and stone monuments (e.g., Seibal Stela 3).

The elaborateness of other types of headdresses suggests that they were meant to be conceived as performative wear. For example, cone-shaped hats containing numerous small tassels or plumes are similar to those worn by a procession of figures participating in a scaffold sacrifice seen on a polychrome vase (fig. 3.21). Taube (1988: 332–335, fig. 12.3) has pointed to the use of scaffolds for public ceremonies and argues that this particular vase depicts an act of sacrifice related to agricultural fertility and renewal. This tasseled headdress appears to be quite common in the Petén Lakes region, with nine examples identified at Motul de San José and environs

(five figurines with heads; four headdress only fragments) (Halperin 2007: fig. 7.7) and a single specimen from Nixtun Ch'ich' (Halperin 2010).

ANTHROPOMORPHIC FEMALES WITH FANS

Fans are also intimately associated with performance during the Classic period (Looper 2009; Prufer et al. 2003: 227–229; Taube 1989).[12] In scenes of dance, they are extensions of the moving body (figs. 3.22, 3.23, 3.24). Like

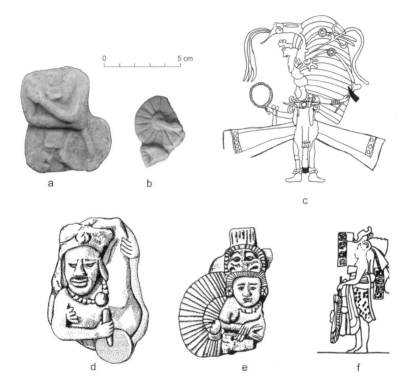

FIGURE 3.22. *Fans and parasols as performance accoutrements: (a) molded male figurine with fan tucked under arm, Poptún, Guatemala (MUNAE Y3-18; photo by author); (b) fragmentary molded figurine showing fan with detail of grasping hand, San Clemente (SCFC277; photo by author); (c) detail of dancing lord holding small circular fan, upper register Room 3, Bonampak murals (drawing by author); (d) fragmentary molded male figurine with fan in dance pose (note: second pair of hands indicates that the figurine was originally a couple), Lubaantun (drawing by author after Joyce 1933: plate V-7); (e) molded male figurine with parasol, Lubaantun (drawing by author after Joyce 1933: plate I-1); (f) detail of subordinate performer with parasol, lower register, Room 1, Bonampak murals (L. Schele drawings from www.famsi.org).*

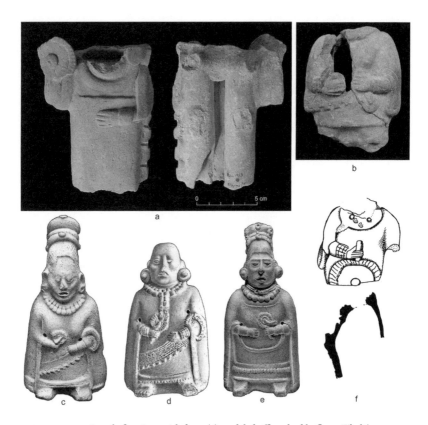

FIGURE 3.23. *Female figurines with fans: (a) modeled effigy double-flute, Tikal (97A-78-93; photo by author); (b) molded figurine, Altar de Sacrificios (MUNAE11893A; photo by author) (scale bar in a applies to b); (c–d) "La Señora de Comalcalco," molded figurine-rattles, Comalcalco (drawing by Luis F. Luin after Gallegos Gómora 2009: fig. 3); (e) unprovenienced molded figurine-rattle (drawing by Luis F. Luin after Schmidt et al. 1988); (f) molded figurine, Aguateca, Str. M8-10 (drawing by author after Inomata 1995: fig. 8.14c).*

the drum-rattle duo, fans were also paired with rattles in a combination of visual and auditory rhythms. As noted, Fray Antonio de Ciudad Real's 1588 account of an elaborate dance performance included an individual carried in a palanquin who held both rattles and a fan. This combination occurs together on a Late Classic sculpted wooden figurine from Xmuqlebal Xheton cave (fig. 3.31f) (Prufer et al. 2003). This practice may extend into contemporary Maya dance performances, such as the "Baile Viejo" in Tabasco, Mexico, which features male dancers wearing elderly male masks and holding a rattle in one hand and a circular straw fan in the other

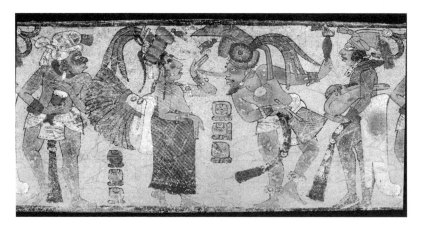

FIGURE 3.24. *Performing couple: dancing female paired with dancing male ritual clown holding fan and rattle, polychrome vase (K1549 © Justin Kerr).*

(Gallegos Gómora 2008, n.d.). On some polychrome vessels, fans do not appear to be in active use or employed as part of a dance. These figures, however, sometimes stand or sit near figures with musical instruments, perhaps denoting an anticipated performance (e.g., K594, K5394).

Although males are commonly associated with fans, figurines portray both males and females holding fans. Female figurines holding fans from the site of Comalcalco, for example, depict standing women holding circular fans with tassels (fig. 3.23c, d). They wear cloth head ties/bands, thick layers of jewelry, and elaborately decorated *huipiles*. The ubiquity of this figurine type at the site prompted archaeologists to name it "la Señora de Camalcalco" (Gallegos Gómora 2003, 2009, n.d.). They are recovered from the site's Plaza Norte (the zone of public temple architecture), in civic and elite residential architecture found in the Gran Acrópolis, and at a commoner household located 2 km from Comalcalco. Other examples occur at Aguateca (Triadan 2007: 277, fig. 10b), at Piedras Negras (Taube and Taube 2009: fig. 9.1b), and in the Alta Verapaz region (Dieseldorff 1926: fig. 38; see also Schele 1997: 18, 183 for unprovenienced specimens). In addition to fans, Marilyn Goldstein (1979: 77) notes that female figurines from Jaina and the Campeche coast hold one of three objects: a fan, copal pouch, or round mirror (fig. 5.7). All items were associated with ritual, for dance, for making offerings, or for divination. The interchangeability of these objects suggests to her that they were allomorphs of one another.[13]

The implication of the ceramic figurines is that the feminine body was

not as absent from performative roles or representative recognition of those roles as is emphasized in other media. Similar forms of recognition appear elsewhere in Mesoamerica, such as among Late Classic Gulf Coast peoples who produced female figurines in a stylized dance pose with both arms in the air (Goldstein 1994; Medellín Zenil 1987; Wyllie 2010: fig. 10). The theme of a performing or dancing female is further reinforced through couple figurines: a grotesque (often half human, half simian) or elderly male figure paired with a young woman on the same figurine.

COUPLES AND IMPLIED MALE-FEMALE DUOS

Couple figurines of grotesque/elderly males and young females often appear in dance pose or hold dance-related paraphernalia: circular fans or musical instruments (Looper 2009: 216–220; Taube 1989; Taube and Taube 2009). In most cases the two figures are posed side-by-side, but in a few examples the female is standing behind or on her partner's shoulders, likely as part of a dance performance (figs. 3.24, 3.25) (e.g., K6294, Looper 2009: 56; Schele 1997: 52–53).

Although these female-grotesque/elderly couple figurines are best known from unprovenienced specimens, the majority of which likely derived from the coast of Campeche (Looper 2009: 216–218; Schele 1997: 52–53; Taube and Taube 2009), a growing body of archaeological data points to more widespread distributions. For example, they are found in both elite and commoner contexts in the Motul de San José region (n = 5; these appear to be mostly residential, except for a single specimen from a ball court at the secondary site of Trinidad) (Halperin 2007: 177, fig. 7.15a, b). In addition, examples are reported from a commoner domestic compound in the periphery of Comalcalco (Gallegos Gómora 2009), a cave context at the site of Aguateca (Ishihara 2007: fig. 7.7g), at Toniná (Becquelin and Baudez 1982: fig. 258c), at Tikal (Laporte 2008: 953), at Pueblito (Laporte et al. 2004: 342), and in a child burial in the site core of San Jose, Belize (Thompson 1939a: fig. 92n). A mold of a female/grotesque pair with the female standing behind her partner was recovered at the site of El Chal in the West Plaza, southeast of the Acropolis (Laporte et al. 2004: 343).

Karl Taube (1989: 367–371) and Rhonda Taube (Taube and Taube 2009) suggest that these couples, portrayed only on small-scale media, represent ritual clowns, a common genre of ancient and contemporary folk festivals, mythology, and popular culture (see the discussion in chapter 4).

a

b

c

FIGURE 3.25. *Couple figurines in dance pose or with dance accoutrements: (a) molded figurine couple, male (with red painted body) and female with circular fan (and blue painted huipil), Motul de San José (MSJ2A-40-5-5a; photo by author); (b) animal/masked male with fan and female in dance pose, molded figurine, Museo de Vidrio, Antigua, Guatemala (drawing by Luis F. Luin after Looper 2009: fig. 6.10); (c) grotesque/masked male and female in dance pose, finely modeled figurine, Jaina or Campeche coast (drawing by Luis F. Luin).*

0 5 cm

a b c

d e f

FIGURE 3.26. *Female and male figures with cotton necklaces: (a) molded female figurine holding cotton necklace, Altar de Sacrificios (MUNAE14405; photograph by author); (b) finely modeled (with possible molded head) female figurine holding cotton necklace, Jaina or Campeche coast (drawing by author after Schele 1997: 45); (c) molded figurine-rattle, female holding cotton necklace, Jaina (drawing by Luis F. Luin after Piña Chán 1968: plate 12); (d) Bird Jaguar IV wearing cotton necklace as part of warrior regalia, Yaxchilán Lintel 16 (courtesy of the Peabody Museum of Archaeology and Ethnology, Harvard University [04.15.6.5.15]); (e) finely modeled figurine wearing cotton necklace and engaged in vomiting or bloodletting, unprovenienced (K2821 © Justin Kerr); (f) way jaguar figure wearing cotton necklace and vomiting, detail from polychrome vase (K3312 drawing by Luis F. Luin).*

The grotesque, simian, and/or elderly qualities of the males contrast with the youthful females. The males are sometimes portrayed fondling the women's breasts or making other lecherous advances. Karl Taube (1989: 371) states that these couple figures, like those from contemporary Highland Guatemalan performances, "refer to actual performances involving the courtship and perhaps even simulated copulation of women with extremely unlikely mates." If this is the case, the figurines would be mimetic versions of performance figures mimicking popular conceptions of social identities. It has also been suggested that some of these performers may have been males impersonating females, wherein female participation is highlighted but female performative agency is suppressed.

Like the embracing couple, other solitary figurines may point to ritual performances conducted as a couple or as performances integrating both males and females. For example, a few solitary females hold twisted cloth (identified by the dotted texture also characteristic of cotton warrior costumes) with a bead and tassel at the end (fig. 3.26a–c) (Schele 1997: 22, 43–44; Willey 1972: fig. 50b). These twisted or hanging cloth strips are worn around the neck by male-gendered figures in states of liminality: as warriors, figures in bouts of heavy drinking and vomiting, ritual clowns, and *way* figures (figs. 3.1a, 3.26d–f, 4.15c, 4.16h) (de Smet and Hellmuth 1986; Schele 1997: 133, 174; Taube 1998, 2003b: 281–282). In a cache of twenty-three figurines from a royal tomb at El Perú, females holding these cotton cloth necklaces are linked to males wearing them around their necks (Freidel et al. 2010). In a rare narrative scene from a polychrome vessel (K5538), the two male-female pairs are brought together

FIGURE 3.27. *Male and female pair at the center of mythological drinking scene; male anthropomorphic and supernatural figures wearing cotton necklaces, polychrome vase (K5538 © Justin Kerr).*

at the center of a mythical plaza or household patio filled with lively oral and anal alcoholic drinking (note the enema in the hand of the standing figure) (fig. 3.27). In general these drinking practices were not part of monumental displays of ceremony and ritual but rather appear in the small-scale media of ceramics (Houston 2009).

NOBILITY, RITUAL SPECIALISTS, AND SUBORDINATE FIGURES

Ceramic figurines materialize a wide range of subordinate social identities that imitated and idealized noble social statuses, scribes and record keepers, priests or ritual specialists, lower-status courtiers, and possibly common people. These figures and their associated headdresses and accoutrements are quite diverse; only a few prominent examples are presented here. These figures speak to the lower echelons of state bureaucracies that interfaced with, supported, and came into conflict with ruling elites.

One signifier of secondary rank is a headdress with goggle-eyes adorning a feathered or stiff cloth wrap (the headdress ties are sometimes visible and project out on each side of the headdress) (fig. 3.28). In most cases a mosaic headband holds the wrap in place. On monuments and carved stone panels, this headdress is worn by nobles and other secondary officials from Palenque (Stuart 2005: 124–125; Zender 2004).[14] As such, it appears to have been related to priestly and military duties of secondary elites. For example, K'awiil Mo', an important vassal to the Palenque king Kan Bahlam II, is portrayed with the headdress as a bound captive on Toniná Monument 27 (Becquelin and Baudez 1982: figs. 165a, 262q; Miller and Martin 2004: 185). Aj Sul, a noble lord from Palenque with the title of *yajaw k'ahk'* (lord of fire), wears the headdress on a stone effigy censer recovered from an elite residence, Palenque Group IV (López Bravo 2000: 43, 2004: fig. 89; Stuart 2005: 124), and Yok ? Tal, a noble lord of the Palenque king, also with the title of *yajaw k'ahk'*, dons the headdress on a stone panel from Palenque's Temple 19 (Miller and Martin 2004: 210, fig. 69).

While these headdresses are strongly associated with lords from Palenque, figurines wearing them appear in many regions beyond Palenque. Such a finding is significant in that it suggests that popular understandings of official state identities had salience beyond the polity from which they may have derived. For example, molded figurines with reductionist versions of the headdress have been excavated from Piedras

FIGURE 3.28. *Secondary elite with goggle headdresses (H13): (a) molded figurine, Trinidad (TRI10D-10-3-5a; drawing by Luis F. Luin); (b) molded figurine, Nixtun Ch'ich' (NC001, Lot 44312); (c) molded figurine, Toniná (drawing by author after Becquelin and Baudez 1982: fig. 262o); (d) molded figurine, Trinidad (TRI10D-10-3-4a; photo by author); (e) stone effigy censer of Aj Sul, Palenque yajaw k'ahk' (lord of fire), Palenque Group IV (drawing by Luis F. Luin after Stuart 2005: fig. 94a); (f) Yok ? Tal, Palenque yajaw k'ahk', stone panel from Temple XIX (drawing by Luis F. Luin after Stuart 2005: fig. 94b); (g) depiction of K'awiil Mo' from Palenque on Toniná Monument 27 (drawing by author after Baudez 1994: fig. 165a) (scale bar applies to a, b, and d).*

Negras (R. Taube, personal communication 2003), Motul de San José and Trinidad, Nixtun Ch'ich' (appendix 3.2), a residential zone of Ixtonton (Ixtonton 51, East Str.) (Laporte et al. 2004), and Toniná (Becquelin and Baudez 1982: fig. 262q; see also Miller and Martin 2004: plate 110 for a modeled figurine with similar characteristics).

Figures wearing either tall, stiff cloth head wraps (most likely made out of pounded bark cloth) or more flexible (drooping) cloth head wraps (Becquelin and Baudez 1982: figs. 259, 264i; Schele 1997: 60, 134) are another theme identified among figure collections.[15] Priests, scribes, and other royal court officials known as *ajk'ujun*, *a-na-b'i*, and other titles (Coe and Kerr 1998; Jackson and Stuart 2001; Zender 2004) in hieroglyphic texts wear both the stiff and drooping cloth headdresses. Some are portrayed with copal bags, with writing paraphernalia in their hands or tied to their head wraps, engaged in bloodletting, and as royal court attendants (figs. 3.29, 4.8a). While these are generally identified as male, some females did possess the *ajk'ujun* title (Jackson and Stuart 2001).

Ceramic figurines broaden our understanding of these cloth head wraps as identifiers of particular forms of male social rank in that both male and female figurines regularly wear simple cloth or stiff paper headdresses (figs. 3.29, 3.30). In fact the range of cloth head wraps is quite diverse, and for the figurines it is often unclear whether they denote royal, noble, or commoner social statuses. In some imagery, this ambiguity may be purposeful: Andrea Stone (1995: 132–134) notes that painted figures on the cave walls of Naj Tunich, many of whom are engaged in ritual acts, all wore variations of simple cloth head wraps (some stiff, some drooping). Stone suggests that in these figures as a group social rank was downplayed. In narrative scenes elsewhere, secondary officials wearing cloth head wraps

(OPPOSITE PAGE) FIGURE 3.29. *Secondary officials and figurines with simple cloth and stiff paper headdresses (H2): (a) molded figurine, Motul de San José (MSJ35H-4-1-1c; drawing by Ingrid Seyb); (b) molded figurine, Motul de San José (MSJ42H-4-2-4a; drawing by Ingrid Seyb); (c) molded figurine, Motul de San José (MSJ39F-1-4-1a; drawing by Ingrid Seyb); (d) molded figurine, Motul de San José (MSJ42D-8-1-1c; drawing by Ingrid Seyb); (e) painted male figure with cloth head wrap, Naj Tunich (drawing by author after Stone 1995: fig. 6-34); (f) head of* sajal *(noble person), detail from Sarcophagus Lid, Temple of the Inscriptions, Palenque (drawing by Luis F. Luin); (g) head of* ajk'ujun *detail from Sarcophagus Lid, Temple of the Inscriptions, Palenque (drawing by Luis F. Luin); (h) secondary officials with stiff cloth or paper headdresses helping Palenque lord (at center) with tribute collection, tablet from Palenque Group XVI (drawing by Luis F. Luin after Stuart 2005: fig. 95).*

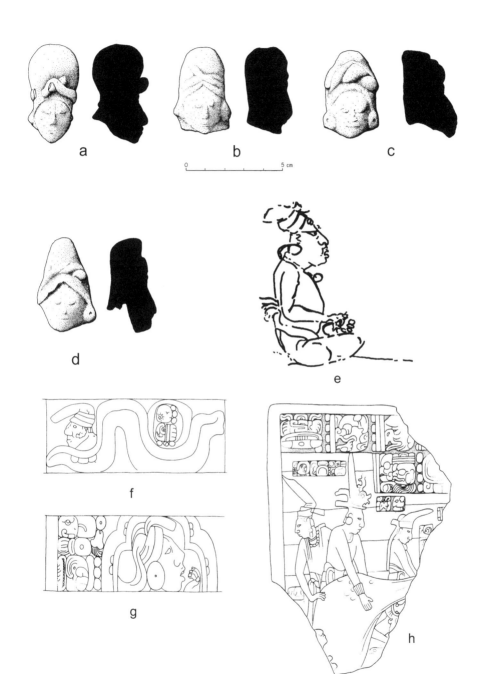

a

b

c

0 5 cm

d

e

f

g

h

often congregate together and are united by common forms of dress such that differences between them are not emphasized.

In the Motul de San José region female figurines wear a cloth head wrap held in place with a thick band decorated with vertical incised lines (fig. 3.31) (Halperin 2007: 150–153, 2009c).[16] Some of these figures hold containers of foodstuffs and wear simple off-shoulder cloth dresses (*cortes*). Figurines in another grouping from the Motul de San José region wear a simple cloth head wrap that ties in the front (fig. 3.29a–d). Like other figurine motifs, the cloth wrap headdresses are found in commoner, middle-status, and elite residential contexts at Motul de San José and its satellite sites (fig. 3.8). Because many of these specimens are fragmentary, however, it is not always clear whether they belonged to male or female figures.

In general it is important to note that adult female forms with breasts or feminine clothing represent a large proportion of identified bodies relative to those of adult males (appendix 3.4). While some range in the ratios of female to male figurine body fragments occurs based on site (and likely also based on sample sizes and methods of identification), female

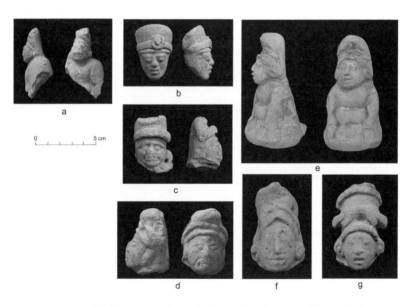

FIGURE 3.30. *Molded figurines with simple cloth and stiff paper headdresses (H2): (a) male figurine, Ixlú (IX051); (b) Pook's Hill (0045); (c) Pook's Hill (0161); (d) Zacpetén (ZP001); (e) surface collection near Trinidad (Casa de Las Americas hotel); (f) Altar de Sacrificios (MUNAE43K-1); (g) Altar de Sacrificios (MUNAE10097Z) (scale bar applies to a–d; all photos by author).*

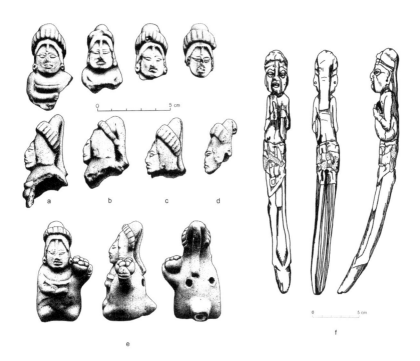

FIGURE 3.31. *Simple cloth headdress on males and females (H1): (a) molded ceramic figurine of female with incised and appliquéd headdress piece, Motul de San José (MSJ2A-40-3-1i); (b) molded ceramic figurine of female with incised and appliquéd headdress piece, Motul de San José (MSJ39G-7-2-1a); (c) molded ceramic figurine with incised and appliquéd headdress piece, Trinidad (TRI12A-6-3-5a); (d) molded ceramic figurine with incised and appliquéd headdress piece, Trinidad (TRI13E-5-3-2b) (a–d faces are identical); (e) molded figurine of female with incised and appliquéd headdress piece and dish of tamales (MSJ2A-40-3-1h; drawings by Luis F. Luin); (f) wooden figurine of male with circular fan and rattle (?), Xmuqlebal Xheton cave (drawing by author after Prufer et al. 2003: fig. 1).*

to male figurines are approximately 1:1 on average. The figurines contrast most significantly with stelae, in which females are a small minority of all figures depicted (e.g., they appear on less than 3 percent of all stelae from Calakmul as well as stelae from Naachtun [Reese-Taylor et al. 2009]; at some sites, such as Motul de San José, women do not appear in monuments at all).

Figurines from other regions also wear variations on the cloth headdress theme. For example, at Tikal one of the most common types of simple headdress forms is a head wrap tied so that two tassels hang on either side of the head (fig. 3.32b). When complete specimens are present, they appear

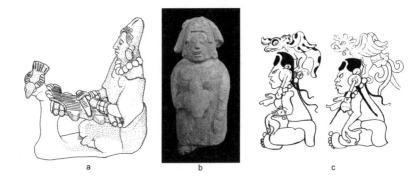

FIGURE 3.32. *Women and birds: (a) finely modeled ceramic figurine of elite woman weaving, Jaina, Mexico (after Schmidt et al. 1988: cat. 182); (b) molded figurine with red and Maya blue paint and appliquéd bird and headdress parts (H22), Tikal (MUNAE, photo by author); (c) two versions of Ixik Kab (Lady Earth), Dresden Codex (1887: 16c; drawing by Luis F. Luin).*

to be associated with standing women wearing a simple, off-shoulder cloth wrap (*corte*). At least one example holds a bird (personal observation 2004, 2006). In other cases, however, figurines may not be depicted with head-dresses, and other accoutrements and traits help define their identities.

BROAD-BRIMMED HATS:
MARKET VENDORS, TRAVELERS, COMMON PEOPLE

In contrast to themes of stately pomp and performance, figurines also reference more mundane activities, clothing, and poses not visible else-where. Some of these figurine themes, such as figurines of women weav-ers or women grinding on metates, have been written about extensively (Halperin 2009c; Joyce 1993, 2000a). Interestingly, these types of figurine motifs are numerically few and geographically restricted (see the discus-sion in Cohodas 2002). Aside from five women weaver figurines thought to derive from the Jaina or Campeche region, this theme does not appear elsewhere in the Maya area (Delgado 1969; Goldstein 1979: 82). In addition, not all of the seemingly mundane figurine themes are associated with activities in and around house lots even if they speak to a more ordinary realm of social activity. For example, figurines with broad-brimmed hats may reference mercantile, traveling, and ceremonial activities integral to communal social life (figs. 3.33, 3.34, 3.35).

The broad-brimmed hats are one of the most common headdresses worn by Late and Terminal Classic period figurines of women throughout the Maya area. In some parts of the Petén, they are the only headdress type that parallels ruler figurines in their frequency and distributions. At the site of Altar de Sacrificios, broad-brimmed hats (n = 17) are one of the most common types of headdresses reported in figurines. Approximately 25 percent of these were recovered from the civic and elite residential architectural complex of Group A; the remaining 75 percent were recovered from excavations of the smaller house mounds to the west of the Main Groups (Mounds 3, 10, 24, 37) (Willey 1972: 44–45). At the site of Nakum, where excavations have focused primarily on the site core, figurines with broad-brimmed hats are the most common headdress type (n = 40, 42.5 percent of identifiable headdresses). In the Motul de San José region, broad-brimmed hats also are the most common type of headdress in the collection (appendix 3.2, 3.3). They are recovered, mostly in fragmentary forms,[17] from primary and secondary midden contexts at

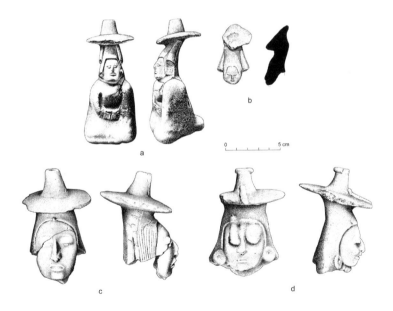

FIGURE 3.33. *Molded figurines with appliquéd broad-brimmed hats: (a) female figurine, Motul de San José (MSJ2A-5-6-15n); (b) broad-brimmed hat partially eroded, Motul de San José (MSJ15A-9-5-5a); (c) San Clemente (SCFC014); (d) Nakum (NKFC221) (note: some Terminal Classic figurines, such as c and d, are larger than those from earlier in the Late Classic period; drawings by Luis F. Luin).*

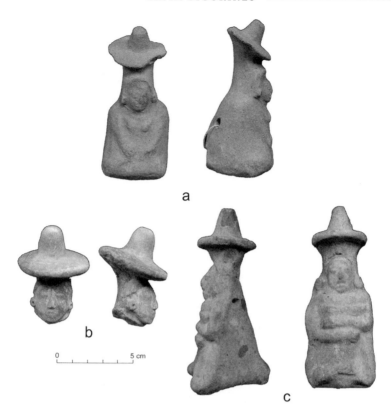

FIGURE 3.34. *Molded figurines with appliquéd broad-brimmed hats: (a) female, Altar de Sacrificios (MUNAE10084A); (b) Altar de Sacrificios (MUNAE10085B); (c) female, Uaxactún (MUNAE8848) (photographs by author).*

the site of Motul de San José as well as at secondary and tertiary centers surrounding Motul, where they are found in high-, middle-, and low-ranking household architectural groups (fig. 3.8).

Other sites in central Petén where broad-brimmed hat figurines have been recovered include Seibal (n = 8) (Willey 1978: 26, figs. 30, 31); San Clemente (n = 8); Tikal (at least 3; personal observation 2006); Nixtun Ch'ich', Ixlú, and Zacpetén (n = 9); Uaxactún (Rands and Rands 1965: fig. 27, MNAE8848); Ixlot Na (n = 1; the hat is missing, but a circular appliqué mark and two tassels remain) (Laporte et al. 2004: 327, fig. 128); and El Zotz (Lukach and Garrido 2009: 431, 434) and La Florida (n = 1) (MUNAEX-44q). Examples are also noted from the Campeche coastal area (Schele 1997: 176–177); Copan (Hendon 2003: 31–32; Longyear 1952: fig. 87h); Cahal

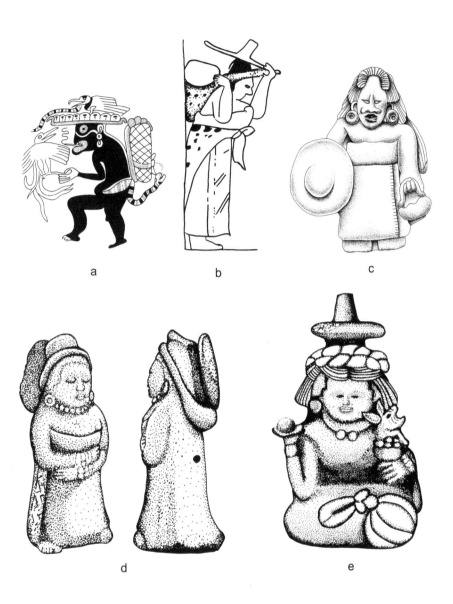

a b c

d e

FIGURE 3.35. *Figures with broad-brimmed hats and cargos: (a) Merchant deity, God L, with tumpline and cargo (after Taube 1992a: fig. 40e); (b) detail from polychrome vessel (drawing by author; K8386); (c) female figurine holding broad-brimmed hat and cargo (drawing by Luis F. Luin after Wegars 1977: fig. 14a); (d) female figurine with tumpline and broad-brimmed hat resting at the back of the head, Tikal (MUNAE, drawings by author); (e) seated female figurine with tumpline and cargo at her knees, Alta Verapaz, Museo Popol Vuh, Guatemala (drawing by author).*

Pech, Belize, in which a woman holds a small child (Audet 2006: fig. 4.17); Lubaantun, Belize (Joyce 1933: plate I-4); Pacbitun, in which a woman holds a small child (Healy 1988: 26); and Dzibilchaltun (Taschek 1994: fig. 51a); not to mention several unprovenienced specimens (Mace 1999: fig. 43; von Wuthenau 1969: fig. 163b).

When breasts and clothing are visible, the figurines with broad-brimmed hats cited above are overwhelmingly female. Most of these women possess stepped-cut hairstyles and wear *huipiles* and simple adornment (such as ear spools). Larger-sized figurines from central Petén, which most likely date to the Terminal Classic period (Halperin 2009b), however, possess center-parted hair, wear off-shoulder wraps or *cortes* lined at the edge with Ik' (T-shaped) and triangle symbols, and have a single-stranded bead necklace. In at least one example from San Clemente (recovered from a large Terminal Classic on-floor midden deposit of an elite household), evidence of face painting remains, similar to depictions of women on polychrome vessels and murals.

Several female figurines with broad-brimmed hats carry or are associated with cargos and may have referenced market women (fig. 3.35). One example from Tikal whose broad-brimmed hat hangs on her back (as if suspended by a hat tie) also holds a cargo with a tumpline (MUNAE9983). A figurine from the northern Highlands of Guatemala with a broad-brimmed hat on exhibit in the Museo Popol Vuh, Guatemala City, holds a ball, perhaps a tamale, in her right hand, and a dog in her left arm (fig. 3.35e). Her cargo sits in front of her. Houston and colleagues (2006: 110, fig. 3.4) interpret another figurine in the same style and content as the Museo Popol Vuh version as a woman vendor selling food. Although her headdress is broken off, she is portrayed seated with a dog, tumpline and cargo, and container of tamales (fig. 3.36d) (see also Dieseldorff 1926: fig. 27). During the time of Spanish contact, both Aztec and Maya women bought and sold goods in the market (Sahagún 1959: 28, 1961: 91–93, figs. 124, 125, 127, 129, 132, 142, 143, 144a; Tozzer 1941: 127). Thus it may not be surprising that women held similar roles earlier in the Classic period.

These broad-brimmed hat figures with cargos or containers of goods are similar in content to other female figurines from Altar de Sacrificios (Willey 1972: fig. 34b), Lubaantun (Joyce 1933: plates IV-3, IV-4, and IV-8), Motul de San José (Halperin 2009c: figs. 13.7, 13.8), Flores (personal observation 2011), and Piedras Negras (Ivic de Monterroso 2002), which are shown without broad-brimmed hats but hold bowls, baskets, and jars of food, drink, and other goods (see also Schele 1997: 42). A child is present in

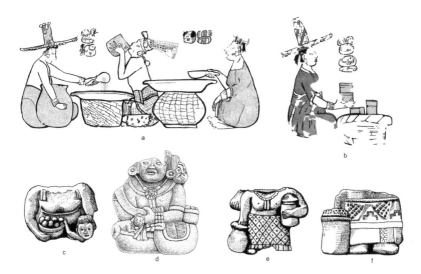

FIGURE 3.36. *Goods vendors and food servers: (a) scene with* aj ul *(maize-gruel person): (left, broad-brimmed hat figure) from Chik Nahb complex murals, Calakmul (drawing by Luis F. Luin after Carrasco Vargas et al. 2009: fig. 5); (b) female* aj jaay *(clay-vessel person) from Chik Nahb complex murals, Calakmul (drawing by Luis F. Luin after Carrasco Vargas et al. 2009: fig. 7); (c) female figurine with bowl of tamales and child (drawing by author after Joyce 1933: plate IV-8); (d) figurine of woman with tumpline, dog, and bowl of tamales, Alta Verapaz (drawing by Taube after Houston et al. 2006: fig. 3–4); (e) molded figurine of woman holding jar and container filled with goods, Lubaantun (drawing by author after Joyce 1933: plate IV-4); (f) molded figurine of woman and container filled with goods, Lubaantun (drawing by author after Joyce 1933: plate IV-2).*

one example, dipping his or her fingers into a bowl of tamales (fig. 3.36c) (Joyce 1933: plate IV-8). These images may have referred to feasting, food serving, and market exchange.

Broad-brimmed hat figurines and female figurines holding containers of goods closely parallel a rare set of scenes painted as a mural from the Chik Nahb Complex at Calakmul. This mural depicts marketing, communal feasting, or festival activities (fig. 3.36a, b) (which were not necessarily mutually exclusive: see, e.g., Halperin et al. 2009). The scenes contain a series of male and female figures, many with broad-brimmed hats, with either tumplines and cargos or containers of food, drinks, and other goods. The large sizes of their baskets, jars, and bowls suggest that a crowd was involved, and the broad-brimmed hats denote an outdoor or relatively open-air venue. Hieroglyphic captions identify their associated wares:

89

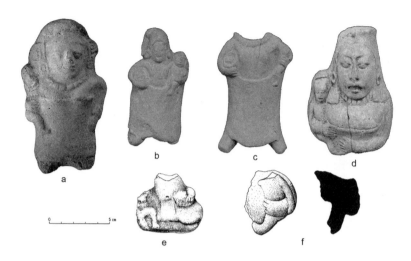

FIGURE 3.37. *Molded figurines with infants or children: (a) female with small child, Yaxhá (YXFC066; photo by author); (b) female with bowl of tamales and infant or small child, Altar de Sacrificios (MUNAE10086B; photo by author); (c) female with bowl of tamales and infant or small child, Altar de Sacrificios (MUNAE9558; photo by author); (d) female with child, Altar de Sacrificios (MUNAE14407; photo by author); (e) seated male with child or animal on right knee, Motul de San José (MSJ2A-1-4-1a; drawings by Luis F. Luin); (f) molded figurine with appliquéd arm and infant, Motul de San José (MSJ39F-4-1-1a; drawing by Ingrid Seyb) (scale bar applies to b, c, e, and f).*

aj ul "maize-gruel person," *aj waaj*, "maize-bread person," *aj jaay*, "clay-vessel person." A small child is also present in the scene, a theme that also frequently appears among ceramic figurines (fig. 3.37). Importantly, the large majority of these figures are not accompanied by personal names or titles, suggesting either that these figures were not titled elite or that this information was not crucial to the scene. If the figurines holding cargos and food were placed together in a scene, they would indeed resemble the Chik Nahb Complex murals.

While figurines with broad-brimmed hats appear to be exclusively female (one exception is a monkey figurine with a broad-brimmed hat perched on a merchant's cargo: Schele 1997: 167), both males and females wear the hat on polychrome vessels and large-scale media, as in the Calakmul murals. Imagery of males shows them associated with trade, travel, and hunting activities. Taube (1992a: 79–88) has linked these activities to the merchant god, God L, who wears a broad-brimmed hat decorated with *moan* feathers and is occasionally depicted with a large cargo and

tumpline. The hunting god is also shown with a broad-brimmed hat (Taube 2003a: 473–474).

Beyond hunting and merchant activity, however, figures with broad-brimmed hats likely referenced travel more generally. Stone (n.d.) suggests that in religious contexts, such as quatrefoil cave openings, they may signify participation in a pilgrimage. Alternatively, in one polychrome vase (K5847), women are being carried in a tumpline by men, a scene that Houston and colleagues (2006) interpret as part of a marriage ceremony in which women are carried to their husbands' residences or town. Although marriage is not referenced in the accompanying texts, more general statements such as *pakax-i* (he/she/it returned [to]) and *lok'ooy* (left) imply travel of some sort (Lopes 2005).

It is important to keep in mind that symbolic associations with adornments such as the broad-brimmed hat varied in time and space. While such a headdress was absent as a monumental symbol of pomp and ceremony among Southern Lowland sites during the Late Classic period, elaborate versions of the broad-brimmed hat (e.g., with tassels and masks) appear both during the Preclassic in an example from Monument 3, an Olmec-style sculpture from Ojo de Agua (Hodgson et al. 2010), and during the Terminal Classic period in the Puuc region and along the Gulf Coast of Mexico (Wyllie 2010).

DISCUSSION

Because many figurines are found within the contexts of households, one may expect to find a rather literal mimetic construal: concerns related to the household, such as the social identities of the family (for example, ancestors of household inhabitants, figurines depicting elite identities in elite households, and figurines depicting commoner identities in commoner households), or the varied activities undertaken in and around houses (including gardening, grinding foodstuffs, cooking, ritual, feasting, agricultural work, caring after children, and crafts production). While in some cases iconographic links to household activities and identities were implicitly portrayed, in general the images do not focus on these themes. Instead the figurines highlight a cast of characters from performances and ceremonial enactments, in many instances too ostentatious to refer only to everyday expressions in and around house compounds. These representations of state officials and performers were folded into the visual repertoires and everyday activities of what people actually did in

household settings. As such, they helped disseminate tangible conceptions of state pomp and ceremony into the reaches of the ordinary, quotidian, and commonplace. These figurative social expressions linked not only state and household but also different polities across the Maya area, as exemplified by the goggle-eyed headdress variant common to Palenque nobles but seen in figurine media from outside the Palenque region.

At the same time, anthropomorphic figurines depict a series of competing figurine types, such as secondary elites and more simply adorned men, women, and children, who may have diversified the material manifestations through which social identities were constituted. Of particular prominence among many figurine collections in Petén, for example, are simply dressed women with broad-brimmed hats. While many of the figurine identities possess counterparts in the narrative histories of the murals of Bonampak, these broad-brimmed hat figures more closely parallel the feasting or market scenes found on the newly discovered Calakmul murals, in which nontitled men and women exchange goods, serve food and drink, and gather in a public social space.

The figurines may at times downplay gender relations in favor of linked forms of status and joint ritual participation, a point that Rosemary Joyce (1996, 2000a) emphasized when pairs of royal males and females appeared in stone monuments. Females are brought into discourse with males or male-gendered supernaturals by the similar types of objects they hold, such as fans or cotton necklaces, or by the similar headdresses they wear. Such discourses are not necessarily about a domestic female identity paired against a public, performing male one, as the modern gaze often assumes: at least some of the females are clearly meant to be thought of as being seen in front of a larger audience (Gustafson 2002; Ortner 1974; cf. Joyce 1996, 2000a). Nor do they represent a discourse that specifically favors women. They do, however, decenter dominant male roles in ritual, politics, and civic life declared through hieroglyphic text and monumental images to provide a more complex palette of myth, history, and social reflection or projection.

Similar to polychrome vessels, social commentary does not explicitly highlight divisions between the most humble and the highest-ranking social identities, because farmers and the large majority of craftspeople are not explicitly portrayed in figurines.[18] Rather, the relations that are invoked, as understood by the prevalence of figurine themes portrayed, were likely between the highest-ranking elite and secondary elite. Such juxtapositions speak to closely allied or competitive social spheres that

were never fully self-evident but continuously reasserted through bodily and material expression both large and small.

Social relations, however, were not just about an articulation of status, gender, and performative roles but were expressed by and actualized through supernatural and animal worlds. In large-scale media, state officials mediated between humans and sacred beings, situating themselves as key pivots between earthly and spiritual realms. Nonetheless, they did not or could not control all spiritual engagements. Ceramic figurines also celebrate a cast of ulterior, humorous, and grotesque supernatural and zoomorphic figures, as explored in the following chapter.

FROM ORAL NARRATIVE
TO FESTIVAL AND BACK

Tricksters, Spirit Companions, Ritual Clowns, and Deities

In both concurrence and tension with Late Classic Maya state representations was a more perverse, liminal, and otherworldly realm that stressed transformation, hybridity, ridicule, and challenge to social boundaries. At the heart of these transgressions were tricksters, ritual clowns, *wayob* or spirit companions, and other grotesque supernatural beings. These figures were both sacred and a celebration of alternatives. They were a counterweight to "official" comportment, mores, and conventions. Royal and noble personages garnered and celebrated close relationships with these anomalous supernatural beings in some cases. In other instances tricksters and ritual clowns may have imitated, mimicked, or parodied state officials, revealing how mimesis can be humorous, ironic, and reflective (Taube 1989; Taube and Taube 2009). In this sense they dance along a central tension: the grotesque was both sanctioned by the state and a challenge to its authority.

Late Classic Maya ceramic figurines and other small-scale media open up this grotesque and supernatural world of trickster tales, ritual clowning, and spiritual transformation in their depiction of dwarves, Fat Men, aged figures, and animal hybrids. These figures, with the exception of dwarves, were rarely part of the sacred and historical commemorations on stone monuments, sculpted public building façades, or lintels. Instead they appear much more often on small-scale media such as elaborately painted polychrome vessels, most of which circulated among royal and noble social circles, and on ceramic figurines. As I emphasize here, these mythic, hybrid, and supernatural figures, like their anthropomorphic counterparts, were likely the subjects of oral narratives and part of the understandings and experiences of many Maya peoples, not just the royal elite. Yet it is clear from their association with fans, dance poses, music,

and masks that we should also think of many of them as part of performances, with their presence felt in public plazas, stepped terraces, and platforms where spectacle and ceremony came alive.

In following a form of grotesque realism (Bakhtin 1984: 184), they are exaggerated, ambiguous, and abnormal in their physicality and behavior. They differ from formal Maya deities in that they were not referred to as *k'uh* (god, sacred entity) in hieroglyphic texts and were not identified by large god-eyes, shine-marks on the body, and other highly codified attributes. They also contrast with the well-proportioned, youthfully portrayed royal body and thus reified this anthropomorphic form as an aesthetic ideal as much as they made fun of it. Because Classic period written texts only peripherally touch upon these figures, their meanings and roles are best explored in relation to contemporary and Contact period Maya festivals and folktale characters (Blaffer 1972; Bricker 1973, 1981; Stross 1978).

Despite long-rooted ties between contemporary and ancient religious practices, however, I attempt to be sensitive to the emergence, appropriations, and alterations of these supernatural beings. In traditional structural analyses, trickster and grotesque figures are seen as "matter out of place," static metaphors for understanding social order, mores, and ideals (Douglas 1966). It is often easy to view these characters as constant and unchanging oppositions to the social order. Nonetheless, the ritual experience of disorder is integral to the process of social and cosmic change, a notion that was not lost on Mesoamerican ruling elites who drew on such experiences in the celebration of calendrical period-endings (Klein 2001; Taube 1989; Turner 1969). Furthermore, "grotesque realism" and religion more generally have a history (Bakhtin 1984). Part of this history is the privileging of some spiritual and supernatural entities over others in particular spaces and times. Some supernatural figures may be officially recognized at one point, to be confined to more intimate interactions or to "hidden transcripts" at some latter point. This shifting of importance can be tied in part to the politics of making and unmaking social boundaries as some social groups differentiate themselves by and through the supernatural. During the Classic period, divisions between rulers and the ruled revolved around the control of the mimetic production and access to patron deities, such as Ajaw K'in or K'inich (the Sun deity), K'awiil (God K), the Maize god, and other deities. In contrast, rulers could not (or did not care to) rigidly set the terms for experiencing the realm of dwarves, Fat Men, and various animal hybrid figures.

TRICKSTERS, RITUAL CLOWNS, SPIRIT COMPANIONS

What are the characteristics of tricksters, ritual clowns, and spirit companions? Tricksters are best known from oral and written stories. In these tales, tricksters' attributes and behaviors contradict social norms: they often choose self over society, are hypersexual, are wanderers, live on the outskirts of the community, and take animal or nonhuman forms (Babcock 1984; Ballinger 2004; Koepping 1985; Shaw 1971). They are also comical, making fun of themselves while simultaneously making fun of society. They play critical roles in mediating between animal and human worlds, between spirits and humans, and between life and death (Lévi-Strauss 1955).

While Coyote is one of the most popular trickster characters among Indian cultures of the North American West Coast, plateau, Great Basin, Southwest, and southeastern plains (Ballinger 2004: 37–38), dwarves are a common trickster figure among ancient and contemporary Maya peoples (Conklin Thompson et al. 2007: 95–96; Mock 2003: 250–251; Redfield 1962; Sosa 1985: 410–411; Thompson 1930: 166). Despite their tendency to be confined to oral traditions since at least the colonial era, dwarf characters do occasionally appear in contemporary festivals. For example, Barbara Tedlock (1982: 147–150) records the appearance of the Tzitzimit or C'oxol, a Quiché Maya dwarf, as a character in the annual performance of the Dance of the Conquest in highland Guatemala. In this performed narrative, the dwarf refuses a Catholic baptism and runs off into the forest. In doing so he preserves ancient customs and symbolizes an alternative order to the imposed Catholic or Spanish one.

A whole host of other trickster figures, also known as spooks and demons, can be identified in contemporary Maya folklore, including *ix tabay* among the Itzá, Yucatec, and other Maya groups (Hofling 1991: 63–67; Thompson 1930: 157), the Black Demon (*h?ihk'al*) and the Wall Demon (*špak'inte?*) among the Tzeltal (Stross 1978), the *ijk'al* or *ñek* among the Chol (Pérez Chacón 1988: 167–168), and the Blackman (*h?ik'al*) among the Tzotzil (Blaffer 1972). Like the figurines described below, these contemporary spooks and demons are often characterized by inverted or unusual physical attributes that separate them from humans. For example, the Zinacantán Blackman is short and black-skinned, has curly hair, sometimes possesses wings on his knees, and is endowed with a six-foot-long penis. The *xtabai* is occasionally described as having a hollow back and walks backward. Like the dwarf, these figures often live in caves and

away from human settlement. They prey on drunks, test humans who veer from social norms, and in some cases are hypersexual (Blaffer 1972: 147–150; Stross 1978: 35–36).

Ritual clowns are tricksters who manifest as performers in sacred ceremonies and festivals (Bricker 1973, 1981; Hutcheson 2009; Mace 1999; Tedlock 1975; Termer 1930). Thus they appear as part of official ceremonial events but often as a commentary on and imitation of the formality and order of this more public realm. For example, during the Contact period, elites in Yucatán, Tlaxcala, and Michoacán patronized jesters, comedians, and buffoons who performed during festivals (Bricker 1973: 193; Clendinnen 2003: 142–143). These *farfantes* (buffoons) impersonated Spanish priests and mocked elders (Bricker 1973: 178–179). Similarly, during contemporary festivals, ritual clowns may have relatively formalized roles with their own *bailes* (dances), designated appearances within theatrical performances, and specialized costumes. Nonetheless, ritual clowns may also perform on the sidelines of planned performances and dances, disrupting their formality and narrative sequence by their spontaneous interjections and burlesque imitations. Performances are highly improvisational in both their formal and informal manifestations, and thus their content and nature shift rapidly (Hutcheson 2009: 880).

For example, contemporary Maya carnival festivities in Chamula, Mexico, include the participation of "dependent" monkeys who are associated with the sponsors of the fiesta and play a role alongside other theatrical characters that mimic and stereotype social roles (e.g., Spanish Lady, Passions). "Independent" monkeys are also present and can be played by anyone who wants to dress up and engage in festive antics. Both sets of monkeys mimic the noises of wild monkeys, dance constantly, quarrel with each other, drink profusely, and make perverse sexual jokes (Bricker 1973: 93–98). In Chenalhó, some "independent" monkeys are played by children (fig. 4.24b) (Bricker 1973: fig. 13). A similar type of ritual clown is the Blackman, who mimics and makes fun of elite women, cargo holders, priests, and other officials in Zinacantán festivities (ibid.: 46–67). As noted earlier, this character is also a prominent figure in Zinacantán folklore.

Karl Taube (1989) has suggested that ritual clowning dates back to at least the Classic period. Ancient festival humor was integral to the celebration of calendrical endings and transitions, such as the Uayeb rites, which are documented in Postclassic codices and described by Bishop Diego de Landa (Tozzer 1941). These characters, some of which are reviewed in this chapter, include the Mam or elderly male, opossum, old men with young

women, spider monkeys, and simian characters often depicted as snake-dancers. They carry fans and musical instruments and are characterized by "ugliness, old age, drunkenness, wanton sexuality, animal impersonation, and shabbiness" (Taube 1989: 377).

Related to contemporary folktale characters and ritual clowns are spirit companions and/or less formalized spiritual beings, some of which are associated with death, sacrifice, renewal, and the underworld. Contemporary Mesoamerican spirit companions, co-essences, or alter egos are often known as *naguales*, an essential component of personhood that manifests during dreaming. They may appear in animal form but also as inanimate objects and aspects of nature (such as lightning) (Foster 1944; Saler 1964). In addition, dwarves are one form of spirit companion among contemporary Maya groups, indicating that folktale characters and spirit companions have the potential to overlap (Houston and Stuart 1989: 2).

Maya folktales often reference these fearsome dreamworlds, such as the stories of Flesh Dropper among the Tzeltal and Fallen Flesh among the Tzotzil. During dreaming, men and women transform into the Flesh Dropper or Fallen Flesh: as their name suggests, they lose their skin to parade around as skeletons. During the night, they run around terrorizing humans who are not safely sleeping in their homes (Laughlin 1977; Meneses López 1986; Stross 1978). Other Maya tales include animal transformations, such as the Yucatecan "Sorcery Story" in which a woman would take her head off during the night and turn into a mule. One night her husband puts ashes on her neck, so she cannot transform back into human form. So she follows her husband around as a mule with a woman's head (Thompson 1930: 158).

Among the K'iche, *naguales* are often conflated with evil transforming witches who can magically metamorphose into animals and steal material possessions of others, make noises during the night, and take sexual advantage of unsuspecting victims (Saler 1964: 312–318). During the seventeenth and eighteenth centuries in Santiago de Guatemala, the *naguales* of women of mixed race (*casta, mulata,* and *mestiza*) would frighten and provoke male *audiencia* and ecclesiastical officials during the night, a testament to women's agency during Spanish colonial rule (Few 1995, 2002).

Classic period spirit companions have been identified with the aid of epigraphic decipherments of the T539 glyph known as *way* (Houston and Stuart 1989). While these *way* spirits can appear in animal form, such as jaguars, monkeys, and serpents, they also appear with anthropomorphic traits, such as the various manifestations of Akan, a *way* associated with

drinking, disease, and death (Grube 2004; Grube and Nahm 1994; Taube 2003a). These *wayob*, whether anthropomorphic or zoomorphic in form, are linked to sacrifice, death, the underworld, and untamed wilderness as well as to gluttony and other human excesses.

Late Classic period polychrome vases depict male *ajawob* (lords) in *way* trances or as impersonating *wayob*. For example, in a series of Ik' Style polychrome vessels thought to have been produced in or near the site of Motul de San José, some elite figures possess animal hands, legs, or foreheads and are shown dancing in a trancelike pose. Other vessels depict Ik' and other polity rulers who are also dancing or playing music. They wear "X-ray costumes," in which their human identities are fully intact below costuming, perhaps purposively referencing such transformations as part of masked performances as seen in X-ray masks in other contexts (e.g., Yaxchilán Stela 11). With a few exceptions, Classic period depictions of *wayob* or those transforming into *wayob* are male-gendered. Interestingly, such representations contrast with both colonial and ethnographic texts, which detail both men and women as possessing *naguales* as well as having the ability to transform into witches (Few 2002; Saler 1964).

Classic period hieroglyphic texts indicate that secondary elites held titles of *wayaab'*. The hieroglyphic spelling of *wayaab'* was the same as *wayib'* ("the dreaming place" and "domicile") (Beliaev 2004). Dmitri Beliaev (ibid.) suggests that these secondary title-holders engaged, perhaps on behalf of their own lineage or household, in special religious duties related to the communication with ancestors and the otherworld. In these instances, *way* experiences may have been particularly relevant to household rituals, if not in tension with those experienced by the high-ranking royalty. As outlined below, figurines and polychrome vessels are instrumental in understanding these various spiritual and trickster-like figures.

Fat Men

Fat Men are one of the most common supernatural figures found in Late and Terminal Classic period figurine assemblages. They are identified primarily by their big bellies, hanging or jowly cheeks, and closed or swollen eyes (appendix 4.1). While they have been previously referred to as Fat Gods, I refer to them here as Fat Men because their status as a formal god during the Late Classic period is questionable. They probably belong to the more ulterior trickster, ritual clown, and *wayob* complex.

Julia Guernsey (2012) and Karl Taube (2004b: 156–161) trace this figure back to the Early and Middle Preclassic period in Mexico and Guatemala,

where a number of miniature masks, figurines, and vessels depict beings with long, jowly cheeks, slit or closed eyes, large lips, and bodies with large bellies (when present). During the Late Preclassic period, however, such figures were prominently displayed as part of large carved stone sculptures, known as potbellies, with the largest weighing several tons from the Pacific piedmont and highland region of Chiapas, Mexico; Guatemala; and El Salvador (fig. 4.1a) (Demarest 1982; McInnis Thompson and Valdez 2008; Parsons 1986). In addition to their characteristic big bellies, hanging or jowly cheeks, and closed or swollen eyes, they are commonly naked or wear little clothing (e.g., loincloths) but sometimes wear collars or circular pendants. Guernsey (2012) notes that a fundamental shift occurred in the transition of the Middle and Late Preclassic periods, a time in which state structures developed and kingship became institutionalized. As part of this transition, domestic ritual was supplanted by an emphasis on larger collectivities, monumentalism, and civic ceremonialism. Ceramic figurines, including potbelly figures with jowly cheeks, were no longer produced and were replaced by monumental versions in stone. Although many of the Late Preclassic stone potbelly sculptures have been moved from their original contexts, the presumption is that they had a formal role in these newly formed state structures and were part of large-scale ceremonial activities.

Although Fat Men had popular appeal throughout Classic Mesoamerica in small-scale media, they recede from large-scale media carved in stone. As such, they no longer appear to have been part of the official canon. Hermann Beyer (1930) first identified "Fat Gods" in Teotihuacan and Veracruz iconography (fig. 4.1b, c) (see also Medellín Zenil 1987: fig. 19). In Classic period Teotihuacan households, they are found on figurines or as leg supports on tripod vessels (Linné 1942: 167–168, fig. 305, 306; Manzanilla 1996: 239) and continue in figurine traditions through the Postclassic and Colonial periods (Goldsmith 2000: 59).

In the Maya area during the Late Classic period, Fat Men were also largely confined to small-scale imagery found in household contexts.[1] An exception to this pattern is a series of stone columns from Campeche and western Yucatán with images of the Fat Man (fig. 4.2a) (Miller 1985: 147; Proskouriakoff 1950: figs. 95i, 97a). Later Classic populations may have been aware of earlier Fat Men manifestations, as suggested in the reuse of Late Preclassic style potbelly sculpture in Late Classic Maya contexts, such as at Sin Cabezas, Copan, and San Bartolo (Craig 2009: 79–80; McInnis Thompson and Valdez 2008: 22–23). Classic period versions of Fat Men

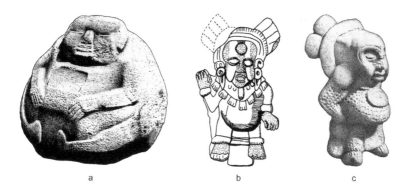

FIGURE 4.1. *Mesoamerican manifestations of the Fat Man: (a) Late Preclassic potbelly sculpture from Monte Alto, Guatemala (drawing by Luis F. Luin); (b) molded Fat Man figurine from Teotihuacan, Mexico (drawing by author after Beyer 1930: fig. 2); (c) molded Fat Man figurine from Veracruz, Mexico (drawing by Luis F. Luin after Medellín Zenil 1987: fig. 19).*

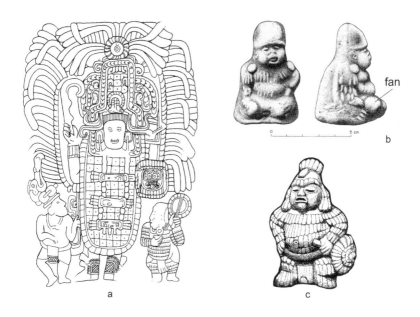

FIGURE 4.2. *Fat Man performers with fans: (a) Worcester Art Museum Column showing ruler flanked by a dancing dwarf (left) and Fat Man (right) (drawing by Luis F. Luin); (b) seated Fat Man with fan in right hand, molded figurine, Nixtun Ch'ich' (NC118); (c) Fat Man with fan, molded figurine, Jaina (drawing by author after Piña Chán 1968: plate 12).*

differ from Late Preclassic potbellies by having tight-fitting body suits, which were likely made of cotton (identified by pock-marking in the clay, a point that I will return to later).

Classic period Fat Men were performers and likely served as ritual clowns (Miller and Taube 1993: 86; Taube 2004b: 159). They are often depicted dancing, holding fans, and/or wearing textured body suits, cloth ear pendants, and knotted scarves or occasionally cotton necklaces, as described in chapter 3 (fig. 4.2b) (Butler 1935: fig. 2i; Dieseldorff 1926: figs. 48, 49; Halperin 2007: fig. 7.2of; Inomata 1995: fig. 7.3a; Rands and Rands 1965: fig. 35; Taube 2004b: fig. 74c). These costume traits are shared by other *wayob*, ceremonial tricksters, and buffoons (Danien 1992; Quirarte 1979; Taube 1989: fig. 24–8a, b, 24–9b, e, f, 24–11a). The cloth ear pendants may have signified sacrifice or liminality: they are the accoutrements of captives whose human marks of social identity (such as ear spools, headgear, and clothing) have been stripped from them as well as figures conducting sacrifices (fig. 4.3d). On a carved stone column housed in the Worcester Art Museum, a dancing Fat Man and a dancing dwarf flank an ornately costumed ruler with feathered backrack (fig. 4.2a). Although the pairing of Fat Men and rulers is rare, such a scene may indicate that Fat Men, like dwarves, were components of large-scale performances that pivoted around performing rulers.

The performative nature of Fat Men is further reinforced by the appearance of Fat Men masks, found primarily in the Petexbatún region of Guatemala (fig. 4.4) (Inomata 1995: 549, figs. 8.16b, 8.17f; Ishihara 2007: fig. 7.6b; Triadan 2007: 277, 279, fig. 3). These masks possess punctated eyes that open into a hollow headpiece, which presumably would have been placed on the head of a complete anthropomorphic figurine. Similar to these figurine masks are Terminal Classic period "Fat-Faced masks" and "Fish-Lipped masks" with punctated eye-holes from the Ulúa Valley,

(OPPOSITE PAGE) FIGURE 4.3. *Liminal figures with cloth ear pendants: (a) Fat Man in dance pose, molded figurine, Alta Verapaz (MUNAE5875, photo by author); (b) Fat Man and dog spirit companion, molded figurine (height 10.4 cm, width 6.7 cm, depth 7.5 cm; Princeton University Art Museum, promised bequest of Gillett G. Griffin, L.1988.147, photo by Bruce M. White); (c) Fat Man as warrior, molded figurine (drawing by author after Eberl 2007: fig. 10.27a); (d) human captives, detail from Yaxchilán Stela 11 (drawing by Luis F. Luin); (e) Fat Man spirit companion (sitz' winik way) with textured body suit and fan decorated with cross bones, detail from polychrome vessel (drawing by Luis F. Luin after Taube 2004b: fig. 74c); (f) sitz' winik way, detail from polychrome vessel (K927, drawing by author).*

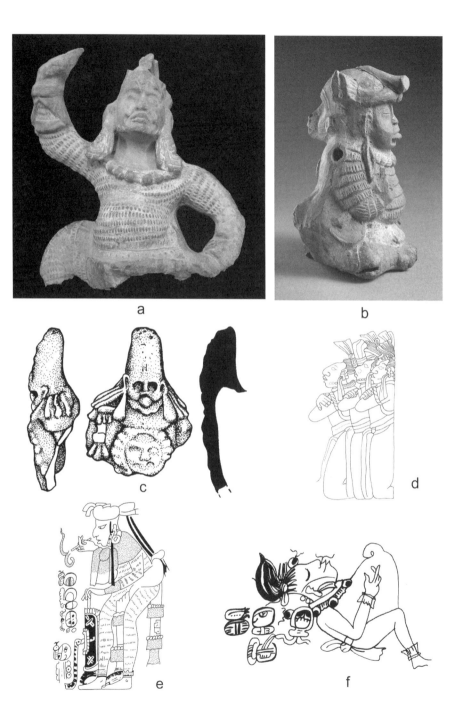

a

b

c

d

e

f

a b

FIGURE 4.4. *Fat Men masks: (a) anthropomorphic figure with Fat Man mask headdress, molded figurine, Aguateca (drawing by author after Inomata 1995: fig. 7.3); (b) Fat Man figurine mask with punctated holes for eyes, Aguateca's grieta (FG189; drawing by Alfredo Román; courtesy of Reiko Ishihara-Brito).*

a b

FIGURE 4.5. *Molded figurines of Fat Men as performing duos: (a) two Fat Men dancing, unprovenienced (MUNAE 8143; dimensions 12.2 × 10.4 cm; photo by author); (b) Fat Man on the shoulders and touching the breast of a young woman, Jaina (drawing by author).*

Honduras (Lopiparo 2003: figs. 5.5a, 5.5c). Fat Men also appear as performing duos in dance poses (fig. 4.5) (Triadan 2007: fig. 9b). In one complete figurine example from Jaina, a Fat Man sits on a young woman's shoulders in a possible dance pose (Looper 2009: fig. 2.11) while he or another figure simultaneously fondles one of her breasts (fig. 4.5b) (Piña Chán 1968: plate 13). This sexually explicit scene parallels a genre of elderly

male figures who sit on the laps of young females and grope their breasts. Taube and Taube (2009) point out that these couples and their poses are contrary to social norms depicted elsewhere and likely provided humorous commentaries on proper moral and social conduct.

Likewise, Fat Men may have provided commentaries on warriors, as they wore their same protective body suits (fig. 4.6). Such mimetic productions, however, are ironic if not humorous: the squat, corpulent Fat Man often holds a fan (rather than a spear or shield) and was not physically fit for combat. Although humor is highly situational, this interplay between mimesis (similarity) and alterity (difference) is essential for comedic acts and reflective understandings of social categories.

In addition to the role of Fat Men as ritual clowns or performers, hieroglyphic texts painted on polychrome vessels refer to a *way* called *sitz' winik* (gluttony man or fat man) (fig. 4.3e, f). This *way* may relate to the Akan complex of *way* figures who embody death, violence, sickness, and gluttony. In at least one example, *sitz' winik* wears the textured body suit seen on examples from figurines (Grube 2004; Grube and Nahm 1994; Miller and Taube 1993: 86; Taube 2004b: 159, fig. 74; see also Schele 1997: 129). An unprovenienced Fat Man figurine from the Princeton University Art Museum also may refer to spirit companions (fig. 4.3b). While most molded figurine backs are plain and undecorated, this Fat Man figurine is rare in that its reverse side is a dog. The animal-counterpart's pose is portrayed with mirrorlike precision. It is unclear, however, whether the dog represents the spirit companion of the Fat Man or the Fat Man represents the spirit companion of the dog.

In terms of their archaeological distributions, Fat Men figurines have been found in fragmentary condition from primary and secondary middens associated with elite and commoner households as well as middens from ceremonial contexts (Laporte 2008: 953). In the Motul de San José region, these figurines were located in relatively similar frequencies from elite-, middle-, and low-status architectural groups (fig. 4.7, appendix 3.3). In these examples, Fat Men wear Mohawk hairstyles or possess simple headdresses, such as a thin headband or a hoodlike element. In and around the capital of Aguateca, Fat Man figurines and Fat Man masks were excavated from elite residences, a commoner household at the site of Nacimiento (located 2.5 km from Aguateca), and a *grieta* (cave) that bisects the site (Eberl 2007: fig. 10.27a; Inomata 1995: 549, figs. 8.16b, 8.17f; Ishihara 2007: fig. 7.6b; Triadan 2007: 277, 279, fig. 3). At the site of Ixtonton, three Fat Man figurines were recovered from the site core

a
b
c
d
e
f

FIGURE 4.6. (OPPOSITE PAGE) *Warrior and Fat Men with quilted bodysuit: (a) finely modeled male warrior figurine with removable headdress, Naranjo (NRFC005); (b) Fat Man, molded figurine, Motul de San José (MSJ2A-3-9-1b; drawing by Luis F. Luin); (c) Fat Man, molded figurine, Motul de San José (MSJ36F-2-2-3a; drawing by Ingrid Seyb); (d) Fat Man, molded figurine, San Clemente (SC106; photo by author); (e) Fat Man, molded figurine, Motul de San José (MSJ2A-3-13-1a); (f) Fat Man, molded figurine, Tikal (45E-41-10; photograph by author) (scale bar applies to b–f).*

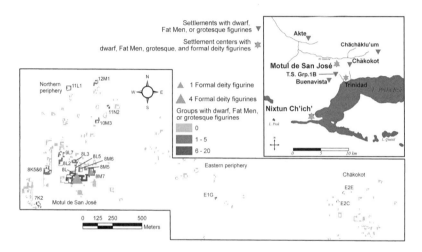

FIGURE 4.7. *Distribution of supernatural figurines at Motul de San José and the East Transect (lower left) and among settlements at the western edge of Lake Petén Itzá (upper right).*

(a Fat Man mask [F-029] and a Fat Man torso [F-030] with abnormally large breasts and loincloth from Plaza B and a Fat Man torso with fan [F041] from the West Pyramid). Their distributions throughout the Maya area are broad: they are commonly recovered from sites in the Petén (appendix 4.1), western Belize (Healy 1988: 27), Alta Verapaz (Dieseldorff 1926: figs. 48, 49), and Jaina and sites along the Campeche coast (Goldstein 1979: 84–85; Miller 1975, 1985; Pina Chán 1968; Schele 1997).

Dwarves

Dwarves, like Fat Men, are ubiquitous among Late and Terminal Classic Maya figurine collections and also were part of the trickster/ritual clowning complex. Following Mary Miller (1985: 141), they are identified by their "small stature, abnormally short and fleshy limbs, a protruding

abdomen, and a disproportionately large head with prominent forehead, sunken face, and drooping lower lip." Because of their chubby faces and squat, corpulent bodies, they are often confused with Fat Men. Unlike Fat Men, however, they appear much more regularly on stone monuments and other large-scale media. They also differ from Fat Men in that they do not wear textured cotton body suits or possess the same closed or slit eyes.

Dwarves first appear in figurine collections and on carved stone monuments from Early to Middle Preclassic Mesoamerica sites, such as San Lorenzo, Cantón Corralito, and La Venta (Cheetham 2009: 169; Covarrubias 1957; Follensbee 2006: 256, 258, table 10.2; Taube 2004b: 57–58, fig. 32b; Taube and Taube 2009: 246). Their role as throne/sky bearers on a carved stone bench found near the Olmec site of San Lorenzo underscores their early role in supporting elite authority as a metaphor of cosmic action. A dancing and singing dwarf also appears in a mythical scene on the Late Preclassic murals at San Bartolo, Guatemala, in which the dwarf plays a role in the cosmic creation and setting up of world trees (Taube et al. 2010: fig. 32). The Preclassic figurines often feature squat bodies with little bodily ornamentation or accoutrement, a pattern that changes during the Classic period.

During the Late and Terminal Classic periods, in particular, dwarves explode onto the scene as both mythical characters and historical figures who resided in royal courts, serving as entertainers, musicians, dancers, buffoons, and assistants (figs. 4.8, 4.9) (e.g., Bacon 2007; Corson 1976; Gallegos Gómora 2003: 51; Goldstein 1979; Miller 1985; Ruiz Guzmán et al. 1999: 41; Willey 1972, 1978). On Late Classic polychrome vessels, they appear as accompaniments to the dancing Maize god, who ascends from the underworld as part of his cyclical journey from death (harvest) to rebirth (sprouting). On stela monuments and lintels, they are frequently found alongside rulers (fig. 4.9a) (Bacon 2003/2004, 2007; Houston 1992: 527). Wendy Bacon (2007) underscores the liminal nature of dwarves who appear on monuments celebrating period-endings, transitions in the calendar in which the world needed to be reordered. At Caracol, for example, dwarves are strategically placed on monuments erected on half k'atun endings, transition periods between the full-fledged k'atun or 20-year cycle.

While dwarves rarely appear in Postclassic period iconography, the account by Bernal Díaz del Castillo (1963: 227) of the entry of Hernán Cortés into Tenochtitlan in the year 1519 documents that dwarves continued to play an important role in royal households and as ritual clowns among

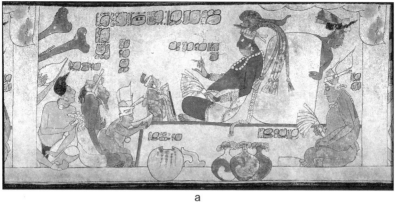

a

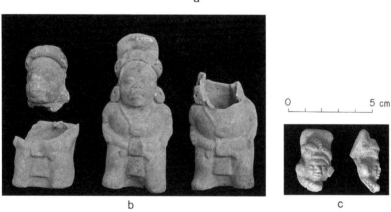

O _____ 5 cm

b c

FIGURE 4.8. *Dwarves as part of royal court and wearing headdress of* aj k'uhun: *(a) drinking dwarf as part of royal court of Ik' ruler, Sihyaj K'awiil, polychrome vessel (K1453 © Justin Kerr); (b) identical molded dwarf figurines, Nakum (NKFC150, 155 and NKFC156); (c) dwarf with stick bundle for writing wrapped in headdress, molded and painted figurine, Nakum (NKFC532; photographs by author).*

the Mexica. He describes a humpbacked dwarf as one of Montezuma's numerous jesters who told jokes, sang, and danced, a role similar to the noble patronage of jesters, comedians, and buffoons in the Maya area and other parts of Mesoamerica during the same period (Bricker 1973: 193; Clendinnen 2003: 142–143). This finding accords well with the Late Classic appearance of dwarves dancing to musical accompaniment or as part of performing ensembles within royal courts (fig. 4.2a). One finely modeled figurine of unknown provenience has a slightly raised foot and arm extended into the air, a typical dance pose (fig. 4.10). This dwarf is

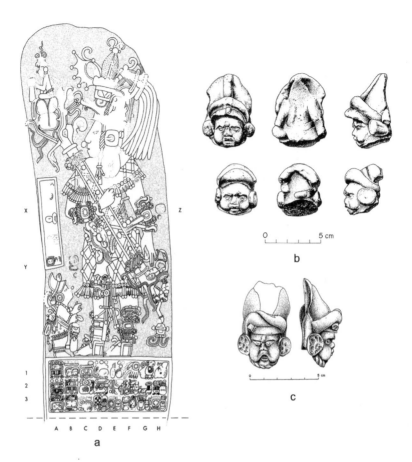

FIGURE 4.9. *Similar headdresses of dwarves on monuments and figurines: (a) Caracol Stela 1 (after Beetz and Satterthwaite 1981: fig. 1; courtesy of University of Pennsylvania); (b) Motul de San José dwarves with similar faces (made from the same mold or set of molds?) but different appliqué headdresses (top: MSJ2A-2-7-1a with a stiff cotton or paper head wrap; bottom: MSJ2A-40-3-1a); (c) Motul de San José dwarf with stiff cotton or paper head wrap (MSJ2A-40-5-1d) (drawings by Luis F. Luin).*

unique in that he wears a mask of himself: the face of a dwarf. Such a mimetic display of oneself recalls the ability of tricksters to make fun of themselves. It also recalls the structure of some contemporary Maya dance dramas, such as those put on by the K'iche Maya, whose ceremonial festival of Joyobaj includes a play within a play that mocks the very saint's day festival in which the nested plays take place. As Maury Hutcheson (2009: 873) asserts, "the complex layering of play within play within

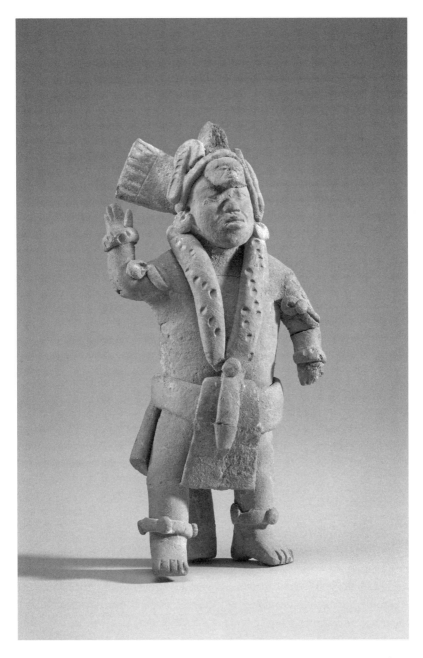

FIGURE 4.10. *Finely modeled dwarf with dwarf mask in dance pose, Jaina or Campeche coast (height 13.2 cm, width 7.1 cm, depth 5.2 cm; Princeton University Art Museum, gift of Gillett G. Griffin, 2010.180, photo by Bruce M. White).*

festival play suggests a history of . . . innovations and ellipses that calls into question many conventional distinctions between ritual and theater, textuality and memory, narrativity and happenstance." These juxtapositions link performance with social reflection and allow for a creative play on ritual play.

Late Classic period dwarves also highlight a dynamic interplay of mimesis and alterity in that they wore the accoutrements of royal courtiers but were never considered full-fledged, reproducing members of royal or noble lineages (fig. 4.8, 4.9). For example, they wear the stiff, bark paper headdresses worn by aj k'uhun (he of the holy paper/books/headband), a scribe or ritual specialist who coordinated artistic and tributary activities for royal courts (compare, for example, with figs. 3.29, 3.30) (Jackson and Stuart 2001). They also wear goggle-like headdresses lined at the forehead with a band of square jewels or designs. As mentioned in chapter 3, these headdresses are worn by nobility titled yajaw k'ahk' (Stuart 2005: 124), some of whom may have had priestly and military duties (Zender 2004). Dwarves wear animal headdresses similar to anthropomorphic ballplayers (Corson 1976: fig. 16d) and occasionally hold balls at their hips (fig. 4.11) (Taube and Taube 2009: fig. 9.7). In one example recovered from Burial 39 at El Perú, a dwarf wears a removable boxer's helmet (Finamore and Houston 2010: fig. 98). Dwarves, with their short stature, probably did not play the ball game and probably were not effective boxers. When considered literally, the donning of royal and noble headdresses and accoutrements by dwarves signified their close affiliations with an elite social sphere. Nonetheless, the combination of what may have been considered an abject body with esteemed markers of rank and privilege may also have pointed to a form of parody, an imitation that resembles at a critical distance, sometimes verging on the ridiculous (Bakhtin 1984; Taube and Taube 2009).

It is clear that dwarf figurines should not be conceived of in isolation. Figurine sets from burials and caches suggest that dwarves were part of performing entourages or mythic reenactments. At the site of Tulipán near Comalcalco, archaeologists recovered a dwarf, a male musician with a trumpet, and a female dancer with both arms raised in the air together within a burial of eleven individuals interpreted as sacrificial victims (Gallegos Gómora n.d.). A lip-to-lip cache from Tierra Nueva contained a similar ensemble: a male musician with a trumpet, a possible dwarf, and two female figurines (one interpreted as a singing female and the other an elderly seated female: ibid.). Similarly, at Aguateca dwarves were

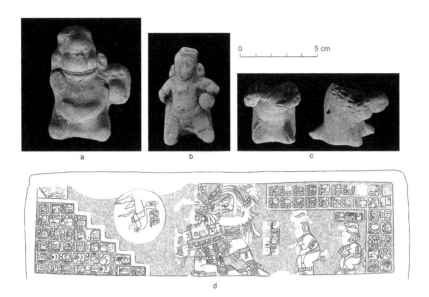

FIGURE 4.11. *Unlikely ballplayers: (a) molded dwarf or Fat Man figurine with appliquéd ball, Tikal (68L-10; photo by author); (b) molded dwarf figurine with appliqué ball, Piedras Negras (photo by R. Taube); (c) molded Fat Man figurine with appliqué ball, Tikal (39E-20; photo by author) (scale bar applies to a–c); (d) short, squatting dwarves contrast with agile striking pose of Bird Jaguar IV in ballgame costume, Panel 7, Structure 33, Yaxchilán (courtesy of the Peabody Museum of Archaeology and Ethnology, Harvard University [04.15.6.7.21]).*

encountered in situ in elite residences with other figurine motifs, such as men and women, and three dwarf figurines in the El Perú figurine cache (Burial 39) were arranged with male and female performing members of a royal court (Freidel et al. 2010).

Not all dwarf figurines, however, explicitly evoked royal or elite identities. At Motul de San José, for example, several dwarves wear simple headbands,[2] short-brimmed hats,[3] or Mohawk hairstyles (single or triple strips running from the front to the back of the head), which date back to the Olmec (Miller 1985: 146). In addition, several examples from central Petén and Belize (e.g., El Zotz, Motul de San José, Nixtun Ch'ich', Pook's Hill) wear animal ears, which appear to be attached to hoods in some cases (fig. 4.12) (Halperin 2010; Lukach and Garrido 2009: 448). These figurines underscore the tremendous variety of dwarf identities and roles. As noted, Mesoamerican ethnographies detail textured oral accounts of dwarves as sacred and mischievous tricksters associated with forests, caves, and

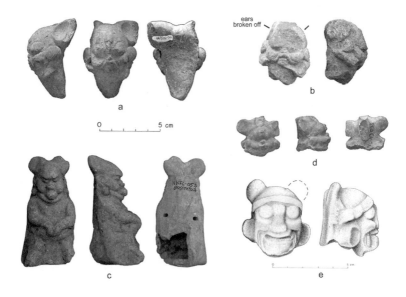

FIGURE 4.12. *Molded figurines with animal ears: (a) dwarf, Nixtun Ch'ich' (NC014; Lot 41,977); (b) eroded dwarf with ears broken off, Chäkokot (CHT44E-17-3-3a) (note: b has the same moustache as a); (c) dwarf, Nakum (NKFC055); (d) dwarf, Nixtun Ch'ich' (NC104; Lot 43,033); (e) elderly figurine, San Clemente (SCFC003) (photos by author; drawing by Luis F. Luin).*

underworld loci as well as earlier temporal eras (Conklin Thompson et al. 2007: 95–96; Mock 2003: 250–251; Redfield 1962; Sosa 1985: 410–411; Thompson 1930: 166). It appears that they had similar popular appeal during the Late Classic period.

In addition to Fat Men, dwarf figurines are one of the most common "supernatural" figurine types (appendix 4.1) and have been excavated from a range of different social contexts and across all regions of the Maya area in which figurines appear. In the Motul de San José region, they have been recovered from Motul de San José, at secondary centers nearby (Trinidad, Akte, Chächäklu'um), and in peripheral rural settlements (Chäkokot and as part of surface collections along the South Transect extending 3 km south from Motul de San José's site core). From excavations in Motul de San José and along its East Transect, they appear within primary and secondary middens from commoner-, middle-, and high-status residential groups (fig. 4.7, appendix 4.2). Similarly, archaeologists have excavated dwarf figurines (and a dwarf figurine mold) both from elite residences in

Aguateca's site core and from its outlying rural settlements (Eberl 2007; Triadan 2007). At the site of Comalcalco, Miriam Gallegos Gómora and colleagues (2007) report dwarf figurines from midden, fill, and collapse contexts in the North Plaza, Temple III, and Temple I zones of the site. Three dwarf figurines, two of which may have been made from the same mold and appear to have possessed animal ears, were excavated from on-floor midden deposits at Pook's Hill, a medium-sized household in the Roaring Creek Valley, Belize (Forbes 2004). They are also found throughout the Maya area along the Campeche coast (Alvarez and Casasola 1985; Corson 1976; Piña Chán 1968, 1996; Schele 1997), along the Usumacinta River (Robertson 1985; Taube and Taube 2009), in central and northern Petén (Halperin 2009b, 2010; Lukach and Garrido 2009; Ruiz Guzmán et al. 1999), and in southeastern Petén (Ashmore n.d.; Laporte et al. 2004).

Other Grotesques

Another characteristic of Late and Terminal Classic Maya figurine collections is a diverse suite of other figures with unusual, exaggerated, and/or animal-like facial attributes who were likely tricksters, *wayob*, ritual clowns, or fantastical performers. They are hybrids in that they often possess both human and supernatural/zoomorphic attributes. While some bodily attributes are exaggerated or deformed, they often wear human adornments and clothing. On more complete specimens, the postcranial body features and poses tend to be more anthropomorphic in nature, while facial features often take on animal and abnormal characteristics. Interestingly, a few examples possess ocarina mouthpieces located at their heads rather than the standard placement at the figures' backs, perhaps suggesting an inversion of order (Willey 1972: fig. 57b).

These grotesque figurines are quite diverse and sometimes difficult to categorize. As a result, they are often ignored or treated as anomalies within figurine collections. But as Mikhail Bakhtin (1984: 30) underscored, the grotesque image "is noncanonical by its very nature." It defies control, classification, and domestication. Nevertheless, some of the grotesque figures appear to draw on an aesthetic of emaciation, death, and age, with wrinkled and sunken faces, grimacing smiles exposing teeth, beards, and deformed heads (figs. 4.13, 4.14), and an aesthetic of fatness,[4] excess, and playful animal-like features and poses (fig. 4.15). Others portray a more straightforward mixing of zoomorphic facial features and anthropomorphic bodily features (fig. 4.16).

Like dwarves and Fat Men, these figurines do not appear to be restricted

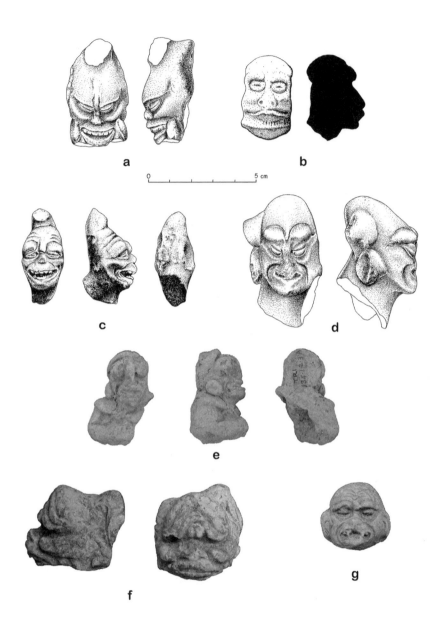

FIGURE 4.13. *Molded grotesque figurine heads with wrinkles, exposed teeth, and/or gruesome, sunken faces: (a) Motul de San José (MSJ17B-14-2-2a); (b) Motul de San José (MSJ36F-2-2-3d); (c) Motul de San José (MSJ46A-5-1-1a); (d) Motul de San José (MSJ17B-15-2-2a); (e) Trinidad (TRI10D-10-3-2c); (f) Nakum (NKFC068); (g) Seibal (MUNAE1292) (drawings by Luis F. Luin, photos by author).*

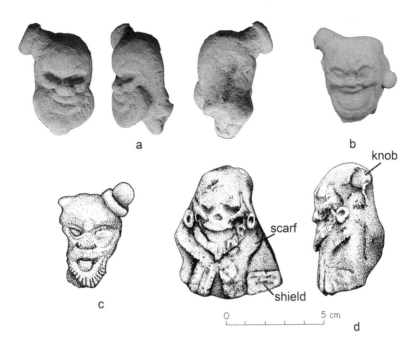

FIGURE 4.14. *Bearded grotesques with knob protrusions on the side of the head: (a) Tikal figurine (1A-3E6); (b) Altar de Sacrificios figurine (MUNAE10087; photos by author); (c) Lagartero figurine-pendant with tongue sticking out (after Ekholm 1979a: fig. 10-5a); (d) Trinidad figurine with knotted scarf and rectangular shield (TRI10D-3-1-2a) (drawing by Luis F. Luin; scale applies to all figurines except c).*

to elite residential contexts (Willey 1972, 1978). For example, some figurines excavated from elite-, middle-, and low-status household contexts in the Motul de San José region are simian hybrids. They have monkey-like features but differ from more "realistic" monkey figurines described below (fig. 4.24). Some possess unusually small faces (disproportionately smaller than the other figurines) with unusually large lips or mouths, pug-shaped or wide noses, and fat, protruding foreheads (Halperin 2007: fig. 7.26a–d). Others have similar enormous lips and big noses, yet they possess relatively long faces (ibid.: fig. 7.26e, f) or rounded heads crowned by a Mohawk or a triad of horns/hair (ibid.: figs. 7.26g, h). Some masks worn by ruling elites on Ik' style polychrome vessels resemble simian-like figurines and may portray performance scenes involving such characters (Halperin 2007: fig. 7.26i). As seen on polychrome vessels, these simian-like characters

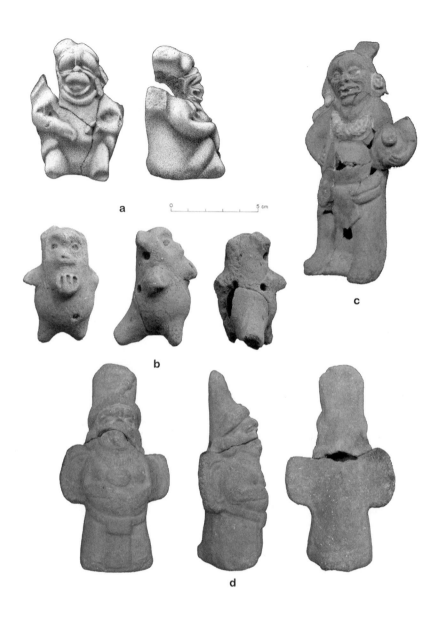

FIGURE 4.15. *Grotesque figurines with attributes of fatness: (a) fat grotesque with cloth ear pendants and collar, molded figurine, Nixtun Ch'ich' (NC004; drawing by Luis F. Luin); (b) fat, wrinkled grotesque with cotton necklace and restricted-neck jar, molded figurine unprovenienced (MUNAE6964); (c) crudely modeled animal-human hybrid, Pook's Hill (O7); (d) molded grotesque with stiff paper headdress, back-rack accoutrement painted in Maya blue, and large belly, Nakum (NKFC148x) (photos by author).*

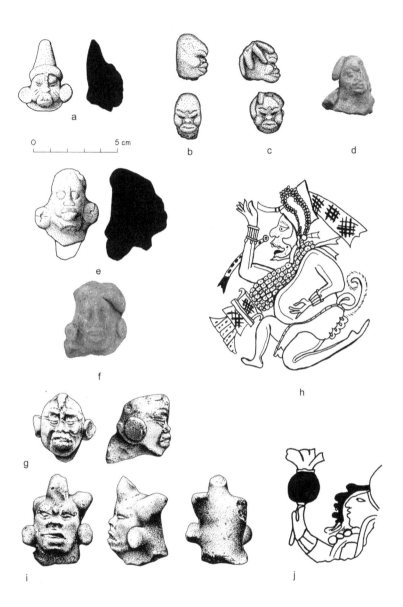

FIGURE 4.16. *Grotesque figures with simian features: (a) Motul de San José figurine (MSJ39C-2-2-3a); (b) Motul de San José figurine (MSJ15A-50-3-4d); (c) Motul de San José figurine (MSJ12B-22-1-1a); (d) Motul de San José figurine with cloth ear pendants (MSJ46A-1-2-2a); (e) Motul de San José figurine (MSJ29F-7-2-3a); (f) Motul de San José figurine (MSJ42B-2-2-1b); (g) Motul de San José figurine (MSJ2A-40-5-1i); (h) simian figure with human clothing (drawing by author after K6738); (i) Motul de San José figurine (MSJ46A-4-3-1b); (j) simian "X-ray" mask on ruler with rattle (Ik' Style vessel; drawing by author after K6888).*

often possess cloth ear pendants and knotted scarves and dance, cavort together as groups, or play musical instruments (Taube 1989: 361–366, figs. 24.6d, 24.6e, 24.8, 24.9). While they tend to be gendered male, there are a few examples of simian grandmother-type figurines with children (Taube and Taube 2009: 255, fig. 9.12; see also fig. 9.13).

Like the versions from polychrome vessels, the ceramic figurine grotesques and hybrids often hold fans or play musical instruments. For example, some figurines from Alta Verapaz and Cancuén combine jaguar and human traits in a way that appears to mark transformation (Danien 1992: figs. 5.2, 5.3; Sears et al. 2004). Other figurines with beards, old, wrinkled faces, and buccal duckbill masks hold turtle carapace drums and antler drum sticks (Goldstein 1979: 96–97; Parsons et al. 1989: fig. 74; Schele 1997: plate 8; Taube and Taube 2009: 251–253). These characters may have been "grotesque" counterparts to youthful Wind god figures who also wore buccal duck-billed masks and were associated with music (see the discussion below; fig. 4.17). Goldstein (1979: 96–97) notes eight examples from Monte Cristo (n = 2), Tabasco (n = 1), Jaina (n = 2), and unknown provenience (n = 3). Other bearded grotesques without the duck-billed buccal masks have been recovered from Altar de Sacrificios (Willey 1972: fig. 42), Copan (Longyear 1952: fig. 87e), Tikal 1A-3E6 (personal observation 2006), Lagartero (Ekholm 1979a: fig. 10–5a, 1985: figs. 1a, b, c, d, e, f), Trinidad (F2535; TRI10D-3–1-2a; Halperin 2007: fig. 7.26a), Palenque (Rands and Rands 1965: figs. 32, 33), and Seibal (Willey 1978: fig. 41c).

Grotesque ceramic imagery also appears in the form of removable figurine masks, further playing on the mimetic concepts of impersonations, transformation, and/or masked performance. One specimen from the Motul de San José region possesses pursed, puckered lips, scarification circles above the nose, and a three-part Mohawk hairstyle also worn by dwarves and Fat Men (fig. 4.18b).[5] The mask's large, rounded, slack lips may denote death or decapitation, as this feature is commonly depicted on decapitated trophy heads as well as Postclassic representations of Xipe or Xipe Totec (Moser 1973: figs. 8, 20, plates IX, X; Taube 1992a: 105–108, 121–122, figs. 54c, 64). This particular figurine mask recalls those worn by ritual clowns, such as the three masked entertainers with puckered lips from an Ik' Style vessel (fig. 4.18a, c).

In addition to masking, music, and buffoonery, grotesque figurines are also linked to death, warfare, and sacrifice, as denoted by their donning of textured cotton body suits and the holding of shields, axes, and clubs (figs. 4.19, 4.20). Similar figures appear in narrative scenes of public human

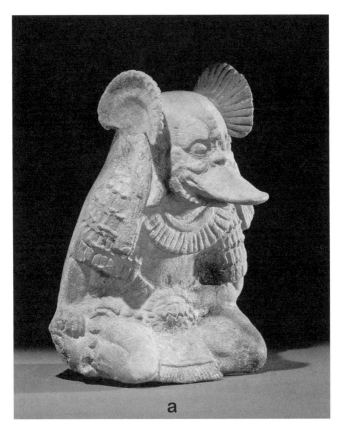

FIGURE 4.17. *Bearded grotesque figurines with duck-billed buccal masks and decorative paper strips on the sides of the head: (a) musician holding a turtle carapace and deer antler (K3550 © Justin Kerr); (b) figurine, Toniná (drawing by author after Becquelin and Baudez 1982: fig. 270).*

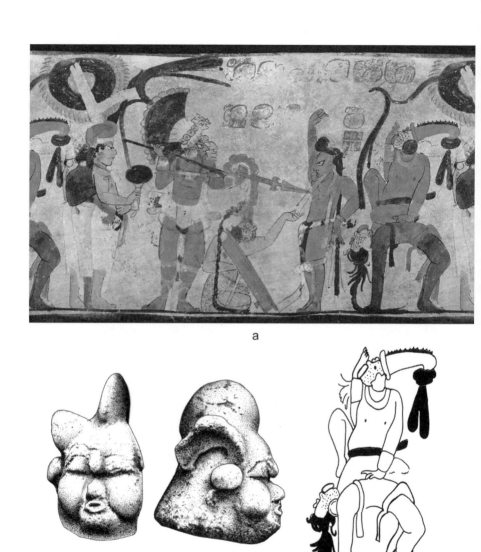

FIGURE 4.18. *Ritual clowns as performers and related to sacrifice: (a) polychrome vase (K2025 © Justin Kerr); (b) hollow figurine mask with puckered lips similar to ritual clowns (TR110D-9-1-3a; drawing by Luis F. Luin); (c) detail of polychrome vase showing two ritual clowns with puckered lips (drawing by author; after K2025).*

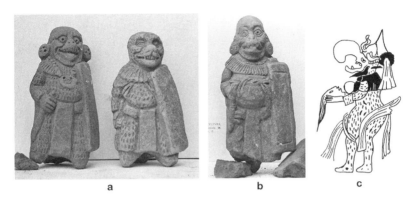

FIGURE 4.19. *Bearded, corpulent grotesque figures associated with violence or sacrifice:* *(a–b) molded figurines with shields and weapons, Palenque (courtesy of the Peabody Museum of Archaeology and Ethnology, Harvard University [34-20/42261 and 34-20/42256]); (c) detail from polychrome vase (K0928; drawing by author).*

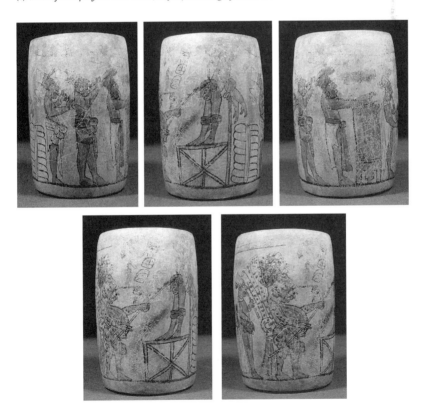

FIGURE 4.20. *Polychrome vessel scene of scaffold ceremony with large grotesque figure engaged in sacrificial activities (far right) (K0206 © Justin Kerr).*

sacrifice detailed on polychrome vases. *Wayob* figures painted on vessels often wear collars lined with eyeballs and hold bowls of dismembered body parts. It was a delicate if not blurred line between the humorous and the perverse, between excess and death.

Elderly Figures

Another component of the trickster and ritual clowning complex is the elderly. As Taube and Taube (2009: 245) remark, "one of the most popular themes of Maya ritual humor is agedness . . . Although this may seem antithetical to Maya conceptions of elders as embodiments of knowledge, dignity, and respect, this genre appears for precisely this reason. It provides a disturbing view of inappropriate behavior with the individuals most esteemed for their civility, dignity, and grace." As mentioned earlier, it is often an elderly man (or another grotesque figure) who makes lecherous advances toward young women in vessel and figurine media.

Thus it is not surprising that other elderly anthropomorphic figurines often closely parallel dwarves, Fat Men, and other grotesques in their costumes and poses. For example, an elderly male figurine from Nixtun Ch'ich' (NC123) sticks his tongue out, a facial expression seen among other "grotesque" figurines from Altar de Sacrificios (Willey 1972: figs. 42a, b, c), a hollow figurine mask from Aguateca (Ishihara 2007: fig. 7.6c), and a possible mask from Trinidad (fig. 4.21) (Halperin 2007: fig. 7.25; see also a mold from Yucatán: Brainerd 1958: fig. 56v). This act may have related to unruliness and uncontrolled bodily functions: decapitated heads are shown with their tongues hanging out (e.g., Baudez 1994: fig. 95a). The *way* figure Mok Chih (likely translated as "sickness/nausea pulque") also exhibits such behavior (fig. 4.21e) (Grube 2004: 67–70). Some elderly figurines, like those depicting dwarves, wear hoods with animal ears (fig. 4.12e). One elderly figurine from Trinidad is hunchbacked (F2484; TRI10D-3-2c), a physical trait shared with dwarves. During the period of Spanish Contact, hunchbacked performers were part of entertainment ensembles patronized by elites (Barrera Vásquez 1965: 71; Díaz del Castillo 1963: 227).

These elderly figures may relate to the aged God N, who was associated with the underworld and the five-day Uayeb, the end of the solar year, in which the order of things was unstable or inverted (Coe 1978; Taube 1992a: 92–99). Indeed some deities were also tricksters. As noted below, however, few elderly male figurines possess God N's characteristic attributes, such as his net headdress, his turtle carapace, or the conch shell

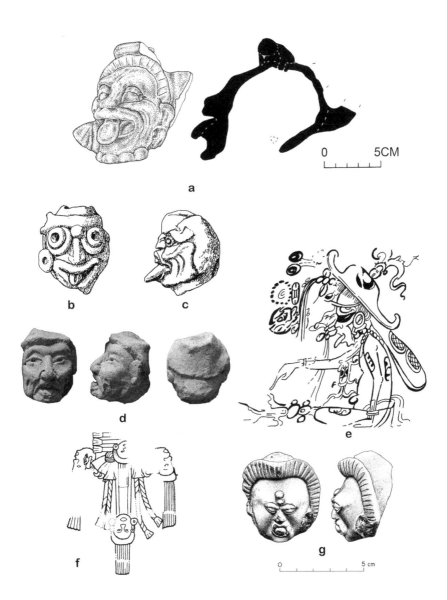

FIGURE 4.21. *Figures with their tongues sticking out: (a) figurine mask from Aguateca grieta (#120 AG31A-9-1-1; drawing by Alfredo Román, courtesy of Reiko Ishihara-Brito); (b–c) figurine heads from Altar de Sacrificios (drawings by author after Willey 1972: fig. 43b, c); (d) elderly figurine head, Nixtun Ch'ich' (NC123; photo by author); (e) way figure, Mok Chih, polychrome vase (K2286; drawing by author); (f) detail of trophy heads hanging on ruler's belt, northwest jamb, Temple 18, Copan (after Baudez 1994: fig. 95a); (g) hollow figurine head/mask, Trinidad (TRI10D-8-2-5a; drawing by Luis F. Luin).*

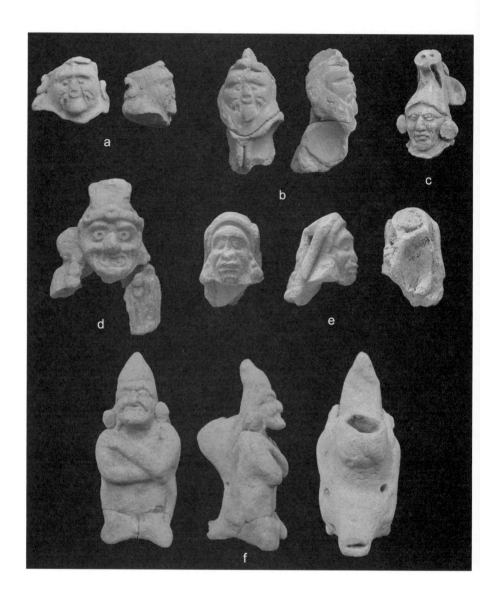

FIGURE 4.22. *Molded elderly figurines with diverse headdresses: (a–b) identical molded elderly figurines, Pook's Hill, Belize (O28 is eroded, O64 with crest or single "Mohawk" hairstyle; double chambered instrument); (c) molded elderly figurine with appliquéd peccary headdress, Uaxactún (MUNAE8847; X10); (d) molded elderly figurine, Holmul (HOL.T.50.25.03.04); (e) molded elderly figure with possible tumpline, Nixtun Ch'ich' (NC039); (f) elderly male with pointed cap and container/cargo on back from Altar de Sacrificios (MUNAE10099c) (all photos by author).*

from which he emerges. Similarly, these elderly figures do not possess the codified features of other aged deities, such as Itzamnaaj, the Maya creator deity, who wears an *ak'ab'* diadem on his forehead, or God L, who is known for his broad-brimmed hat and is associated with the *moan* owl. If the figurines related to these elderly deities, no rigid attempt was made to codify them through iconographic conventions (fig. 4.22).

Monkeys

Zoomorphic figurines may have also represented trickster or other folk-tale figures, *wayob*, or ritual clowns (Taube 1989; Taube and Taube 2009). They are frequently present in contemporary folklore and ancient narratives (such as the Popol Vuh) and are some of the most common spirit companions among both contemporary and ancient Maya groups. As Victoria Bricker (1973: 215–216) states, "In no region of Middle America is animal symbolism lacking as an ingredient of ritual humor. Animal traits chosen for representation in humor are, however, not peculiar to animals. They are exhibited by human beings who are incapable of exerting self-control. Thus, while some animals are by nature gluttonous or sexually promiscuous, human beings are endowed with the capacity for controlling these tendencies."

Zoomorphic figurine collections often include birds (including owls, which are quite common), crocodiles, deer, dogs, bats, frogs, jaguars, lizards or reptiles, monkeys, peccaries, opossum, rodents, tapirs, turtles, and a number of other creatures (Halperin 2007: table 7.5). While it is critical to examine these other zoomorphic figurines, I concentrate here on monkeys, who are some of the most frequently portrayed of all zoomorphic figurines and who share many attributes with other trickster and performance figures already mentioned. Some monkey figurines may represent humans with monkey costumes or monkey impersonators: specimens from Altar de Sacrificios exhibit hollow heads and punctated eyeholes (Willey 1972: fig. 12a, b), similar to Fat Man masks (fig. 4.23f, g). Monkey figurines often wear cloth ear pendants and are depicted with erect penises (figs. 4.23b, f, h, i, j) (Ashmore n.d.: 51; Halperin 2007; Schele 1997: 167; Willey 1972: figs. 11, 12).

Monkeys were the embodiments of social deviance and creativity. On polychrome vessels, they are shown as licentious figures, engaging in dance, drink, or copulation (Taube 1989: 377). In the Popol Vuh and other mythologies, humans who do not follow the social and moral order are turned into monkeys, including the half-brothers of the Hero Twins

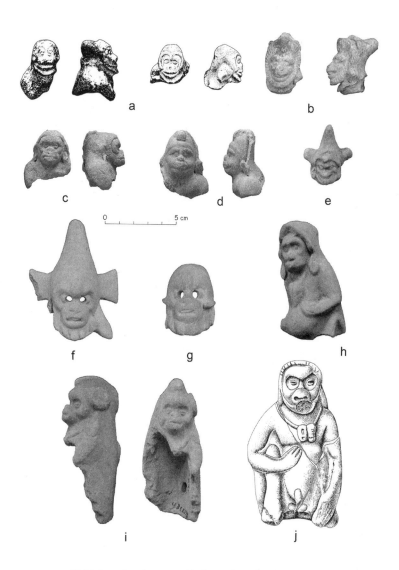

FIGURE 4.23. *Molded monkey figurines: (a) identical monkey figurines in different states of erosion, Chächäklu'um and Motul de San José (CHA1A-1-1-2a; MSJ15A-26-1-1a); (b) monkey with cloth ear pendants, Motul de San José (MSJ2A-40-5-4d); (c) monkey with cloth ear pendants, Nixtun Ch'ich' (NC011); (d) monkey with cloth ear pendants, Nixtun Ch'ich' (NC035); (e) monkey with cloth ear pendant and tripartite headdress, Seibal (MUNAE1602); (f) monkey mask, Altar de Sacrificios (Museo Nacional de Arqueología e Etnografía, MUNAE10089b); (g) monkey mask, Altar de Sacrificios (MUNAE10089c); (h) monkey with cloth ear pendants, Altar de Sacrificios (MUNAE7889); (i) monkey with cloth ear pendants, Altar de Sacrificios (MUNAE7889; 43[D]-8); (j) monkey with erect penis and cloth ear pendants, Altar de Sacrificios (drawing by Luis F. Luin after Willey 1972: fig. 11a).*

a

b

FIGURE 4.24. *Ancient and contemporary monkey manifestations: (a) monkey way with cloth ear pendant, knotted cloth scarf, and bowl containing hand, eyeballs, and other sacrificial items (drawing by Luis F. Luin after K1203); (b) informal monkey ritual clowns, Zinacantán, Chiapas, Mexico (after Bricker 1973: fig. 13).*

(Benson 1994; Blaffer 1972: 78–79; Tedlock 1996: 72–73). They are also labeled as spirit companions, wear knotted scarves or eyeball collars, and hold dishes with sacrificial body parts (fig. 4.24a) (Grube and Nahm 1994: 695–697; Spero and Kerr 1994). In this sense they represent ancestral forms of human life as well as social alterity and deviance. At the same time, the monkey is often depicted as a scribe or artist, such as Huun Bats' and Huun Chuwen from the Popol Vuh. Such roles may have some inspiration in the capuchin monkey (*Cebus capucinus*), which is quite dexterous (Baker 1992; Miller and Taube 1993: 118). As Elizabeth Benson (1994: 143) points out, "to explore artistic creativity, it is necessary to be open, experimental, playful . . . The 'chaos' that the monkey signifies is requisite for creativity."

Considering their common appearance within other small-scale media as well as in ancient and contemporary Maya folklore (fig. 4.24b), it is

not surprising that zoomorphic figurines are ubiquitous in various social contexts. In fact zoomorphic figurines as a category may appear in slightly higher frequencies in more peripheral settlements. For instance, Lisa LeCount (1996) notes that most figurines recovered from the relatively large center of Xunantunich were anthropomorphic figures. This pattern contrasts with the recovery of high percentages of figurines from rural and more peripheral settlements elsewhere in the Belize Valley, such as Pook's Hill and Barton Ramie (Halperin 2009a; Willey et al. 1965). Similarly, zoomorphic figurine frequencies are slightly higher at peripheral settlements of Aguateca than at Aguateca proper (Eberl 2007; Triadan 2007).

DEITIES

Despite the proliferation of a range of spiritual, mythical, and performative representations, some forms of mimesis were more rigidly controlled. Perhaps not surprisingly, such control included the reproduction of and access to a number of more formalized deities, many of whom related to major cosmic forces, such as the Sun god (Ajaw K'inich or Jaguar God of the Underworld), Maize god, Rain or Storm god (Chak), and God K (K'awiil) (Coe and Van Stone 2001: 109; Miller and Taube 1993; Schellhas 1904; Taube 1992a). Likewise, ruling elites from different polities drew upon their own patron deities or some variant of one of the principal deities, underscoring the political fissures and multiple claims to religious authority in Late Classic Maya society (Houston and Stuart 1996: 302).

Such deities, however, are rare among ceramic figurine collections. They often constitute between 0 and 7 percent of identified supernatural figurine types and even smaller frequencies when all identified figurine types (anthropomorphic and zoomorphic) are considered (fig. 4.25). In cases in which provenience is known, deity figurines are found in elite contexts. For example, Roberto Ruiz Guzmán et al. (1999: 43) reports figurines of Gods A, D, E, G, L, and N (using the classification of Schellhas 1904) from royal residential and ceremonial zones of the epicenter of Calakmul, although he does not provide illustrations of these figurines. In the Motul de San José region, the six identified deities (0.01 percent of all figurines with heads [n = 445] and 5.8 percent of all identified supernatural figurines [n = 103]) were excavated from royal or elite household midden deposits located in the site core of Motul de San José and an elite residential compound from the secondary site of Trinidad (fig. 4.7).

In this sense political elites restricted the production of images,

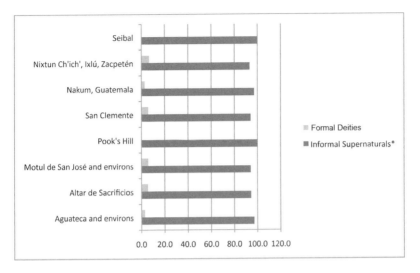

FIGURE 4.25. *Frequencies of Late Classic deity figurines (informal supernaturals include dwarves, Fat Men, grotesques, and animal-human hybrids: see appendix 4.1 for raw data).*

conventions surrounding their material identification (such as large god-eyes, shine marks, and particular accoutrements), distribution, and ritual access to these figures as a means to appropriate and claim ties to the deities' essence, power, and aura. Such relations are detailed in texts in which rulers impersonate deities and descend from royal lineages, which move from ancestors to more distant and revered deities (Houston and Stuart 1996). Part of this process was also a physical linking of the royal body with deity representations, dress, and symbols (as discussed in chapters 1 and 3). Deities hover above, are held by, or are seen in social interactions with elite figures in some scenes. Furthermore, royal and noble officials cloaked themselves with supernatural essences: they wore headdresses, jewelry, sandals, and clothing with the faces, attributes, and essences of deities. The identities of deities themselves were fluid: they sometimes combine the attributes of multiple deities or have spirit companions themselves. I briefly remark on only a small selection of the major deities in figurine collections below.

Sun God (God G)

The Sun god, Ajaw K'in or K'inich (sun-eyed), was related to decapitation, fire, jaguars, and of course the sun (Schele and Miller 1986: 50–51; Taube

1992a: 53–56). The Sun god is often depicted with *k'in* signs, symbols of flowers, the sky, and the solar day on his body, large god-eyes, a large "Roman" nose, and T-shaped front incisors. His image has a number of manifestations, including the Jaguar God of the Underworld, identified by a twisted "cruller" between and under his eyes (fig. 4.26a). This manifestation likely embodied the sun as it undertook its passageway through the underworld during the night. Royal elites drew from the images and identity of the Sun god, particularly the title *k'inich*, which marked their royal status and accession as kings (Eberl and Graña-Behrens 2004). Early Classic monumental depictions of Tikal rulers, for example, show them holding the head of the Sun god or holding a double-headed serpent bar with the Sun god emerging from the serpent's maws.

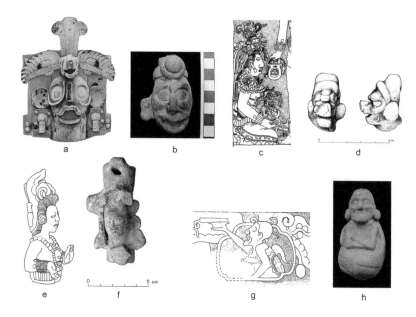

FIGURE 4.26. *Deities: (a) effigy incensario with image of Sun deity as Jaguar God of the Underworld, Tikal (drawing by Luis F. Luin); (b) figurine of Sun deity as Jaguar God of the Underworld, Aguateca grieta (#127 AG31D-1-5-1; photo courtesy of R. Ishihara-Brito); (c) K'awiil effigy held by Palenque royal mother, Lady Tz'akb'u Ajaw (rendering by author of detail from Dumbarton Oaks Panel); (d) molded K'awiil figurine, San Clemente (SCFC006; drawing by Luis F. Luin); (e) Maize deity sculpture, Str. 10L-22, Copan (L. Schele drawing 3518 from www.famsi.org); (f) possible Maize deity modeled effigy flute (MSJ2A-5-6-15u; photo by author); (g) God N in turtle carapace, Altar 4, Tikal (Jones and Satterthwaite 1982: fig. 58; courtesy of University of Pennsylvania); (h) figurine of God N in shell, Altar de Sacrificios (MUNAE10096b; photo by author).*

While appearing in carved stone monuments and polychrome vessels, Sun god imagery also appears with some regularity on Classic period ceramic effigy censers. Prudence Rice (1999), in her review of Lowland Maya censers, argued that effigy censers (rather than the more ubiquitous appliqué censers) were associated with the cult of divine Classic Maya rulers. They "were instruments used by the 'kings'/*ajaws* as living representations of the ancestors and conduits of divine inspiration" (Rice 1999: 41). Unlike those portraying historic personages, effigy censers of the Jaguar God of the Underworld have been uncovered primarily from large-scale ceremonial contexts, such as on or alongside temple pyramids situated at the edges of plazas and from caves (Carrasco 2005; Cuevas García 2004; Ferree 1972; López Bravo 2004; Rands et al. 1978; Rands and Rands 1959; Rice 1999; for an exception, see Chase and Chase 2004).

At the site of Palenque, flanged deity censer stands may have been the focus of state religious cults, while anthropomorphic censer stands may have been the focus of domestic ancestor cults, suggesting some bifurcation in state and household practices. Roberto López Bravo (2000, 2004) records the presence of flanged effigy censer stands (made from plaster, stone, or clay) depicting anthropomorphic heads from elite residential compounds as opposed to the more public ceremonial architecture from Palenque. Some of these censer stands possess hieroglyphic texts that name royal and noble figures. Mary Miller and Simon Martin (2004: 205, 225, 230–231) argue that the human faces depicted on these stands were actual portraits of the named individuals. They appear to date later than the deity versions from the public ceremonial architecture of the Cross Group, as they are primarily recovered in Murciélagos (AD 700–750) or Balunté (AD 750–850) ceramic complex contexts. These censers underscore the growing political and religious claims to power by noble households at the end of the Late Classic period.

In contrast with effigy censers, Late Classic ceramic figurines rarely portray Sun gods or Sun god-related attributes, such as the "cruller" feature located above and below the eyes. Willey (1972: 52) documents two figurines from Altar de Sacrificios with large eyes and the characteristic twisted cruller. Other figurines with the cruller face element are noted from the *grieta* bisecting the site of Aguateca (fig. 4.26b) (Ishihara 2007: fig. 7.7e), Lubaantun (Hammond 1975: 372), and Quiriguá (Ashmore n.d.: 36).

K'awiil (God K)

K'awiil was the personification of lightning and was associated with

divination and the conjuring of spiritual realms. He is identified by a large upturned snout, a single serpent foot, and a flint axe or cigar protruding from his forehead. Like many other manifestations of Classic period deities, he is depicted with large god-eyes. K'awiil was the patron god of numerous royal lineages throughout the Maya area; as such, he was evoked in royal titles and held in the form of a scepter by ruling elites during period-ending ceremonies and events of royal investiture. Images and references to K'awiil are ubiquitous on stone stela monuments, particularly those that document period-ending ceremonies (fig. 4.26c).

Actual K'awiil effigies or scepters rarely are recovered archaeologically. Many were likely carved from wood or bone, such as four stucco-coated wooden K'awiil effigies recovered from an elite burial (Burial 195) at Tikal (Coe 1967: 57) and carved K'awiil effigy bones from an elite burial (Tomb 2, Str. 23) at Yaxchilán (Miller and Martin 2004: 113, plate 55). Some examples, however, were produced by highly skilled artisans/ritual specialists as eccentric flints (Miller and Martin 2004: 150–151). Not surprisingly, K'awiil rarely appears in figurine collections: one possible example derives from an on-floor midden of an elite residential group at the site of San Clemente (SC006) (fig. 4.26d) (Halperin 2009b; Salas 2006). At least one of the ceramic figurine-pendants from Lagatero portrays K'awiil with his large upturned nose (Ekholm 1985: fig. 3a). This example was excavated from a large "ceremonial" midden in the site's northwest plaza at the edge of a large pyramid.

Maize God (God E)

The Maize god embodied the agricultural cycle of emergence, growth, death, and rebirth (fig. 4.26e). He is often depicted as a youthful male with a flat forehead and corn foliage emanating from his head (sometimes only at the very top when representing a mature ear of corn) (Bassie-Sweet 2002; Just 2009; Quenon and Le Fort 1997; Taube 1985, 1992a, 1996). In stone monuments and polychrome vessels, Maize gods are depicted at the fissures of earthly realms, signifying their metaphorical emergence and growth as a corn plant. Classic period rulers often impersonate or take on the essential attributes of the Maize god during critical points of transition, such as when they become exalted ancestors in death.

There are few known examples of Maize god figurines. A single effigy flute from a secondary midden at the edge of the Motul de San José royal palace (Group C) may portray a Maize god (fig. 4.26f). The figure's head is lined with foliage and exhibits an elongated cranium with a very

pronounced, flat forehead. An effigy flute from a child burial excavated from the palace at Holmul may also portray a figure with an elongated cranium, although no other details would suggest affiliation with the deity (fig. 6.7) (Mongelluzzo 2011). Other Maize god figurines include a Classic period dancing version from Alta Verapaz who dances with ears of corn (Dieseldorff 1926: figs. 30, 31; Rands and Rands 1965: fig. 38). His pose resembles dancing Maize god figures on polychrome vessels from northeast Petén and western Belize. Other possible examples include several finely modeled figurines from Jaina, although most of these more closely resemble unidentified figures emerging from flowers (Kurbjuhn 1985). Foliage frames these figures' faces in a manner similar to the Motul de San José specimen. It is also noteworthy that few figurines have been documented with the beaded net costume shared by the Maize deity, the Moon goddess, and royal figures as they celebrate period-endings and accessions to office.

God N

As noted, God N was associated with the underworld, mountains, and thunder and was a liminal figure presiding over the five-day Uayeb (fig. 4.26g, h) (Coe 1978; Taube 1989, 1992a: 92–99). This aged deity is often shown emerging out of a turtle carapace or conch shell (symbolic of earth and earthly openings) and identified with a net headdress. During the Terminal Classic period, God N takes on an increased importance as a quadripartite sky bearer as seen on carved stone columns at Chichen Itzá. While many Late Classic elderly figurines may be interpreted as God N or other aged deities, few actually possess any of his identifying attributes, such as an example from Altar de Sacrificios (Willey 1972: fig. 42n) in which an elderly male figure emerges from a shell and an example from Nakum in which an elderly male wears a turtle carapace shell (Halperin 2009b).

Goddess O

During the Classic period, Goddess O is identified as a curer and midwife. She navigated the realm between life and death and was associated with weaving and jaguars (fig. 4.27a) (e.g., K6020, K5113; Miller 2005; Taube 1992a, 1994). She often wears a spindle with spun cotton in her headdress, in the form of a coiled snake or "figure eight" headdress (see also the discussion in Ciaramella 1999 regarding this headdress), has sagging exposed breasts, and wears a skirt decorated with cross bones. Much of what is known of Goddess O, however, derives from the Postclassic and Contact

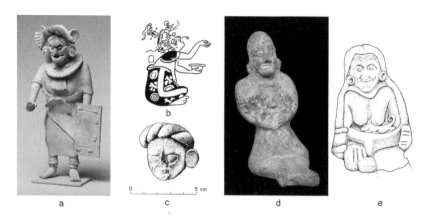

a c d e

FIGURE 4.27. *Goddess O and elderly females: (a) Goddess O with shield and knife (traces of Maya blue pigment, height 26.0 cm, width 13.0 cm, depth 13.6 cm; Princeton University Art Museum, gift of J. Lionberger Davis, Class of 1900, y1965.197, photo by Bruce M. White); (b) seated Goddess O with vessel to gather vomit (detail from polychrome vessel scene; drawing by author after Taube 1992a: fig. 51c); (c) Goddess O molded figurine head fragment with appliquéd twisted headdress, Motul de San José (MSJ15A-50-3-4b); (d) elderly female figurine with child, unprovenienced (MUNAE5882); (e) elderly female with dog, molded figurine, Lubaantun (drawing by Luis F. Luin after Wegars 1977: fig. 16a).*

periods, and scholarship has often conflated her with other female deities from diverse periods (Ardren 2006; Thompson 1939b).

While Goddess O held prominent roles alongside male deities during the Postclassic period, her appearance during the Classic period is more muted. During the Early Postclassic period at Chichen Itzá, skeletal depictions of supernatural females with skirts decorated with cross bones appear in sky-bearer poses on columns of civic-ceremonial architecture. These depictions are paired with columns depicting male deities, such as God N, who also manifest as sky bearers and were likely seen as complementary to one another (Joyce 2000a: 105–109). In Late Postclassic murals and codices, Goddess O is referred to as Chak Chel (and later as Ix Chel during the Colonial period) and is associated with Itzamnaaj as the primordial pair of destruction and creation as well as with other male-gendered deities such as Chak (Taube 1992a: 101; Vail 2000; Vail and Stone 2002: 226). Ethnohistorical sources suggest that Ix Chel was the focus of a cult of pilgrimage to the island of Cozumel during both the Postclassic and later Colonial periods (Ardren 2006; Patel 2005).

During the Classic period, however, Goddess O was not part of public religious and political culture: she is absent from large-scale media and

appears only on ceramic polychrome vessels and figurines (fig. 4.28a). Her status as a deity is often expressed with god-eyes, and she was undoubtedly linked to primordial acts of creation (Houston et al. 2006: 53, fig. 1.56). On polychrome vessels, she wears the black skirt with cross bones, similar to her Postclassic period manifestations. A single unprovenienced figurine depicts her dressed as a warrior with knife and shield, showing a rather fierce side of this deity (Miller 2005: fig. 1). Old women figurines, some with twisted cloth head wraps, are known from Alta Verapaz, Lubaantun, Jaina, and the Campeche coast (Dieseldorff 1926: figs. 42, 45, 47; Joyce 1933: plates VI-2, VI-3, VI-4, 17; Schele 1997: plates 30, 31, 32, 34; Wegars 1977: fig. 16a, b). Most do not have god-eyes, jaguar attributes, or other diagnostic features. One exception is a head fragment found in a midden located in the patio of a royal elite residential group (Group D) at the site of Motul de San José (fig. 4.28c). Thus it is not clear whether aged females represented deities, mythical figures, historic personages, and/or a generalized social identity. Many of the elderly women without god-eyes hold dogs or a small child, a theme that parallels youthful women figurines holding children or animals (fig. 3.37) (Joyce 1993; Pohl 1991). Some old women figurines from Comalcalco who do possess the twisted cloth head wrap have their arms held in the air, probably signifying dance (Gallegos Gómora n.d.: fig. 11). It is likely that elderly women's hairstyles and other identities informed understandings of deities in the same way that representations of deities shaped human expectations of age and gender.

Moon Goddess

In addition to her association with the moon, the Classic Maya Moon goddess was associated with maize, cyclical transformation, and regeneration. She is identified by a moon crescent and a rabbit, which sits on her lap or in her arms (fig. 4.28). She may wear the same beaded net skirt as the Maize deity and was likely his female counterpart. Several variants of a young female goddess appear in the Postclassic period codices (Vail 2000; Vail and Stone 2002). In some cases she has been identified as Ixik Kab, who was not specifically related to the moon but to the earth. She is depicted carrying cargos or with birds, which may have been messengers or auguries (fig. 3.32c).[6]

Like Goddess O, the moon goddess does not directly take part in public monumental discourses but is known primarily from polychrome vessels. Nonetheless, elite men and women who don the net beaded skirt or dress on stelae indirectly may invoke either the Maize deity or the Moon

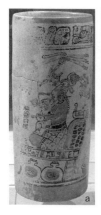

0 3CM

a b c

FIGURE 4.28. *Moon goddess with rabbit: (a) Moon goddess seated on celestial throne, detail from polychrome vessel, Sacul, Guatemala, Museo Regional de Sureste de Petén (photo by author); (b) molded Moon Goddess figurine (traces of red and Maya blue pigment, height 12.4 cm, width 7.7 cm, depth 5.4 cm; Princeton University Art Museum, promised bequest of Gillett G. Griffin, L.1974.8, photo by Bruce M. White); (c) Moon goddess figurine in moon crescent/cave, Aguateca (drawing by author after Valdés et al. 2001).*

goddess. A few unprovenienced figurines appear to portray the Moon goddess in the form of a young woman seated with a rabbit, although these examples are quite rare. Arguably, many female figurines with a youthful appearance and elongated cranium can be identified as Moon goddesses. I resist such identifications, however, because these features were also generalized aesthetic ideals of femininity and are indistinguishable from depictions of historic women. Thus if the Moon goddess was regularly evoked in figurine media, there is little attempt to portray her in conventionalized tropes with a net-beaded skirt, rabbit, crescent, or other moon symbolism.

Wind God (Ik' K'uh, God H)

Late and Terminal Classic Maya Wind gods were embodiments of wind and the breath soul and were associated with music and a flowery paradise. Their Classic period manifestation was clearly linked to Postclassic period Ehecatl-Quetzalcoatl in Central Mexico and to a duck-billed deity with an *ik'* eye in the Dresden Codex (p. 44c) (O'Mack 1991; Seler 1966; Taube 2000a, 2004a, 2004b).

Ehecatl was tied to agricultural cycles as the harbinger of rain. As Fray

138

Bernadino de Sahagún (1970: 9) notes, "he was the wind; he was the guide, the roadsweeper of the rain gods."

In comparison to other contemporary deities, the Late Classic period Wind god, identified by his buccal duck mask and a flower headband, is impersonated, portrayed in imagery, and/or appears in written texts much less frequently (e.g., occasionally as the personified head of the number three) (fig. 4.29) (Taube 1992a, 2004a). David Stuart identified the Maya Wind god on a carved step from Yaxchilán (Taube 2004b: 173).

FIGURE 4.29. *Wind deities with buccal mask and flower at the forehead: (a) molded figurine, Nixtun Ch'ich' (NC002); (b) Hieroglyphic Stair, Panel 10, Temple 33, Yaxchilán (after Freidel et al. 1993: fig. 8.4b); (c) molded figurine, Motul de San José figurine (MSJ2A-40-5-4a); (d) masked Ik' deity performer, detail from Bonampak murals, west wall, Room 1 (L. Schele drawing from www.famsi.org); (e) molded figurine, Motul de San José (MSJ2A-5-6-16a); (f) molded figurine, Motul de San José (MSJ2A-5-6-16b) (all figurine drawings by Luis F. Luin).*

The glyphs next to the deity reads *ik' k'u* or "wind god": appropriately, the youthful-looking figure possesses a duck-billed buccal mask and a flower at the crown of its forehead. Because a number of inscriptions mention the impersonation of Wind gods (*ik' k'uh*) by nobles (Houston et al. 2006: 274), it is possible that the Wind god was evoked more by secondary elites than by the highest royal officials. For example, narrative scenes that depict duck-billed figures portray them as subsidiary characters linked to music and performance. In the Bonampak murals, a masked Wind god impersonator with buccal mask and *ik'* sign in its eye stands between an ensemble of musicians. In Terminal Classic Stela 3 from Seibal, a duck-billed Wind god shakes a rattle to the accompaniment of a figure playing a drum, both of whom sit below the central figure in the scene (Graham 1996: fig. 7–17).

Interestingly, a number of Wind god figurines have been recovered from Motul de San José, the presumed capital of the Ik' polity (fig. 4.29a, c, e, f) (Halperin and Foias 2012). Three figurines were excavated from a large secondary midden at the edge of Motul de San José's royal palace (Group C). Although the figurines are fragmentary, they all possess buccal duck-billed masks, and some clearly bear a three-lobed flower on their foreheads. Their headdresses possess horizontal winged feather sprays, similar to those worn by musicians and secondary elite figures, as noted in chapter 3 (MSJ2A-5-6-16b does not exhibit this headdress element, although it shows signs of breakage where it would have be located). Two strikingly similar Wind god figurines were also found near Motul de San José: one excavated from Nixtun Ch'ich' (Halperin 2010), and another recovered during building construction of a hotel at the northwestern edge of Lake Petén Itzá.

Elsewhere in the Maya area, a Late Classic period duck-billed, masked figurine was reported from Seibal (Willey 1978: figs. 39d, 41a) and a head fragment with a buccal duck-billed mask is noted from the site of Piedras Negras (R. Taube, personal communication 2004). A Late Classic figurine-whistle from Honduras also wears a duck-billed mask (Joyce 1993: fig. 4). These figures, however, do not appear with a three-petal flower at the crown of the head as in the Motul de San José specimens.

DISCUSSION

The large majority of supernatural figures found in Late Classic figurine collections do not represent highly codified and/or patron deities of Maya

state religion but mythical tricksters, ritual clowns, performers, and spirit companions. As regular components of household media, figurines may have served in part as cues for popular oral narratives recounted and enacted in small-scale settings, such as residential compounds. Rather than representing an isolated complex of supernatural figures, however, these grotesques attest to an underlying tension between state and household. They embodied notions of disorder, excess, old age, sacrifice, hybridity, and transformation, which were invoked to comment on, if not occasionally make fun of, the social mores and identities of Maya society, especially the royal body and the cult of the warrior. The iconography of the figurines with their dance poses, masks, and fans also makes reference to ritual and theatrical performances. These figures may have played secondary, informal, or marginal roles within large-scale state ceremonies, perhaps similar to those identified in ethnohistoric and ethnographic sources. In this sense state officials tolerated—if not actively incorporated—the power of the grotesque for their own interests. They could not do so entirely on their own terms, however, as the meanings and forms of the grotesque also had a life of their own in the household domain and likely other inconspicuous places (such as caves, forests, and fields).

Grotesque, animal-hybrid, and other ulterior supernatural figurines are all depicted as male gendered. This pattern coincides with data from polychrome vessels, in which only a handful of *way* figures are women (Grube and Nahm 1994). Interestingly, some figurines draw on a close connection between women and birds. Examples include women weaver figurines with birds perched on their looms and a Tikal figurine of a woman holding a bird at her breast (fig. 3.32). This example resonates with contemporary oral narratives surrounding a young woman who is abducted or impregnated by a god disguised as a hummingbird (or sometimes as an insect) (Chinchilla 2010). In fact an important turning point of the myth is when the young woman brings the bird close to her chest. In ancient and contemporary Mesoamerican thought, birds are also known as messengers, bringing omens and serving as communication links between earthly and divine realms (Houston et al. 2006: 229–243). The Classic period figurines appear to have some parallel manifestations during the Postclassic period in the form of birds perched on the shoulders of young female goddesses (Lady Earth) in the Dresden Codex. As noted, colonial sources mention that women of mixed races transformed into birds during the night to taunt and prey on Spanish male colonial officials. Thus multiple models exist for female-animal interactions, from encounters in oral narratives

to spirit companions, despite the seemingly narrow options presented through Classic period iconographic convention.

The mimetic circumscription of prominent deities by ruling and noble elites was one of the principal mechanisms for defining social boundaries between rulers and ruled. Such practices are noted archaeologically elsewhere. For example, the Aztec state privileged Huitzilopochtli, their patron deity of war, and Tlaloc, the storm deity, above all other gods in their dedication of the Temple Mayor, the cosmic and political epicenter of Aztec life. Ceramic figurines of these deities are rare and are absent from both rural villages and larger centers outside the capital (Klein and Lona 2009; Olson 2007; Otis Charlton 1994; Parsons 1972; Smith 2002). The Maya and Aztec patterns, however, contrast with patterns from Classic period Teotihuacan, where Tlaloc was a prominent part of both domestic rituals (as seen in ceramic figurines, vases, and murals from apartment compounds) and state religion (as seen, for example, from Tlaloc vases placed in principal dedicatory caches of the major pyramids at the site) (Manzanilla 1996; Sugiyama and López Luján 2007). Even in the Maya area, however, these boundaries get pushed, such as at Caracol during the Terminal Classic period, when middle-status households began to make offerings and enacted rituals with effigy jaguar sun deity censers, items normally restricted to public ceremonial contexts (Chase and Chase 2005; López Bravo 2004; Rice 1999). In this sense where and how deities were invoked speaks to the inclusive and exclusive ways in which states and households defined themselves in relation to each other.

FIGURINE POLITICAL ECONOMIES

Culture is produced in the collision of meaningful representations and political economic practices. In other words, the practices of production, exchange, and consumption are influenced by but also constrain the beliefs, dispositions, and ideologies surrounding material culture. This chapter takes up the project that was initiated in the preceding two chapters by contextualizing figurine representations as part of broader social practices. It places greater emphasis on the process of mimesis in behavioral terms, however: the mechanisms in which mimetic representations were physically produced and circulated throughout the social landscape. In many parts of the Southern Maya Lowlands, ceramic figurines served as a form of popular culture and linked diverse households into a broader community, facilitating the making of the state, broadly conceived (households as part of the state). This more encompassing perspective of state-making, however, does not reveal a single community, such as a unitary state, but multiple sometimes overlapping communities created by networks or spheres of production and exchange relations centered around polity capitals.

In order to understand such interaction spheres, I assess the political economy of ceramic figurines in terms of the production of elite art, folk culture, and mass media, the last two of which are considered popular culture (DiMaggio 1987; Mukerji and Schudson 1986; Storey 2003). These categories are never static but are constantly reproduced, invented, and appropriated in space and time. Nonetheless, they provide heuristic classifications from which one can interpret the politics of figurine economies as they came to represent and take on significance for particular social groups. My adoption of these models is in recognition that even mundane or "low-valued" goods can have social and political connotations. That is, because material culture can become tied to particular social groups

or particular places, they can (but do not always) become the subject of contestation and negotiation as these or other social groups redefine themselves.

Archaeologists often consider elite material culture to have functioned as prestige goods, wherein their material production and distribution were restricted primarily to elite social circles. As noted in chapter 1, such processes of control may occur through "attached" production, in which elite groups patronize production conducted by nonelite groups, through elite production of the goods themselves and/or elite intervention in some stage of the distribution process (Brumfiel and Earle 1987; Costin 2001; Friedman and Rowlands 1977; Inomata 2001b; Sinopoli 1988).

In contrast, folk culture refers to the material culture, beliefs, and practices of commoners.[1] Although use of the term "folk culture" has roots in eighteenth- and nineteenth-century historical and literary works in Europe, it is broadly understood here to refer to material culture produced and consumed primarily by common people.[2] According to Gramsci, folk culture can be in opposition to official conceptions of the world and the political elite who heavily influence such conceptions. For him, folk culture tends to be unsystematic and unelaborated (Crehan 2002: 105–127), what archaeologists might refer to as decentralized or involving low-levels of labor investment. These generalizations are problematic, however, in that village-level economies and resource specializations are often quite complex (Scarborough et al. 2003). In the archaeology of state societies, commoner material culture is a central component in reconstructions of political economies (for example, as contributing to the staple finance of the state) (D'Altroy and Earle 1985; Earle 2002), but it is often implicitly or explicitly treated as lacking any social or political import, with attention focused on adaptive, rational, and efficient economic practices. This indeed may have been the case, but not necessarily in all times and spaces. For example, Stephen Silliman (2001) in documenting laborers at the Colonial period Rancho Petaluma, California, has found that indigenous peoples produced and used their own obsidian tools, although metal tools were readily available. He argues that their continued manufacture and use of obsidian represented small-scale political choices (in his words "practical politics") to promote their own indigenous sense of identity in reference to a colonial "Other" (Silliman 2001: 203). Do the political economic patterns of Late Classic Maya figurines indicate that common people used figurines for similar purposes?

Finally, "mass media" refers to artifacts that emerge in large quantities

from political and commercial centers and are distributed widely, creating a relatively homogeneous material landscape.[3] These material productions and flows align more with centralized political economic systems, which invariably operate in conjunction with more decentralized material flows (such as small-scale gifting and informal trading). In terms of political implications, social theorists have suggested that mass media can help shape passive, uncritical dispositions (socialization, ideological domination) or were platforms for critical self-reflection and creative appropriation (Adorno 1991 [1967]; Adorno and Horkheimer 1972 [1944]; Benjamin 1969 [1936]; Collins et al. 1986; Marcuse 1964). I see both processes as viable options even if such nuances of meaning are not always verifiable in the archaeological record (Halperin 2009c). Perhaps more tangible to the archaeologist, however, is its role in documenting the extent of a state's political economic influence and the ways in which communities intersected despite inequalities in privilege, wealth, and status.

Thus, in order to explore figurines as popular culture and tease out some of the possible social implications that such a designation entails, one must delve into the ways they operated within the political economic system. I look in particular at figurine distributions, the organization of figurine production, manufacturing methods, and paste analyses of figurines throughout the Maya area.

FIGURINE DISTRIBUTIONS

As suggested in preceding chapters, figurine frequencies and distributions support the notion that figurines were a form of popular culture: they are often recovered archaeologically from elite and commoner residential contexts as well as large and small settlements. Nevertheless, figurine distributions were not uniform from region to region, suggesting that figurine practices and their social and political roles were reproduced differently throughout the Maya area.

In the Motul de San José region, figurines are reported from all sites excavated by the Motul de San José Archaeological Project, revealing their occurrence at the primary site of Motul de San José, secondary sites such as Trinidad, Akte, and Chächäklu'um, and tertiary centers, Buenavista and Chäkokot (fig. 1.1). In addition, at Motul de San José and Chäkokot, where systematic test-pitting was undertaken, all households regardless of social class had access to figurines. They occur primarily within fill, collapse, and midden contexts (appendices 5.1, 5.2). Despite

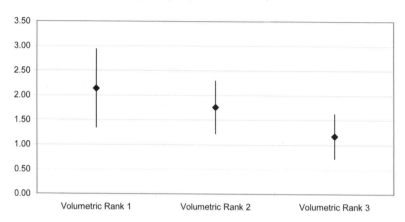

**Figurine/1000 Sherd Ratio Means
and 95% Confidence Intervals**
(excluding samples with <100 sherds)

FIGURE 5.1. *Figurine density (figurine to ceramic sherd ratios × 1,000) means and 95 percent confidence intervals by volumetrically ranked architectural groups from Motul de San José and the East Transect (rankings roughly translate as Rank 1 = highest elite; Rank 2 = middle-status; Rank 3 = commoner).*

this pattern, figurine density (calculated by the ratio of figurines to 1,000 ceramic sherds) means were positively correlated with household status, although differences were not highly significant (fig. 5.1; appendix 5.3). These distribution patterns appear to parallel those of finished obsidian blades and simple polychrome ceramics (without hieroglyphic texts or figural scenes) at many Maya sites during the Late Classic: households of all social classes possessed them, but elite and higher-status households possessed higher frequencies in comparison to commoner or peripherally located households (Aoyama 2001; Foias 2006: table 6.1; Foias et al. 2012; Fry 1979: 496, 1980: 5; Palka 1997: 298; Rice 1987; Sheets 2000). Such patterns are often indicative of centralized exchanges and/or the presence of commercial centers (Hirth 1998).

While figurine densities (as ratios of figurines to ceramic sherds or figurines to volume excavated) are not reported for other sites, descriptions of figurine quantities and/or their locations underscore the wide social net in which figurines were used. At the large urban center of Tikal, for instance, Late and Terminal Classic figurines were recovered from excavations by the University of Pennsylvania in all household architectural group types,

"constituting part of the basic domestic inventory" (Moholy-Nagy 2003: 98). Although figurine counts are not provided, Moholy-Nagy notes that figurines are more frequent in lower-ranked Small Structure Groups than in the larger and more complex architectural groups, a reversal of the Motul de San José data. Later excavations by the Guatemalan Institute of Archaeology and History (IDAEH) also recovered figurines within midden deposits in the residential and ceremonial zones of the Mundo Perdido Group and North Zone of the site as well as the humbler architectural groups south of the Mundo Perdido Group (Laporte 2008).

Other Petén sites reveal widespread figurine distributions (fig. 5.2). Willey (1978: 9) notes that concentrations of figurines were found in palatial contexts within the Site Core at Seibal as well as in the relatively small structures beyond the public, monumental architecture (e.g., Court A, Group D, Structures C-24, C-32, C-33, 24). His analysis of the figurines from Altar de Sacrificios documents figurines from domestic debris and construction fill from large buildings in the Site Core as well as from smaller architectural groups surrounding the civic ceremonial architecture (Willey 1972: 8). Recent excavations at the site of Piedras Negras have uncovered figurines primarily from habitation zones of the site and much less frequently from temple and plaza contexts. These habitation zones include the royal elite residential and administrative zone of the Acropolis, Structures C-10, C-14, and R-20, as well as commoner residences from the site's Sector U (Ivic de Monterroso 2002). At the site of Aguateca (Eberl 2007; Inomata 1995; Ishihara 2007; Triadan 2007), large numbers of figurines were excavated from both the royal place, noble elite residences along the site's main causeway, the *grieta* bisecting the site, and residential areas from Nacimiento and Dos Ceibas, two settlements located to the south of Aguateca described by Markus Eberl (2007: 530) as "small peasant communities."

These distribution patterns also appear in sites in the western zone of the Maya area. For example, Gallegos Gómora (2008) notes that figurines from Comalcalco were uncovered from peripheral domestic zones as well as from monumental architecture within the Site Core. Figurines from Maya sites in the western coastal zone share many stylistic traits with those from Veracruz, Mexico, where figurines are also occur in high frequencies and among a range of social status contexts (Goldstein 1994; Stark 2001).

In the eastern part of the Maya area, Hammond (1975: 372–373) reports that large numbers of ceramic figurines were excavated from humus, fill,

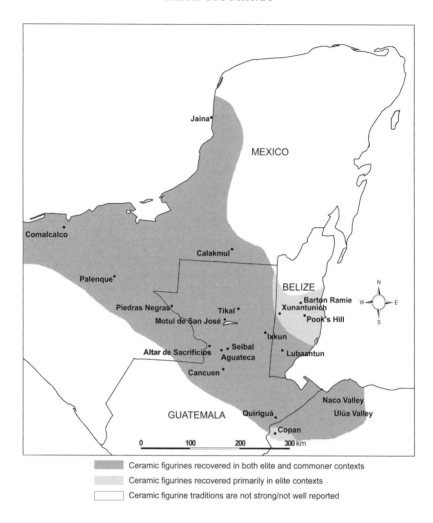

FIGURE 5.2. *Hypothetical Late Classic figurine distribution patterns based on data from labeled sites (note: Highland sites were not considered; some dark gray patterns may shade into light gray or white the farther one travels from major centers; boundaries are subject to further testing, especially with systematic studies of site peripheries).*

and midden contexts from the ceremonial center of Lubaantun in southern Belize, especially around the site's Plaza IV. He also notes a "large minority" of figurines deriving from surface collections in the foothills around Lubaantun and in the fields of contemporary farmers from the surrounding towns of San Antonio, San Pedro, and San Miguel, suggesting that

148

figurines were a part of the material culture repertories of Lubaantun's less conspicuous outlying settlements. These patterns, however, are not universal. For example, figurines are relatively rare in northern Yucatán during the Late Classic period (fig. 5.2) (Brainerd 1958; Taschek 1994).

In some regions, figurines are present in large site centers and elite contexts therein but relatively absent from farming households or architectural areas in smaller peripheral settlements. This pattern suggests that in these regions figurines were part of the production of more exclusive elite or urban social identities. At the site of Xunantunich, Belize, archaeologists have uncovered figurines and figurine molds in elite residential zones (Briggs Braswell 1998: 288, 696; LeCount 1996: 427, fig. E.35). This site was a major political center within the Belize Valley but politically subordinate during part of the Late Classic period to the large urban center of Naranjo in Petén, Guatemala. Most of the figurines "are representations of kings with large headdresses" (LeCount 1996: 427). In contrast, few figurines were recovered from the center's peripheral settlements. Two anthropomorphic figurine whistles were found with other ritual items (e.g., a bone flute, *incensario* fragments, high frequencies of serving vessels and faunal remains) from the "public ritual" structure SL-13 at the commoner site of San Lorenzo (Yaeger 2000: 857–858). None, however, were recovered from the extensive excavations of households throughout San Lorenzo. In addition, no figurines were reported from the horizontal and test-pitting excavations at the rural sites of Chan Nòohol and Dos Chombitos Cik'in (Robin 1999) or from intensive excavations from Chan's northeast group (Blackmore 2008). Likewise, comparatively few figurines (n = 7) are reported from the minor center of Barton Ramie, Belize (Willey et al. 1965), although tens of thousands of ceramic sherds were uncovered from the small house mounds at the site (Gifford 1976; Willey et al. 1965: figs. 257a, b, 257 c, 257 i, j, 257g, h).

In addition, figurines were not a common part of the domestic inventories of farming and lower-status households in the outlying settlements of Copan, Honduras, although they were frequently excavated from elite and noble residences in the site center (fig. 5.3). Excavations between 1981 and 1984 by the Copan Archaeological Project Phase II recovered 511 figurines from thirteen residential compounds in the "noble-status" Las Sepulturas neighborhood located in Copan's Site Core (Hendon 2003: 29). In contrast, archaeologists recovered only five figurines from commoner (Type 1) residential groups from the rural region of Copan (Gonlin 2007: 99–100). This discrepancy between noble elite and commoner households

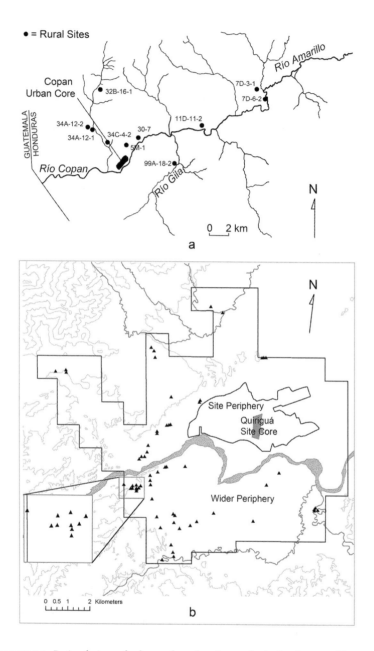

FIGURE 5.3. *Regional views of urban and rural settlement in the Southeastern Maya Lowlands: (a) rural sites with excavated Type 1 households in relation to the Copan urban site core (after Gonlin 1994: fig. 81); (b) Wider Periphery and Site Periphery in relation to the Quiriguá Site Core (after Ashmore 2007: fig. 2.5).*

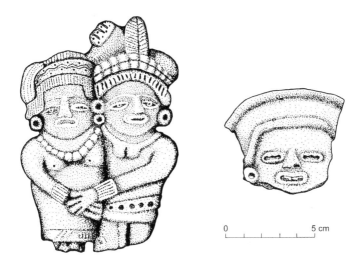

0 _____ 5 cm

FIGURE 5.4. *Uluá style figurines from Las Sepulturas, Copan (drawing by author after Gerstle 1988: fig. 5-2).*

may relate to the possibility that many figurines at Copan were probably imports. Hendon (1991: 909, 2003: 32) notes, for example, that 70 percent align in style and paste with figurines from non-Maya sites in the Naco, Lower Ulúa, and Comayagua Valleys to the northeast (fig. 5.4) (cf. Gerstle 1988: table 5.13).[4] Interestingly, figurines are a common component in both elite and commoner domestic debris as well as in rural and more populous centers in northern Honduras (Douglas 2002; Lopiparo and Hendon 2009; Schortman and Urban 1994; Stockett 2007). As discussed in chapter 2 in relation to the changing meanings of social valuables, imported figurines from the Las Sepulturas neighborhood may have increased or shifted in social and economic value, perhaps as a result of increased social distance, once they were imported to the Copan region.

The Copan data differ from those of the nearby center of Quiriguá, which more closely parallels the patterns found in Petén and Lubaantun (Ashmore 2007: 121–122). This contrast is perhaps not surprising, because ceramic vessels and other artifact types are markedly different between the two sites. In addition, Late Classic hieroglyphic texts outline a history of hostile political relations. Figurines have been recovered from a wide range of architectural groups at Quiriguá, most of which are thought to have been domestic in nature, including those from the Site

Core (containing the public monumental architecture and elite residential zones), the Floodplain Periphery, and the villages and farmsteads in the Wider Periphery. As Ashmore (ibid.) notes, 315 of the 349 figurines reported from the site were found in the latter two periphery zones. Late Classic figurine styles appear to align more with those of the Petén than with the Naco Valley, Ulúa Valley, and Comayagua Valley figurine styles (Ashmore n.d.). More research, however, is needed to substantiate such divergent stylistic patterns between Quiriguá and Copan.

In general the variation in figurine distributions suggests that figurine values and their associated social meanings were constituted differently throughout the Maya area. Figurines appear to have been a form of popular culture in many regions, as they belonged to the household inventories of multiple social groups. They may have been considered more of a prestige item or as helping to produce a more "urban" social identity in other regions. While this section treats figurines as a homogeneous artifact category, as an artifact class figurines were themselves quite diverse in the methods of their manufacture.

VARIATIONS IN MIMETIC REPLICATION TECHNIQUES: MOLDING AND MODELING

One way in which Late Classic figurine variation can be assessed is by the manufacturing techniques used to produce them. Some of the most common criteria used to distinguish figurines are the degree and type of modeling or molding undertaken in their production. These techniques have implications for the ways in which people interacted with and aesthetically perceived them. In most cases figurines were manufactured using a combination of both molding and modeling, but with greater reliance on one or the other. At one end of the continuum are the frontally molded figurine-ocarinas (Type 1), which are ubiquitous and portray the broadest range of iconography. At the other end are the finely modeled figurines (Type 4a, b), which are relatively rare and highlight elite visual discourses, particularly those of the male-gendered body. This typology is based on previous research of Southern Lowland Maya figurines (Corson 1976; Halperin 2007, 2012; Ivic de Monterroso 1999, 2002; Willey 1972) and only broadly captures figurine manufacturing variation during the Late Classic period. In addition, this typology corresponds roughly but not perfectly with differences noted in the musical capacities of the figurines (see chapter 6).

Type 1: Molded Figurines

Molded Type 1 figurines are the most common of all manufacturing types and portray a diverse array of anthropomorphic, supernatural, zoomorphic, and hybrid identities (Goldstein 1979: 52–56; Halperin 2007: 116–118, 2009b; Hammond 1975: 371–372; Ivic de Monterroso 1999, 2002; Schlosser 1978: 46–51; Triadan 2007: 274–275) (figs. 5.5, 5.6, appendices 5.4–5.6). They occur within elite and commoner contexts as well as in both Site Core and periphery settlement loci in which Late Classic figurines are recorded. For example, in the Motul de San José region, Type 1 figurines represent over 77 percent of all identifiable fragments and were not restricted spatially in relation to household status or settlement rank.

In general Type 1 figurines are hollow ocarinas (wind instruments with at least two air stops and a mouthpiece), with some variations in musical production. For example, female molded figurines from the Campeche coast are often rattles (they possess two resonator holes at the figure's armpits, and their hollow interiors contain a ceramic ball) rather than ocarinas (fig. 5.7) (Corson 1976; Gallegos Gómora 2003). Both the ocarina and rattle varieties are produced with one-sided press molds or separate head and body molds.[5] As a result, bodily features are depicted in low relief with little protrusions. In contrast, the figurines' backs and bases

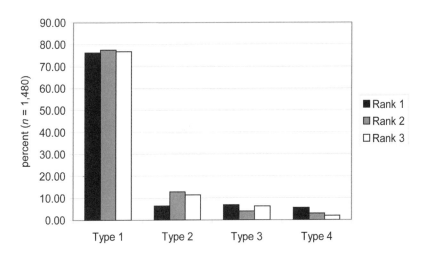

FIGURE 5.5. *Manufacturing types by volumetrically ranked archaeological groups from Motul de San José and its East Transect.*

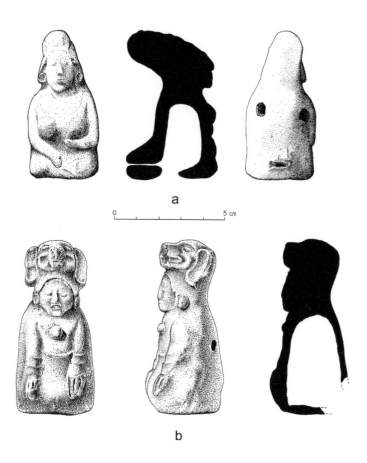

a

0 _____ 5 cm

b

FIGURE 5.6. *Type 1 molded figurine ocarinas: (a) seated woman with appliquéd broad-brimmed hat broken off, Akte (ATE-2A-1; drawing by Ingrid Seyb); (b) figurine with dog headdress, Motul de San José (MSJ2A-3-12-1i; ocarina mouthpiece broken off; drawing by Luis F. Luin).*

are hand-modeled as flat slabs and do not depict bodily contours. Some of the Type 1 figurines were then adorned with additional appliqué elements (e.g., ear spools, hair, headdress elements).

It is likely that Type 1 figurines, like other figurine form types, were often painted (red, blue, and yellow pigments are most notable), although varying states of erosion often impede identification.[6] Unlike many Preclassic and Postclassic ceramic figurines, Late Classic period specimens were not slipped. In addition, some Type 1 figurines are decorated with

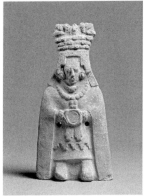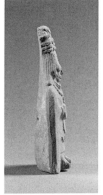

FIGURE 5.7. *Type 1 molded rattle figurine, female with mirror (height 18.3 cm, width 9.2 cm, depth 4.7 cm; Princeton University Art Museum, gift of Francis E. Ross, y1966 203, photo by Bruce M. White).*

incised lines to define body parts or decorative features. Despite these decorative additions, ethnographic analogy suggests that these molded figurines required low skill levels and low labor costs in comparison to the more elaborately modeled Type 3 or 4 figurines (Halperin 2004a, 2007). The molded figurine-ocarina types largely disappear at the end of the Terminal Classic period, when many political dynasties fell apart and centers were abandoned at an increasing pace (Halperin 2011). In regions of the Southern Maya Lowlands where continued occupation is documented into the Postclassic period, the relatively abrupt disappearance of molded figurine-ocarinas between the Classic and Postclassic periods contrasts with gradual shifts documented for many utilitarian and monochrome vessel traditions (Cecil 2001; Graham 1987; Rice 1986; Rice and Rice 2009). This suggests that on some level figurine production or circulation was linked to the Classic period state.

Type 2: Crudely Modeled Figurines

Type 2 figurines are crudely modeled specimens in which the entire figurine body (including the head) was modeled by hand (figs. 5.8, 5.9, appendices 5.4–5.6). The modeling techniques are relatively simple, with minimal shaping techniques (such as smoothing and contouring) and a lack of reductive techniques (like scraping and shaving). Thus they tend to result in unrealistic body proportions and possess only generalized

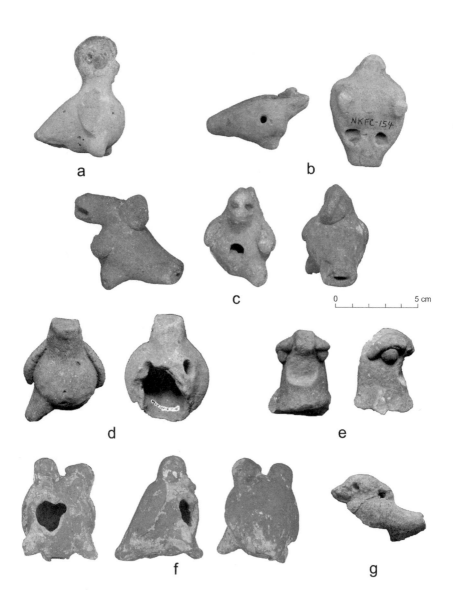

a

b

c

0 5 cm

d

e

f

g

FIGURE 5.8. *Type 2 crudely modeled figurines from central Petén: (a) bird whistle, Nakum (NKFC145; 14-36-02); (b) zoomorphic ocarina with two air ducts at mouthpiece, Nakum (NKFC154; 16-37-05); (c) tapir(?) whistle, Nakum (NKFC153; 16-21-03); (d) bird ocarina, Motul de San José (MSJ19A-6-1-16a); (e) bird head fragment, Motul de San José (MSJ38F-5-1-2a); (f) bird pair whistle or ocarina, Motul de San José (MSJ2A-40-4-1e); (g) bird ocarina with suspension hole, Motul de San José (MSJ15A-40-2-4a) (photographs by author).*

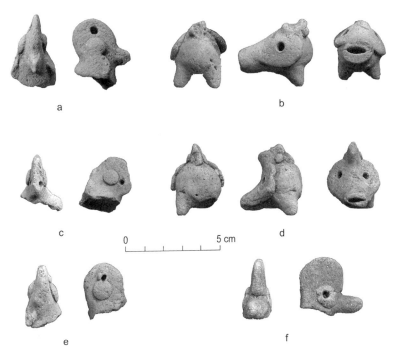

FIGURE 5.9. *Type 2 crudely modeled crested bird figurines (many with suspension holes) from Pook's Hill, Belize: (a) O1; (b) O3; (c) O6; (d) O8; (e) O59; (f) O76 (photographs by author).*

features (e.g., globular bodies, plain circular appendages for eyes and other features, small nubs for arms and legs).[7] These figurines probably also required low labor and skill levels. Type 2 versions were either ocarinas, which possess two stops, or whistles, which possess only a single stop and/ or air vent for the production of sound (Lee 1969: 65). In some cases they also had suspension holes for hanging by a cord or string. Most crudely modeled figurines depict animals, the majority of which tend to be birds. Interestingly, in Piña Chán's (1996) documentation of burials from Jaina, zoomorphic figurine-whistles are only mentioned in reference to burials of children (Entierros 12, 52, 22, 30, 32). In comparison to Type 1, Type 2 figurines are smaller and could easily have been played by children. My own attempts to blow on the small mouthpieces of these crudely modeled figurines were quite clumsy and awkward due to their small size.

Crudely modeled figurines are recovered in both elite and nonelite domestic debris, although it is possible that greater frequencies occur in

the latter context. At Altar de Sacrificios, crudely modeled birds were excavated from royal and civic-ceremonial architecture (Group A) and commonly recovered from the smaller Mounds 2, 5, 6, 24, 33, and 38. At Motul de San José and Chäkokot, commoner and middle-status architectural groups had slightly higher percentages of the Type 2 crudely modeled figurines (with the exception of the tubular variety, Type 2b) than elite architectural groups. In addition, excavations at Pook's Hill, a "medium-sized" household group in central Belize, and at the minor center of Barton Ramie, Belize, appear to have recovered a disproportionately large number of crudely modeled figurines in comparison to larger, more politically prominent centers nearby (e.g., Baking Pot), although these differences also may reflect regional figurine trends (Audet 2006; Forbes 2004; Helmke 2006a; Piehl 2006; Willey et al. 1965).

Type 2 crudely modeled figurine-ocarinas or figurine-whistles of birds possess great temporal longevity in the Maya area. Unlike the Type I figurines, their production, exchange, and/or use do not appear to have been intertwined significantly with the rise and fall of polities, including the tremendous cultural, religious, and political changes during the period of Spanish contact, when Spanish officials fervently extirpated figurines and "idols." For example, Preclassic crudely modeled zoomorphic figurines have been reported from the site of Uaxactún, Guatemala (Ricketson 1937: 216–217, figs. 140b, d), in a Swasey phase child's burial from Cuello (Robin 1989: 360–361, SF1734), and from Middle Preclassic contexts in the highlands and Pacific coast of Guatemala (Guernsey, personal communication 2012; Palma 2008). Some of these examples possess "coffee bean" eyes typical of the Middle Preclassic period. Simple modeled bird and animal whistles were found in Postclassic household lots, ceremonial zones, and children's burials at the site of Mayapan (Smith 1971: figs. 35c, 65g), and glazed bird whistles and other zoomorphic figurines appear in Colonial period excavations at Santa María de Jesús, Departmento de Sacatepéquez, Guatemala (Ramos et al. 2002: 739, fig. 4a). As discussed later (see chapter 6), small zoomorphic ceramic whistles continue to be played by children as part of contemporary Los Posadas festivities in Flores, Guatemala.

Type 3: Miscellaneous Molded and Modeled Figurines

Type 3 figurines also combined modeled and molded techniques (fig. 5.10). They consist of molded heads attached to hollow modeled bodies and portray anthropomorphic, zoomorphic, and supernatural figures. Hollow

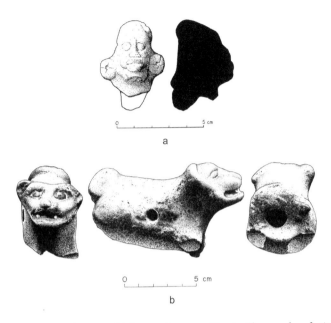

FIGURE 5.10. *Type 3 figurines: (a) Type 3a, "grotesque" head with appendage for insertion into hollow body, Motul de San José (MSJ29F-7-2-3a; drawing by Ingrid Seyb); (b) Type 3b, feline ocarina, Trinidad (TR16D-9-2-1a; drawing by Luis F. Luin).*

modeled bodies serve as ocarinas equipped with stops and mouthpieces. The modeling of Type 3 figurines is more elaborate and detailed than the Type 2 crudely modeled versions. Thus they were likely aesthetically different and perhaps required higher levels of skill and/or labor. Some more closely parallel Type 4 finely modeled versions, and it is possible that these types could be conflated. Because figurine collections consist of fragmentary specimens and because skill levels are sometimes better classified along a continuum than as rigid categories, the manufacturing categories as outlined here can be somewhat problematic. In the Motul de San José typology, molded heads with a plug-like neck part (fig. 5.10a) are labeled as Type 3b because they are often considered to have been attached to modeled bodies (see also Ivic de Monterroso 1999, 2002). In some cases modeled upper torsos possess broken circular apertures where these heads were once inserted (before firing) to form the complete figurine. Nonetheless, it is possible that these molded heads with plugs were also inserted into molded bodies.

Type 4: Finely Modeled Figurines, Effigy Flutes, and Rare Forms

Like Type 3, Type 4 figurines were finely modeled. In some cases Type 4 faces may have been molded, but their identification is often difficult because other head features were finely modeled, such as headdress parts, ear spools, and hair. These finely modeled specimens include non-music-producing figurines (Types 4a and b) and effigy flutes (Types 4c and d). Both versions are relatively rare in figurine collections throughout the Maya area. In the Motul de San José region, they were recovered from multiple social status contexts but were more common in elite architectural groups, an inverse of the pattern identified for the crudely modeled Type 2 figurines.

The non-music-producing finely modeled figurines are hollow and often possess small circular holes at the sides (by the hips) (Types 4a, b; subtype b represents fragmentary finely modeled bodies missing heads: figs. 5.11, 5.12, 5.13b, 5.14).[8] Unlike the crudely modeled figurine-ocarinas and figurine-whistles, finely modeled bodies possess realistic features and contours produced by using smoothing and reductive techniques to shape details such as the arms, torsos, knees, calves, and ankles. Many of the nonmusical finely modeled figurines share artistic conventions with stone and stucco sculptures in their attention to bodily curves, graceful poses, and shaping of features.

These Type 4a and 4b finely modeled figurines tend to portray elite male figures or male supernaturals. They are best known from the island of Jaina, where they were recovered within burials and from museum collections, in which they are often attributed to collections from Jaina or the Campeche coast (fig. 5.11). Christopher Corson (1976) categorizes finely modeled figurines from this region as Jaina Group B, C, E, and F and Jaina Modeled Miscellaneous figurines, of which only Groups C and E were ocarinas (Corson 1976). Of the finely modeled figurines, 78 percent (n = 63) were male, most of which appear to have portrayed anthropomorphic elite male rulers, ritual specialists, dignitaries, warriors, or performers. The females were numerically fewer (19 percent, n = 15).[9] The majority represent youthful elite females in that they lack wrinkles and wear thick, beaded jewelry and *huipiles*. They may engage in various activities: one, for example, holds a screen-folded book, and another holds a small child. In contrast, Corson's sample of molded figurines contained more female than male figures (fig. 5.15).[10]

Matilde Ivic de Monterroso (2002: 556) also notes that modeled figurines

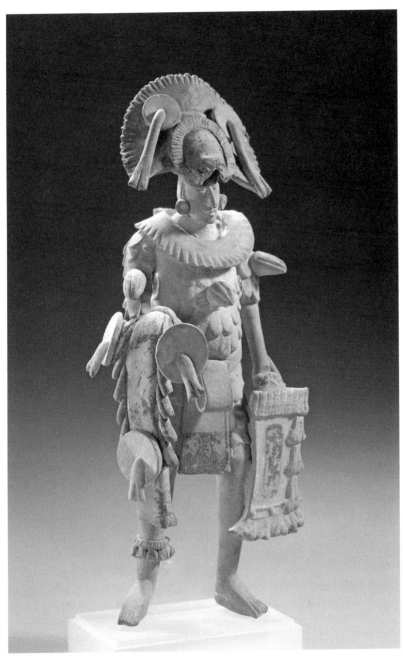

FIGURE 5.11. *Type 4 finely modeled Jaina style figurine of warrior with detachable shield and headdress, Maya blue paint (K1503 © Justin Kerr).*

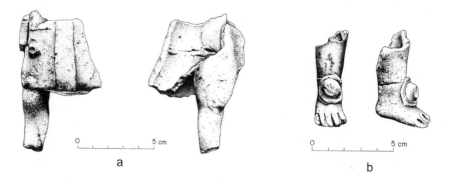

FIGURE 5.12. *Type 4b finely modeled figurines from Motul de San José: (a) anthropomorphic male torso and lower leg (MSJ39G-7-2-1n); (b) anthropomorphic leg and foot (MSJ2B-1-4-1j) (drawings by Luis F. Luin).*

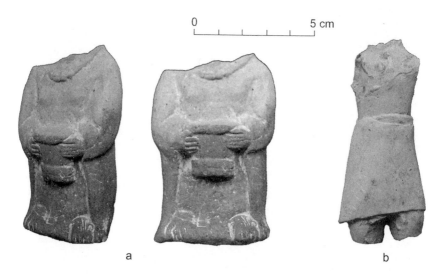

FIGURE 5.13. *Comparison of Willey's (1972) Altar de Sacrificios figurine categories: (a) molded (Type 1) woman holding censer or basket (?) from "Semisolid, Simply Dressed Type: Women" category (MUNAE7888; see also Willey 1972: fig. 38h); (b) finely modeled "Semisolid, Simply Dressed Type: Men" category (MUNAE9556; see also Willey 1972: fig. 37d) (photographs by author).*

(OPPOSITE PAGE) FIGURE 5.14. *Type 4 finely modeled male figurines: (a) Naranjo (NRFC006); (b) Tikal (Lot 68G-31a-5) (photos by author).*

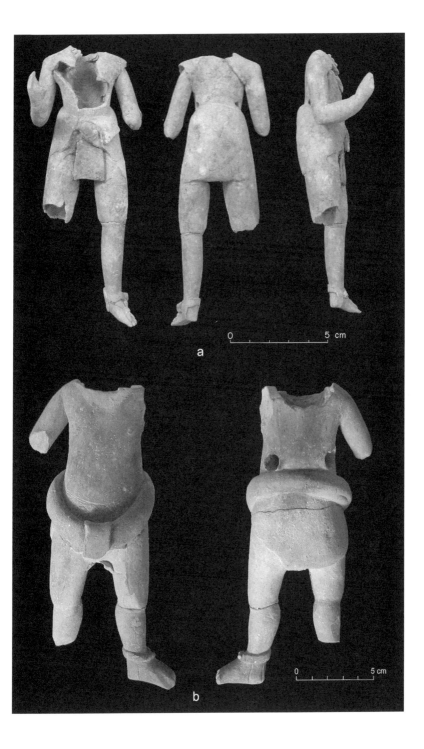

a

0 5 cm

b

0 5 cm

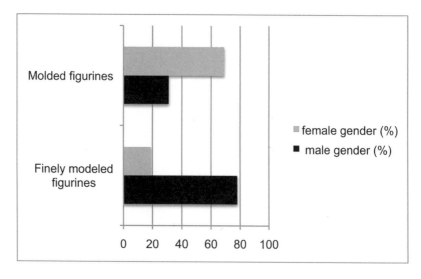

FIGURE 5.15. *Comparison of finely modeled (Types 3 and 4) and molded (Type 1) Jaina figurines by gender (data compiled from Corson 1976).*

at Piedras Negras tended to represent males, while a greater number of molded figurines represented females. Willey (1972: 45–49, fig. 37) suggests that four of the figurines in his "Semisolid, Simply Dressed Type: Men" category from Altar de Sacrificios were modeled, not likely to have functioned as instruments, and characterized by "a more elegant rendering of the human body than is typical of the other Late Classic Maya figurines." In contrast, the "Semisolid, Simply Dressed Type: Women" were molded ocarinas and did "not display the same clean sculptural quality" as the four male specimens (fig. 5.13) (Willey 1972: 49). At Motul de San José, finely modeled (presumably non-music-producing) figurines were largely fragmentary but predominately represented male torsos (with loincloths) and legs (naked with sandals). They were recovered from multiple household status contexts, but in slightly larger percentages from elite and middle-status household groups. In addition, archaeologists from the Proyecto Protección de Sitios Arqueológicos en Petén recovered three finely modeled male figurines, two of which wear warrior costumes, from a looter's back dirt in the site center of Naranjo (fig. 4.6a, 5.14a). The more limited representations of females in these finely modeled figurines parallel asymmetrical gender representations in stone monuments, sculptures, and polychrome vessels.

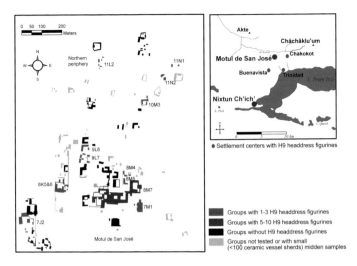

FIGURE 3.8. *Distribution of ruler figurines in Motul de San José's site core and northern periphery (left) and among settlements at the western edge of Lake Petén Itzá (upper right). H9 headdress = fan-shaped feathered ruler headdress with deity or zoomorphic mask at the center. (Note: only the MSJ Site Core and northern periphery were subject to intensive test-pitting with multiple test pits placed in each group; the East Transect test-pitting program was less intensive [half of eastern periphery and CHT] with a single 1.0 × 1.0 m unit per group; see chapter 1 notes for more details on sampling.)*

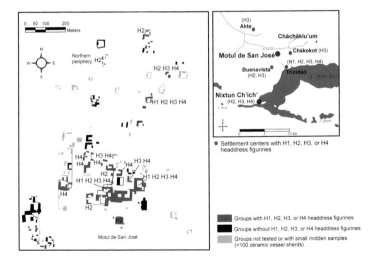

FIGURE 3.19. *Distribution of figurine headdress types in the Motul de San José site core and northern periphery (left) as well as among settlements at the western edge of Lake Petén Itzá (upper right). H1 = simple cloth head wrap with decorated band (see fig. 3.31); H2 = simple cloth or paper head wrap with tie in front (see figs. 3.29, 3.30, and porters in 4.13); H3 = broad-brimmed hat (see figs. 3.33–3.35); H4 = winged feather headdress (see fig. 3.18).*

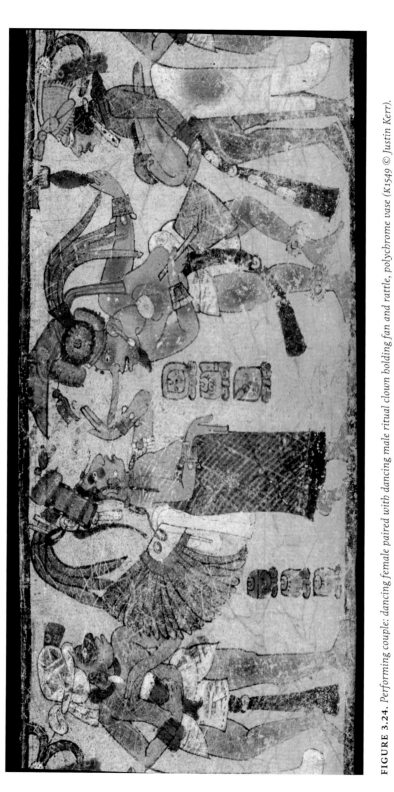

FIGURE 3.24. *Performing couple: dancing female paired with dancing male ritual clown holding fan and rattle, polychrome vase (K1549 © Justin Kerr).*

FIGURE 3.27. *Male and female pair at the center of mythological drinking scene; male anthropomorphic and supernatural figures wearing cotton necklaces, polychrome vase (K5538 © Justin Kerr).*

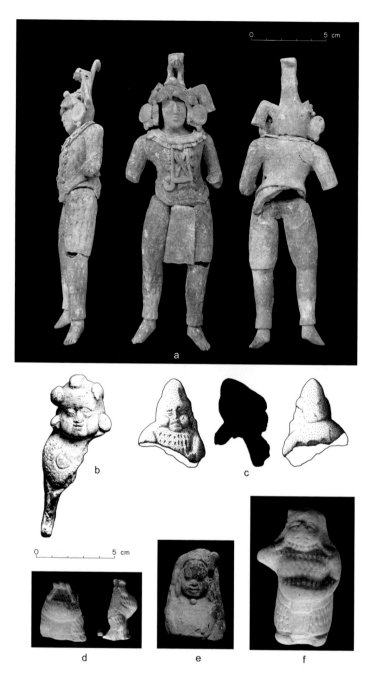

FIGURE 4.6. *Warrior and Fat Men with quilted bodysuit: (a) finely modeled male warrior figurine with removable headdress, Naranjo (NRFC005); (b) Fat Man, molded figurine, Motul de San José (MSJ2A-3-9-1b; drawing by Luis F. Luin); (c) Fat Man, molded figurine, Motul de San José (MSJ36F-2-2-3a; drawing by Ingrid Seyb); (d) Fat Man, molded figurine, San Clemente (SC106; photo by author); (e) Fat Man, molded figurine, Motul de San José (MSJ2A-3-13-1a); (f) Fat Man, molded figurine, Tikal (45E-41-10; photograph by author) (scale bar applies to b–f).*

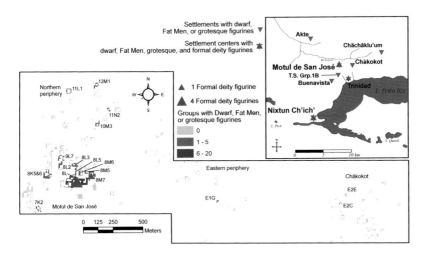

FIGURE 4.7. *Distribution of supernatural figurines at Motul de San José and the East Transect (lower left) and among settlements at the western edge of Lake Petén Itzá (upper right).*

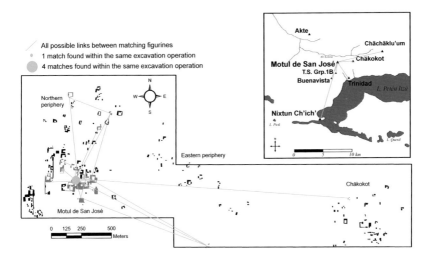

FIGURE 5.19. *Distributions of matching figurines at Motul de San José and the East Transect (lower left) and at the western edge of Lake Petén Itzá (upper right) with lines connecting matching sets.*

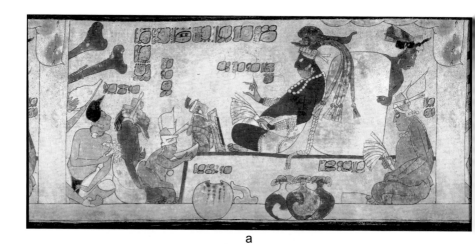

a

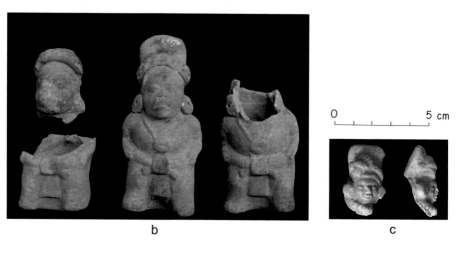

b

0 ⊢—⊢—⊢—⊢—⊢—⊢ 5 cm

c

FIGURE 4.8. *Dwarves as part of royal court and wearing headdress of* aj k'uhun: *(a) drinking dwarf as part of royal court of Ik' ruler, Sihyaj K'awiil, polychrome vessel (K1453 © Justin Kerr); (b) identical molded dwarf figurines, Nakum (NKFC150, 155 and NKFC156); (c) dwarf with stick bundle for writing wrapped in headdress, molded and painted figurine, Nakum (NKFC532; photographs by author).*

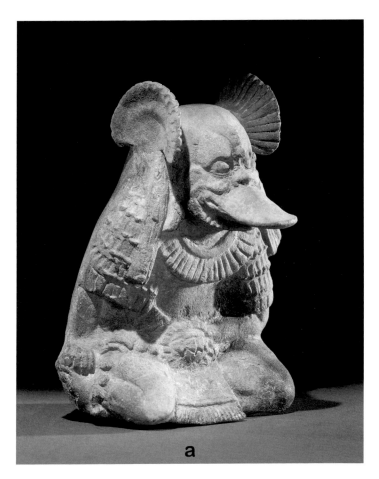

a

b

FIGURE 4.17. *Bearded grotesque figurines with duck-billed buccal masks and decorative paper strips on the sides of the head: (a) musician holding a turtle carapace and deer antler (K3550 © Justin Kerr); (b) figurine, Toniná (drawing by author after Becquelin and Baudez 1982: fig. 270).*

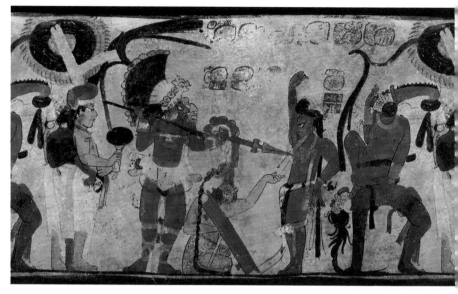

a

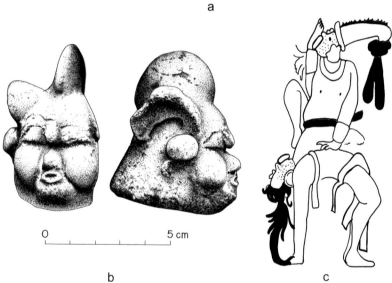

b

c

FIGURE 4.18. *Ritual clowns as performers and related to sacrifice: (a) polychrome vase (K2025 © Justin Kerr); (b) hollow figurine mask with puckered lips similar to ritual clowns (TRI10D-9-1-3a; drawing by Luis F. Luin); (c) detail of polychrome vase showing two ritual clowns with puckered lips (drawing by author; after K2025).*

Effigy flutes were produced in large part by modeled techniques, using a mold only for the face (figs. 5.16, 5.17, 5.18). The faces were relatively flat in order to fit without too much protrusion on the circular, modeled flute.[11] Their production likely required specialized knowledge of their musical capacities. Some, for example, are goiter flutes, which possess a bulbous chamber that produces a reedlike sound (Howell 2009). These bulbous chambers often double as the bellies of monkeys and grotesque characters (figs. 5.16a, 5.17). Other flutes were adorned at the ends with a flower (fig. 5.16e) (Halperin 2007: fig. 6.7f; Healy 1988: 30; Willey 1972: fig. 57l), perhaps cross-referencing the sweet scent of flowers with the sound of music (Houston and Taube 2000; Taube 2000a: 114–115, fig. 102). Effigy

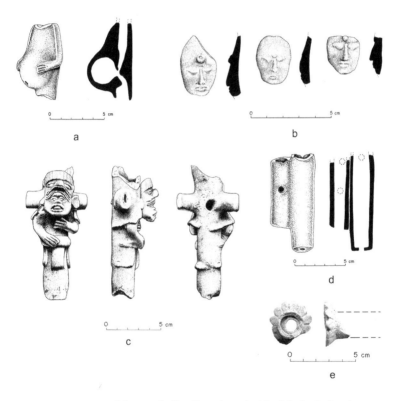

a

b

c

d

e

FIGURE 5.16. *Type 4c, d flutes and effigy flutes from the Motul de San José region: (a) Type 4c, finely modeled effigy goiter flute of bloated figure (MSJ3A-3-12-1f); (b) flat molded heads possibly intended for effigy flutes (MSJ15A-12-2-5a; MSJ10A-3-7-8a; MSJ17D-9-1-2a); (c) Type 4c, finely modeled effigy flute of dwarf (TRI13E-5-3-1b); (d) Type 4d, modeled double-chambered flute (MSJ2A-3-12-1a); (e) Type 4d, modeled single-chambered flute with flower on distal end (MSJ46A-1-2-4a) (drawings by Luis F. Luin; photo by author).*

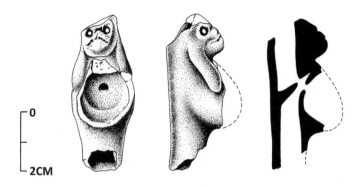

FIGURE 5.17. *Type 4c effigy goiter flute of monkey with ear pendants from Toniná (drawing by Luis F. Luin after Becquelin and Baudez 1982: fig. 268j).*

a

b

FIGURE 5.18. *Type 4c zoomorphic flutes or flute-like musical instruments: (a) Altar de Sacrificios (MUNAE10100B&C); (b) Trinidad (TRI13E-5-2-2b) (photographs by author).*

flutes parallel finely modeled figurine Types 4a and 4b in their common portrayal of male-gendered or animal-hybrid/supernatural figures.[12] Like the disappearance of figurine-ocarinas at the end of the Terminal Classic period, the production of finely modeled figurines with graceful bodily postures and realistic bodily proportions also ceases during this time, if not earlier at the onset of the Terminal Classic period.

MECHANICAL REPRODUCTION: IDENTICAL IMAGERY

Unlike these rarer finely modeled specimens, molded figurine manufacture can be equated with what Benjamin (1969 [1936]) called "mechanical reproduction," in which art takes on a homogeneous quality from the repetitive production of the same imagery, as seen in printmaking, photography, film, and other mass media (Halperin 2009c). On some level mechanically reproduced artifacts lack the individuality and uniqueness that can be achieved with what he referred to as "classical art," whose singularity more readily embodied its producer(s) and owner(s) and created an "aura" of authenticity and power. While mass production is often equated with the emergence of industrial capitalism during the eighteenth century and afterward, ancient craft producers at different moments and places in history engaged in varying technical practices and levels of specialization, some of which produced highly standardized products (Blackman et al. 1993; Costin 1991; Mukerji 1983) and facilitated a relatively homogeneous distribution of material culture across a broad social spectrum.[13]

As underscored in chapters 3 and 4, diverse Maya households and settlement types engaged with many of the same iconographic figurine themes. An examination of identical molded figurine imagery and its distribution, however, further suggests that figurines were not necessarily singular items for restricted access but were exchanged broadly as in mass media. Diverse social groups with identical imagery may have had access to the same production workshop or source, had access to the same distribution network(s), or had access to the same molds or mold replicas, or a combination of these factors.[14]

In the Motul de San José region, at least eighteen sets of figurine matches have been identified. These matches, which range from two to six duplicates per set, were recovered from palace-type and elite residences within the Motul de San José Site Core, households in its northern, eastern, and southern peripheries, and its satellite centers, including Trinidad, Chächäklu'um, and Chäkokot (figs. 5.19, 5.20). In addition, although no

FIGURE 5.19. *Distributions of matching figurines at Motul de San José and the East Transect (lower left) and at the western edge of Lake Petén Itzá (upper right) with lines connecting matching sets.*

matches were found between the Motul de San José region and sites along the eastern side of the Petén Lakes region, at least one match was found between Motul de San José and Nixtun Ch'ich'. Although these matches represent only a small percentage of the total figurines excavated (many were too fragmentary to identify their iconography), the distribution of the matches suggests that either figurine molds or the figurines themselves were exchanged broadly within a 10 km radius throughout the region without constraints as to settlement hierarchy. In addition, they indicate that both commoner and elite households as well as both the polity capital and its satellite centers had access to identical forms of iconography. For example, a ruler figurine with War Serpent headdress from a commoner farming household from Chäkokot (Op. 44E, Group E2E) matches one from an excavation unit located at the edge of the royal palace (Group C) from Motul de San José's site center (fig. 5.21). Another War Serpent headdress figurine recovered from a royal household in central Motul de San José (Op. 15A, Group 8M7) matches one from a small household group in the northern periphery of the site (Op. 42F, Group 11N2). In addition to ruler figurines, other matches include female figures (some of which likely had broad-brimmed hats due to the circular types of fractures at the crown of the head where the hat was broken off), ballplayers, warriors

FIGURE 5.20. *Matching set of ruler figurines with War Serpent headdresses from Motul de San José (above: MSJ2A-40-5-2a; below: MSJ4A-1-2-1a) (drawings by Luis F. Luin).*

FIGURE 5.21. *Matching set of ruler figurines shown in profile, front, and back with War Serpent headdresses: (a) Chäkokot (CHT44E-14-3-1a); (b) Motul de San José (MSJ2A-1-7-1a) (photos by author).*

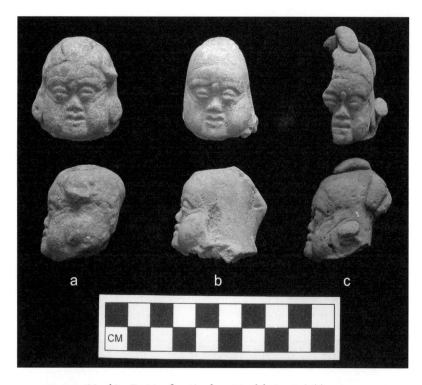

FIGURE 5.22. *Matching Fat Man figurines from Motul de San José: (a) MSJ2B-1-5-1a; (b) MSJ33D-12-1-1a; (c) MSJ2A-3-9-1a (photos by author).*

or performers with rectangular shields, dogs, monkeys, grotesques, Fat Men, and dwarves (fig. 5.22) (Halperin 2009c: table 13.1).

Other regions have yielded identical figurines, suggesting social and economic ties within and between diverse types of settlements (fig. 5.23). The large regional capital of Tikal in particular may have been an important center for the production of figurines: not only have match mates been identified between different areas of the site (personal observation, Tikal *bodega*, 2006), but what appear to be identical figurines occur at both the site and settlements outside the Tikal region. For example, a palanquin figurine with a seated ruler from Tikal (Lot No. 47A-50, Gr. 5D-010) matches a complete version excavated from the smaller site of San José, Belize (Burial C12), and fragmentary figurine pieces excavated from the sites of Yaxhá and San Clemente (in this case from a midden context) (fig. 3.11). A seated female figurine-ocarina with a feathered headdress from Tikal (Lot No. 17–1-1, #1878–2, Gr. 5D-003) is identical to a

figurine-ocarina from the site of Pacbitun, Belize (fig. 5.24). The Pacbitun specimen was one of several figurines from a Terminal Classic burial crypt of an elite woman (Healy 1988: 28–31).[15]

Identical almost complete figurines (but in different states of erosion) of a seated ruler with a large fan-shaped headdress were excavated from Tikal and Yaxhá (fig. 5.25). Likewise, fragmentary ruler figurines with headdresses exhibiting three stacked deity masks link the sites of Tikal,

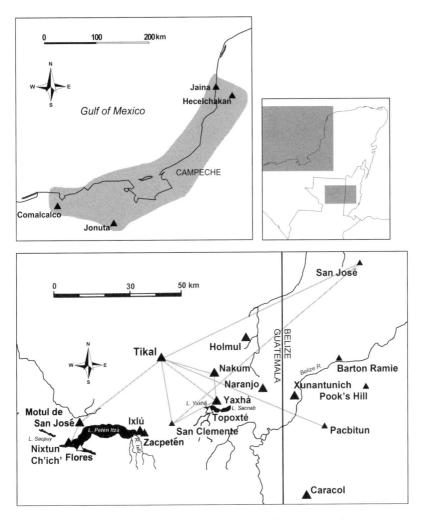

FIGURE 5.23. *Regions linked through matching figurines:* (above) *Campeche coast;* (below) *Petén, Guatemala, and western Belize with lines connecting matching sets.*

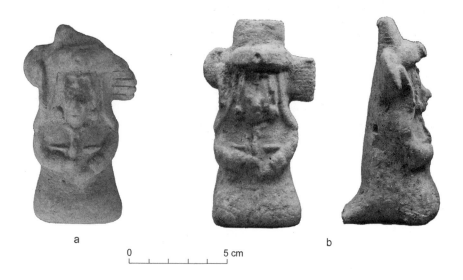

FIGURE 5.24. *Identical molded female figurines both with traces of red and Maya blue paint: (a) Tikal figurine (#17-1-1-1878); (b) Pacbitun figurine (Cat #28/189-3-6) (photograph courtesy of Paul Healy, Trent University).*

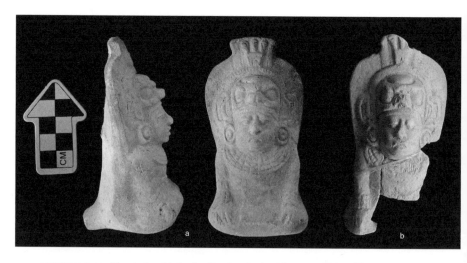

FIGURE 5.25. *Identical molded ruler figurines both with traces of Maya blue paint: (a) Yaxhá (YXFC075); (b) Tikal (#17-1-1-X) (photographs by author).*

Yaxhá, and Nakum (and possibly Zacpetén, but this last specimen is too small to verify its status as a match mate) (fig. 3.6). Several ballplayer figurines from Tikal, Nakum, and Nixtun Ch'ich' may have been produced from the same mold or set of molds, although these connections also need further verification. Finally, three matching Fat Man figurine heads were excavated from the Motul de San José region (fig. 5.22). While two of these figures possess local pastes and wear additional appliqué headdress pieces attached to the molded heads, the third specimen was chemically sourced to the Tikal region using INAA (fig. 5.22b). Tikal figurines not only were imported to the Motul de San José region (as detailed further below in the section on figurine pastes) but may have been replicated by Motul de San José artisans by making molds of imported figurines.

These material linkages support textual evidence that details Tikal's political rule over Yaxhá and Motul de San José. As noted in chapter 1, Motul de San José Stela 1 records Yeh Te' K'inich I, an Ik' ruler, as a vassal of Jasaw Chan K'awiil, the powerful Tikal ruler responsible for revitalizing Tikal's central role in regional politics at the beginning of the eighth century (Tokovinine and Zender 2012). Yaxhá was defeated by Tikal in AD 743 under the rein of Jasaw Chan K'awiil's son, Yik'in Chan K'awiil (Martin and Grube 2000: 51). Likewise, Yaxhá shares similar monumental architecture programs and ceramics with Tikal (Culbert 2003: 60; Rice 2004: 145).

The figurines, however, also detail possible relations in which textual data are silent. For example, few written data are available for the small center of San Clemente, which flourished in the Late to Terminal Classic period (Salas 2006). Although geographically it falls into the orbit of polities in the Petén Lakes region, the figurine matches (and paste data described below) reveal its connections, in particular, with Tikal and sites in the eastern side of the Petén Lakes region. Figurine match mates that link Tikal with smaller centers in Belize, such as San Jose (over 80 km away) and Pacbitun (over 70 km away), reveal more surprising connections between distant regions. Primary Late Classic political capitals, such as Naranjo and Caracol (in the case of Pacbitun), are closer. These long-distance networks speak to centralized, regional state networks in addition to localized ones at a provincial level.

Gallegos Gómora (2008) reports on identical figurines found between the western Maya sites of Comalcalco, Jonuta, Jaina, and Hecelchakan and suggests that these sites were connected through trading networks (fig. 5.23). Identical figurines are also reported from excavations at Jaina

and from museum collections (Schele 1997: 178–183), within the same ceremonial deposit in the Site Core of Lagartero (Ekholm 1979a: 174, 185), at Lubaantun (Hammond 1975: 372), from on-floor primary refuse at Pook's Hill (fig. 4.22a, b), at Nakum (Halperin 2009b), within the Site Core of Aguateca (Triadan 2005: fig. 20), and from two adjacent residential groups at the small periphery site of Dos Ceibas (Eberl 2007: 452, fig. 10.30d, e). In some cases duplicate figurines from the same circumscribed context may be indicative of figurine production, because production workshops or loci tend to have greater frequencies of the same products than zones in which they are thought to have been consumed. Figurine production workshops elsewhere in Mesoamerica report broken identical figurines found in association with other evidence of ceramic production (Barbour 1975: 118–119; Feinman 1999: 92; Hernández et al. 1999: 77). Figurine production is best identified when other lines of evidence are also found alongside duplicate figurines.

ORGANIZATION OF PRODUCTION:
CERAMIC FIGURINE MOLD DISTRIBUTIONS

The contexts of molded figurine production can be inferred from the recovery of figurine molds, especially if found in conjunction with other ceramic production evidence, such as evidence of burning, firing features, ceramic wasters, and ceramic production tools, including burnishers, polishers, and paint pots (figs. 5.26, 5.27; appendix 5.7) (Stark 1985). Ceramic production data in general are quite rare in the Maya area, partly because ceramics may have been fired in open pits and partly because sampling strategies tend not to target off-mound loci (Halperin and Foias 2010).

An overview of figurine mold distributions from the Maya area indicates that molded figurines often follow a mass media model in which goods are produced from commercial or political centers. Although the archaeological contexts of figurine molds represent discard locations and do not necessarily identify the actual sites of figurine production, at minimum they reveal general access patterns of figurine production tools with particular social groups and settlement loci. Evidence for figurine production generally is more prominent at major centers than in site peripheries or rural zones. Although more systematic research is needed in these latter contexts, the available evidence does not support a folk culture model of production. Nor was figurine production rigidly controlled by royal or elite sectors of society, as one might expect of elite or elite-sponsored (e.g.,

"attached") production of prestige goods, because some molds were found in middle-status and nonelite architectural groups. Like other forms of crafts specialization throughout Mesoamerica, figurine production appears to have been organized by and through household settings rather than as autonomous workshops (Feinman 1999).

Figurine molds excavated from elite and commoner contexts at politically prominent site centers include the sites of Aguateca, Altar de Sacrificios, Copan, El Chal, Ixtonton, Lagatero, Lubaantun, Motul de San José, Nakum, Palenque, Quiriguá, Seibal, Tikal, and Xunantunich. In some cases figurine molds have been recovered from periphery or rural areas, such as at a domestic residence outside the large center of Comalcalco and at the site of Dos Ceibas, a rural peripheral community of Aguateca. At Lubaantun in southern Belize, for example, Hammond (1975: 373) reports that all of the molds with known provenience come from an area around Plaza IV where elite residences and the main ceremonial and administrative structures are located.

At Palenque, two of the four figurine molds with known provenience

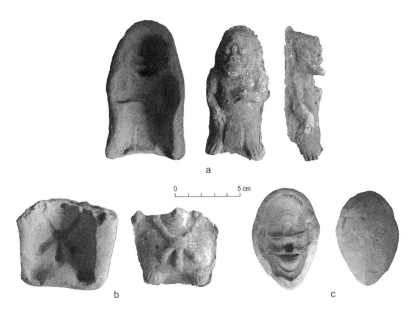

FIGURE 5.26. *Figurine molds from Tikal: (a) mold of male-gendered grotesque and positive impressions; (b) mold fragment of unidentified zoomorphic, hybrid, or supernatural figurine body and positive impression; (c) mold of grotesque head with beard (front and back) (photographs by author).*

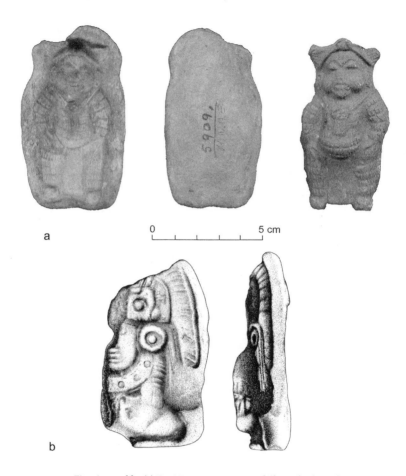

0 5 cm

a

b

FIGURE 5.27. *Figurine molds: (a) Fat Man, unprovenienced (front, back, and positive impression) (MUNAE5909; photograph by author); (b) seated ruler with War Serpent headdress, Nakum (NKFC100; drawing by Luis F. Luin).*

documented by Schele and Mathews (1979: figs. 902, 903) were found in the ceremonial precinct of the site, 100 m west of the Temple of Inscriptions. One of these is a rare figurine form, an architectural replica of a pyramid structure (similar to the Temple of Inscriptions); the other is a figure with a large feathered headdress. Rands and Rands (1959: 225; Rands 1967: 143) also note that cache vessels, *incensarios*, serving vessels, and 98 percent of figurine molds and figurines all share the same quartz-tempered, red-brown paste and were probably made locally, at or close

to the site. The figurines contrast with everyday ceramic vessels from Palenque, which are thought to have been produced in the Palenque hinterlands and imported to the center.

Thirteen figurine molds were recovered in the site epicenter of Aguateca (Inomata 1995: tables 7.12, 7.14; Triadan 2007). Based on an early phase of excavations (1991–1994), Inomata (1995: 551) argued that two structures, Str. K7-11 and M8-19, may have been sites of figurine production because they possessed both figurine molds and high frequencies of figurines. The structures consisted of low rectangular featureless platforms. Later excavations also uncovered two molds (one Fat Man and one grotesque head) associated with a high frequency of figurines (n = 223; 31.72 percent of all figurines excavated from 1996 to 2003) from an elite residence along the site's main causeway (Str. M8-4). A single mold of a dwarf was found from plaza fill of Group MP11 at the periphery settlement of Dos Ceibas (Eberl 2007: fig. 10.3).

In some cases figurine molds have been found associated with other ceramic production evidence, providing additional support for figurine production in or near their locations of recovery. A single ceramic figurine mold fragment was excavated from a large secondary midden located adjacent to Motul de San José's royal palace (Group C). The secondary refuse also contained large deposits of ash, burnt clay, iron oxide mineral deposits that may have been used in the production of paint pigments, miniature paint pots with interiors stained by red specular hematite, pottery burnishers and polishers, polychrome vessel wasters, and bone pins with red paint on their distal ends (Halperin and Foias 2010, 2012; Halperin and Salguero 2006). In addition, the secondary midden possessed the largest number of identical figurine matches (n = 15; with 4 of the matching match mates found in the same context). These materials were mixed in with other domestic trash (e.g., grinding stones, ceramic storage and serving wares, obsidian blades), suggesting that production may have occurred within an elite household or several elite households in Motul de San José's epicenter.

Four figurine molds (and a censer mold) were also excavated from a polychrome pottery-producing neighborhood located in the eastern section of the large urban center of Tikal (Becker 1973: 399, 2003; Haviland 1985: tables 43, 46). Architectural groups from this neighborhood are interpreted as "middle-status" residences. Polychrome pottery production is inferred from the enormous quantities of polychrome vessel wasters (de facto wasters, sherds presumably broken during the process of production)

recovered in and around these residences. In addition, excavations of Small Structure Groups 4F-1 and 4F-2 from Tikal yielded one figurine mold each, although no other ceramic production evidence is reported.

Figurine molds were found both in the Site Core at Quiriguá and in at least four loci in the surrounding Floodplain Periphery, although none were detected from the Wider Periphery (fig. 5.3) (Ashmore 1988: 164, 2007: 122, 126, 173, 260, 283, 315). The most pervasive evidence for figurine production was at Mound 7C-1 in the Floodplain Periphery, where twenty-eight molds and vessel production evidence (a pebble possibly used to burnish vessels, a concave stamp for decorating vessels, and lumps of unfired clay adhering to the interior of bowl sherds) were identified in conjunction with other domestic debris (Ashmore 2007: 317). Mound 7C-1 belongs to one of the larger of the lower-ranked architectural groups. Thus, while figurine production does not appear to have been exclusively in the hands of or controlled by elites, it was not a bottom-up affair in which we would expect to see greater evidence of production in periphery sites and lower-status households.

The Maya evidence for figurine production contrasts with evidence from decentralized polities southeast of the Maya area. There figurine molds are more frequently recovered and widely scattered among hinterland households, small villages, or secondary sites than in many parts of the Maya area. Excavations by Edward Schortman, Patricia Urban, and colleagues (Douglas 2002; Schortman and Urban 1994; Schortman et al. 2001; Urban et al. 1997) in the Naco Valley, Honduras, document evidence of figurine production (as seen from figurine molds and firing features) in the core of the regional capital of La Sierra as well as the rural centers and hamlets located over 7 km from the site. From the 117 figurine molds reported in 2001 (Schortman et al. 2001: table 1), 78 percent were found outside the regional capital of La Sierra. As noted in chapter 2, research by Lopiparo (2003, 2006) also reported a decentralized organization of figurine-ocarina and figurine-whistle production at sites CR-103, CR-381, and CR-132 in the Ulúa Valley, Honduras. Lopiparo (2003: 227–230, 2006: 158–161) found that the figurines from each household excavated had remarkably distinct and "almost totemic" iconographic elements and designs, particularly in the case of the anthropomorphic headdresses. Based on these stylistic variations among households and the decentralized nature of figurine production, she finds that figurine iconography was quite diverse, a contrast to the relatively homogeneous distributions of identical or similar iconographic figurine themes found in the Maya area.

FIGURINE PASTE ANALYSES

Figurine paste analyses also suggest that molded figurines follow a mass media model of distribution: figurines with the same paste recipes were widely distributed across household and settlement contexts of different statuses (Halperin et al. 2009). In the Motul de San José region, a combined modal (visual examination using a 100× microscope, 100 percent sample coverage; $n = 2{,}767$), petrographic ($n = 62$), and INAA ($n = 104$) paste study identified local and imported paste groups that cross-cut elite, middle, and low-status architectural groups at Motul de San José and Chäkokot as well as variously ranked settlements within an 8 km radius of Motul de San José (fig. 5.28, appendix 5.8, 5.9). In addition, modal paste categories occur with the same frequencies in these different status and settlement contexts. These paste distributions follow patterns indicative of market exchange where relatively similar frequencies of foreign artifacts in comparison to nonforeign goods are found in both low- and high-status households, because market systems would allow all social groups access to the same products. Models of centralized market exchange recognize that different households might have the same range of items (for example, imported versus local) available in the marketplace, but higher-status households may have larger numbers of these items as a result of their greater purchasing power and social conscriptions (Hirth 1998: 456).

Local figurine pastes from the Motul de San José region were Petén Gloss wares similar to those used to produce serving vessels (polychrome and monochrome dishes, bowls, restricted neck jars, and vases). They consisted primarily of red ash-tempered pastes (labeled as "A" and "B" modal categories) and some tan ash-tempered wares (labeled as "C" and "E" modal categories).[16] All identified imported figurine pastes (13 percent of figurines chemically sampled [$n = 104$] and 15.5 percent of figurines chemically sampled and assigned a paste group [$n = 84$]) matched paste signatures from in and around Tikal. These imported figurines included both Type 1 molded figurine-ocarinas ($n = 10$) and Type 4a and b ($n = 2$) finely modeled types (an additional figurine import was too fragmentary to identify manufacturing type). These imported pastes were also tan ash-tempered pastes belonging to the Petén Gloss ware tradition (labeled as "C" and "E" modal categories; these imported figurines are indistinguishable from local figurines based on visual examination alone).

As mentioned earlier, the linkage between Motul de San José and Tikal is significant in that it reinforces hieroglyphic evidence indicating that the

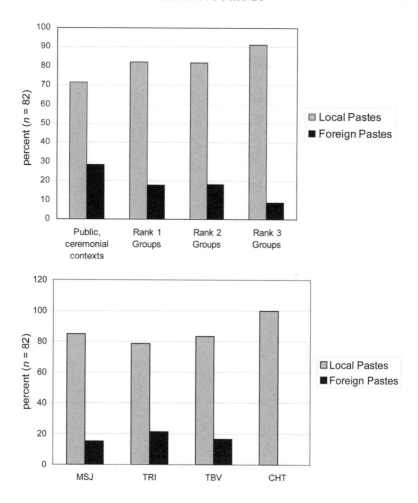

FIGURE 5.28. *Comparison of local and nonlocal INAA paste groups by architectural group status (top) and comparison of local and nonlocal INAA paste groups by site (bottom: MSJ: Motul de San José [site capital]; TRI: Trinidad [secondary site]; TBV: Buenavista [tertiary site]; CHT: Chäkokot [tertiary site]).*

Ik' polity, thought to have been centered at Motul de San José, was linked politically to the larger and more powerful center of Tikal. Interestingly, the INAA research did not show any figurine imports from the Petexbatún region or from Yaxchilán, although written texts indicate that Motul de San José also formed political networks with these regions. In addition, a number of elaborate polychrome vessels with hieroglyphic texts that

chemically and stylistically match vessels from the Motul de San José region have been found in royal tombs in the Petexbatún region, such as Aguateca, Altar de Sacrificios, and Dos Pilas (Halperin and Foias 2010; Reents-Budet and Bishop 2012; Reents-Budet et al. 1994; Reents-Budet et al. 2007). These vessels were likely gifted by Ik' lords to Petexbatún elites and underscore political alliances between the elites at these sites. While more research on figurines is needed from these regions, it is likely that certain political negotiations documented through written texts and through the exchange of finely painted pottery did not affect the broader spectrum of participants or types of activities that are more indicative for the circulation of figurines. In other words, molded figurines may speak to more inclusive and/or broader-based political-economic connections than the precarious alliances formed solely at the top of the social hierarchy (Halperin 2014).

Halperin and colleagues (2009) suggest that figurine exchanges may have occurred during festival-markets or as part of inclusive ceremonial occasions. Ethnographic and ethnohistoric evidence indicates that Mesoamerican market exchanges correlated with ceremonies, festivals, and pilgrimages (Morinis 1992; Pohl et al. 1997; Wells and Nelson 2007). In these examples, markets are not only timed to occur on religious holidays and large-scale ceremonial productions (or visa versa) but were spatially located near or en route to the church, the main procession roads, and other performance spaces, a pattern similar to the spatial overlap of Classic period Mesoamerican plazas and civic-ceremonial architecture (such as causeways, ball courts, and temple pyramids). For example, during the Colonial period the center of Izamal in Yucatán, Mexico, was a pilgrimage center dedicated to Our Lady of Izamal. It also held a feast of the Immaculate Conception on December 8 that was followed by a week-long festival, which drew in people not only from the town's immediate vicinity but from centers outside the province, to exchange goods as well as to participate in the ceremonial festivities (Farriss 1984: 307–308). In the Motul de San José region, both the capital (Motul de San José) and the larger secondary site of Trinidad possessed large plazas that could have hosted markets (figs. 1.2, 6.9) (Dahlin et al. 2010). If figurines were acquired on such occasions,[17] they could have served as important tokens of one's experiences at these state ceremonies and large-scale performances marking communal life. Such connections would have been further reinforced through figurine iconographic themes of state pomp and ceremony, as discussed above.

My more recent analysis of figurine pastes (through visual examina-
tion using a 100× microscope) (Halperin 2010, 2014) from multiple sites
in the Petén Lakes region reveals that sites along the entire western side
of Lake Petén Itzá shared Late Classic figurines with the same red ash-
tempered pastes (fig. 5.29, appendix 5.9). This analysis includes figurines
from Flores and Tayasal, which are not formally discussed here (Halperin
2014). The distributions of the red-pasted figurines reveal that western
Lake Petén Itzá sites participated in the same exchange networks. It is
possible that they were politically allied with one another, perhaps as
part of a confederation of sites belonging to the Ik' polity (Halperin 2014).
Interestingly, during the Postclassic and Contact periods, ethnohistoric
evidence indicates that this western region was the geopolitical territory
of Itzá Maya whose capital was centered at Noj Petén, the modern town
of Flores. Kowoj and Yalain territories, in contrast, were located along the
eastern side of the Petén Lakes region, the same locations in which Late
Classic tan ash-tempered figurines predominate. Hieroglyphic evidence

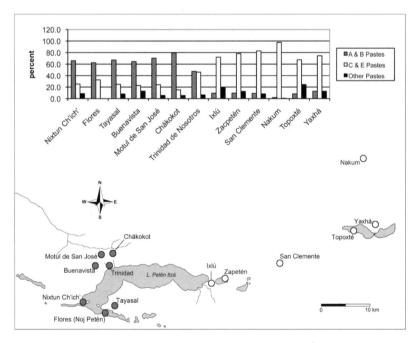

FIGURE 5.29. *Comparisons of red ash-tempered (A and B) and tan ash-tempered
(C and E) figurine pastes in the Petén Lakes region, showing distinctions between western
and eastern zones of the lakes (after Halperin 2013: fig. 8).*

points to ties in rulership between the two periods: a lord of Motul de San José (Ik' polity) during the Terminal Classic period and lords from Noj Petén during the Postclassic/Contact periods possess the same name (or title): Kan Ek' (Jones 1998: 7–28; Rice and Rice 2004: 127). While a great deal of political change occurred from the Late Classic to Contact periods, the possible continuity or reworking of geopolitical territories in this region is worth further exploration.

Few figurine studies focus on paste composition. Nonetheless, an early INAA and iconographic figurine study by Goldstein (1979, 1980) documented the widespread distribution of molded figurines from several different settlements up and down the Campeche coast. She argues that the molded figurines, in particular, were mass-produced and widely traded. These relationships are supported by the research of Gallegos Gómora (2008) on molded figurine matches mentioned earlier. An ongoing figurine study by Sears and colleagues in and around Cancuén also reveals that figurines from Cancuén possess pastes that match those from local ceramics, those from Raxruha Viejo (less than 20 km south of Cancuén), and those from Salinas de los Nueve Cerros, located further away in Alta Verapaz (Sears 2007; Sears et al. 2004). These case studies support the Petén Lakes region data in indicating that figurine exchanges were regularly made within broad regional networks in addition to interaction spheres of individual polities (or a single capital and its hinterland).

The Late Classic Maya figurine data parallel patterns identified for Teotihuacan figurines during the Classic period and Aztec figurines during the Postclassic period. Kristin Sullivan (2007), for example, argues that figurines were acquired through markets, as the types of figurines produced at both a household ceramic workshop and a state-run ceramic workshop were consumed throughout the city regardless of the social status of the apartment compound. Although state-run ceramic production facilities are not known for the Maya area, the widespread exchange of Teotihuacan figurines speaks to patterns found in some Maya regions. Like the Motul de San José region finds, Teotihuacan figurines made from the same mold also linked many different apartment compounds throughout the city (Allen 1980).

In the Aztec case, Cynthia Otis Charlton (1994) documents nucleated figurine production in a neighborhood of the large center of Otumba. She notes that the same figurine types found at the Otumba workshops were also found throughout the city and the surrounding hinterland. Research on figurines from the urban site of Yautepec and the more rural

sites of Cuexcomate and Capilco in Morelos, Mexico, by Jan Olson (2007) indicates that both Aztec commoner and elite households had access to a range of figurine types, including imported figurines. These relatively homogeneous distribution patterns follow material expectations of market exchange (Hirth 1998; Smith 2003), and market exchange spheres were closely tied to shifts in political alliances and developments of the Aztec state (Minc 2006; Nichols et al. 2002).

DISCUSSION

Ceramic figurines are implicated in the making of states in that they helped formulate polity-wide networks that cross-cut lines of status, rank, lineage, and house. For places such as the Petén, production and distribution patterns of molded figurines support a mass media model in which political capitals were highly integrated with households from periphery settlements and, to some extent, with other capital centers, both neighboring and distant. Chemical and mineralogical research combined with data on figurine matches indicates that figurine exchange spheres were implicated in regional relationships between capital centers (for example, with the circulation of imported figurines) in addition to provincial spheres of interaction between a single capital and its hinterlands (such as the circulation of locally produced figurines). In this sense both centralized and decentralized models of the Late Classic Maya state are supported and likely existed in tension with one another.

I argue that these political economic networks were not just autonomous exchanges but implicate the way in which households were both conceptually and materially tied to capital centers and to each other in the making of community. Political capitals and their associated state ceremonies, festival-fairs, and/or market activities may have been key places where figurines were distributed and exchanged. These centers brought diverse households together, reinforcing political obligations and social ties among households. The figurines themselves may have served as tokens of people's experiences in the market, in the public plaza, or on roads to and from the ceremonial center. Despite the power of such nodal centers to influence these social relations, such exchanges were not entirely top-down. For example, production and exchange of the figurines do not appear to have been rigidly controlled by political elites or undertaken in state-run workshops. As detailed in chapter 6, households also incorporated the figurines into their own localized experiences as they

became a regular part of household visual culture, ritual, entertainment, and play.

Not all figurines, however, were treated equally. Finely modeled, non-music producing-figurines were rare and may have been part of prestige-building relations on a more intimate level than the simpler molded figurines. They parallel stone sculptures and polychrome pottery in their focus on male elite and divine bodies as the principal subject matter, which suggests that the artisans who produced them were trained in the same aesthetic traditions or held similar social values as those who produced these other works.

Importantly, the relatively broad distribution patterns of molded figurines found in the Petén, in the Usumacinta River zone, along the Campeche coast, and perhaps in southern Belize and the Alta Verapaz regions were not necessarily evident elsewhere, such as at Copan and in central and northern Belize. In those areas, figurines may have been more instrumental in producing elite or urban social identities than an inclusive community identity of polity or region. These discrepancies point to the variability of political economic structures and networks throughout the Maya area, such as the "dual economies" models described by Vernon Scarborough and Fred Valdez (2009). While Maya scholars never conceived of the Late Classic Maya world as being a unitary, all-encompassing state, figurine political economies help shape our understanding of the relationships within and between polities as understood from a popular level of participation (or lack thereof).

FIGURATIVE PERFORMANCES

Perhaps more than other types of visual media, figurines are character-ized by a remarkable flexibility of meaning in that they are small and extremely portable and thus can be arranged, rearranged, and divorced from other objects (including other figurines), spaces, and people whose interactions indexically create signification. This chapter more closely examines how small figurative representations come to life as part of diverse social practices,[1] thus underscoring the critical role of mimetic images as a process and a component of lived experience. I argue that the performative nature of Late Classic Maya figurines is best characterized by their informality: they probably "worked" as both ritual and playful media and in a range of social contexts where their meanings and roles may have shifted. For example, in addition to activities in and around the household, figurines may have been a part of large-scale ceremonies and social gatherings where their visual efficacy was less important than their auditory capabilities. Moreover, multiple social groups, including women and children, had access to figurines and perhaps directly manipu-lated them. This relative informality and flexibility in their use provides a critical vantage point for thinking about Maya society as creatively produced and multiauthored. As such, they bring into focus the power of the ordinary in the shaping of state and household.

RITUAL, ENTERTAINMENT, AND PLAY

One of the enduring questions of figurine studies is what their "func-tion" was. Figurines from throughout Mesoamerica and beyond are often asserted or assumed to have been either toys (e.g., Ruscheinsky 2003; Spence 2002; Winter 2002: 69) or ritual items (e.g., Hendon 2003; Marcus

1996, 1998b, 2009; Moholy-Nagy 2003; Schlosser 1978; Stockett 2007: 100–101). The question of a single function has always been a source of dissatisfaction, however, partly because the notion of function often entails a means to an end and a behavioral endeavor that is transposable (a figurine in one context is used and has the same meaning as a figurine in any other context). The diversity of figurine forms, even those from the same period and cultural region (as discussed in chapter 5), suggests that a single function cannot be attributed to all small figurative forms made of clay (see also Blomster 2002: 171; Hendon 2010; Lesure 2011). Furthermore, such conflating practices ignore how objects take on different meanings and uses as a component of human practice. As Victor Turner (1982: 23) observes, "When symbols are rigidified into logical operators and subordinated to implicit syntax-like rules by some of our modern investigators, those of us who take them too seriously become blind to the creative or innovative potential of symbols as factors in human action." The large range of contexts in which archaeologists have recovered figurines suggests that "human actions" incorporating these small figurative objects cross-cut elements of ritual, entertainment, and play.

Thus far my attention to figurine deposition contexts as cues to figurative performances has concentrated primarily on either broad regional categories (such as sites or geographic regions) or household contexts, with attention to social status affiliations. Indeed primary and secondary refuse contexts from residential zones are the most common loci for the recovery of figurines (figs. 6.1, 6.2, 6.3; appendices 5.1, 5.2) (Ashmore 2007; Hendon 2003; Inomata 1995: fig. 7.14; Ivic de Monterroso 2002; Moholy-Nagy 2003; Triadan 2007; Willey 1972, 1978). As mentioned earlier, discarded locations do not necessarily represent "original" use contexts. Nonetheless, midden locations help provide some parameters for the *general* locations where they may have been visible or audible and who had access to such objects. On another level, their discard with other household trash remains *was* part of their use lives and speaks to the relative value of these small figurative works in comparison to carefully cached, inherited, and curated items, such as Annette Weiner's (1985, 1992) inalienable possessions. To augment this focus, I explore rare in situ evidence from households of rapidly abandoned sites, caches, burials, caves, and public architectural spaces. With the exception of burials from the island of Jaina, it is striking that figurines are such infrequent components of cache and burial contexts.

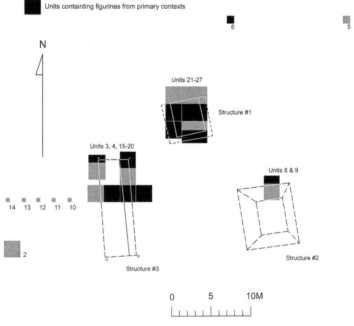

FIGURE 6.1. *Rank 3 architectural group from Chäkokot, a small farming village east of Motul de San José, showing* (above) *simple architectural foundation of Group E2C's Structure 1 and* (below) *the distribution of figurines from primary midden contexts (units with figurines highlighted in black) at Group E2C (photo and plan by author).*

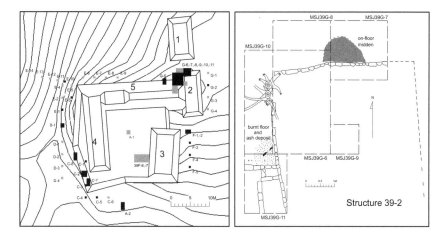

FIGURE 6.2. *Rank 2 architectural group (10M3; Op. 39) from Motul de San José's Northern Periphery, showing (left) the distribution of figurines from midden contexts (units with figurines highlighted in black) and (right) detail of Structure 39-2, showing excavated architecture and on-floor midden (shaded) containing broken ceramic figurines and domestic debris (plans by author).*

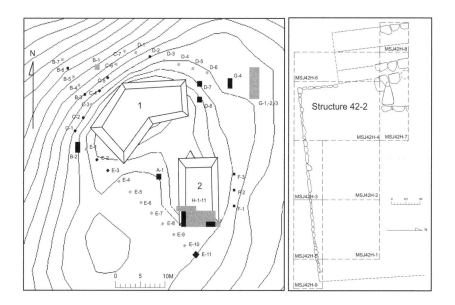

FIGURE 6.3. *Rank 3 architectural group (11N2; Op. 42) from Motul de San José's Northern Periphery, showing (left) the distribution of figurines from midden contexts (units with figurines highlighted in black) and (right) detail of Structure 42-2, showing excavated architecture (plans by author).*

Locating Figurines within the Household

Investigations of rapidly abandoned sites have uncovered figurines in their original contexts of use or storage. These finds indicate that figurines were displayed, handled, or kept within both "ritual" and "nonritual" rooms or zones of household compounds. At the site of Cerén in El Salvador, a volcanic eruption around 650 CE caused the abrupt abandonment of the community and the burial of complete artifact assemblages and architecture below 6 m of ash. Four ceramic figurines and a single carved bone figurine were found in these commoner households (Brown et al. 2002: 84). The figurines did not possess musical or sound-making capacities. The bone figurine was found in a household *bodega* (storage area). One of the ceramic figurines was recovered from the rafters in Household 1, which was also a zone for storing items. Another figurine was recovered in a midden behind the household's sweat bath. The remaining two figurines (an anthropomorphic female and an animal head) were found in Structure 12 of Household 1, interpreted as a ceremonial building used for divination, possibly by a female ritual specialist (Sheets 2006: 101–107). They were accompanied by half a ceramic double ring, shell fragments, and a small pile of beans within a niche inside the structure (Brown et al. 2002: 90; Sheets 2006: 105, fig. 7-3). As one might expect, a strict distinction of ritual and nonritual space is blurred in these households, as indicated by other artifacts, such as a ceramic vessel used for burning incense and a ladle-handled effigy *incensario*, which were located in each of the domestic buildings but absent from the ceremonial structure (Brown et al. 2002: 83–84).

The recovery of a figurine in a midden behind the sweat bath from Cerén is particularly noteworthy in that excavations of sweat baths elsewhere have also yielded figurines and may point to their role in curing rituals.[2] As noted, these architectural features were used for cleansing, birthing, and healing (Alcina Franch et al. 1982; Houston 1996; Sheets 2006: 96–100). The Proyecto Arqueológico Piedras Negras, for example, excavated 221 figurine fragments from sweat baths. These figurines include Early Classic "flat Mexican" types, old women, bound (tied) figures, dwarves, and animals (such as frogs, jaguars, rabbits, and birds) (Ivic de Monterroso 2002: 558). Outside the Maya area, figurines have also been found inside domestic sweat baths, such as the Early Postclassic UA-1 household from the site of Cholula, Mexico (McCafferty 2007: 224–225).

Investigations by Inomata, Triadan, and their colleagues at the site of Aguateca in Petén, Guatemala, recovered large quantities of figurines (Inomata 1995; Inomata and Stiver 1998; Inomata et al. 2002: 313, figs. 7, 9; Triadan 2007). Many of the early ninth century elite residents rapidly abandoned the site, leaving their household artifact assemblages in situ. In some cases figurines were excavated from what have been considered storage and food preparation areas: the northern room of Structure M8-4 (Inomata et al. 2002: 313–316) and the south and north additions of Structure M8-10, the House of the Scribe (fig. 6.4) (Inomata 1995: 682–685, fig. 8.3).[3] In Structure M7-35, most in situ figurines were found in the East Room, a zone designated as a sleeping area (Inomata 1995: 693, fig. 8.51). Figurines derive not only from in situ and midden contexts from elite residences and their auxiliary structures but also from a possible communal feasting platform, M7–34 (Triadan 2007: 279–285) and a small shrine, M8-17 (Inomata 1995: 697–698).[4] Like figurine collections elsewhere, the majority of the figurines were molded whistles or ocarinas (Triadan 2007: table 2).

Beyond figurines' diverse distribution patterns in middens, storage rooms, sleeping areas, and specialized ritual contexts, Triadan (2007: 285)

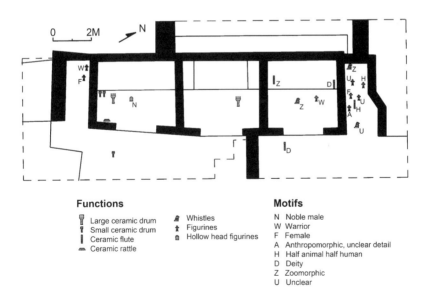

Functions

🥁 Large ceramic drum		🎎 Whistles	N Noble male
🎺 Small ceramic drum		⚱ Figurines	W Warrior
‖ Ceramic flute		🏺 Hollow head figurines	F Female
➰ Ceramic rattle			A Anthropomorphic, unclear detail
			H Half animal half human
			D Deity
			Z Zoomorphic
			U Unclear

Motifs

FIGURE 6.4. *Plan map of elite residence (M8-10) from the site of Aguateca showing locations of in situ figurines (drawing by author after Inomata 1995: fig. 8.3).*

makes two important contextual observations. First, figurines were found in the same recovery contexts as other musical instruments, such as turtle carapaces, ceramic drums, and bone rasps (ibid.: 285), suggesting that they were associated with other objects used in musical performances (a point to which I will return below). Second, multiple complete figurines (unbroken at the time of abandonment) were found in each household. The figurine collections of each household (between four and thirty-seven figurines per household) included diverse figurine imagery as identified by the following categories: male, female, animal, supernatural, grotesque, indeterminate anthropomorph, and indeterminate (Triadan 2007: fig. 13). As a result, Triadan (ibid.: 288–289) has suggested that the figurines were meant to relate to one another as part of a larger narrative and/or to be arranged as part of a larger group. Alternatively, their numerical frequency per household may suggest that multiple household members could have engaged with figurines at the same time.

Similar to the Cerén and Aguateca finds, excavations by William Folan et al. (2001: 245–246; Ruiz Guzmán et al. 1999) excavated figurines from both domestic and ritual zones of the major pyramid groups at Calakmul. They recovered 80 percent of the collection (734 figurine-ocarinas, figurine-whistles, and effigy flutes) from the largest pyramid complex at the site, Structure II (55 m in height with a 140-meter square base). One-fourth of the collection was found from on-floor contexts in the rooms and on the stairways of the complex. Last occupied during the Terminal Classic period, Structure II was a tiered acropolis where craft production and culinary activities were conducted on the lower tiers and elite residential and ritual activities were centered on the middle and upper tiers (fig. 6.5). The figurines cross-cut these contexts: they were recovered from the lower tiers, the middle royal palatial zone (Structure IIB), and along the edges of the uppermost temple stairway, but not on the temple platform or in the temple itself (Structure IIA). Ceramic figurines have not been found in situ in temple contexts reported elsewhere, so it is clear that this pattern was not specific just to Calakmul. While Structure II served as a royal court during the Terminal Classic period, it was also associated with a number of stela monuments and held important public functions. These distributions suggest that while figurines were part of the activities of the royal court, if not the more public ceremonies focusing on the court, they were not considered potent material symbols to be cared for and housed in the temple sanctuaries of patron gods and ancestors.

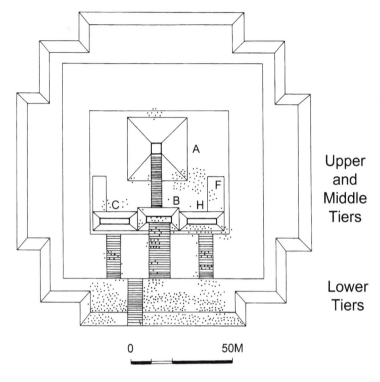

FIGURE 6.5. *Distribution pattern of figurines (includes ocarinas, whistles, and flutes; marked by dots on map) from Structure II, Calakmul (plan by Luis F. Luin after Folan et al. 2001: fig. 8.12).*

Burials

Burial data also provide evidence for the plurality of social groups associated with ceramic figurines. They are found in burials of adult males, juveniles, children, and, in particular, adult females. The assumption is that the interred individuals used, owned, or were somehow related to the item(s) placed in the burial, although this may not have always been the case, as burial goods may have also been tokens of mourners and family members of the deceased.

The most famous burials with figurines are those from the island of Jaina (Corson 1976; Piña Chán 1968, 1996, 2001 [1948]). These include both finely modeled specimens and molded figurine ocarinas, whistles, and rattles. Piña Chán's (2001 [1948]) burial report indicates that figurines were

placed more frequently in women's and children's burials than in those of men (appendix 6.1). Piña Chán used the terminology of "ídolo" (idol), "idolillo" (little idol), "figurilla" (figurine), and "silbato zoomorfo" (zoomorphic whistle) to refer to figurines and did not correlate iconography with particular burials. Nevertheless, zoomorphic figurine-whistles were mentioned only in reference to burials of children (Entierros 12, 52, 22, 30, 32; see also the discussion in chapter 5). Not surprisingly, burials with larger quantities of nonfigurine grave goods (such as ceramic vessels, ear spools, and other ornaments) also possessed multiple figurines (Entierros 58, 61, 71). Unfortunately, this report only provides a small sample of total burials excavated from the site, and other reports divorce the figurine imagery/type data from the burial contexts.

Outside the site of Jaina, the placement of figurines in burials is rare. For example, not a single Classic period figurine has been recovered from burials at sites where figurines are well documented, such as Aguateca (Inomata 1995; Triadan 2007), Altar de Sacrificios (Willey 1972), and Tikal (Laporte 2008). A single child burial is reported with a figurine whistle from Seibal (Welsh 1988: 324). At Motul de San José, none of the seven burials at the site contained figurines. An adult burial (Burial 7) of unidentified sex from the nearby center of Trinidad contained two broken figurine heads, although the burial was surrounded by a large ceremonial refuse midden discussed below, so it is unclear whether the figurines were midden materials or grave goods. Likewise, none of the figurines from Pook's Hill, San Clemente, Ixlú, Nixtun Ch'ich', or Zacpetén are reported as coming from burials.

A number of notable exceptions do occur, however. Hendon (1991, 2003) recorded the presence of figurines in burials of both adults and children from excavations at Copan Groups 9N-8, 9M-22, and 9M-24. As discussed in chapter 5, figurines may have been treated as prestige goods or been available primarily among elite social circles at Copan. Figurines have been found in the burials of elite females at Palenque (finely modeled figurines), Yaxuná (a rare slipped and painted Early Classic figurine with Teotihuacan stylistic traits), and Pacbitun (molded figurine-ocarinas) (Ardren 2002: 81–85; Healy 1988; López Bravo 2000). Despite their placement within female burials in these cases, Burial 39 from El Perú included the remains of a royal male individual (Freidel et al. 2010). As noted earlier, this early seventh century tomb contained twenty-three finely modeled ceramic figurines (Type 4) arranged in a scene and placed

alongside a suite of other luxury goods. Most of them were finely modeled and painted.

In addition to the Jaina examples, figurines occur in Late Classic child burials in other regions. At the site of San Jose, Belize, five child burials (B8, B11, B21, A11, C12; 31 percent of child burials; 10 percent of total burials) contained one or more Late or Terminal Classic figurines (Thompson 1939a: 156, 218–219). A burial of a child approximately ten years old (Burial 23) below a floor in the royal palace at Holmul (Group III) contained thirty *Pomacea* shells and six figurines, some of which were in fragmentary condition. A complete ballplayer figurine-ocarina was recovered at the head of the burial, and the remaining figurines (including a fragmentary molded ruler, a molded elderly figure, and a modeled effigy flute of an anthropomorphic male figure with an elongated cranium) were clustered in a pile at the feet of the burial (figs. 6.6, 6.7) (Mongelluzzo 2011: 121–122). Four figurine-ocarinas and a finely modeled figurine without musical capacity were also placed in a child burial at Cancuén (Sears 2007; Sears et al. 2004).

FIGURE 6.6. *Burial 23, Holmul, Guatemala, with location of figurines marked by black ellipses (image courtesy of the Holmul Archaeological Project; burial photo taken by Ryan Mongelluzzo).*

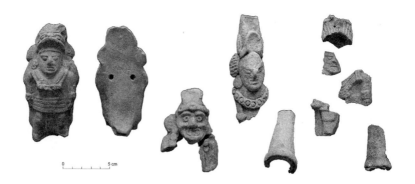

FIGURE 6.7. *Figurines from Burial 23, Holmul, Guatemala (courtesy of the Holmul Archaeological Project; photos by author).*

Caches

In addition to their relative absence from burials, Late Classic Maya ceramic figurines were not commonly placed as offerings in dedicatory caches. Rather, Classic Maya caches, sometimes consisting of unslipped lip-to-lip ceramic vessels, tend to include sculpted stone and shell figures (for example, abstract standing figures with their arms on their stomachs), chert or obsidian eccentrics and flakes, and faunal and botanical remains (Coe 1959; Mock 1998; Thompson 1939a: 184–192). Some exceptions include a deposit of twenty-six molded and modeled figurines found sprinkled with specular hematite in a chultun (underground pit) in the central area of Tikal (Moholy-Nagy 2003: 100). Interestingly, none of the figurines were complete. Small deity heads of unfired clay also have been recovered from early Late Classic structure caches at Tikal (Moholy-Nagy 2003: 97–98). A single bird figurine was found in the center of a circular arrangement of stones from a household at the site of Cancuén (Sears et al. 2004: 774). As noted in chapter 4, groupings of figurines were deposited as offerings at the site of Tulipán (with human remains) and Tierra Nueva (placed between two vessels and deposited below a floor) (Gallegos Gómora n.d.; Piña Chán and Navarrete 1967: 30–31). At Saturday Creek, a small provincial center in central Belize, commoner and elite inhabitants of the site deposited figurine fragments among other objects (e.g., marine shell, obsidian blades, mammalian fauna remains) in building dedication caches (Lucero 2003: table 3).

A ruler figurine with a War Serpent headdress and with a chemical

paste signature similar to ceramics from Tikal was recovered at Motul de San José from below the humus and just above the fill level on a stela platform in front of one of the most prominent temples at the site: an eastern twin temple at the eastern edge of the site's Plaza I (fig. 1.2). While excavators did not report the find as part of a cache, its complete nature, nonlocal origin, and location in front of a stela and large, public building may indicate that it had been intended as an offering. This find is similar to the recovery of a figurine head (broken off from its body) with a similar fan-shaped feathered headdress (and two prismatic obsidian blades) near the plaza surface between the butt of Stela 6 and its altar at the site of Xutilha, Guatemala (Satterthwaite 1961: 181, fig. 73). It is possible that these two examples were not meant as formal dedicatory offerings of the monuments but as informal offerings placed after monument erection.

Caves

Some cave investigations in the Maya area have also recovered figurines, testifying to their use as a component of cave-related rituals. These include caves in the Petexbatún region of Guatemala (Brady 1990a: 337, 348, figs. 17.7, 17.9, 17.10, 17.11; 1990b: 458, 461, fig. 22.9; Ishihara 2007) and in Belize (Brady 1989: 252–253, figs. 6.1, 6.2; Pendergast 1971: 74; Peterson 2006: 130–131; Prufer 2002: 278, fig. 8.14b; Prufer et al. 2003). Like most ceramic vessels recovered from cave contexts, figurines are found in fragmentary conditions and are often unreconstructible. Reiko Ishihara-Brito (2008) documents large quantities of broken figurine-ocarinas and other instruments (ceramic flutes and bone rasps) from the *grieta* bisecting the site of Aguateca. She suggests that the instruments were played as part of rain-calling ceremonies focused on a small hill in the cave where air currents push cold air upward to form clouds of mist. Other evidence of ritual activity in this location includes the caching of vessels, the burning of offerings, and the interment of human remains (ibid.: 175).

One cave site, Cueva de los Quetzales, in Petén, Guatemala, contained a ceremonial refuse deposit that included fifty-one whole or fragmentary figurine-ocarinas (fig. 6.8) (Brady 1997; Brady and Rodas 1995). The deposit (approximately 10 × 4 × 3 m deep) was located at the bottom of a shaft or chimney-shaped entrance to the cave that opens to the central plaza of the site of Las Pacayas. Due to the location of the cave and the position of the midden within the cave, James Brady and Irma Rodas (1995) argued that the objects from the deposit were used in a public context outside the cave before being dropped down the cave's chimney-shaped entrance.

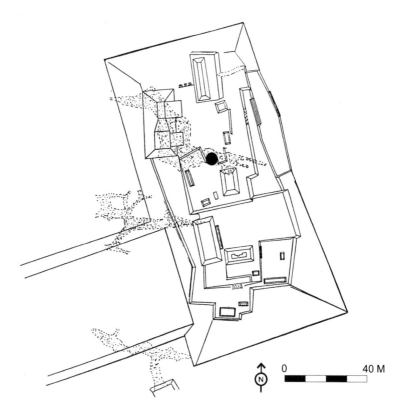

● Location of sinkhole cave entrance where large ceremonial midden
was encountered

FIGURE 6.8. *Plan map of Las Pacayas, showing the location of the cave, Cueva de los Quetzales, and the location of the ceremonial deposit at its sinkhole entrance (after Brady 1997: fig. 8).*

In addition to the figurine-ocarinas, the midden contained a bone rasp, turtle shells (perhaps used as drums), over three hundred ceramic drum sherds, over one hundred modeled or appliqué *incensario* sherds, and both utilitarian and elaborate serving vessels (Brady and Rodas 1995: 20–21, 24). While this ceremonial refuse deposit provides evidence for discard rather than use contexts, it alludes to the possibility of figurine-ocarina use alongside other large-scale ceremonial activities, similar to the Aguateca household finds (reported by Triadan 2007).

Public Ceremonial Zones of Centers

The Cueva de los Quetzales ceremonial deposit has a number of parallels with public ceremonial zones elsewhere. At the site of Trinidad, 169 of the figurines (49 percent) recovered from the site were found in the more public architectural Groups A, F, and E (fig. 6.9). Of these figurines, 155 derive from a ceremonial deposit located behind the site's ball court (Moriarty and Foias 2006). They consisted primarily of figurine-ocarinas. While these primary middens contained a variety of materials, including items often considered "domestic" (for example, spindle whorls, lithic

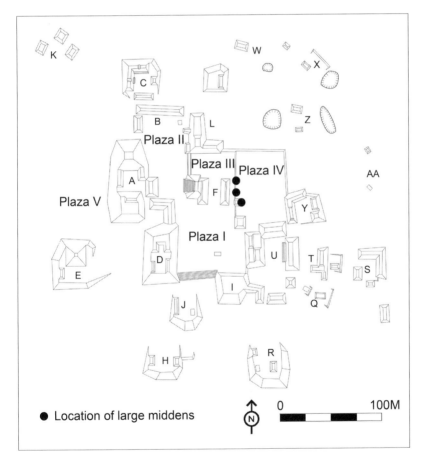

FIGURE 6.9. *Plan map of the ceremonial core of Trinidad, showing the location of the ceremonial refuse deposits containing ceramic figurine-ocarinas and other musical instruments (after Moriarty 2012: fig. 7.1).*

production debris, and groundstone tools), it also featured rarer artifacts used for performances, such as fourteen ceramic drums, three bone rasps, and possible censers. In addition, the unusually high percentage of serving vessels (82.1 percent of all ceramic rim sherds) from the deposit has led Matthew Moriarty and Antonia Foias (2006: 5–6) to suggest that the refuse was related to feasting that may have occurred in conjunction with the ball game.

Susanna Ekholm (1979a, 1979b, 1985, 1990) reported a massive ceremonial deposit containing figurines (some of which are figurine-pendants and figurine-whistles) at the site of Lagartero. She has suggested that the materials were deposited during a single episode for a period-ending ceremony. This interpretation is due to the deposit's lack of stratigraphy, its location at the edge of a large pyramid structure (Mound 7a) in the central plaza of the site, and its overall contents, which included a homogeneous collection of polychrome serving vessels, bone implements, groundstone tools, chert, and other musical instruments such as drums and flutes decorated with skeletal figures (Ekholm 1990: 455). In addition to this deposit, excavations of the site's ball court recovered large numbers of figurines, figurine-pendants, and figurine-whistles (n = 815) (Rivero Torres 2002). Likewise, figurines have been reported in and around all three ball courts excavated at the site of Lubaantun (Wegars 1977: fig. 2a).

Robert Rands and Barbara Rands (1965: 558) also note an abundance of figurines found in middens around the public temple and plaza areas. Ceramic figurine-ocarinas and figurine-whistles also were found on the plaza surfaces and plaza-facing staircases of the Main Plaza group at Las Canoas, Honduras (Stockett 2007: 98–101). Not only were they accompanied by *incensarios*, but they occurred in greater frequencies in this public ceremonial zone than in any other context at the site. Although most plaza spaces are swept clean of artifacts and bear few residues of activities (but see Dahlin et al. 2007; Dahlin et al. 2010), these ceremonial midden deposits allude to some public roles for these small objects.

RETHINKING DIVIDES BETWEEN RITUAL AND PLAY

While ritual is characterized by formality, the setting-apart and methodical ordering of particular practices (Bell 1992, 1997), play is "free from external constraints, where any combination of variable can be 'played' with" (Turner 1982: 34). In functionalist terms, ritual is a means to produce some type of effect, while play does not always require an objective

(Turner 1982: 34). Although the line between ritual and play is often starkly drawn, particularly in contemporary Western societies, such a division can be problematic for a number of reasons. First, ritual can share many qualities of play when examined through the lens of performance (e.g., the experience of disorder, antistructure). Second, nonspecialists also participate in ritual. As marginal participants or onlookers, they may contribute to, or alternatively disrupt, the formality of ritual by priests and shamans and other specialists. While their participation may not be described as "play," neither is it easily recognized as part of the formal components of ritual. Finally, objects designated for one purpose, meaning, and value can be appropriated by others depending on their context. Late Classic Maya figurines highlight the blurriness of such boundaries.

One of the most striking patterns of Late Classic figurine deposition is their relative absence from caches, burials, and in situ temple locations, whether in household, civic-ceremonial, or cave contexts. Their overwhelming recovery in broken, fragmentary condition may indicate that one of the ways in which figurines "worked" was by ritually breaking or "killing" the pieces during particular episodes within the calendrical or household cycle. In a few examples, the faces of figurines may have been scratched or rubbed out, similar to the way in which monuments are treated (fig. 3.2i, 3.3b). It is interesting that the figurine examples of scratched faces are also of rulers. It must be noted, however, that Late Classic Maya figurines do not exhibit evidence of typical "kill" holes: small circular perforations found on ceramic vessels.[5] Breakage patterns occur in areas where the figurine is structurally weakest (necks, appendages), making it difficult to distinguish whether they were broken by accident or on purpose. In addition, fragmentary remains are not often found together, so few specimens are reconstructible. Instead they are found mixed in with other domestic debris, such as ceramic vessels, chert flakes, and broken obsidian blades.

These deposition contexts may suggest that in general most figurines were not inalienable possessions that were carefully curated and passed down over many generations but were readily available in the market or distributed at regular temporal intervals, such as solar New Year's ceremonies or period-endings of different incremental periods (see chapter 5). It is likely that most figurines were not personal items intimately associated with or "owned" by individuals in the way in which material objects such as ear spools, elaborate painted polychrome vessels, or carved bone tools inscribed with personal names were extensions of personhood and

reciprocally defined an individual's social identity (Dacus 2005; Houston and Taube 1987; Joyce 2003a; Reents-Budet 1994). Diego de Landa's description of idols during the Contact period in Yucatán suggests that some figurative works were indeed considered inalienable while others were less so: "They had some idols of stone, but very few, and others of wood, and carved but of small size but not as many of those of clay. The wooden idols were so much esteemed that they were considered as heirlooms and were [considered] as the most important part of the inherited property" (Tozzer 1941: 110–111). For the Late Classic period, ceramic figurines did not seem to have the status of Contact period wooden "idols." While many of the molded figurine-ocarinas and figurine-whistles appear to have been accessible to children and critical for their socialization, they were not exclusive to children such that they could specifically be called "children's toys" in the modern sense of the term. If they were neither potent objects regularly placed in caches nor exclusively children's toys, what were they?

One avenue to consider is the way in which both children and adult household members engaged in ritual and entertainment within relatively informal settings. As suggested in chapter 4, they may have served as cues for oral narratives. Another possibility is that Late Classic figurines were similar to Hopi *tithu* (also referred to as kachina "dolls"), which are both sacred objects and everyday images found in households in the U.S. Southwest. Kachina impersonators and dancers make painted wooden *tithu* figures and present them to infants (both boys and girls), female children, and adult women during the Powamuya ceremony in February (Teiwes 1991; Wright 1977). These figures are not playthings but bear a portion of the kachina spirit's power. Barton Wright (1977: 6) notes that the *tithu*

> are often spoken of, in the literature, as mnemonic devices but this seems far less likely than that they represent an effort to bring the benefits of association with the kachina supernaturals to the women. Once the doll is presented it is not treated as a toy but rather as a valued possession and is hung from a beam or wall in the house out of harm's way.

The Hopi *tithu* may parallel the Late Classic Maya figurines in their distribution at centralized gatherings for subsequent use within households (see chapter 5), their close association with women and children,

and their imagery, which ties some aspects of public or more formal ceremonies to smaller-scale settings (see chapter 3). The blurring of ritual and play, however, becomes evident not only from the semiotic perspective of interpreting their imagery and the socioeconomic perspective of understanding their material circulation but from the standpoint of auditory experience.

PERFORMANCE AND INCORPORATING
THE FIFTH SENSE: SOUND

Sound is often forgotten in archaeological interpretations of ritual and performance because of its fleeting and largely immaterial nature (cf. Hammond 1972; Healy 1988; Hendon 2010; Houston 2006; Houston and Taube 2000; Rodens 2008). As noted in chapter 5, however, most figurines had the capacity for musical production as ocarinas, whistles, flutes, and other aerophones. Music production as a performative act bridges the sacred and magical qualities of some rituals with entertainment and play. According to performance theorist Richard Schechner (1988 [1977]: 140), entertainment is "the passing of time in play and fun that can be intimately interrelated with the efficacious aspects of ritual and the communicatory aspects of symbolic systems." And as Gregory Bateson (1955) pointed out, the implementation of frames, such as those set off by music, communicates to observers and participants alike the distinction between play and nonplay in the same way that music can define and tap into sacred time.

Cross-culturally, music and dance are a means by which trance, altered states of consciousness, and communion with the supernatural occur. While music is sometimes played to activate or bring forth particular spirits or messages, the combination of image and instrument within a single device (in the case of the figurine-ocarinas, figurine-whistles, and figurine-flutes) may signify an embodied form of animation in which the blowing of air into the figurine body activates it, bringing its representational form to life (Brumfiel and Overholtzer 2009; Houston 2006: 143; Houston et al. 2006: 267; Lopiparo 2006: 160–161). Brian Stross (1998: 32), for example, remarks that blowing, breathing, and spitting are ways in which Maya shamans animate the inanimate. As Alfred Gell (1998) underscored (see chapter 2), it is through such material-human interactions that material objects become imbued with agency.

Musical instruments and dancing are often paired with other sacrificial

objects and ritual offerings, suggesting that they are conceptually related (Houston et al. 2006: 254; Houston and Taube 2000; Reents-Budet 2001: 215). A strong parallel exists between the figurine-ocarinas/flutes and effigy incense burners in which both objects may have summoned the spiritual world using sensory cues. In the Dresden Codex, page 34a depicts a number of offerings that engage the senses in different ways: tamales (taste), incense (smell), a decapitated head (human corporeality?), and the playing of music by a flute, rattle, and double-chambered drum (sound). All may have been considered "food for the gods." Houston and Taube (2000: 261, 263) suggest that the sound of music and the smell of flowers, in particular, were conceptually related as a "synaesthesia" or "cross-modality experience," in which the perception of one sensation may precipitate another. In this sense the material instruments may not have been offerings themselves but rather the noise and music that are produced from them. This shift in focus from object to practice has important implications for archaeology, in which the recovery contexts of artifacts (for example, middens rather than caches) are only one of several indicators for understanding their past roles.

The role of music as an offering or as a route to the supernatural does not preclude its role in entertainment and play. Accounts by Spanish officials during the Contact period indicate that the music played in the homes of rulers did have entertainment value and often accompanied food and drink (Díaz del Castillo 1963: 226–227; Jones 1998: 194). Thus the occasions for music-making may have been sporadic and informal or centered specifically on certain calendrical events, commemorations of household ancestors, and rites of passage. While it is not clear whether figurine-ocarinas or figurine-flutes were employed in any or all of these types of situations (and many others doubtless existed), their dispersed nature across the social landscape suggests that they were played by diverse social groups and for diverse purposes.

ALTERNATIVE "VOICES" IN FESTIVALS AND CEREMONIES

Limited evidence of figurine-ocarinas and figurine-whistles from public plaza contexts and ceremonial deposits suggests that figurines may also have been employed in large-scale settings. I argue that more "marginal" participants, such as common people, women (elite or common), and

perhaps even children produced music (or at least raucous sounds!) during state ceremonies in an informal—albeit active—capacity.

Research on Classic Maya performances by Houston (2006), Inomata (2001a, 2006b), and Looper (2009) indicates that the rulers and other elite figures, usually male, were the principal performers both in the royal court and in larger, more community-wide spectacles and festivals. Inomata (2006b: 206) states that the "importance of public events for the integration of a community implies that the preparation, organization, and execution of such events were primary concerns for Classic Maya elites." This focus on elites relates in part to their dominance within iconographic depictions of such ceremonies as well as to architectural and spatial clues in regard to site lines and visibility (Inomata 2001a, 2006b). Such asymmetrical depictions undermine common people's participation, agency, and roles. As Inomata points out, however, the labor of common people was necessary for creating the public plazas, causeways, and buildings that served as the settings for large-scale performance (Inomata 2006b: 206). In addition, women's labor in processing and cooking feasting items as well as their performative roles during the event, albeit more marginal, were essential to the event's overall success and, in turn, the legitimacy and power of the "leading" participants.

Figurine-ocarinas and figurine-whistles may shed light on the more marginal participants and practices, as they do not appear to have been part of formal musical ensembles. They contrast with other nonperishable musical instruments in that they were more accessible and numerous. Furthermore, figurine-ocarinas are not depicted in iconographic depictions of "official" musicians—even in the figurine imagery itself. Rather, depictions of formal musical ensembles (the most complete of which is painted in Room 1 of the Bonampak murals) consisted of gourd rattle players, *huehuetl* drum players, turtle-shell players, and trumpet players (fig. 3.17d) (Miller 1988).

Thus, if figurine-ocarinas were played during large-scale ceremonies, it is likely that they were not components of official musical ensembles but were part of unfocused interactions. According to Erving Goffman (1963: 24), focused interactions are "the kind of interaction that occurs when persons gather close together and openly cooperate to sustain a single focus of attention," while unfocused interactions are types of communication without a sustained focus of attention and have to "do largely with the management of sheer and mere copresence." The "less-official"

noise and music-making of the figurine-ocarinas and figurine-whistles may have been instigated by more marginal participants (and likewise permitted by the focused performers) in processions, people watching processions, those along the sidelines of ball games, and audience members. The burial and distribution data suggest that they may have included common people, including both adult women and men, and children. Ethnohistoric evidence in fact indicates that large festivals were inclusive affairs in which the entire community participated, including women (Barrera Vásquez 1965: 71–72; Clendinnen 1982: 429; Roys 1972: 28–29, 31).

This distinction between "official," focused music production and informal, unfocused music and noise-making is exemplified in a contemporary festival in Flores, Guatemala. During Las Posadas, held at the beginning of December, people of all ages in the community take part in the ceremonies (fig. 6.10) (singing, handing out food and drink, eating, taking the idols of the baby Jesus, Joseph, and Mary on a procession between residences and through the town; Luis José Hernández González, personal

FIGURE 6.10. *Las Posadas Festival, Flores, Guatemala: (a) typical glazed ceramic figurine-whistles (4.2 × 5.0 cm; 4.2 × 5.6 cm) used by children as part of processional fanfare (note: these figurine-whistles are the same sizes as crudely modeled bird figurine-whistles and figurine-ocarinas dating to the Late Classic period); (b) procession around the town involving adults and children of all ages; (c) marimba band serving as the "official" musical accompaniment (all photographs by author).*

communication 2005–2006; personal observation 2005). A marimba band, representing the "official" musicians during the event, is composed of elderly male members of the community. The marimba is carried and played in the procession and at household stops along the way. Along the sidelines, however, noise is created on a number of levels by children blowing on glazed ceramic zoomorphic whistles, by people talking, and by raucous firecrackers (fig. 6.10a). This example seems to reinforce an association of children with simple zoomorphic ocarinas or whistles, a finding that parallels the Jaina burial data (see chapter 5). Interestingly, a parallel phenomenon occurs in Calkini, Campeche, where small anthropomorphic and zoomorphic effigy whistles, ocarinas, and flutes manufactured in Tepakan are given to children for the Chac Chac and Catholic Semana Santa ceremonies. The children blow on the instruments to petition for rain. If the instruments are broken, they are discarded. Otherwise they are stored in the church (Folan et al. 2001: 245–246).

Despite "focused" attention on leading performers, audience members and marginal performers are not passive participants. Rather, the mood and the efficacy of the performance are co-created by both dominant and marginal figures. John MacAloon (1984: 243) points out that an important part of spectacles are the "bicameral roles of actors and audience, performers and spectators," who both play necessary roles in the overall performance. Music and sound, as "alternative voices," have the capacity to set the tone, stimulate moods, and guide action. Thus the consideration of "unofficial" noise-making by audience members and more marginal participants points to a more dispersed perspective in the production of state power. More "marginal" participants may not have set the structural terms for state performances, but they nonetheless played active, integral roles in their outcomes.

SOME THOUGHTS ON THE ORDINARY AND THE EXTRAORDINARY

It is often assumed that large-scale performances are more effective or powerful than smaller-scale rituals or everyday routines and experiences. But it is not always a question of more, but of how power is enacted. Large-scale rituals such as spectacles, state-sponsored ceremonies, and public sporting events are integral for molding collective consciousness (Durkheim 1965 [1915]). Moreover, these large-scale performances help produce political consensus and conflict. They define or defy political

agendas and dispositions as embodied acts: engaged participation and the sensuous experience of revelry, awe, and grandeur (Foucault 1977; Inomata 2006a; Kertzer 1988; Scott 1990).

Large-scale performances often employ monumental works: large stone sculpture, massive pyramids, sacred and civic buildings, and enormous plazas. These monumental works and their spatial organization help structure people's participation and movements and thus their relations to each other within a hierarchical order (Ashmore and Sabloff 2002; Low 2000). They involve large-scale labor efforts whose material end products can become the source of contestation and control. They also exude a sense of durability, facilitating the repeated citation and memorialization of performances across generations. In this sense mimesis as the repetition of embodied acts may be quite continuous, taken for granted, or habitual.

Informal rituals and everyday practices can also be habitual and taken for granted, but they enact a different form of power that plays on dispersion, flexibility, and diversity. As such, the minutiae of these practices are multiply authored and do not derive from a single source or linear movement (Bourdieu 1977, 1990; De Certeau 1984; Foucault 1977, 1980; Robin 2002). In this sense everyday practices can both defy and reinforce social and political orders produced on a large scale. Through repetition they may produce political subjects and instill social norms as self-evident. Through dispersion and flexibility, however, they may serve as outlets for creativity and as hidden or alternative sources of social reflection and expression. In turn, the material culture of ordinary life, what James Deetz (1977) calls "small things forgotten," is part and parcel of the nondiscursive production of culture while also operating as a powerful source of heterogeneity, subjectivity, and self-determination. Indeed Maya ceramic figurines may have played an important role in the creativity of Classic Maya cultural production. Most people may not have been able to change the content of these images, unlike easily malleable media such as rubber, corn dough, or paper.[6] They could, however, alter their meanings through localized practices and physical arrangements with other figurines or objects. The people who handled figurines, particularly molded figurines, likely were quite diverse.

Everyday practices can also be collective even if they are not orchestrated or hierarchically controlled. As Michel De Certeau (1984) points out, the spatial order of a city is partially created from its buildings, streets, and other material components, which structure the experience of the individuals who inhabit it. Yet these spatial orders are only fully actualized

by the movements of the city dwellers themselves, whose walking and inhabiting are a form of place-making. Instead of succumbing completely to the disciplinary structures of the city, the masses react to and subvert it in the course of these everyday practices. Such collective movements, De Certeau contends, create an urban "text" by authors who do not read it. Figurines may have also been part of collective place-making, as non-specialists and "marginal" participants of large-scale festivities "voiced" their participation through musical fanfare or as multiple households throughout a polity concurrently played, arranged, handled, and stored similar figurines, reproducing creative variations of a common culture.

Collective practices of the ordinary, however, need not always be relegated to the unconscious, as De Certeau asserts. As mimetic representations in diminutive form (copies of the "truly" real, copies of copies, simulacra), figurines have the capacity to disembody, bringing people to reflect on themselves and their world in new ways. For example, the American Barbie doll has become a focal point around which contemporary scholars, feminist groups, parents, and market-driven corporations discuss and renegotiate gender, weight and eating habits, and other social norms. Resistance to or reinvention of particular cultural norms or political orders does not always entail commemorative events, such as open revolt or boycotts, but more often involves the everyday struggle of carving out a place in one's material and social worlds (Scott 1985, 1990).

It is not always clear if, how, where, or when figurines served as sources of social reflection. These moments are often fleeting and without clear material correlates. Some opportunities for reflections and shifts in meaning may have surfaced at junctures in political rule when the imagery and practices related to state pomp and ceremony were questioned: at the transition between the Terminal Classic and Postclassic periods, when figurine production declined significantly (Halperin 2011); between elite figurine "owners" and nonelite figurine "owners" in some places in the Belize Valley or in Copan; or during increased interactions and migrations between figurine-producing Petén polities and non-figurine-producing polities in which the status of the "ordinary" may have been called into question. This focus on regionalism, temporal shifts, and social interaction in figurine studies is a critical avenue for future intellectual inquiry.

COMMENTS ON MAYA STATE
AND HOUSEHOLD

Previous inquiries into ancient complex societies have undermined the notion that states were bounded, unitary entities and place emphasis on the relationships between states and "world systems" as part of broader, shifting interaction spheres. Often lost in these analyses are the links and disjunctures that relate the state, as political leaders, institutions, and the warfare and pageantry that surrounds them, to the state as produced by the varied participants of social life from the humble rural household to the royal court. In focusing on the everyday materials and practices of households, I am confronted with the contradiction of households being both separate from and a part of the state. In examining the state solely in terms of political elites, however, it is often assumed that they were omnipotent, because the effects on and engagement with the rest of society are ignored. At the same time, the exclusive focus on households can often assume that their production and reproduction operated autonomously from the centralized workings and symbolism of the state, even if this may sometimes have been the case. I argue that Late Classic Maya ceramic figurines directly address this contradiction, highlighting the ways in which different households and their diverse constituents related both to each other and to the symbols and claims of high power. As such, they reveal relational perspectives of Maya state religion, social identity, and political economic networks.

MAYA STATE RELIGION

Throughout many regions of the Southern Maya Lowlands, Late Classic households consumed and reflected upon state religious symbols in the form of the royal body. Households, in this sense, were part of the state in actively participating in the visual discourses of political pomp and

ceremony. In both small-scale and large-scale manifestations, representations of the *k'uhul ajaw* or divine lord portrayed the royal body as a pivotal conduit to and mediator with divine realms. Male and female ruler figurines are one of the most common and widespread figurine motifs throughout the Petén, parts of western Belize, the Usumacinta River zone, and western coastal regions of the Southern Maya Lowlands. They reinforce or were in dialog with the most publicly visible commemorations of royal personhood: carved stone monuments and sculpted architectural façades. In their small-scale versions, the heads of state likely were physically handled and reflected upon by diverse households and diverse members of these households, including young adults, the elderly, children, men, women, nonkin members of households, and servants. In some cases Maya ruler figurines exhibit many similarities with those from outside the Maya area, such as Oaxaca and Teotihuacan, highlighting the ways in which symbols of performance and power were closely interrelated on a popular level throughout Mesoamerica in the Classic period.

The connection between royal bodies and divine beings was made explicit through the most potent and socially significant part of the body, the head, which wore a large headdress carrying a deity mask lined with feathers. While stela monuments, lintels, and carved stone panels from the Maya area juxtapose the royal body with supporting historical and divine figures, cosmological symbolism, elaborate accoutrements of war, ritual paraphernalia, and hieroglyphic texts, ceramic figurines rely primarily on the headdress as the focal signifier of royal power. Some exceptions include the presence of shields and weapons and the positioning of rulers on palanquins, litters, or thrones. Nonetheless, all of these portrayals emphasize the royal body as a performer, meant to be seen and experienced in one or many of its manifestations: in human flesh, stone, ceramic, or other media. There is some indication that even the more ubiquitous ceramic molded or partly molded figurines captured the essence of the royal self. It is the ruler figurine type, in particular, in which faces were scratched, perhaps to deanimate the royal person similar to the practice of defacing and rubbing out the face of the *k'uhul ajaw* carved in stone monuments.

The *k'uhul ajaw*, however, was not the only performer of state pomp, acts and reenactments of war, accessions to office, and celebrations of period-endings. Many of the other iconographic figurine motifs serve as reminders that various other social figures participated in such performances. Clothing, ornamentation, objects held, and poses make reference

to ball games, sacrifices, warfare, music, masking, and dancing. Some of these ceremonial and stately events are depicted in the murals from Bonampak, a historic narrative detailing the events of royal accession, tribute presentations, musical processions (Room 1), warfare (Room 2), ceremonial sacrifice, and an elaborate dance scene (Room 3). As others have pointed out, some polychrome vessels, especially Ik' vessels produced in and around Lake Petén Itzá, recall or anticipate many of the same types of historic events. Other polychrome vessel scenes reference mythical narratives, detailing the activities of ancestors, deities, and other supernatural beings as metaphors of, commentaries on, and links to human practices. Due to limitations of pictorial space, these vessel events, both historic and mythic, were often represented through only a few key individuals who stood in for what would have been a larger group of participants. For the figurines, rare cache scenes and in situ household finds from Aguateca indicate that in some cases figurines were placed in groups. When examined in relation to one another, figurines may depict (or enact) a much broader range of protagonists in these historic and mythic performances (a point to which I will return below).

The claims that the royal body was a key mediator with divine realms are further reinforced through the mimetic restriction of deities, especially images of powerful patron deities of royal lineages, such as K'awiil, K'inich Ajaw, Itzamnaaj, Chak, and the Maize god. The figurines of these highly codified deities were both rare and significantly circumscribed to elite residential and ceremonial contexts, distributions that parallel their manifestations in obsidian, jade, bone, shell, carved limestone, and other materials. Such control is played out partly through elite artisan training of and conformity to particular written, artistic, and aesthetic conventions that designated and legitimated how and on what terms deities were portrayed. We see this pattern in many other state societies, such as those in ancient Egypt and the Andes. In some cases the mimetic control over deities accentuates a division between state and household in which such images appeared most explicitly within public ceremonial spaces but were downplayed as a component of household ritual. In other cases, however, the division may have been more deeply felt as a tension between royal households and nonroyal households.

Unlike unitary or more centralized states in other parts of the world, different Late Classic Maya polities (and during different periods) exercised a certain degree of autonomy in their celebrations of deities. Although royal peoples drew from shared traditions of supernatural figures, they

also expressed polity or lineage specific linkages to divine ancestors and drew on localized variations of divine beings, such as triads of deities (e.g., GI [Chak Xib Chaak], GII [K'awiil], and GIII [K'inich Ajaw, Jaguar God of the Underworld]) or pairs of deities (for example, the paddler gods) (Houston and Stuart 1996). Such variability speaks to the relative autonomy that some royal lineages exercised in communing with the divine. The paucity of ceramic figurines that directly invoke many of these patron deities indicates that popular household media in general did not weigh in on how these political and religious particulars were played out, emphasizing, in this case, households as separate from the state.

At the same time, figurines may reference supernatural beings rarely portrayed in large-scale media. For example, a small number of females in both figurines and ceramic vessels portray the elderly Chak Chel (Goddess O) and the Moon goddess. In more official venues, the preference for depicting sacred (k'uh) bodies was overwhelmingly in the male form. Despite this eschewal of divine female bodies in monuments, female ancestors are commonly referenced in texts recounting the historical and sacred foundations of rule. Some royal women on stelae impersonate the Moon goddess/Maize god through the donning of jade beaded skirts, and these same women possess the titles and are shown holding the accoutrements of political and religious power in ways similar to their royal male counterparts. Thus the female body held a contradictory status as marginalized in divine form yet divinely sanctioned to partake in royal prerogatives. One must also keep in mind that such valuations vary over time and space. During the Postclassic period, for example, some female deities took on prominent roles within murals from sites in eastern Yucatán and as the focus of devotion (Chak Chel or Ix Chel) at Cozumel.

While some highly codified deities do appear as the subjects of ceramic figurines, emphasis was placed on a more informal grotesque or exaggerated supernatural body: Fat Men, dwarves, monkey-like beings, and those invoking death, old age, and excessive corpulence. These figures likely referenced popular trickster figures, ritual clowns, underworld beings, and *way* figures that formed part of household rituals, play, and oral narratives recounted in these realms. Their popularity extended beyond the Maya area: some figures, such as the Fat Man, were also common figurine motifs among Classic period peoples on the Gulf Coast and in the Basin of Mexico. These figures, however, were not just "matter out of place" (Douglas 1966), static metaphors of disorder used to understand proper social orders and mores. They have a transformative capacity in

being critical components of change. As Taube and Taube (2009) point out, they held important discursive roles, stimulating social commentary and reflection, sometimes in ironic and potentially humorous ways.

These grotesque figures directly speak to the ongoing tensions of state and household: they occasionally were sanctioned participants in state ceremonialism, and yet they also may have critiqued political officials and cultural norms, providing space for alternative, popular expressions. Late Classic Maya political elites drew on the power of the dwarf, in particular, during key moments of instability and transition, such as k'atun or half k'atun period-ending ceremonies and New Year's ceremonies. Grotesque figures, underworld beings, and animal hybrids also likely came alive during public performances, as both polychrome pottery and figurines reference these grotesque and ulterior figures in performative capacities: as masks of human performers, in acts of sacrifice/violence, in dancing poses, holding fans, and in close interaction with musicians. In societies across the globe, sanctioned ritualized acts of rebellion and social deviance are not necessarily a threat to a society's social fabric but a reaffirmation of the practices and moral values that those rituals seem to challenge (Bergesen 1984; Gluckman 1965). Political and religious authorities may not only tolerate subversive acts and symbols but may fully embrace them as a form of contrast to promote an aura of stability and order.

Yet the ceramic figurines also provide an alternative perspective to the state-sanctioned ritual clown by underscoring how such figures thrived as components in household oral narratives, play, and ritual performances. In describing the grotesque-masked and animal-masked figures at the bottom registrar of Room 1 of the Bonampak murals, Miller (1988: 325) noted that these characters (fig. 3.17d) were not "very important" to the overall scene of pomp and ceremony related to kingly accession. In contrast, Fat Men, dwarves, monkey-like beings, and other grotesque entities were highly celebrated among the visual culture of households across the Southern Maya Lowlands. In fact we find the most variation and complexity in their depictions in the figurines and ceramic vessels, indicating that these characters flourished in household settings. Such variability parallels the rich ethnographic Maya descriptions of ritual clowns and trickster characters whose playful improvisations and deviations are often difficult to pin down.

Thus, despite the incorporation of select grotesque figures into public transcripts, these figures also had a life of their own outside this realm. Their potential contradictory status as reinforcing state structures while

also serving as the mechanisms to undercut those structures underscores the lived dynamics of material culture as it shapes and is shaped by those who engage with it. In this sense they make room for a certain degree of ambivalence that is not as easily recognized in elite canons of artistic expression.

SOCIAL RELATIONS

Scholars have long commented on the role of ceramic figurines from different cultural areas and periods in showcasing female identities and perspectives. Late Classic Maya figurines provide a diversity of feminine characters, which derived from and helped reproduce female social ideals related to ritual, social and biological reproduction, and political life. In addition, they shed light on the practices and representations of the elderly, children, and infants, who are less commonly portrayed in monumental media. Such identities, however, are better viewed as a series of relations that are negotiated through material objects such as figurative representations and in multiple, sometimes conflicting, social spaces.

One way to conceive of these relations is through the possible juxtaposition of social identities portrayed in the figurines themselves. Male and female figurines, for example, are often linked through similar headdresses or objects that they hold and wear, such as cotton necklaces or mirrors, perhaps indicating that gendered relations were strongly tied to social status and in some cases joint male and female ritual participation (see also Joyce 1996, 2000a for a discussion of rare examples of paired male and female monuments). Such linkages are then cross-cut by the portrayal of specific gendered roles, such as masculine associations with music and masking and feminine associations with the offering, serving, and selling of food.

Another way to think about social relations is in the comparison of large-scale and small-scale media, such as monuments and figurines. These contrasts emphasize differences and overlaps between "official" state media targeted toward large audiences and artistic productions most easily seen (but not necessarily played or heard) in small-scale settings, such as households or small social gatherings elsewhere. In many cases the subject matters of figurines and monuments are not radically different. The figurines offer a more amplified perspective on the same types of events invoked in monuments. Such a vantage point focuses on a broader cast of participating characters, such as musicians, female performers and

audience members, ritual clowns, and masked male figures or imperson-
ators. In this sense the narrative lens is widened.

Figurines as well as painted media, however, also highlight altogether
different events, identities, and social relations that are ignored within
monumental discourses. Rosemary Joyce (1993, 2000a) has suggested previ-
ously that female identities are played out as a series of tensions between
royal and noble households: royal houses emphasized joint male and
female ritual participation in monumental media, while noble house-
holds recognized women's labor, such as weaving and grinding corn,
as depicted in ceramic figurines. "Figurines made women's production
a topic for social reflection, a permanent commemoration of fleeting
action" (Joyce 2000a: 89). Despite the relatively few examples of female
weaver or female corn-grinding figurines known in the archaeological
record, ceramic figurines did indeed help celebrate a greater diversity of
women's social roles than was seen in other media.

Among many figurine collections from Petén, Guatemala, the principal
paradigm competing with the ruler headdress was the broad-brimmed
hat. Although both men and women wear the broad-brimmed hat in
other media, females almost exclusively wear these hats in figurines. The
broad-brimmed hat as a signifier for and embodiment of social identity
made reference to either elite or common people and their activities in
public market exchanges, ceremonial occasions, pilgrimages, and daily
travel. The juxtaposition of the ruler headdress and broad-brimmed hat
underscores two popular sources of social commentary tied to social and
economic networking: one was officially sanctioned and supported by
institutionalized linkages, and the other was formed through more unoffi-
cial channels that included both kin and nonkin connections (for example,
the market woman who meets and negotiates with people from near and
far or the woman who travels back and forth from her natal village to her
husband's village, creating alliances between distinct social groups). In this
case the tension is not so much between household production and the
state but between two different perspectives on how social capital (who
the individual knows as a linked component of socioeconomic power)
was acquired in ancient Maya society.

As emphasized earlier, Maya sociality should not be conceived of apart
from animal and supernatural forms. In both contemporary and more
ancient narratives, such as the eighteenth-century Popol Vuh and its
earlier manifestations in visual media, animal and supernatural characters
occur alongside and in interaction with those with anthropomorphic

features. Moreover, spiritual connections with animal and supernatural beings formed a social sense of personhood and structured relations between people. Late Classic Maya figurine imagery explicitly invoked these connections in depictions of masking, impersonation, and hybrid or blurred anthropomorphic-supernatural, anthropomorphic-zoomorphic, and supernatural-zoomorphic bodily forms. In these instances men are predominately shown engaged in such spiritual transformations, a finding that is at odds with ethnographic and ethnohistoric data detailing both male and female abilities to transform into spiritual co-essences and zoomorphic beings.

It may be useful to think about ways of interacting with spiritual realms other than through masking or impersonation. For example, human-animal relations may transpire through other forms of communication: the receiving of omens or messages to gain spiritual insight, a theme that might be highlighted in the depictions of female figurines with birds. Birds are a common animal form among molded (Type 1 and 3) and crudely modeled (Type 2) figurines. Both women and children, in addition to men, may have played with these figurines to communicate with spiritual realms. Likewise, the possible juxtaposition of zoomorphic and supernatural figurines with either male or female figurines also provides for more flexible enactments of human-spiritual entanglements even if only in small figurative form. For example, while scenes with dwarves on monuments, lintels, and ceramic vessels tend to portray these figures in relation to males or male deities, dwarf figurines may have been placed alongside female figurines within household settings. Such juxtapositions disrupt the canonical positioning of dwarf-ruler pairs and of the homosocial male courtly entourage.

As in the bird figurine example mentioned above, it is important not to forget human-material relations in which actual people handled, played with, ritually activated, destroyed, and discarded these small figurative works. I argue that their performance qualities likely followed an informal structure that allowed for creative expression, learning, and reflection. This lack of a rigid structure of engagement is not only based on the portable quality of figurines themselves, which could be arranged and rearranged in multiple combinations and in multiple social spaces. It is also based on archaeological evidence of their discard and placement in and around multiple types of contexts: households, caves, and even large public plazas. In addition, limited burial data suggest that they were associated with a range of social groups, including adult males and females

of different social statuses, the elderly, and children. Given these different contexts of recovery, it is likely that even children had the capacity to situate themselves in relation to durable figurative identities as they and others in their households handled these objects, blew air into their chambers, recounted events, retold myths, created their own stories, and reflected upon their lives.

As an added performance dimension, many Late Classic figurines had the capability to make noise and music, a quality that distinguishes them from many Preclassic and Postclassic ceramic figurines (figurines-whistle and figurines-ocarina also existed during these periods, but alongside the more common non-music-producing figurines). Their auditory dimension allowed them to be projected further than their visual dimension alone. While they appear to have been marginalized from the musical productions of formal musical ensembles (with the exception of effigy flutes and other rare forms), they may have been played within the contexts of households, smaller community gatherings, and even informally in large-scale festive performances. In addition to being used in revelry, entertainment, and celebration, music was an important mechanism for engaging with the spiritual realm and also a ritual offering itself. In this sense women and children, as well as the commonly celebrated male performer, had performative "voices" that may have spoken to spiritual and social realms alike.

POLITICAL ECONOMIC NETWORKS

Figurines were part of political-economic activities that helped form the many overlapping contours of Maya states (households as part of the state). Because the material exchange of figurines tied together households from primary and secondary capitals and these capitals with households from smaller settlements, they were active in the production of political economic regions as much as in the conceptual making of states through representation. These political economic relations implicate not only administrative heads, often the only social groups that are ascribed agency in political economic models, but different types of households across the social landscape. In this sense households and their diverse members dynamically shaped the political economic networks that tied them to each other and to broader political communities.

I argue that ceramic figurine exchanges were centralized at political centers in many parts of the Southern Maya Lowlands and as such

help reveal the intertwined regional relationships of Late Classic polities. Although these regional political economic relationships may not always have coincided with the official boundaries of a polity, they highlight the on-the-ground practices of household members who traveled or were connected with particular political centers, wherein they may have also fulfilled obligations such as labor drafts, the payment of tribute/taxes, or the making of offerings or engaged in commercial, religious, political, or social activities to meet their own needs. In this sense figurines help fill an important void in our understanding of regional politics: their circulation spheres both overlapped with and incorporated a wider social net than the exchange of many prestige goods.

In many parts of the Southern Maya Lowlands, such as in Petén and along the Usumacinta River and western coastal zones, figurine production appears to have been concentrated more at populous centers rather than in small peripheral settlements, even though figurines appear in both contexts. Although better sampling from periphery zones is needed, figurine molds are more commonly found at these larger centers, where elite, middle-status, or commoner households may have produced figurines. Due to aesthetic conventions of shape and form, elite households likely produced many of the elaborate, finely modeled figurines. These patterns contrast with decentralized political economic relationships in the Ulúa and Naco Valleys of Honduras, where substantial evidence of figurine molds and evidence of production is found in more hinterland zones alongside those from major centers. They also contrast with expectations for models of "folk culture," in which rural and commoner populations would be expected to play a larger role in figurine production and exchange. Instead the Maya figurine data more closely parallel the centralized redistribution patterns of Early Nasca polychrome vessels in the Andean region and the market exchange Teotihuacan ceramic figurines in Central Mexico in the Classic period.

Based on paste composition research and matching molded figurines, figurines (or the molds to produce them) were often exchanged broadly and reveal both large regional networks (between polities or within large regional polities) and provincial political economic communities (within smaller polities or between a single center and its outlying settlements). For example, Tikal-produced figurines found in elite, middle-status, and commoner households from the Motul de San José region indicate ties between Tikal and the Motul de San José area and underscore Tikal's emerging regional dominance during the Late Classic period. That the

Motul de San José region possessed its own figurine producers and thus did not need to obtain figurines from the Tikal zone indicates that more was at stake than an efficient means to acquire a product. The spheres of local production and distribution from the Petén Lakes region are suggestive of local Ik' provincial politics, where sites along the western zone of the Lake Petén Itzá were closely tied to each other through regular exchanges and visits. Yet figurine exchanges are silent on other political negotiations, such as those between Motul de San José and the Petexbatún region, which are indicated by polychrome vessel exchanges and written texts (Halperin 2014). While such silences may be due to sampling issues, it is likely that some political alliances and elite maneuvering simply did not have significant repercussions for the political economic relations of a broad range of households in a polity.

These political economic relations, however, were more than just indices of production and exchange relationships. If figurines were exchanged during festival-fairs or during important ceremonial occasions, as I have suggested, they would also have served as tokens of participation at these events and of social experiences in market stalls and plazas as well as historical memories of pilgrimages made to particular centers. In many cases the power of political centers was tied not just to the ability to demand labor and goods but to the ability to attract people through commercial, religious, and other avenues. The experiences at and obligations to these centers were then entangled into the everyday practices of households as the figurines were viewed, played with, and stored in these more intimate domains.

Beyond the making of polities, differences in figurine political economies also point to the disconnect of political, economic, and social relationships. In some regions, for example, figurines (whether finely modeled or molded) were restricted to elite contexts. This is in contrast to the Petén and Usumacinta River regions, where commoner or elite households, whether hinterland or urban, had access to figurines even if urban elite households tended to have more of them. In some cases these differences appear between Maya centers that are geographically quite close and whose dynastic histories were considerably intertwined, such as Quiriguá and Copan. In other areas, such as in and around Xunantunich, figurine patterns follow the patterns of polychrome vessels: both classes of artifacts were relatively rare throughout the region and were found in elite contexts where they did appear. Furthermore, in some regions, such as in some parts of the Northern Maya Lowlands, figurines were not a

significant part of social life, whether elite or common. These differences point to the uneven expressions of ritual, play, and entertainment across the Maya area and provide evidence for regional interaction spheres felt on the level of households.

The contradiction of the concept of the state outlined here stresses the state as both of and separate from households. It exposes the fundamental ways in which social groups of any kind must always contend with a simultaneous likeness and difference, mimesis and alterity, belonging to and exclusion from others. More importantly, the exploration of such contradictions helps us better identify the hinges upon which relationships were forged. The focus on state and household among the Late Classic Maya, for example, brings to light how relationships between rulers and ruled often hinged around conceptions of, performances surrounding, and material control (or lack of control) over different types of supernatural beings. In addition to relationships between rulers and ruled, however, the framework of state and household also underscores regional, gendered, and class or status relationships as they were negotiated in different social realms and in turn helped define those social realms (as polities, communities, households, and so forth). While ideas of the state are often conjured from the realm of the monumental, its more subtle presence among the inconspicuous and the ordinary reveals the complementary role of popular participation and negotiation in the making of the state.

APPENDICES

APPENDIX I.1

Late and Terminal Classic Figurine Counts (Fragmentary and Complete) by Site

SITE	ARCHAEOLOGICAL PROJECT	N
Motul de San José	PAMSJ	2,256
Trinidad	PAMSJ	347
Akte	PAMSJ	7
Buenavista	PAMSJ	62
Chäkokot	PAMSJ	92
Chächäklu'um	PAMSJ	3
Nakum	PROSIAPETEN	423
San Clemente	PROSIAPETEN	341
Naranjo	PROSIAPETEN	20
Topoxté	PROSIAPETEN	37
Yaxhá	PROSIAPETEN	45
Nixtun Ch'ich'	PAIP, PMC	127
Ixlú	PAIP, PMC	86
Zacpetén	PAIP, PMC	32
Pook's Hill	BVAR	171

APPENDIX 3.1

Comparison of Basic Figurine Motifs among Maya Figurine Collections

SITE	REFERENCE	PERIOD	ANTHROPO-MORPHIC* (%)	SUPER-NATURAL (%)	ZOOMOR-PHIC (%)	N**
Aguateca, Guatemala	Triadan 2007: table 3; Inomata 1995: table 7.13	Late Classic, Tepeu 2	70.0	6.4	23.6	250
Aguateca (grieta)	Ishihara 2007: table 7.19	Late Classic, Tepeu 1 & 2	68.4	10.1	21.5	79
Aguateca environs (Nacimiento, Dos Ceibas)	Eberl 2007: table 10.11	Late Classic, Tepeu 1 & 2	54.6	15.2	30.3	66
Altar de Sacrificios, Guatemala	Willey 1972	Late and Terminal Classic, mostly Pasión, Boca, Jimba phases	63.9	10.4	25.7	521
Motul de San José, Guatemala, and environs	Halperin 2007: table 7.1	Late and Terminal Classic, mostly Tepeu 2 & 3	47.1	21.5	31.4	414
Pook's Hill, Belize	Halperin 2009a	Terminal Classic, Spanish Lookout	19.5	7.8	72.7	77
San Clemente, Guatemala	Halperin 2009b	Terminal Classic	73.8	10.6	15.6	160
Nakum, Guatemala	Halperin 2009b	Terminal Classic	74.3	12.3	13.4	292
Nixtun Ch'ich'; Ixlú, Zacpetén, Guatemala	Halperin 2010	Late and Terminal Classic	63.0	18.5	18.5	162
Seibal, Guatemala	Willey 1978	Late and Terminal Classic (mostly Bayal phase)	61.7	10.8	27.5	167
Copan, Honduras (Las Sepulturas)	Hendon 2003: 31	Late Classic	60.0	0.0	40.0	332

Note: Classification systems may vary by investigator; as mentioned in the text, these categories are often fluid and ambiguous.
* May include unidentifed supernatural figures with anthropomorphic traits.
** Excludes indeterminate specimens; these numbers represent a smaller portion of total figurine counts.

APPENDIX 3.2

Figurine Headdress Themes

MOTUL DE SAN JOSÉ REGION (MSJ, TRI, CHA, ATE, TBV, CHT)

HEADDRESS	CODE	N	%	% (WITHOUT H)
Broad-brimmed hat	H3	50	16.1	19.92
Fan-shaped feather headdress with mask	H9	39	12.6	15.54
Two feather sprays at ears	H4	29	9.4	11.55
Unidentified feather headdress	H17	27	8.7	10.76
Cloth or paper head wrap, with tie in front	H2	19	6.1	7.57
Cone-shaped with tassels on top	H12	17	5.5	6.77
Animal headdress (no feathers)	H11	13	4.2	5.18
Single thin headband	H6	10	3.2	3.98
Cloth head wrap, band in front	H1	9	2.9	3.59
Cone-shaped with tassels along sides	H7	9	2.9	3.59
Thick headband	H5	8	2.6	3.19
Goggle-eyes, paper/feathered headdress	H13	5	1.6	1.99
Twisted cloth	H15	5	1.6	1.99
Other miscellaneous types (includes masks)	H19	4	1.3	1.59
Rounded headdress, made with stiff cloth?	H10	3	1.0	1.20
Short-brimmed hat	H16	3	1.0	1.20
Cylinder-shaped with feathers	H14	1	0.3	0.40
Eroded, fragmentary, unidentified	H	59	19.0	
TOTAL		310	100.0	100.00

Note: The Motul de San José region includes the sites of Motul de San José, Trinidad, Chäkokot, Chächäklu'um, Akte, and Buenavista. Not all figurines possessed headdresses; 445 figurine heads were identified in the collection. This table conflates supernatural and anthropomorphic headdresses (see Halperin 2007: table 7.12 for their separation).

* Conical appliqués previously coded as H8 in Halperin 2007: table 7.12 were omitted here because many may be censer spikes.

NAKUM

HEADDRESS	CODE	N	%	% (WITHOUT H)
Broad-brimmed hat	H3	40	40	42.55
Fan-shaped feather headdress with mask	H9	25	25	26.60
Animal headdress (no feathers)	H11	9	9	9.57
Single thin headband	H6	7	7	7.45
Other miscellaneous	H19	5	5	5.32
Short-brimmed hat	H16	2	2	2.13
Unidentified feather headdress	H17	2	2	2.13
Cloth head wrap with beads/ ornaments	H20	2	2	2.13
Thick headband	H5	1	1	1.06
Cloth or paper head wrap, with tie in front	H2	1	1	1.06
Removable headdress/mask	H21	0	0	0.00
Cone-shaped with tassels	H7	0	0	0.00
Eroded, fragmentary, unidentified	H	6	6	
TOTAL		100	100	100.00

SAN CLEMENTE

HEADDRESS	CODE	N	%	% (WITHOUT H)
Fan-shaped feather headdress with mask	H9	13	23.64	29.55
Broad-brimmed hat	H3	8	14.55	18.18
Single thin headband	H6	7	12.73	15.91
Unidentified feather headdress	H17	5	9.09	11.36
Other miscellaneous	H19	5	9.09	11.36
Animal headdress (no feathers)	H11	3	5.45	6.82
Cloth or paper head wrap, with tie in front	H2	1	1.82	2.27
Cone-shaped with tassels	H7	1	1.82	2.27

HEADDRESS	CODE	N	%	% (WITHOUT H)
Thick headband	H5	0	0.00	0.00
Short-brimmed hat	H16	0	0.00	0.00
Cloth head wrap with beads/ ornaments	H20	0	0.00	0.00
Eroded, fragmentary, unidentified	H	11	20.00	
TOTAL		55	100.00	100.00

NIXTUN CH'ICH', IXLÚ, ZACPETÉN*

HEADDRESS	CODE	N	%	% (WITHOUT H)
Fan-shaped feather headdress with mask	H9	13	32.5	41.94
Broad-brimmed hat	H3	8	20.0	25.81
Cloth or paper head wrap, with tie in front	H2	3	7.5	9.68
Single thin headband	H6	1	2.5	3.23
Cone-shaped with tassels along sides	H7	1	2.5	3.23
Cone-shaped head or headdress	H8	1	2.5	3.23
Animal headdress (no feathers)	H11	1	2.5	3.23
Goggle-eyes, paper/feathered headdress	H13	1	2.5	3.23
Removable headdress/mask	H21	1	2.5	3.23
Cloth wrap, with two tassels hanging to the sides	H22	1	2.5	3.23
Eroded, fragmentary, unidentified	H	9	22.5	
TOTAL		40	100.0	100.00

* Supernatural figurines excluded from headdress counts.

POOK'S HILL

HEADDRESS	CODE	N	%	% (WITHOUT H)
Cloth head wrap, band in front	H1	2	28.57	50.00
Other miscellaneous	H19	2	28.57	50.00
Eroded, fragmentary, unidentified	H	3	42.86	
TOTAL		7	100.00	100.00

TOPOXTÉ

HEADDRESS	CODE	N	%	% (WITHOUT H)
Fan-shaped feather headdress with mask	H9	3	37.5	42.86
Broad-brimmed hat	H3	2	25.0	28.57
Removable headdress/mask	H21	1	12.5	14.29
Animal headdress (no feathers)	H11	1	12.5	14.29
Eroded, fragmentary, unidentified	H	1	12.5	
TOTAL		8	100.0	100.00

YAXHÁ

HEADDRESS	CODE	N	%
Fan-shaped feather headdress with mask	H9	5	41.67
Animal headdress (no feathers)	H11	3	25.00
Two feather sprays at ears	H4	1	8.33
Single thin headband	H6	1	8.33
Cone-shaped with tassels on top	H12	1	8.33
Other miscellaneous	H19	1	8.33
TOTAL		12	100.00

APPENDIX 3.3

Common Motul de San José and East Transect (MSJ, CHT) Iconographic Figurine Motifs by Architectural Group Rank

	VOLUMETRIC RANK 1		VOLUMETRIC RANK 2		VOLUMETRIC RANK 3	
	n	%	*n*	%	*n*	%
ANTHROPOMORPHIC						
H1	6	8.33	1	3.45	0	0.00
H2	5	6.94	8	27.59	3	12.50
H3	29	40.28	3	10.34	8	33.33
H4*	10	13.89	8	27.59	3	12.50
H9	17	23.61	7	24.14	8	33.33
H11	5	6.94	2	6.90	2	8.33
SUBTOTAL	72		29		24	
SUPERNATURAL						
Formal Deities	5	13.89	0	0.00	0	0.00
Dwarves	14	38.89	13	48.15	8	53.33
Fat Gods	9	25.00	9	33.33	4	26.67
Other "Grotesques"	8	22.22	5	18.52	3	20.00
SUBTOTAL	36		27		15	
ZOOMORPHIC						
Monkeys	3	8.57	2	6.06	2	14.29
Felines	8	22.86	4	12.12	1	7.14
Dogs	2	5.71	3	9.09	1	7.14
Owls	12	34.29	7	21.21	5	35.71
Birds (Not Owls)	10	28.57	17	51.52	5	35.71
SUBTOTAL	35		33		14	

* Supernatural figures with H4 headdresses are not included here.

APPENDIX 3.4

Comparison of Gendered/Sexed Late Classic Figurine Bodies

SITE	FEMALE (N)	MALE (N)	FEMALE (%)	MALE (%)	TOTAL (N)
Aguateca (after Triadan 2007)	32	66	32.65	67.35	98
El Zotz (after Lukach and Garrido 2009)	5	9	35.71	64.29	14
Ixlú, Nixtun Ch'ich', Zacpetén	12	5	70.59	29.41	17
Motul de San José region	53	45	54.08	45.92	98
Nakum	35	36	49.30	50.70	71
Pook's Hill	1	0	100	0	1
San Clemente	15	11	57.69	42.31	26
Topoxté	7	3	70	30	10
Yaxhá	8	2	80	20	10

Note: Gender/sex categories (for all except Aguateca and El Zotz) were based on anatomical parts (flat, bare chest = male; breasts = female) and clothing (e.g., loincloth, textured suit or top = male; huipil or off-shoulder dress = female). Supernatural figurines (such as dwarves and Fat Men) are not included in counts.

APPENDIX 4.1

Supernatural Figurine Motifs by Site/Region

MOTUL DE SAN JOSÉ REGION		
SUPERNATURAL DESCRIPTION	N	%
Bloated Grotesque	2	2.0
Deity	6	5.9
Dwarf	31	30.4
Dwarf or Fat Man	10	9.8
Elderly	1	1.0
Fat Man	20	19.6
Grotesque	21	20.6
Hunchbacked Figure	1	1.0
Mask/Masked Figure	5	4.9
Unidentified Supernatural	5	4.9
TOTAL	102	100.0

ALTAR DE SACRIFICIOS (AFTER WILLEY 1972)

SUPERNATURAL DESCRIPTION	N	%
Grotesque: Fat Faces*	19	35.2
Monsters	7	13.0
Old Men, Grimacing Faces, Gods**	28	51.9
TOTAL	54	100.0

* This category consists of dwarves and Fat Men.
** Two of these figurines possess Sun god (God G) attributes, and one may represent God N.

SEIBAL (AFTER WILLEY 1978)

SUPERNATURAL DESCRIPTION	N	%
Grotesque: Fat Faces	10	55.6
Grotesque: Others	8	44.4
TOTAL	18	100.0

IXLÚ, NIXTUN CH'ICH', AND ZACPETÉN

SUPERNATURAL DESCRIPTION	N	%
Bloated Grotesque?	1	3.3
Deity	2	6.7
Dwarf	10	33.3
Elderly	4	13.3
Fat Man	5	16.7
Grotesque	7	23.3
Supernatural or Zoomorphic?	1	3.3
TOTAL	30	100.0

POOK'S HILL

SUPERNATURAL DESCRIPTION	N	%
Dwarf	3	50.0
Elderly	2	33.3
Unidentified Supernatural	1	16.7
TOTAL	6	100.0

SAN CLEMENTE

SUPERNATURAL DESCRIPTION	N	%
Deity	1	5.9
Dwarf or Fat Man	1	5.9
Elderly	2	11.8
Fat Man	5	29.4
Grotesque	5	29.4
Unidentified Supernatural	3	17.6
TOTAL	17	100.0

NAKUM

SUPERNATURAL DESCRIPTION	N	%
Bloated Grotesque?	1	2.9
Deity	1	2.9
Dwarf	11	32.4
Elderly	3	8.8
Fat Man	7	20.6
Grotesque	8	23.5
Unidentified Supernatural	3	8.8
TOTAL	34	100.0

APPENDIX 4.2

Comparison of Late Classic Deity Figurine Motifs

SITE	REFERENCE	DWARVES, FAT MEN, GROTESQUES, ELDERLY MALES, HYBRIDS, OTHER SUPERNATURALS (%)	FORMAL DEITIES (%)	FORMAL DEITY IDENTIFICATIONS	TOTAL SUPERNATURAL FIGURINES
Aguateca and environs, Guatemala	Eberl 2007: table 10.11; Ishihara 2007: table 7.19; Triadan 2007: table 3	97.1	2.9	1 Jaguar God of the Underworld	34
Altar de Sacrificios, Guatemala	Willey 1972	94.4	5.6	2 with Sun god attributes; 1 God N	54
Motul de San José, Guatemala and environs	Halperin 2007: 186–207	94.2	5.8	3 Wind gods; 1 Goddess O; 1 unidentified deity with god-eyes; 1 possible Maize god	103
Pook's Hill, Belize	Halperin 2009a	100.0	0.0	NA	6
San Clemente, Guatemala	Halperin 2009b	94.1	5.9	1 God K	17
Nakum, Guatemala	Halperin 2009b	97.1	2.9	1 God N	34
Nixtun Ch'ich', Ixlú, Zacpetén, Guatemala	Halperin 2010	93.3	6.7	1 Wind god; 1 Chak triangular adorno	30
Seibal, Guatemala	Willey 1978	100.0	0.0	NA	18

APPENDIX 5.1

Motul de San José Region (ATE, CHT, CHA, MSJ, TRI, TBV) Late Classic Figurine Contexts by Deposition Category

CONTEXTS	N	%
Looter's backdirt	61	2.20
Humus	687	24.83
Midden	1,023	36.97
Collapse	297	10.73
On-floor cultural surface	49	1.77
Architectural fill	483	17.46
Cache	1	0.04
Burial*	2	0.07
Undifferentiated soil or rock matrix	80	2.89
Surface collection	12	0.43
Unknown	72	2.60
TOTAL	2,767	100.0

* Burial was found in a midden; it is difficult to ascertain whether the two figurines were part of the burial or midden.

APPENDIX 5.2

Pook's Hill Late and Terminal Classic Figurine Contexts by Deposition Category

DEPOSITIONAL CONTEXT	N	%
Humus	11	6.43
Humus and collapse	67	39.18
Collapse	36	21.05
Collapse & terminal occupation debris	1	0.58
Collapse & midden	12	7.02
Terminal occupation midden	24	14.04
Midden	1	0.58
Architectural fill	18	10.53
Cache	0	0.00
Burial	0	0.00
Clearing backfill	1	0.58
TOTAL	171	100.0

APPENDIX 5.3

Figurine to Ceramic Sherd Ratios (× 1,000) by Volumetric Structure Group Rank from Motul de San José and the East Transect (MSJ, CHT)

	MEAN	STANDARD DEVIATION	N	95% CONFIDENCE
RESIDENTIAL STRUCTURE GROUPS				
Volumetric Rank 1	2.14	0.90	5	±0.79
Volumetric Rank 2	1.76	1.28	22	±0.55
Volumetric Rank 3	1.17	1.10	23	±0.43
Temple Pyramid Groups	1.16	1.18	2	±1.64

Note: Excludes groups with less than 100 sherds.

APPENDIX 5.4

Motul de San José Region Figurine Manufacturing Types, Descriptions, and
Frequencies

TYPE	DESCRIPTION	N	% (TOTAL)	% (IDENTIFIED) N = 1,769	MUSIC
Appliqué	Modeled appliqué part; could have been attached to any figurine type	556	20.09		
Mold	Mold fragment	2	0.07		
Type 1	Full-figure, 1-sided press mold; plainly modeled back and base	1,375	49.69	77.73	ocarina
Type 1a	Molded head and molded body; plainly modeled back and base	2	0.07	0.11	ocarina
Type 1 or 3	Molded head; unknown body type	68	2.46	3.84	ocarina?
Type 2	Crudely modeled head and body	64	2.31	3.62	ocarina or whistle
Type 2a	Crudely modeled body (head not present for identification)	98	3.54	5.54	ocarina or whistle
Type 2b	Crudely modeled head and body; body is the shape of a small tube	2	0.07	0.11	ocarina
Type 3a	Partly molded; molded heads (some with plugs) attached to modeled bodies (not crudely modeled)	30	1.08	1.70	some are ocarinas

TYPE	DESCRIPTION	N	% (TOTAL)	% (IDENTIFIED) N = 1,769	MUSIC
Type 3b	Molded head with plug (body missing, but presumably plug head was inserted into modeled body)	22	0.80	1.24	some are ocarinas
Type 3c	Partly molded?; modeled body (neither crudely nor finely modeled) missing head	40	1.45	2.26	some are ocarinas
Type 4a	Finely modeled head and body	9	0.33	0.51	NA
Type 4b	Finely modeled body missing head	26	0.94	1.47	NA
Type 4c	Modeled flutes with finely modeled bodies and flat molded faces*	17	0.61	0.96	1-chamber flute
Type 4d	Modeled flute	16	0.58	0.90	1-, 2-, or 3-chamber flutes
Indeterminate		440	15.90		
TOTAL		2,767	100	100	

* One of the figurines labeled type 4c (F2669; TRI13E-5-2-2b) is a finely modeled head with two stops, attached to a hollow modeled tube; another in the type 4c category has an unusual bulbous chamber (F1993; MSJ3A-12-1f).

APPENDIX 5.5

Ixlú, Nixtun Ch'ich', and Zacpetén Late and Terminal Classic Figurine Manufacturing Types

FIGURINE MANU-FACTURING TYPE	DESCRIPTION	N	%	MUSIC
Type 1	Full-figure, 1-sided press mold; plainly modeled back and base	144	58.8	ocarina
Type 2	Crudely modeled head and body	10	4.1	ocarina or whistle
Type 3b	Molded head with plug (inserted in either molded or modeled body)	4	1.6	ocarina?
Type 1 or 3	Molded head (unknown whether it had a molded or modeled body)	13	5.3	ocarina?
Type 4	Finely modeled bodies (with or without heads)	6	2.4	NA
Appliqué	Modeled appliqué part; could have been attached to either molded or modeled figurines	33	13.5	
Unknown	Unidentified	35	14.3	
TOTAL		245	100	

APPENDIX 5.6

Pook's Hill Figurine Manufacturing Types

MANUFACTUR-ING TYPE	DESCRIPTION	N	%	% IDENTIFIED (N = 89)	MUSICAL/ SOUND CAPACITY
Type 1	Full-figure, 1-sided press mold; plainly modeled back and base	31	18.13	34.83	ocarina or whistle
Type 1 or 3	Molded head; unknown whether body is molded or modeled	7	4.09	7.87	NA
Type 3	Molded head with modeled body (front and back)	2	1.17	2.25	ocarina* or whistle
TOTAL MOLDED		40	23.39	44.95	
Type 2	Crudely modeled head and body	43	25.15	48.31	ocarina or whistle**
Type 2a	Crudely modeled body; head or neck missing	6	3.51	6.74	ocarina or whistle
TOTAL CRUDELY MODELED		49	28.66	55.05	
Appliqué	Appliqué may have been attached to Type 1, 2, or 3	72	42.11		many are ocarina or whistle mouthpieces
Unidentifiable	Too small or fragmentary for identification	10	5.85		NA
TOTAL MISCELLANEOUS		82	47.96		
TOTAL		171	100	100	

* One specimen (O64) possesses two chambers and may have more than the typical two air stops of ocarinas.

** One specimen (O92) also possesses a single rattle ball in its head.

APPENDIX 5.7

Late and Terminal Classic Figurine Mold Distributions in the Maya Area

SITE	CITATION	NO. OF MOLDS	MOLD RECOVERY LOCATIONS
Aguateca, Guatemala	Inomata 1995: tables 7.12, 7.114	8	Site core; structures K7-11, M6-18, and M8-19
	Triadan 2007: table 2	5	Site core; elite domestic structures
Akte, Guatemala	Yorgey 2005: 58–59	1	Site core; 1 possible mold fragment found in association with the central elite residential group of the site
Altar de Sacrificios	Willey 1972: 72–74, figs. 59, 60	3	Site core; 1, Mound 20; 1, Structure A-I; 1, Structure A-II
Cancuén, Guatemala	Sears 2007	4	NA
Comalcalco, Mexico	Gallegos Gómora 2003: 48	NA	Site periphery; molds and 480 figurine fragments found from a single residential structure
Copan, Honduras	Hendon 2003: 32	1	Site core; 1 mold of an animal whistle figurine found in the eastern sector of Copan where noble residential compounds were located
El Chal, Guatemala	Laporte et al. 2004: 343, F-189	1	Site core; BS-044 (anthropomorphic head)
Ixtonton, Guatemala	Laporte et al. 2004: 303, H033	1	Site core; Plaza B; Est. Sur (couple figurine mold)
Lagartero, Mexico	Ekholm 1979a: 185	20	Site core; large ceremonial refuse midden located in the central plaza of the site
	Rivero Torres 2002: 47–50	37	Site core; ball court and associated altars
Lubaantun, Belize	Hammond 1975: 373	NA	Site core; all of the molds with known provenience come from the area around Plaza IV where the main ceremonial and administrative structures are located

SITE	CITATION	NO. OF MOLDS	MOLD RECOVERY LOCATIONS
Motul de San José, Guatemala	Halperin 2007	1	Site core; 1 figurine mold fragment found in a large midden (Op. 2A) at the edge of the Main Acropolis*
Nakum, Guatemala	Halperin 2009b	2	Site core
Palenque, Mexico	Rands and Rands 1959: 225, 1965: 554	NA	Site core; molds are reported as "fairly numerous at the site"
	Schele and Mathews 1979: figs. 902, 903	4	Site core; two of standing male figures have no provenience data, and two were found 100 m west of the Temple of Inscriptions
Piedras Negras, Guatemala	Schlosser 1978: 44	2	NA
	Ivic de Monterroso 2002: 556, fig. 3	2	NA
Quiriguá, Guatemala	Ashmore 1988: 164, 2007: 121–122, 173, 260, 283, 315	34	Two molds were found in the Site Core; remaining molds were found in four loci within Quiriguá's Floodplain Periphery (1A-28, 1 mold; Str. 3C-13, 2 molds; Group 3E-3, 1 mold; Mdn. 7C-1, 28 molds)*
Seibal, Guatemala	Willey 1978: 9, 37–38, fig. 44	6	Site core; 5 molds from residential structures located adjacent to the main plazas or near the principal causeways; 1 was found by Temple 5113
Tikal, Guatemala	Becker 1973: 399, 2003	4	Site core; Plaza Plan 2 residential Group 4H-1 belonging to "middle-class" inhabitants*
	Haviland 1985: tables 43, 46	2	Site core; small structure residential Groups 4F-1 and 4F-2 had 1 figurine mold each
Xunantunich, Belize	LeCount 1996: 427; Briggs Braswell 1998: 696	3	Site core; three molds found in Structure D-7 in elite residential Group D

* Evidence of vessel production found in the same context.

APPENDIX 5.8

Percentages of Modal Paste Types by Volumetrically Ranked Architectural Groups from Motul de San José and the East Transect

PASTE TYPE	VOLUMETRIC RANK 1		VOLUMETRIC RANK 2		VOLUMETRIC RANK 3		STANDARD DEVIATION
	N	%	N	%	N	%	%
A1	322	30.58	260	29.02	109	27.05	1.45
A2	196	18.61	164	18.30	87	21.59	1.48
A3	57	5.41	68	7.59	24	5.96	0.92
A4	6	0.57	2	0.22	0	0.00	0.23
TOTAL A	581	55.17	494	55.13	220	54.59	0.27
B1	104	9.88	112	12.50	39	9.68	1.29
B2	50	4.75	40	4.46	15	3.72	0.43
B3	5	0.47	2	0.22	0	0.00	0.19
B4	0	0.00	1	0.11	1	0.25	0.10
TOTAL B	159	15.10	155	17.30	55	13.65	1.50
C1	151	14.34	103	11.50	42	10.42	1.65
C2	47	4.46	36	4.02	19	4.71	0.29
C3	7	0.66	9	1.00	5	1.24	0.24
C4	0	0.00	1	0.11	3	0.74	0.33
TOTAL C	205	19.46	149	16.63	69	17.12	1.24
E1	58	5.51	29	3.24	19	4.71	0.94
E2	12	1.14	9	1.00	6	1.49	0.20
E3	1	0.09	1	0.11	0	0.00	0.05
TOTAL E	71	6.74	39	4.35	25	6.20	1.02
X1	11	1.04	17	1.90	0	0.00	0.78
X2	6	0.57	29	3.24	19	4.71	1.72
X3	4	0.38	7	0.78	10	2.48	0.91
TOTAL X	21	1.99	53	5.92	29	7.20	2.21
Z1	6	0.57	4	0.45	4	0.99	0.23
Z2	9	0.85	1	0.11	1	0.25	0.32
Z4	1	0.09	1	0.11	0	0.00	0.05
TOTAL Z	16	1.51	6	0.67	5	1.24	0.35
TOTAL	1,053		896		403		

APPENDIX 5.8 (CONTINUED)

A = red (2.5YR5/6, 2.5YR5/8, 2.5YR4/6, and 2.5YR4/8) and light red (2.5YR6/6, 2.5YR6/8)
B = reddish yellow (5YR7/6, 5YR7/8, 5YR6/6, 5YR6/8)
C = reddish yellow (7.5YR7/6, 7.5YR8/6) and pink (7.5YR8/3, 7.5YR8/4, 7.5YR7/4)
E = very pale brown (10YR7/3, 10YR7/4, 10YR8/3, 10YR8/4) and yellow (10YR7/6, 10YR8/6)

1 = ash temper, fine

2 = ash temper, medium

3 = ash temper, coarse

4 = miscellaneous nonash temper

APPENDIX 5.9

Paste Comparison of Late and Terminal Classic Figurines from the Petén Lakes Region (after Halperin 2014: table 2)

	RED		TAN		MISCELLANEOUS		
	A & B	%	C & E	%	OTHER*	%	TOTAL
Nixtun Ch'ich'	84	66.1	32	25.2	11	8.7	127
Flores	10	62.5	6	37.5	0	0.0	16
Tayasal	125	67.2	46	24.7	15	8.1	186
Buenavista	40	64.5	14	22.6	8	12.9	62
Motul de San José	1,588	70.4	544	24.1	124	5.5	2,256
Chäkokot	73	79.3	14	15.2	5	5.4	92
Trinidad de Nosotros	141	47.5	137	46.1	19	6.4	297
Ixlú	8	9.3	62	72.1	16	18.6	86
Zacpetén	3	9.4	25	78.1	4	12.5	32
San Clemente	31	9.0	286	82.9	28	8.1	345
Nakum	6	1.8	318	97.5	2	0.6	326
Topoxté	3	8.1	25	67.6	9	24.3	37
Yaxhá	6	12.8	35	74.5	6	12.8	47

Note: Many Nakum figurines were recently burned in a laboratory fire and are not included in the totals.

* Other miscellaneous paste types include imitation fine gray, fine orange, and unidentified/burned pastes.

A = red (2.5YR5/6, 2.5YR5/8, 2.5YR4/6, and 2.5YR4/8) and light red (2.5YR6/6, 2.5YR6/8)
B = reddish yellow (5YR7/6, 5YR7/8, 5YR6/6, 5YR6/8)
C = reddish yellow (7.5YR7/6, 7.5YR8/6) and pink (7.5YR8/3, 7.5YR8/4, 7.5YR7/4)
E = very pale brown (10YR7/3, 10YR7/4, 10YR8/3, 10YR8/4) and yellow (10YR7/6, 10YR8/6)

APPENDIX 6.1

Jaina Burials Containing Figurines by Age and Sex (after Piña Chán 2001 [1948])

AGE AND SEX OF INTERRED	NUMBER OF BURIALS WITH FIGURINES PRESENT* (N)	TOTAL BURIALS (N)	BURIALS WITH FIGURINES (%)
Adult Female	6	7	85.7
Adult Male	9	17	52.9
Adult (indeterminate sex)	13	21	61.9
Youth	2	2	100.0
Child**	23	29	79.3

* Either 1 or 2 figurines per burial.
** Two children in burials with figurines are reported as more than one year old.

NOTES

INTRODUCTION

1. I define figurines as small (less than 15–20 cm in height) bodily figures in roughly three-dimensional forms. Although this definition arbitrarily excludes small architectural models, such forms were not common in Maya ceramic traditions (cf. West Mexican figurines, some Aztec figurines). Because effigy vessels are less common during the Late Classic period than in the Early Classic period, I do not consider them here. I conflate the rare effigy flutes with figurine-ocarinas, figurine-whistles, and non-music-producing figurines. Although these classifications are etic in nature (produced by the scholar), analyses throughout the book attempt to test and draw out different emic values and treatments (classifications produced by the people who made and used them) of the various figurine form types.

2. Figurines of the Motul de San José region derive from investigations conducted at Motul de San José and five of its satellite sites: Akte, Buenavista, Chäkokot, Chächäklu'um, and Trinidad de Nosotros (Foias and Emery 2012). In all 2,800 figurines (2,767 of which date to the Late and Terminal Classic periods) have been recovered from investigations undertaken between 1998 and 2005. Horizontal excavations were undertaken at Motul de San José (MSJ operations 2A, 15, 29, 31, 39, 42, and 46A), Buenavista (TBV operation 1A&B, 2A), Chäkokot (CHT operations 44C and 44E), and Trinidad de Nosotros (TRI operations 2D, 4A, 5A, 6, 12). An intensive test-pitting program at Motul de San José targeted 60 percent of the architectural groups in the site core and northern periphery and included multiple 1 × 1 m and 0.5 × 0.5 m test units at each group. Figurines were also recovered from survey transects that ran outward from Motul de San José. While limited surface collection was conducted on two transects (the Northeast Transect, 0.25 × 2 km, and the South Transect, 0.25 × 3 km), only a few figurines were found on the South Transect surface collection. On the East Transect (an area of 0.4 × 2 km), figurines were recovered from systematic test-pitting of architectural groups, which encompassed the eastern zone of Motul de San José and the small settlement of Chäkokot. Test-pitting in these areas consisted of a single 1 × 1 m test pit; thus sampling is significantly lower at Chäkokot than at Motul de San José proper. Test excavations were also undertaken at the satellite settlements of Akte, Chächäklu'um, and Trinidad, although testing was the most intensive at Trinidad. At Akte 1 × 1 m test pits (n = 12) were placed in the center plaza of all architectural groups (Yorgey 2005). At Chächäklu'um three 1 × 1 m test

pits were placed in the ceremonial plaza of the site and in two residential groups (Spensley 2007). Test excavations at Trinidad included one 1 × 1 m test pit excavated to bedrock in each architectural group, posthole testing north of Group C, and small 0.5 × 0.5 m test pits around most architectural groups (Moriarty et al. 2007).

3. Systematic analysis refers to the analysis of all figurines in the collection with the same standard methodological procedures (appendix I.1) (see Halperin 2007, 2009a, 2009b, 2010). The analysis of museum collections often followed these standard procedures, but comparative frequencies of figurine types were not undertaken because collections were sometimes partial (containing only complete or the "best" pieces from a site).

4. The earliest ceramic figurine in Mesoamerica, however, dates to the Late Archaic period. This single figurine was found in situ near a hearth and milling stones at the site of Tlapacoya-Zhoapilco (dated to 2300 ± 110 b.c., 2300 BCE) (Niederberger 2000: 176).

5. These case studies are not meant to provide a systematic review of figurine studies (see, for example, Faust and Halperin 2009 for a recent review of Mesoamerican figurine research; and Lesure 2002, 2011 for recent reviews of Paleolithic, Neolithic, and Formative Mesoamerican figurine investigations).

CHAPTER 1

1. In addition, Helmke (2006a: 67) notes that domed, circular sweat baths may belong to a vernacular, commoner sweat bath tradition while square or rectangular sweat baths may belong to a more elite residential and monumental sweat bath tradition.

CHAPTER 2

1. See also Meskell (2008) and Meskell et al. (2008) for similar arguments linking Catalhöyük household identities and memory-making with figurine production, circulation, and discard.

2. This approach to ancient figurines is what Lesure (2011) calls a "window-on-society" analysis.

CHAPTER 3

1. Spectacles, ceremonies, festivals, and other "public events" are often identified by their grandeur, sensory elaboration, and large-scale participation (Beeman 1993; Houston 2006; MacAloon 1984). During the Classic period, such ceremonies included celebrations of period-endings (especially 20-year k'atun cycles and solar end of the year ceremonies), accessions to office, and possibly military celebrations, royal funerary ceremonies, and marriage celebrations.

2. Unfortunately, correlations between figurine imagery and social context (beyond region or site) are rarely reported and cannot be extended to many of the figurine collections. In addition, because of archaeological sampling biases toward the excavation of site cores and elite households, fewer commoner households and their material remains are available for comparisons.

3. Hairstyles were also critical points of identity formation and negotiation (Joyce 2000a, 2000b, 2003b; Robertson 1985).

4. These headdresses are coded as H9 (Halperin 2007, 2009b). Gordon Willey (1972) refers to these figurines as "Maya Priest Figures."

5. These headdresses are coded as H9a (Halperin 2007, 2009b).

6. These headdresses are coded as H9b (Halperin 2007, 2009b).

7. These headdresses are coded as H9c (Halperin 2007).

8. In addition, some Late Classic figurines with fan-shaped headdresses from the Campeche coast and Tabasco region possess amorphous bodies (Schele 1997: 112–114). Similar to figurines from Teotihuacan, these likely represent mortuary bundles of prominent elite personages. Like the palanquins, mortuary bundles were likely carried during processions and ceremonies.

9. Numbers beginning with the letter K refer to an archive of rollout photographs of Maya vessels available for viewing at http://research.mayavase.com/kerrmaya.html.

10. Ballplayers are portrayed as far back as the Preclassic period among figurine collections throughout Mesoamerica (Bradley 2001; Day 1998; Ekholm 1991; Niederberger 2000: 179; Reyna Robles 1971: 88, plate 113). They were popular in the Maya area during the Classic period (Folan et al. 2001: 245; Rands and Rands 1965: 543, fig. 30; Schele 1997: 120–126) but declined in popularity or disappeared completely among Maya figurine media during the Postclassic period even though the ball game was depicted in other media (such as stone panels and codices) (Scarborough and Wilcox 1991).

11. These headdresses are coded as H4 (Halperin 2007 and appendices 3.2, 3.3). Postclassic codices, stone monuments, and ceramic censers depict both deities and elite historical figures wearing similar winged feather elements in their headdresses. They are similar to *amacuexpalli* or paper neck fans of the Aztec. For example, Aztec Group II and III female figurines are often interpreted as deities and wear *amacuexpalli* (Millian 1981: 66–71, figs. 51, 52, 62, 63). These figurines contrast with the common Aztec Group I female figurines, which are depicted with two loops of hair on either side of the head and do not wear *amacuexpalli*. Aztec Group I figurine types relate to more quotidian representations of Aztec women (Klein and Lona 2009).

12. Dance, ritual, and performance fans are often circular or roughly square. They contrast with those worn by seated elite courtly figures, who often hold flower- or feather-tasseled "fans" (e.g., K594, K1453, K1599, K2914).

13. In fact, all three of these objects (fan, copal pouch, and mirror) appear together on some elite figures (e.g., Cerro de las Mesas Monument 2: Wyllie 2010: fig. 29).

14. This headdress is coded as H13 (Halperin 2007 and appendix 3.2).

15. These headdresses are shared by dwarves and grotesques, as discussed in chapter 4.

16. This headdress is coded as H1 (Halperin 2007 and appendix 3.2).

17. Broad-brimmed hats, which are typically appliquéd onto molded figurines, form the weakest structural part of the figurine and thus easily break off. Figurine analyses that only record heads or complete figurines will not catch the presence of fragmentary hats.

18. Farmers and craftspeople, however, may certainly have taken on roles as musicians, performers, ballplayers, and so forth. As Joyce (1993, 2000a) notes, the identities of laborers are often only implicit in the objects that figurative works carry (e.g., flint axes, bowls of tamales).

CHAPTER 4

1. Figurine Fat Men have been previously identified as the "Clothed Fat Man" (Butler 1935) and "Men in Bumpy Suits" (Miller 1975: 17).

2. This headdress is coded as H6 (Halperin 2007).

3. This headdress is coded as H16 (Halperin 2007).

4. Bloated male figurine bodies with missing heads may also fall in this genre. They are similar to Fat Men in their large, protruding belly but differ from both Fat Men and dwarves in their long thin legs and long thin arms that rest on their bellies. They have been recovered from Motul de San José (F761, MSJ2A-1-8-1a; F1993, MSJ3A-3-12-1f), Ixlú, and Jaina and the Campeche coastal area (Goldstein 1979: 88; Schele 1997: 161). Complete specimens wear loincloths, have puffy cheeks, and wear elaborate headdresses that are unique to each figurine. Unlike other figurine types, they are all finely modeled or at least partially modeled. Some functioned as rattles (K. Taube, personal communication 2003).

5. The bottom of the figurine piece was smoothed at the neckline before firing. This hollow piece is large enough to have been placed over the head of a separate figurine and probably served as a detachable mask.

6. Ixik Kab also has an elderly manifestation who oversees rituals, spins and weaves, and takes care of bees. Similarly, multiple variants of goddesses likely existed during the Classic period. For example, while the Classic period head variant of the number one (who has a long lock of hair and bead at her forehead) is also often associated with the moon (Thompson 1950), Karen Bassie-Sweet (2002) identifies this goddess as a Maize goddess and equates her long lock of hair with corn silk.

CHAPTER 5

1. Borhegyi (1956) loosely referred to ancient Maya figurines as part of a "folk" tradition, but little effort has been made to substantiate this designation.

2. Commoners have emerged as different sectors of society, sometimes referencing peasants, small-scale farmers, working-class proletariats, pastoralists, and others. In comparing Western capitalist culture with indigenous groups (whether "fully" integrated into the capitalist world system or not), scholars have also considered folk culture or folklore belonging to the indigenous cultural realm more generally (Storey 2003: 1–15).

3. Like the category of folk culture, the notion of mass media refers primarily to signifying practices that shape and are shaped by capitalism. Nonetheless, the concept is useful here in thinking about similar processes, albeit different in scale, in other political economic contexts (see, for example, Mukerji 1983).

4. Gerstle (1988: table 5-13), however, reports 152 Ulúa-style figurines (30 percent) from a total of 515 figurines recovered from the same excavations.

5. In the Maya highlands, such as in the Alta Verapaz region and at Lagartero, as well as in the Pacific coastal region (Castillo Aguilar et al. 2008), Late and Terminal Classic period molded figurines were produced using two-sided vertical molds and thus have elaborate molded details on both the front and the back.

6. I have not found a distinction in the application of paint among figurine form types. In addition, I have not found evidence of other types of applications, such as

chapapote, as seen from some Gulf Coast region figurines (Medellín Zenil 1987: 66; Stark 2001: 193; but see Gallegos Gómora n.d.: fig. 3).

7. One variation of this crudely modeled type designated as Type 2b consists of a tubular body with the ocarina stops located on the ends and decorated with crude feet and head parts protruding from the center of the tube (Halperin 2007).

8. The awkward placement of these holes in the middle of the figurine does not suggest that they were used for suspension or as a pendant. It is possible that they aided in the firing process.

9. Of the sixty-three male modeled figurines, four represented male dwarves and several others could be considered grotesques or supernaturals. Of the fifteen female modeled figurines, three may have portrayed elderly females or a manifestation of Goddess O (see chapters 3 and 4). The genders of three modeled figurines were classified as indeterminate (Corson 1976: 10–33).

10. Of the seventy-three molded male figurines, twenty-two represented dwarfs, grotesques, or masked performers.

11. While grouped together here, ceramic flutes varied in their musical capacities (locations of mouthpiece, number of stops, number of flute chambers [single-, double-, and triple-chambered flutes]), and the shape of the flute chambers can vary substantially to produce different types of sounds. Such variations underscore a complex understanding of the mechanics of sound production (Rodens 2008).

12. Effigy flutes from Altar de Sacrificios are monkeys with ear pendants and other adornments (*n* = 3) or birds (*n* = 2) (Willey 1972: 68–70). With one exception in Mound 38, these effigy flutes were all recovered from refuse located in the palatial and monumental architecture of Altar de Sacrificios (Structures A-1, A-III). An effigy flute from Toniná portrays a monkey with ear pendants (Becquelin and Baudez 1982: fig. 268j). In the Motul de San José region, effigy flutes depicted only male anthropomorphic or supernatural figures, such as a possible Maize god, a dwarf, and a bloated grotesque. They were recovered from elite, middle, and (less often) commoner architectural groups. A complete flute with six stops from an elite context in the site core of Aguateca portrays an animal head wearing a winged feather headdress (see H4 in chapter 3) with an anthropomorphic upper torso with arms positioned as if in a dance pose. A grotesque version with hanging ear pendants was also found in the site's *grieta* (Ishihara 2007: fig. 7.8a). A Fat Man effigy flute was recovered from Nacimiento (Eberl 2007: fig. 10.36a).

13. Homogeneity of material culture, of course, is not dependent on some form of mechanical reproduction (e.g., stylistically similar Clovis points).

14. Identical molded imagery, however, is difficult to detect archaeologically because identical objects may have different states of erosion depending on their differential treatment throughout their use lives and depositional contexts (for example, secondary midden within fill tends to preserve artifacts better than primary midden on the ground surface).

15. The crypt contained a slate roof and was located in a large monumental building (Str. 2) in the site's Plaza A.

16. "A" pastes represent red (e.g., 2.5YR 5/6, 2.5YR 5/8, 2.5YR 4/6, and 2.5YR 4/8) and light red (e.g., 2.5YR 6/6, 2.5YR 6/8) following the Munsell color schemes, while "B" pastes represent reddish yellow (e.g., 5YR 7/6, 5YR 7/8, 5YR 6/6, 5YR 6/8). Ferruginous

inclusions were also frequently noted in all of the "A" and "B" paste variants. "C" pastes are reddish yellow (e.g., 7.5YR 7/6, 7.5YR 8/6) and pink (e.g., 7.5YR 8/3, 7.5YR 8/4, 7.5YR 7/4) (no category "D" exists). "E" pastes are very pale brown (e.g., 10YR 7/3, 10YR 7/4, 10YR 8/3, 10YR 8/4) or yellow (e.g., 10YR 7/6, 10YR 8/6). Unlike some of their redder counterparts, they did not contain visible or frequent quartz (with one exception) or calcite inclusions. They tended to fall at the finer end of the texture spectrum. Differences between local and nonlocal wares were identified through INAA based on the major, minor, and trace elements of ceramic paste compositions. INAA was conducted by Ronald Bishop, James Blackman, and Erin Sears at the Smithsonian Institution in Washington, D.C. INAA paste groups were designated using multivariate statistical cluster analyses. Local paste groups were determined through the criterion of abundance and by matching one of the local paste categories to a clay sample taken from between Motul de San José and Trinidad (for more details on paste categories, see Halperin et al. 2009).

17. Figurines may have been acquired as gifts from the state or through barter/trade/market exchanges. Because figurines do not appear to have been produced in highly specialized, state-run production facilities, however, I favor a festival-market exchange model (see also the discussion in Halperin et al. 2009).

CHAPTER 6

1. The phrase "come to life" can be interpreted as the animation of figurative pieces. It may refer to the figurine's spiritual animation and/or pertain to the imbuing of meaning, whereby the figurine affects action, thought, and emotion as much as it is guided by it (see the discussion on materiality in chapter 2).

2. Bishop Diego de Landa mentions that "sorceresses" placed "an idol of a goddess called Ix Chel whom they said was the goddess of making children" under the bed of women in labor (Tozzer 1941: 129). Such practices recall contemporary Kuna healing rituals in which wooden idols are placed near or below the hammock of those who are sick (Chapin 1997). Similarly, Klein and Lona (2009) argue based on a combination of iconographic, ethnohistoric, and ethnographic data that Aztec figurines related to curing practices.

3. Spindle whorls were also found in the north room of Str. M8-4, leading Inomata et al. (2002: 324, fig. 8) to suggest that it was a women's activity area.

4. Inomata (1995: 697–698) interprets the structure as a shrine due to an architectural configuration that is typical of temples in central Petén, together with the recovery of an *incensario* and two stingray spines as well as its relatively low density of artifacts.

5. Some Terminal Classic period figurines exhibit postfire perforated holes, but these occur only on fragmented figurine pieces, suggesting that the figurine was already broken before the perforation occurred or, less likely, that the figurine was "killed" more than once (Halperin 2011). I do know of a single ruler figurine with a possible "kill hole" excavated from the site of Tayasal (personal observation 2012). The hole shows signs of perforation and was located at the center of the ruler's deity mask rather than on the ruler's face.

6. See, for example, Klein and Lona 2009; Sandstrom 2009.

REFERENCES

Abercrombie, Nicholas, Stephen Hill, and Bryan S. Turner
1980 *The Dominant Ideology Thesis.* George Allen and Unwin, London.
Abrams, Philip
1977/1988 Notes on the Difficulty of Studying the State. *Journal of Historical Sociology* 1:58–89.
Adamson, Walter L.
1980 *Hegemony and Revolution: A Study of Antonio Gramsci's Political and Cultural Theory.* University of California Press, Berkeley.
Adorno, Theodor W.
1991 [1967] *Culture Industry: Selected Essays on Mass Culture.* Routledge, London.
Adorno, Theodor W., and Max Horkheimer
1972 [1944] *Dialectic of Enlightenment.* Seabury, New York.
Alcina Franch, José, Andrés Ciudad Ruiz, and Josepha Iglesias Ponce de León
1982 El "temazcal" en Mesoamerica: Evolución, forma y función. *Revista Española de Antropología Americana* 10:93–132.
Allen, Lawrence P.
1980 Intra-urban Exchange at Teotihuacan: Evidence from Mold-Made Figurines. In *Models and Methods in Regional Exchange,* edited by Robert E. Fry, pp. 83–94. SAA Papers No. 1. Society for American Archaeology, Washington, DC.
Althusser, Louis
1971 Ideology and Ideological State Apparatuses. In *Lenin and Philosophy and Other Essays,* edited by Louis Althusser, pp. 123–172. New Left Books, London.
Alvarez, Carlos, and Luis Casasola
1985 *Las figurillas de Jonuta, Tabasco.* Universidad Autónoma de México, Mexico City.
Aoyama, Kazuo
2001 Classic Maya State, Urbanism, and Exchange: Chipped Stone Evidence of the Copán Valley. *American Anthropologist* 103(2):346–360.
Appadurai, Arjun (editor)
1986 *The Social Life of Things: Commodities in Cultural Perspective.* Cambridge University Press, Cambridge.
Ardren, Traci
2002 Death Became Her: Images of Female Power from Yaxuna Burials. In *Ancient Maya Women,* edited by Traci Ardren, pp. 68–88. Altamira Press, Walnut Creek, CA.
2006 Mending the Past: Ix Chel and the Invention of a Modern Pop Goddess. *Antiquity* 80(307):25–37.

Aristotle

2011 *The Poetics*. Translated by S. H. Butcher. Witch Books, Lexington, KY.

Arroyo, Bárbara

2002 Classification of La Blanca Figurines. In *Early Complex Society in Pacific Guatemala: Settlements and Chronology of the Río Naranjo, Guatemala*, edited by Michael Love, pp. 205–235. Papers of the New World Archaeological Foundation No. 66. Brigham Young University, Provo.

1988 Household and Community at Classic Quiriguá. In *Household and Community in the Mesoamerican Past*, edited by Wendy Ashmore and Richard R. Wilk, pp. 153–169. University of New Mexico Press, Albuquerque.

1991 Site-Planning Principles and Concepts of Directionality among the Ancient Maya. *Latin American Antiquity* 2:199–226.

2007 *Settlement Archaeology at Quiriguá, Guatemala*. University Museum Monograph 126. University of Pennsylvania Museum of Archaeology and Anthropology, Philadelphia.

n.d. Appendix: Quiriguá Artifacts in the Middle American Research Institute. In *Quiriguá Reports, Volume V (Artifacts and Conclusions)*. University of Pennsylvania Museum (Museum Monographs), Philadelphia.

Ashmore, Wendy (editor)

1981 *Lowland Maya Settlement Patterns*. University of New Mexico Press, Albuquerque.

Ashmore, Wendy, and Jeremy A. Sabloff

2002 Spatial Orders in Maya Civic Plans. *Latin American Antiquity* 13(2):201–215.

Ashmore, Wendy, and Richard R. Wilk

1988 Household and Community in the Mesoamerican Past. In *Household and Community in the Mesoamerican Past*, edited by Richard R. Wilk and Wendy Ashmore, pp. 1–28. University of New Mexico Press, Albuquerque.

Ashmore, Wendy, Jason Yaeger, and Cynthia Robin

2004 Commoner Sense: Late and Terminal Classic Social Strategies in the Xunantunich Area. In *The Terminal Classic in the Maya Lowlands: Collapse, Transition, and Transformation*, edited by Arthur A. Demarest, Prudence M. Rice, and Don S. Rice, pp. 302–323. University Press of Colorado, Boulder.

Audet, Carolyn M.

2006 Political Organization in the Belize Valley: Excavations at Baking Pot, Cahal Pech, and Xunantunich. PhD dissertation, Department of Anthropology, Vanderbilt University, Nashville.

Babcock, Barbara A.

1984 Arrange Me into Disorder: Fragments and Reflections on Ritual Clowning. In *Rite, Drama, Festival, Spectacle: Rehearsals toward a Theory of Cultural Performance*, edited by John J. MacAloon, pp. 1–20. Institute for the Study of Human Issues, Philadelphia.

Bacon, Wendy J.

2003/2004 Dwarves, Lords, and Kingdoms in Classic Maya Monumental Iconography: A Survey of Polity Interaction and the Achondroplastic Motif. *Codex* 12:12–46.

2007 The Dwarf Motif in Classic Maya Monumental Iconography: A Spatial Analysis. PhD dissertation, Department of Anthropology, University of Pennsylvania, Philadelphia.

Bailey, Douglass W.

1996 Interpreting Figurines: The Emergence of Illusion and New Ways of Seeing. *Cambridge Archaeological Journal* 6(2):291–295.

2005 *Prehistoric Figurines: Representation and Corporeality in the Neolithic.* Routledge, London.

Baker, Mary

1992 Capuchin Monkeys (*Cebus capucinus*) and the Ancient Maya. *Ancient Mesoamerica* 3(2):219–226.

Bakhtin, Mikhail

1984 *Rabelais and His World.* Translated by Hélène Iswolsky. Indiana University Press, Bloomington.

Ball, Joseph W.

1993 Pottery, Potters, Palaces, and Politics: Some Socioeconomic and Political Implications of Late Classic Maya Ceramic Industries. In *Lowland Maya Civilization in the Eighth Century A.D.*, edited by Jeremy A. Sabloff and John S. Henderson, pp. 243–272. Dumbarton Oaks, Washington, DC.

Ballinger, Franchot

2004 *Living Sideways: Tricksters in American Indian Oral Traditions.* University of Oklahoma Press, Norman.

Barbour, Warren D. T.

1975 The Figurines and Figurine Chronology of Ancient Teotihuacán, Mexico. PhD dissertation, Department of Anthropology, University of Rochester, Rochester, NY.

Barrera Vásquez, Alfredo

1965 *El libro de los cantares de Dzitbalché: Una traducción con notas y una introducción.* Instituto Nacional de Antropología y Historia, Mexico City.

Bassie, Karen, Nicholas A. Hopkins, and J. Kathryn Josserand

n.d. A Classic Maya Headdress. Manuscript on file with the author.

Bassie-Sweet, Karen

1991 *From the Mouth of the Dark Cave: Commemorative Sculpture of the Late Classic Maya.* University of Oklahoma Press, Norman.

2002 Corn Deities and the Male/Female Principle. In *Ancient Maya Gender Identity and Relations*, edited by Lowell S. Gustafson and Amelia M. Trevelyan, pp. 169–191. Bergin and Garvey, Westport.

2008 *Maya Sacred Geography and the Creator Deities.* University of Oklahoma Press, Norman.

Bateson, Gregory

1955 A Theory of Play and Fantasy. *Psychiatric Research Reports* 2:39–51.

Baudez, Claude-François

1994 *Maya Sculpture of Copán: The Iconography.* University of Oklahoma Press, Norman.

Bayman, James M.

2002 Hohokam Craft Economies in the North American Southwest. *Journal of Archaeological Method and Theory* 9:69–95.

Beaudry, Marilyn P.

1989 Red Painted Surfaces on Selected Mesoamerican Ceramics: A Case Study in the Use of Materials Analysis on Archaeological Ceramics. In *Scientific Analysis in Archaeology*, edited by Julian Henderson, pp. 82–111. Oxford University Committee for Archaeology, Oxford.

Becker, Marshall J.

1973 Archaeological Evidence for Occupational Specialization among the Classic Period Maya at Tikal, Guatemala. *American Antiquity* 38(4):396–406.

2003 A Classic Period Barrio Producing Fine Polychrome Ceramics at Tikal, Guatemala. *Ancient Mesoamerica* 14:95–112.

Becquelin, Pierre, and Claude-François Baudez

1982 *Tonina: Une cité maya du Chiapas, Tome III*. Éditions Recherche sur les Civilisations, Paris.

Beeman, William O.

1993 The Anthropology of Theatre and Spectacle. *Annual Review of Anthropology* 22:369–393.

Beetz, Carl P., and Linton Satterthwaite

1981 *The Monuments and Inscriptions of Caracol, Belize*. University Museum, University of Pennsylvania, Philadelphia.

Beliaev, Dmitri

2004 *Wayaab'* Title in Maya Hieroglyphic Inscriptions: On the Problem of Religious Specialization in Classic Maya Society. In *Continuity and Change: Maya Religious Practices in Temporal Perspective*, edited by Daniel Graña Behrens, Nikolai Grube, Christian M. Prager, Frauke Sachse, Stefanie Teufel, and Elisabeth Wagner, pp. 121–130. Fifth European Maya Conference, University of Bonn. Verlag Anton Saurwein, Markt Schwaben, Germany.

Bell, Catherine

1992 *Ritual Theory, Ritual Practice*. Oxford University Press, New York.

1997 *Ritual: Perspectives and Dimensions*. Oxford University Press, New York.

Benjamin, Walter

1969 [1936] *Illuminations*. Schocken, New York.

Benson, Elizabeth P.

1994 The Multimedia Monkey, or, the Failed Man: The Monkey as Artist. In *Seventh Palenque Round Table, 1989*, edited by Merle Greene Robertson and Virginia M. Fields, pp. 137–143. University of Texas Press, Austin.

Bergesen, Albert

1984 *The Sacred and the Subversive: Political Witch-Hunts as National Rituals*. Society for the Scientific Study of Religion, Storrs, CT.

Beyer, Hermann

1930 A Deity Common to Teotihuacan and Totonac Cultures. *Proceedings of the 23rd International Congress of Americanists* (1928), pp. 82–84. New York.

Bhabha, Homi K.

1994/2004 *The Location of Culture*. Routledge, New York.

Binford, Lewis

1964 A Reconsideration of Archaeological Research Design. *American Antiquity* 29:425–441.

Blackman, M. James, Gil J. Stein, and Pamela B. Vandiver

1993 The Standardization Hypothesis and Ceramic Mass Production: Technological, Compositional, and Metric Indexes of Craft Specialization at Tell Leilan, Syria. *American Antiquity* 58(1):60–80.

Blackmore, Chelsea

2008 Challenging "Commoner": An Examination of Status and Identity at the Ancient Maya Village of Chan, Belize. PhD dissertation, Department of Anthropology, University of California, Riverside.

Blaffer, Sarah C.

1972 *The Black-man of Zinacantan: A Central American Legend*. University of Texas Press, Austin.

Blanton, Richard E., Gary E. Feinman, Stephen A. Kowaleski, and Peter N. Peregrine
1996 A Dual-Processual Theory for the Evolution of Mesoamerican Civilization.
 Current Anthropology 37(1):1–65.

Blomster, Jeffrey P.
2002 What and Where Is Olmec Style?: Regional Perspectives on Hollow Figurines in
 Early Formative Mesoamerica. *Ancient Mesoamerica* 13:171–195.
2009 Identity, Gender, and Power: Representational Juxtapositions in Early Formative
 Figurines from Oaxaca, Mexico. In *Mesoamerican Figurines: Small-Scale Indices of Large-
 Scale Social Phenomena*, edited by Christina T. Halperin, Katherine A. Faust, Rhonda
 Taube, and Aurora Giguet, pp. 119–148. University Press of Florida, Gainesville.

Borhegyi, Stephen F.
1956 The Development of Folk and Complex Cultures in the Southern Maya Area.
 American Antiquity 21(4):343-356.

Bourdieu, Pierre
1977 *Outline of a Theory of Practice*. Cambridge University Press, Cambridge.
1990 *The Logic of Practice*. Polity, Cambridge.

Bozarth, Steven R., and Thomas H. Guderjan
2004 Biosilicate Analysis of Residue in Maya Dedicatory Cache Vessels from Blue
 Creek, Belize. *Journal of Archaeological Science* 31:205–215.

Bradley, Douglas E.
2001 Gender, Power, and Fertility in the Olmec Ritual Ballgame. In *The Sport of Life
 and Death: The Mesoamerican Ballgame*, edited by Michael Whittington, pp. 33–39.
 Thames and Hudson, New York.

Brady, James E.
1989 An Investigation of Maya Ritual Cave Use with Special Reference to Naj Tunich.
 PhD dissertation, Interdisciplinary Archaeology Program, University of Califor-
 nia, Los Angeles.
1990a Investigaciones en la Cueva de el Duende. In Proyecto Arqueologico Regional
 Petexbatun: Informe preliminar #2, Segunda temporada 1990, edited by Arthur
 A. Demarest and Stephen D. Houston, pp. 334–351. Vanderbilt University,
 Nashville.
1990b Investigaciones en la Cueva de Sangre y otras cuevas de la región de Petexbatun.
 In Proyecto Arqueologico Regional Petexbatun: Informe preliminar #2, Segunda
 temporada 1990, edited by Arthur A. Demarest and Stephen D. Houston, pp.
 438–479. Vanderbilt University, Nashville.
1997 Settlement Configuration and Cosmology: The Role of Caves at Dos Pilas.
 American Anthropologist 99(3):602–618.

Brady, James E., and Wendy Ashmore
1999 Mountains, Caves, Water: Ideational Landscapes of the Ancient Maya. In
 Archaeologies of Landscape: Contemporary Perspectives, edited by Wendy Ashmore
 and A. Bernard Knapp, pp. 124–145. Blackwell Publishers, Malden, MA.

Brady, James E., and Irma Rodas
1995 Maya Ritual Cave Deposits: Recent Insights from the Cueva de Los Queztales.
 Institute of Maya Studies Journal 1(1):17–25.

Brainerd, George W.
1958 *The Archaeological Ceramics of Yucatan*. Anthropological Records, 19. University
 of California, Berkeley.

Bricker, Victoria R.
1973 *Ritual Humor in Highland Chiapas*. University of Texas Press, Austin.

1981 *The Indian Christ, the Indian King: The Historical Substrate of Maya Myth and Ritual.* University of Texas Press, Austin.

Briggs Braswell, Jennifer

1998 Archaeological Investigations at Group D, Xunantunich, Belize. PhD dissertation, Department of Anthropology, Tulane University, New Orleans.

Brown, Linda A., Scott E. Simmons, and Payson Sheets

2002 Household Production of Extra-Household Ritual at the Cerén Site, El Salvador. In *Domestic Ritual in Ancient Mesoamerica*, edited by Patricia Plunket, pp. 83–92. Cotsen Institute of Archaeology, University of California, Los Angeles.

Brumfiel, Elizabeth M.

1983 Aztec State Making: Ecology, Structure, and the Origin of the State. *American Anthropologist* 85(2):261–284.

1991a Tribute and Commerce in Imperial Cities: The Case of Xaltocan. In *Early State Economics*, edited by Henri J. M. Claessen and Pieter van de Velde, pp. 177–198. Transaction Publishers, New Brunswick.

1991b Weaving and Cooking: Women's Production in Aztec Mexico. In *Engendering Archaeology: Women and Prehistory*, edited by Joan M. Gero and Margaret W. Conkey, pp. 224–254. Basil Blackwell, Oxford.

1996a Figurines and the Aztec State: Testing the Effectiveness of Ideological Domination. In *Gender and Archaeology*, edited by Rita P. Wright, pp. 143–166. University of Pennsylvania Press, Philadelphia.

1996b The Quality of Tribute Cloth: The Place of Evidence in Archaeological Argument. *American Antiquity* 61(3):453–462.

Brumfiel, Elizabeth M., and Timothy K. Earle

1987 Specialization, Exchange, and Complex Societies: An Introduction. In *Specialization, Exchange, and Complex Societies*, edited by Elizabeth M. Brumfiel and Timothy K. Earle, pp. 1–9. Cambridge University Press, Cambridge.

Brumfiel, Elizabeth M., and Lisa Overholtzer

2009 Alien Bodies, Everyday People, and Hollow Spaces: Embodiment, Figurines, and Social Discourse in Postclassic Mexico. In *Mesoamerican Figurines: Small-Scale Indices of Large-Scale Phenomena*, edited by Christina T. Halperin, Katherine A. Faust, Rhonda Taube, and Aurora Giguet, pp. 297–323. University Press of Florida, Gainesville.

Butler, Judith

1993 *Bodies That Matter: On the Discursive Limits of "Sex."* Routledge, New York.

Butler, Mary

1935 A Study of Maya Mouldmade Figurines. *American Anthropologist* 37:636–672.

Carneiro, Robert L.

1967 On the Relationship between Size of Population and Complexity of Social Organization. *Southwestern Journal of Anthropology* 23:234–243.

Carrasco, Michael David

2005 The Mask Flange Iconographic Complex: The Art, Ritual, and History of a Maya Sacred Image. PhD dissertation, Department of Art History, University of Texas, Austin.

Carrasco Vargas, Rámon, Verónica A. Vázquez López, and Simon Martin

2009 Daily Life of the Ancient Maya Recorded on Murals at Calakmul, Mexico. *PNAS (Proceedings of the National Academy of Sciences)* 106(46):19245–19249.

Caso, Alfonso, and Ignacio Bernal

1952 *Urnas de Oaxaca.* Memorias del Institute Nacional de Antropología e Historia, Mexico City.

Castillo Aguilar, Victor, et al.
2008 Mujeres y contrahechos: Las figurillas moldeadas de la Costa Sur de Guatemala. In *XXII Simposio de Investigaciones Arqueológicas en Guatemala*, edited by J. P. Laporte, B. Arroyo, and H. E. Mejía, pp. 899–912. Instituto de Antropología e Historia, Asociación Tikal, Guatemala City.

Cecil, Leslie G.
2001 Technological Styles of Late Postclassic Slipped Pottery from the Central Péten Lakes Region, El Péten, Guatemala. PhD dissertation, Department of Anthropology, Southern Illinois University, Carbondale.

Chapin, Mac
1997 The World of Spirit, Disease, and Curing. In *The Art of Being Kuna: Layers of Meaning among the Kuna of Panama*, edited by Mari Lyn Salvador, pp. 219–243. UCLA Fowler Museum of Cultural History, Los Angeles.

Chapman, John
2000 *Fragmentation in Archaeology: People, Places, and Broken Objects in the Prehistory of South Eastern Europe.* Routledge, London.

Chase, Arlen F., and Diane Z. Chase
1996a A Mighty Maya Nation. *Archaeology* (September/October):67–72.
1996b More Than Kin and King: Centralized Political Organization among the Late Classic Maya. *Current Anthropology* 37(5):803–810.
2001a Ancient Maya Causeways and Site Organization at Caracol, Belize. *Ancient Mesoamerica* 12(1):273–281.
2001b The Royal Court of Caracol, Belize: Its Palaces and People. In *Royal Courts of the Ancient Maya: Volume 2: Data and Case Studies*, edited by Takeshi Inomata and Stephen D. Houston, pp. 102–137. Westview Press, Boulder.
2005 Contextualizing the Collapse Hegemony and Terminal Classic Ceramics from Caracol. In *Geographies of Power: Understanding the Nature of Terminal Classic Pottery in the Maya Lowlands*, edited by Sandra L. López Varela and Antonia E. Foias, pp. 73–91. BAR International Series 1447. BAR, Oxford.

Chase, Diane Z., and Arlen F. Chase
2004 Archaeological Perspectives on Classic Maya Social Organization from Caracol, Belize. *Ancient Mesoamerica* 15:139–147.

Cheetham, David
2009 Early Olmec Figurines from Two Regions: Style as Cultural Imperative. In *Mesoamerican Figurines: Small-Scale Indices of Large-Scale Social Phenomena*, edited by Christina T. Halperin, Katherine A. Faust, Rhonda Taube, and Aurora Giguet, pp. 149–179. University Press of Florida, Gainesville.

Child, Mark B.
2006 The Symbolic Space of the Ancient Maya Sweatbath. In *Space and Spatial Analysis in Archaeology*, edited by Elizabeth C. Robertson, Jeffrey D. Seibert, Deepika C. Fernandez, and Marc U. Zender, pp. 157–167. University of Calgary Press, Calgary.
2007 Ritual Purification and the Ancient Maya Sweatbath at Palenque. In *Palenque: Recent Investigations at the Classic Maya Center*, edited by Damien B. Marken, pp. 233–262. AltaMira Press, Lanham.

Childe, V. Gordon
1951 *Social Evolution.* Watts, London.

Chinchilla, Oswaldo.
2010. Of Birds and Insects: The Hummingbird Myth in Ancient Mesoamerica. *Ancient Mesoamerica* 21 (2010):45–61.

Ciaramella, Mary

1999 *The Weavers in the Codices*. Center for Maya Research, Research Reports on Ancient
 Maya Writing, 44. Center for Maya Research, Washington, DC.

Claessen, Henri J. M., and Peter Skalník

1978 The Early State: Theories and Hypotheses. In *The Early State*, edited by Henri J. M.
 Claessen and Peter Skalník, pp. 3–29. Mouton Publishers, New York.

Claessen, Henri J. M., and Pieter van de Velde (editors)

1991 *Early State Economics*. Transaction Publishers, New Brunswick.

Clancy, Flora S.

2009 *The Monuments of Piedras Negras, an Ancient Maya City*. University of New Mexico
 Press, Albuquerque.

Clark, David L.

1972 A Provisional Model of an Iron Age Society and Its Settlement System. In *Models
 in Archaeology*, edited by David L. Clark, pp. 801–869. Methuen, London.

1977 *Spatial Archaeology*. Academic Press, London.

Clark, John E.

2007a In Craft Specialization's Penumbra: Things, Persons, Action, Value, and Surplus.
 In *Rethinking Craft Specialization in Complex Societies: Archaeological Analyses of the Social
 Meaning of Production*, edited by Zachary X. Hruby and Rowan K. Flad, pp. 20–36.
 Archaeological Papers of the American Anthropological Association, No. 17.
 American Anthropological Association, Arlington, VA.

2007b Mesoamerica's First State. In *The Political Economy of Ancient Mesoamerica: Transfor-
 mation during the Formative and Classic Periods*, edited by Vernon L. Scarborough and
 John E. Clark, pp. 11–46. University of New Mexico Press, Albuquerque.

Clark, John E., and A. Colman

2008 Time Reckoning and Memorials in Mesoamerica. *Cambridge Archaeological Journal*
 18(1):93–99.

Clendinnen, Inga

1982 Yucatec Maya Women and the Spanish Conquest: Role and Ritual in Historical
 Reconstruction. *Journal of Social History* 15(3):427–442.

2003 *Ambivalent Conquests: Maya and Spaniard in Yucatan 1517–1570*. 2nd ed. Cambridge
 University Press, Cambridge.

Coe, Michael D.

1965 Caches and Offering Practices of the Maya Lowlands. In *Archaeology of the South-
 ern Maya Lowlands*, edited by Gordon R. Willey, pp. 462–468 (*Handbook of Middle
 American Indians*). University of Texas Press, Austin.

1978 *Lords of the Underworld: Masterpieces of Classic Maya Ceramics*. Princeton University
 Press, Princeton.

Coe, Michael D., and Justin Kerr

1998 *The Art of the Maya Scribe*. Harry N. Abrams, New York.

Coe, Michael D., and Mark Van Stone

2001 *Reading the Maya Glyphs*. Thames and Hudson, London.

Coe, William R.

1959 *Piedras Negras Archaeology: Artifacts, Caches, and Burials*. University Museum, Univer-
 sity of Pennsylvania, Philadelphia.

1967 *Tikal: A Handbook of the Ancient Maya Ruins*. University of Pennsylvania,
 Philadelphia.

Cohen, Ronald

1978 Introduction. In *Origins of the State: An Anthropology of Political Evolution*, edited by

Ronald Cohen and Elman R. Service, pp. 1–20. Institute for the Study of Human Issues, Philadelphia.

Cohen, Ronald, and Elman R. Service (editors)

1978 *Origins of the State: The Anthropology of Political Evolution.* Institute for the Study of Human Issues, Philadelphia.

Cohodas, Marvin

2002 Multiplicity and Discourse in Maya Gender Relations. In *Ancient Maya Gender Identity and Relations*, edited by Lowell S. Gustafson and Amelia M. Trevelyan, pp. 11–54. Bergin and Garvey, Westport.

Collins, Richard, James Curran, Nicholas Garnham, Paddy Scannell, Philip Schlesinger, and Colin Sparks (editors)

1986 *Media, Culture and Society: A Critical Reader.* Sage Publications, London.

Conkey, Margaret W., and Christine A. Hastorf (editors)

1993 *The Uses of Style in Archaeology.* Cambridge University Press, Cambridge.

Conkey, Margaret W., and Ruth E. Tringham

1995 Archaeology and the Goddess: Exploring the Contours of Feminist Archaeology. In *Feminisms in the Academy*, edited by Domna C. Stanton and Abigail J. Stewart, pp. 199–247. University of Michigan Press, Ann Arbor.

Conklin Thompson, Susan, Keith Steven Thompson, and Lidia López de López (editors)

2007 *Maya Folktales.* Libraries Unlimited, Westport.

Cook, Anita G.

1992 The Stone Ancestors: Idioms of Imperial Attire and Rank among Huari Figurines. *Latin American Antiquity* 3(4):341–364.

Corson, Christopher

1976 *Maya Anthropomorphic Figurines from Jaina Island, Campeche.* Ballena Press Studies in Mesoamerican Art, Archaeology and Ethnohistory No. 1. Ballena Press, Ramona, CA.

Costin, Cathy L.

1991 Craft Specialization: Issues in Defining, Documenting, and Explaining the Organization of Production. In *Archaeological Method and Theory*, edited by Michael B. Schiffer, pp. 1–56. Vol. 3. University of Arizona Press, Tucson.

2001 Craft Production Systems. In *Archaeology at the Millennium: A Sourcebook*, edited by Gary M. Feinman and T. Douglas Price, pp. 273–344. Kluwer Academic/Plenum Publishers, New York.

Covarrubias, Miguel

1957 *Indian Art of Mexico and Central America.* Alfred A. Knopf, New York.

Cowgill, George L.

1993 Distinguished Lecture in Archaeology: Beyond Criticizing New Archaeology. *American Anthropologist* 95(3):551–573.

Craig, Jessica

2009 Shifting Perceptions of Sacred Spaces: Ceremonial Reuse of Maya Architecture and Monuments at San Bartolo, Guatemala. PhD dissertation, Department of Anthropology, University of Kansas, Lawrence.

Crehan, Kate

2002 *Gramsci, Culture and Anthropology.* University of California Press, Los Angeles.

Cuevas García, Martha

2004 The Cult of Patron and Ancestor Gods in Censers at Palenque. In *Courtly Art of the Ancient Maya*, edited by Mary Miller and Simon Martin, pp. 253–255. Thames and Hudson, New York.

Culbert, T. Patrick
2003 The Ceramics of Tikal. In *Tikal: Dynasties, Foreigners, and Affairs of State*, edited by Jeremy A. Sabloff, pp. 47–82. School of American Research Advanced Seminar Series, Santa Fe.

Culbert, T. Patrick, and Don S. Rice (editors)
1990 *Precolumbian Population History in the Maya Lowlands*. University of New Mexico Press, Albuquerque.

Cyphers Guillén, Ann
1998 Women, Rituals, and Social Dynamics at Ancient Chalcatzingo. In *Reader in Gender Archaeology*, edited by Kelley Hays-Gilpin and David S. Whitley, pp. 269–289. Routledge, London.

Dacus, Chelsea
2005 Weaving the Past: An Examination of Bones Buried with an Elite Maya Woman. Master's thesis, Department of Art History, Southern Methodist University, Dallas.

Dahlin, Bruce H., Daniel Bair, Timothy Beach, Matthew D. Moriarty, and Richard Terry
2010 The Dirt on Food: Ancient Feasts and Markets among the Lowland Maya. In *PreColumbian Foodways: Landscapes of Creation and Origin*, edited by John E. Staller and Michael B. Carrasco, pp. 191–232. Springer, New York.

Dahlin, Bruce H., Christopher T. Jensen, Richard E. Terry, David R. Wright, and Timothy Beach
2007 In Search of an Ancient Maya Market. *Latin American Antiquity* 18(4):363–385.

D'Altroy, Terence N., and Timothy K. Earle
1985 Staple Finance, Wealth Finance, and Storage in the Inka Political Economy. *Current Anthropology* 26(2):187–206.

D'Altroy, Terence N., and Christine A. Hastorf (editors)
2001 *Empire and Domestic Economy*. Kluer Academic/Plenum Publishers, New York.

Danien, Elin C.
1992 Excavating among the Collections: A Reexamination of Three Figurines. In *New Theories on the Ancient Maya*, edited by Elin C. Danien and Robert Sharer, pp. 92–98. University of Pennsylvania Press, Philadelphia.

Day, Jane Stevenson
1998 The West Mexican Ballgame. In *Ancient West Mexico: Art and Archaeology of the Unknown Past*, edited by Richard F. Townsend, pp. 151–168. Thames and Hudson, New York.

De Certeau, Michel
1984 *The Practice of Everyday Life*. University of California Press, Berkeley.

Deetz, James
1977 *In Small Things Forgotten: An Archaeology of Early American Life*. Anchor Books, New York.

Delgado, Hilda S.
1969 Figurines of Backstrap Loom Weavers from the Maya Area. In *Verhandlungen des XXXVIII Amerikanistenkongresses, Stuttgart-München 12. bis 18. August 1968: Vol. I*, pp. 139–149. Kommissionsverlag Klaus Renner, Munich.

Delle, James A.
1999 The Landscapes of Class Negotiation on Coffee Plantations in the Blue Mountains of Jamaica, 1790–1850. *Historical Archeology* 33(1):136–159.

Demarest, Arthur A.
1982 The Dating and Cultural Associations of the "Potbellied" Sculptural Style: New Evidence from Western El Salvador. *American Antiquity* 43(3):557–571.

Demarest, Arthur A., Prudence M. Rice, and Don S. Rice (editors)
2004 *The Terminal Classic in the Maya Lowlands: Collapse, Transition, and Transformation.* University Press of Colorado, Boulder.
DeMarrais, Elizabeth, Luis Jaime Castillo, and Timothy Earle
1996 Ideology, Materialization and Power Strategies. *Current Anthropology* 37:15–31.
DeMarrais, Elizabeth, Chris Gosden, and Colin Renfrew (editors)
2004 *Rethinking Materiality: The Engagement of Mind with the Material World.* McDonald Institute for Archaeological Research, Cambridge.
de Smet, Peter A. G. M., and Nicholas M. Hellmuth
1986 A Multidisciplinary Approach to Ritual Enema Scenes on Ancient Maya Pottery. *Journal of Ethnopharmacology* 16(2–3):213–262.
Díaz del Castillo, Bernal
1963 *The Conquest of New Spain.* Translated by J. M. Cohen. Penguin Books, London.
Dieseldorff, E. P.
1926 *Kunst und Religion der Mayavolker: Im Alten und Heutigen Mittelamerika.* Verlag Von Julius Springer, Berlin.
DiMaggio, Paul
1987 Classification in Art. *American Sociological Review* 52(4):440–455.
Douglas, John G.
2002 *Hinterland Households: Rural Agrarian Household Diversity in Northwestern Honduras.* University Press of Colorado, Boulder.
Douglas, Mary
1966 *Purity and Danger: An Analysis of the Concepts of Pollution and Taboo.* Routledge, New York.
Durkheim, Emile
1965 [1915] *The Elementary Forms of Religious Life.* George Allen and Unwin/Free Press, New York.
Eagleton, Terry
1991 *Ideology: An Introduction.* Verso, London.
Earle, Timothy
1997 *How Chiefs Come to Power: The Political Economy in Prehistory.* Stanford University Press, Stanford.
2002 *Bronze Age Economics: The Beginnings of Political Economies.* Westview Press, Boulder.
Eberl, Markus
2007 Community Heterogeneity and Integration: The Maya Sites of Nacimiento, Dos Ceibas, and Cerro de Cheyo (El Petén, Guatemala) during the Late Classic. PhD dissertation, Anthropology, Tulane University, New Orleans.
Eberl, Markus, and Daniel Graña-Behrens
2004 Proper Names and Throne Names: On the Naming Practice of Classic Maya Rulers. In *Continuity and Change: Maya Religious Practices in Temporal Perspective,* edited by Daniel Graña Behrens, Nikolai Grube, Christian M. Prager, Frauke Sachse, Stefanie Teufel, and Elisabeth Wagner, pp. 101–120. Verlag Anton Saurwein, Markt Schwaben, Germany.
Ekholm, Susanna M.
1979a The Lagartero Figurines. In *Maya Archaeology and Ethnohistory,* edited by Norman Hammond and Gordon R. Willey, pp. 172–186. University of Texas Press, Austin.
1979b The Significance of an Extraordinary Maya Ceremonial Refuse Deposit at Lagartero, Chiapas. *Proceedings of the International Congress of Americanists* 8(8):147–159.
1985 The Lagartero Ceramic "Pendants." In *The Fourth Palenque Round Table, 1980, Vol.*

VII, edited by Merle Greene Robertson and Elizabeth P. Benson, pp. 211–219. Pre-Columbian Art Research Institute, San Francisco.

1990 Una ceremonia de fin-de-ciclo: El gran basuero ceremonial de Lagartero, Chiapas. In *La epoca clásica: Nuevo hallazgods, nuevas ideas*, edited by Amalia Cardós de Méndez, pp. 455–467. Museo Nacional de Arqueología, Mexico City.

1991 Ceramic Figurines and the Mesoamerican Ballgame. In *The Mesoamerican Ballgame*, edited by Vernon L. Scarborough and David R. Wilcox, pp. 241–249. University of Arizona Press, Tucson.

Elson, Christina M., and R. Alan Covey (editors)

2006 *Intermediate Elites in Pre-Columbian States and Empires*. University of Arizona Press, Tucson.

Emerson, Thomas E.

1997 *Cahokia and the Archaeology of Power*. University of Alabama Press, Tuscaloosa.

Evans, Susan Toby

1998 Sexual Politics in the Aztec Palace. *RES: Anthropology and Aesthetics* 33:167–183.

Farriss, Nancy M.

1984 *Maya Society under Colonial Rule: The Collective Enterprise of Survival*. Princeton University Press, Princeton.

Fash, Barbara W.

1992 Late Classic Architectural Sculpture Themes in Copan. *Ancient Mesoamerica* 3:89–104.

Fash, Barbara W., and William L. Fash

2007 The Roles of Ballgames in Mesoamerican Ritual Economy. In *Mesoamerican Ritual Economy: Archaeological and Ethnological Perspectives*, edited by E. Christian Wells and Karla L. Davis-Salazar, pp. 267–284. University Press of Colorado, Boulder.

Faust, Katherine A., and Christina T. Halperin

2009 Approaching Mesoamerican Figurines. In *Mesoamerican Figurines: Small-Scale Indices of Large-Scale Phenomena*, edited by Christina T. Halperin, Katherine A. Faust, Rhonda Taube and Aurora Giguet, pp. 1–22. University Press of Florida, Gainesville.

Fedick, Scott L. (editor)

1996 *The Managed Mosaic: Ancient Maya Agriculture and Resource Use*. University of Utah Press, Salt Lake City.

Feinman, Gary M.

1998 Scale and Social Organization: Perspectives on the Archaic State. In *Archaic States*, edited by Gary E. Feinman and Joyce Marcus, pp. 95–133. School of American Research, Santa Fe.

1999 Rethinking Our Assumptions: Economic Specialization at the Household Scale in Ancient Ejutla, Oaxaca, Mexico. In *Pottery and People: A Dynamic Interaction*, edited by James M. Skibo and Gary M. Feinman, pp. 81–98. University of Utah Press, Salt Lake City.

Feinman, Gary M., and Joyce Marcus (editors)

1998 *Archaic States*. School of American Research, Santa Fe.

Ferree, Lisa

1972 The Pottery Censers of Tikal, Guatemala. PhD dissertation, Department of Anthropology, Southern Illinois University, Carbondale.

Few, Martha

1995 Women, Religion, and Power: Gender and Resistance in Daily Life in Late-Seventeenth-Century Santiago de Guatemala. *Ethnohistory* 42(4):627–637.

2002 *Women Who Live Evil Lives: Gender, Religion, and the Politics of Power in Colonial Guatemala*. University of Texas Press, Austin.

Finamore, Daniel, and Stephen D. Houston (editors)

2010 *Fiery Pool: The Maya and the Mythic Sea*. Yale University Press, New Haven.

Flannery, Kent V.

1999 The Ground Plans of Archaic States. In *Archaic States*, edited by Gary M. Feinman and Joyce Marcus, pp. 15–58. School of American Research, Santa Fe.

Foias, Antonia E.

2006 Ritual, Politics, and Pottery Economies in the Classic Maya Southern Lowlands. In *Mesoamerican Ritual Economy: Archaeological and Ethnological Perspectives*, edited by E. Christian Wells and Karla L. Davis-Salazar, pp. 167–194. University Press of Colorado, Boulder.

Foias, Antonia E., and Ronald L. Bishop

2007 Pots, Sherds, Glyphs: Pottery Production and Exchange in the Petexbatun Polity, Petén, Guatemala. In *Pottery Economics in Mesoamerica*, edited by Christopher A. Pool and George J. Bey III, pp. 212–236. University of Arizona Press, Tucson.

Foias, Antonia E., and Kitty F. Emery (editors)

2012 *Motul de San José: Politics, History, and Economy in a Classic Maya Polity*. University Press of Florida, Gainesville.

Foias, Antonia E., Christina T. Halperin, and Ellen Spensley

2012 Excavations in the Center of Motul de San José: Architecture, Volumetrics, and Social Status. In *Motul de San José: Politics, History, and Economy in a Classic Maya Polity*, edited by Antonia E. Foias and Kitty F. Emery, pp. 94–138. University Press of Florida, Gainesville.

Folan, William J.

1992 Calakmul, Campeche: A Centralized Urban Administrative Center in the Northern Peten. *World Archaeology* 24(1):158–168.

Folan, William J., Joel D. Gunn, and María del Rosario Domínguez Carrasco

2001 Triadic Temples, Central Plazas, and Dynastic Palaces: A Diachronic Analysis of the Royal Court Complex, Calakmul, Mexico. In *Royal Courts of the Ancient Maya: Volume 2, Data and Case Studies*, edited by Takeshi Inomata and Stephen D. Houston, pp. 223–265. Westview Press, Boulder.

Follensbee, Billie J. A.

2006 The Child and the Childlike in Olmec Art and Archaeology. In *The Social Experience of Childhood in Ancient Mesoamerica*, edited by Traci Ardren and Scott R. Hutson, pp. 249–282. University Press of Colorado, Boulder.

Forbes, John

2004 Ocarinas in the Maya World. BA honors thesis, University College London, London.

Foster, George

1944 Nagualism in Mexico and Guatemala. *Acta Americana* 2:85–103.

Foucault, Michel

1977 *Discipline and Punish: The Birth of the Prison*. Vintage Books, New York.

1980 *Power/Knowledge: Selected Interviews and Other Writings 1972–1977*. Pantheon Books, New York.

Fox, John G.

1996 Playing with Power: Ballcourts and Political Rituals in Southern Mesoamerica. *Current Anthropology* 37(3):483–510.

Fox, John W., Garrett W. Cook, Arlen F. Chase, and Diane Z. Chase
1996 Questions of Political and Economic Integration: Segmentary versus Centralized States among the Ancient Maya. *Current Anthropology* 37(5):795–801.

Freidel, David, and Stanley Guenter
2003 Bearers of War and Creation. *Archaeology*. www.archaeology.org/online/features /siteq2/ (accessed March 23, 2011).

Freidel, David A., Maria Masucci, Susan Jaeger, and Robin A. Robertson
1991 The Bearer, the Burden, and the Burnt: The Stacking Principal in the Iconography of the Late Preclassic Maya Lowlands. In *Sixth Palenque Round Table, 1986*, edited by Merle Green Robertson and Virginia M. Fields, pp. 175–183. University of Oklahoma Press, Norman.

Freidel, David, Michelle Rich, and F. Kent Reilly III
2010 Resurrecting the Maize King. *Archaeology* 63(5):42–45.

Freidel, David A., Linda Schele, and Joy Parker
1993 *Maya Cosmos: Three Thousand Years on the Shaman's Path*. Morrow, New York.

Fried, Morton H.
1967 *The Evolution of Political Society*. Random House, New York.

Friedman, Jonathan, and Michael J. Rowlands (editors)
1977 *The Evolution of Social Systems*. University of Pittsburgh Press, Pittsburgh.

Fry, Robert E.
1979 The Economics of Pottery at Tikal: Models of Exchange for Serving Vessels. *American Antiquity* 44(3):494–512.

1980 Models of Exchange for Major Shape Classes of Lowland Maya Pottery. In *Models and Methods in Regional Exchange*, edited by Robert E. Fry, pp. 3–18. SAA Papers No. 1. Society for American Archaeology, Washington, DC.

Gailey, Christine W.
1987a Culture Wars: Resistance to State Formation. In *Power Relations and State Formation*, edited by Thomas C. Patterson and Christine W. Gailey, pp. 35–56. American Anthropological Association, Washington, DC.

1987b *Kinship to Kingship: Gender Hierarchy and State Formation in the Tongan Islands*. University of Texas Press, Austin.

Gailey, Christine W., and Thomas C. Patterson
1987 State Formation and Uneven Development. In *The Emergence and Development of Social Hierarchy and Political Centralisation*, edited by John Gledhill, Barbara Bender, and Mogens Larsen, pp. 77–90. George Allen Unwin, London.

Gallegos Gómora, Miriam Judith
2003 Mujeres y hombres de barro: Figurillas de Comalcalco. *Arqueología Mexicana* 11(61):48–51.

2008 Manufactura, iconografía, y distribución de figurillas en Comalcalco Tabasco, México. In *XXII Simposio de Investigaciones Arqueológicas en Guatemala*, edited by Juan Pedro Laporte, Bárbara Arroyo, and Héctor E. Mejía, pp. 1051–1061. Instituto de Antropología e Historia (IDAEH) y Asociación Tikal, Guatemala City.

2009 Las figurillas de Chinchicapa: Producción, representaciones, y asociación de materiales en una unidad habitacional del Clásico Maya en Tabasco. Manuscript on file with the author.

n.d. La Corte Real de Joy'Chan a través de las mujeres, hombres, y dioses de barro: Estudio preliminar de género. Manuscript on file with the author.

Gallegos Gómora, Miriam Judith, Ricardo Armijo Torres, and Claudio Charosky

2007 Figurillas y representaciones de enanos en el mundo prehispánico maya. In *Los Investigadores de la Cultura Maya* 16(II). Campeche, Mexico.

Geertz, Clifford

1980 *Negara: The Theatre State in Nineteenth-Century Bali.* Princeton University Press, Princeton.

Gell, Alfred

1998 *Art and Agency: An Anthropological Theory.* Clarendon Press, Oxford.

Gerstle, Andrea Irene

1988 Maya-Lenca Ethnic Relations in Late Classic Period Copan, Honduras. PhD dissertation, Anthropology, University of California, Santa Barbara.

Gifford, James C.

1976 *Prehistoric Pottery Analysis and the Ceramics of Barton Ramie in the Belize Valley.* Memoirs of the Peabody Museum of Archaeology and Ethnology 18. Harvard University, Cambridge. MA.

Gilchrist, Roberta

1999 *Gender and Archaeology: Contesting the Past.* Routledge, London.

Gillespie, Susan D.

2000 Rethinking Ancient Maya Social Organization: Replacing "Lineage" with "House." *American Anthropologist* 102(3):467–484.

2008 Embodied Persons and Heroic Kings in Late Classic Maya Imagery. In *Past Bodies: Body-Centered Research in Archaeology*, edited by Dusan Boric and John Robb, pp. 125–134. Oxbow Books, Oxford.

Gluckman, Max

1965 *Politics, Law, and Ritual in Tribal Society.* Aldine Publishing, Chicago.

Goffman, Erving

1963 *Behavior in Public Places: Notes on the Social Organization of Gatherings.* Free Press, Glencoe.

Goldsmith, Kim Cynthia

2000 Forgotten Images: A Study of the Ceramic Figurines from Teotihuacan, Mexico. PhD dissertation, Anthropology, University of California, Riverside.

Goldstein, Marilyn M.

1979 Maya Figurines from Campeche, Mexico: Classification on the Basis of Clay Chemistry, Style and Iconography. PhD dissertation, Department of Anthropology, Columbia University, New York.

1980 Relationships between the Figurines of Jaina and Palenque. In *The Third Palenque Round Table, 1978, Part 2*, edited by Merle Greene Robertson, pp. 91–98. University of Texas Press, Austin.

1994 Late Classic Maya-Veracruz Figurines: A Consideration of the Significance of Some Traits Rejected in the Cultural Exchange. In *Seventh Palenque Round Table, 1989*, edited by Merle Greene Robertson and Virginia M. Fields, pp. 169–175. University of Texas Press, Austin.

Gonlin, Nancy

1994 Rural Household Diversity in Late Classic Copan, Honduras. In *Archaeological Views from the Countryside: Village Communities in Early Complex Societies*, edited by G. M. Schwartz and S. E. Falconer, pp. 177–197. Smithsonian Institution Press, Washington, DC.

2007 Ritual and Ideology among Classic Maya Rural Commoners at Copán, Honduras. In *Commoner Ritual and Ideology in Ancient Mesoamerica*, edited by Nancy Gonlin and Jon C. Lohse, pp. 83–121. University Press of Colorado, Boulder.

Gonlin, Nancy, and Jon C. Lohse (editors)
2007 Commoner Ritual and Ideology in Ancient Mesoamerica. University Press of Colorado, Boulder.
Graham, Elizabeth
1987 Terminal Classic to Early Historic Period Vessel Forms from Belize. In Maya Ceramics: Papers from the 1985 Maya Ceramic Conference, edited by Prudence M. Rice and Robert J. Sharer, pp. 73–98. BAR International Series 34.5(i), BAR, Oxford.
Graham, Ian
1996 Corpus of Maya Hieroglyphic Inscriptions, Vol. 7, Part 1: Seibal. Peabody Museum of Archaeology and Ethnology, Harvard University, Cambridge, MA.
Gramsci, Antonio
1973 Letters from Prison: Antonio Gramsci: Selected, Translated from the Italian, and Introduced by Lynne Lawner. Harper and Row, New York.
Grove, David C., and Susan D. Gillespie
1992 Ideology and Evolution at the Pre-State Level: Formative Period Mesoamerica. In Ideology and Pre-Columbian Civilizations, edited by Arthur A. Demarest and Geoffrey W. Conrad, pp. 15–36. School of American Research Press, Santa Fe.
Grube, Nikolai
2004 Akan: The God of Drinking, Disease, and Death. In Continuity and Change: Maya Religious Practices in Temporal Perspective, edited by Daniel Graña Behrens, Nikolai Grube, Christian M. Prager, Frauke Sachse, Stefanie Teufel, and Elisabeth Wagner, pp. 59–76. Fifth European Maya Conference, University of Bonn. Verlag Anton Saurwein, Markt Schwaben, Germany.
Grube, Nikolai, and Werner Nahm
1994 A Census of Xibalba: A Complete Inventory of Way Characters on Maya Ceramics. In The Maya Vase Database: A Corpus of Rollout Photographs of Maya Vases, edited by Justin Kerr, pp. 686–715. Kerr Associates, New York.
Guernsey, Julia
2006 Ritual and Power in Stone: The Performance of Rulership in Mesoamerica Izapan Style Art. University of Texas Press, Austin.
2012 Sculpture and Social Dynamics in Preclassic Mesoamerica. Cambridge University Press, Cambridge.
Gustafson, Lowell S.
2002 Shared Gender Relations: Early Mesoamerica and the Maya. In Ancient Maya Gender Identity and Relations, edited by Lowell S. Gustafson and Amelia M. Trevelyan, pp. 141–168. Bergin and Garvey, Westport.
Hall, Stuart
2006 Popular Culture and the State. In The Anthropology of the State, edited by Aradhana Sharma and Akhil Gupta, pp. 360–380. Blackwell, Malden, MA.
Halliwell, Stephen
2002 The Aesthetics of Mimesis: Ancient Texts and Modern Problems. Princeton University Press, Princeton, NJ.
Halperin, Christina T.
2004a Las figurillas de Motul de San José: Producción y representación. In XVIII Simposio de investigaciones arqueológicas en Guatemala, edited by Juan Pedro Laporte, Bárbara Arroyo, and Héctor E. Mejía, pp. 781–793. Instituto de Antropología e Historia (IDAEH) y Asociación Tikal, Guatemala City.
2004b Realeza maya y figurillas con tocados de la Serpiente de Guerra de Motul de San José, Guatemala. Mayab 17:45–60.

2007 Materiality, Bodies, and Practice: The Political Economy of Late Classic Figurines from Motul de San José, Petén, Guatemala. PhD dissertation, Department of Anthropology, University of California, Riverside, Riverside.

2008a Classic Maya Textile Production: Insights from Motul de San José, Peten, Guatemala. *Ancient Mesoamerica* 19:111–125.

2008b Economic Representations in Archaeology: Cultural Evolution, Gender, and Craft Production. In *Economic Representation: Academic and Everyday*, edited by David Ruccio, pp. 125–138. Routledge, New York.

2009a Analysis of Ceramic Figurines from Pook's Hill, Cayo District, Belize. Manuscript on file with the author.

2009b El colapso maya y las figurillas del noreste del Petén: Figurillas del Proyecto Protección de Sitios Arqueológicos en Petén (PROSIAPETEN). In Report Submitted to the Instituto de Antropología e Historia (IDAEH), Ministerio de Cultura y Deportes and the Consejo Técnico de Arqueología. Guatemala City.

2009c Figurines as Bearers of and Burdens in Late Classic Maya State Politics. In *Mesoamerican Figurines: Small-Scale Indices of Large-Scale Phenomena*, edited by Christina T. Halperin, Katherine A. Faust, Rhonda Taube, and Aurora Giguet, pp. 378–403. University Press of Florida, Gainesville.

2010 Late Classic–Postclassic (ca. AD 600–1525) Maya Figurines from Sites in the Petén Lakes Region, Guatemala. Proyecto Arqueológico Itzá del Petén (PAIP) and Proyecto Maya Colonial (PMC) Figurine Report. Manuscript on file with the author.

2011 La transición política durante el Periodo Clásico Terminal: Una perspectiva de las figurillas de cerámica. In *XXV Simposio de Investigaciones Arqueológicas en Guatemala*, edited by Bárbara Arroyo, Lorena Paiz, and Héctor Mejía. Instituto de Antropología e Historia de Guatemala, Asociación Tikal, Guatemala City.

2012 The Political Economy of Motul de San José Figurines. In *Motul de San José: Politics, History, and Economy in a Classic Maya Polity*, edited by Antonia E. Foias and Kitty F. Emery, pp. 139–166. University Press of Florida, Gainesville.

2014 Circulation as Place-Making: Late Classic Maya Polities and Portable Objects. *American Anthropologist*.

Halperin, Christina T., Ronald L. Bishop, Ellen Spensley, and M. James Blackman
2009 Late Classic (A.D. 600–900) Maya Market Exchange: Analysis of Figurines from the Motul de San José Region, Guatemala. *Journal of Field Archaeology* 43(4):457–480.

Halperin, Christina T., and Antonia E. Foias
2010 Pottery Politics: Late Classic Maya Palace Production at Motul de San José, Petén, Guatemala. *Journal of Anthropological Archaeology* 29:392–411.

2012 Motul de San José Palace Pottery Production: Reconstructions from Wasters and Debris. In *Motul de San José: Politics, History, and Economy in a Classic Maya Polity*, edited by Antonia E. Foias and Kitty F. Emery, pp. 167–193. University Press of Florida, Gainesville.

Halperin, Christina T., and Gerson Martínez Salguero
2006 Localizando evidencia de basureros y producción cerámica por medio de reconocimiento geofísico en Motul de San José, Petén. In *XX Simposio de Investigaciones Arqueológicas en Guatemala*, edited by Juan Pedro Laporte, Bárbara Arroyo, and Héctor E. Mejía, pp. 1073–1084. Instituto de Antropología e Historia de Guatemala, Asociación Tikal, Guatemala City.

Hammel, E. A.

1980 Household Structure in Fourteenth-Century Macedonia. *Journal of Family History* 5:242–273.

1984 On the *** of Studying Household Form and Function. In *Households: Comparative and Historical Studies of the Domestic Group*, edited by Robert McC. Netting, Richard R. Wilk, and Eric J. Arnould, pp. 29–44. University of California Press, Berkeley.

Hammond, Norman

1972 Classic Maya Music: Part II, Rattles, Shakers, Raspers, Wind and String Instruments. *Archaeology* 25(3):222–228.

1975 *Lubaantun: A Classic Maya Realm*. Peabody Museum Monographs, No. 2. Harvard University, Cambridge, MA.

Hammond, Norman, and Jeremy R. Bauer

2001 A Preclassic Maya Sweatbath at Cuello, Belize. *Antiquity* 75:683–684.

Hastorf, Christine

1991 Gender, Space, and Food in Prehistory. In *Engendering Archaeology: Women and Prehistory*, edited by Joan M. Gero and Margaret W. Conkey, pp. 132–159. Basil Blackwell, Oxford.

2001 Agricultural Production and Consumption. In *Empire and Domestic Economy*, edited by Terence N. D'Altroy and Christine E. Hastorf, pp. 155–178. Kluwer Academic/Plenum Publishers, New York.

Haviland, William A.

1985 *Tikal Report No. 19: Excavations in Small Residential Groups of Tikal—Groups 4F-1 and 4F-2*. University Museum Monographs 58. University Museum, University of Pennsylvania, Philadelphia.

Healy, Paul F.

1988 Music of the Maya. *Archaeology* 41(1):24–31.

Helmke, Christophe G. B.

2006a A Report of the 2005 Season of Archaeological Investigations at Pook's Hill, Cayo District, Belize. In *The Belize Valley Archaeological Reconnaissance Project: A Report of the 2005 Field Season*, edited by Christophe G. B. Helmke and Jaime J. Awe, pp. 39–92. Institute of Archaeology, National Institute of Culture and History, Belmopan.

2006b A Summary of the 1999–2002 Seasons of Archaeological Investigations at Pook's Hill, Cayo District, Belize. *Research Reports in Belizean Archaeology* 3:173–191.

Helms, Mary W.

1993 *Craft and the Kingly Ideal: Art, Trade, and Power*. University of Texas Press, Austin.

Hendon, Julia A.

1991 Status and Power in Classic Maya Society: An Archaeological Study. *American Anthropologist* 93:894–918.

1996 Archaeological Approaches to the Organization of Domestic Labor: Household Practice and Domestic Relations. *Annual Review of Anthropology* 25:45–61.

2000 Having and Holding: Storage, Memory, Knowledge, and Social Relations. *American Anthropologist* 102:42–53.

2003 In the House: Maya Nobility and Their Figurine-Whistles. *Expedition* 45(3):28–33.

2007 The Engendered Household. In *Women in Antiquity: Theoretical Approaches to Gender and Archaeology*, edited by Sarah Milledge Nelson, pp. 141–168. AltaMira Press, Walnut Creek, CA.

2010 *Houses in a Landscape: Memory and Everyday Life in Mesoamerica*. Duke University Press, Durham.

Hermes, Bernard

2000 Ofrendas. In *El sitio maya de Topoxte: Investigaciones en una isla del lago Yaxhá, Petén, Guatemala*, edited by Wolfgang W. Wurster, pp. 77–91. Verlag Philipp Von Zabern, Mainz am Rhein.

Hernández, Carlos, Robert H. Cobean, Alba Guadalupe Mastache, and María Elena Suárez

1999 Un taller de alfareros en la antigua ciudad de Tula. *Arqueología* 22:69–88.

Hirth, Kenneth G.

1998 The Distributional Approach: A New Way to Identify Marketplace Exchange in the Archaeological Record. *Current Anthropology* 39(4):451–476.

Hobsbawm, Eric

1983 Introduction: Inventing Tradition. In *The Invention of Tradition*, edited by Eric Hobsbawm and T. Ranger, pp. 1–14. Cambridge University Press, Cambridge.

Hodgson, John G., John E. Clark, and Emiliano Gallaga Murrieta

2010 Ojo de Agua Monument 3: A New Olmec Sculpture from Ojo de Agua, Chiapas, Mexico. *Mexicon* 32(6):139–144.

Hofling, C. Andrew

1991 *Itzá Maya Texts with a Grammatical Overview*. University of Utah Press, Salt Lake City.

Houston, Stephen D.

1992 A Name Glyph for Classic Maya Dwarfs. In *The Maya Vase Book: A Corpus of Rollout Photographs of Maya Vases*, edited by Justin Kerr, pp. 526–531. Vol. 3. Kerr Associates, New York.

1996 Symbolic Sweatbaths of the Maya: Architectural Meaning in the Cross Group at Palenque, Mexico. *Latin American Antiquity* 7(2):132–151.

1998 Finding Function and Meaning in Classic Maya Architecture. In *Function and Meaning in Classic Maya Architecture*, edited by Stephen D. Houston, pp. 519–538. Dumbarton Oaks Research Library and Collection, Washington, DC.

2006 Impersonation, Dance, and the Problem of Spectacle among the Classic Maya. In *Archaeology of Performance: Theatres of Power, Community, and Politics*, edited by Takeshi Inomata and Lawrence S. Coben, pp. 135–155. AltaMira Press, Lanham, MD.

2009 A Splendid Predicament: Young Men in Classic Maya Society. *Cambridge Archaeological Journal* 19(2):149–178.

Houston, Stephen D., and Patricia A. McAnany

2003 Bodies and Blood: Critiquing Social Construction in Maya Archaeology. *Journal of Anthropological Archaeology* 22:26–41.

Houston, Stephen, and David Stuart

1989 The *Way* Glyph: Evidence for "Co-essences" among the Classic Maya. *Research Reports on Ancient Maya Writing* 30:1–16.

1996 Of Gods, Glyphs and Kings: Divinity and Rulership among the Classic Maya. *Antiquity* 70:289–312.

1998 The Ancient Maya Self: Personhood and Portraiture in the Classic Period. *RES: Anthropology and Aesthetics* 33:73–101.

Houston, Stephen, David Stuart, and Karl Taube

2006 *The Memory of Bones: Body, Being, and Experience among the Classic Maya*. University of Texas Press, Austin.

Houston, Stephen, and Karl Taube

1987 Name-Tagging in Classic Maya Script. *Mexicon* 9(2):38–41.

2000 An Archaeology of the Senses: Perception and Cultural Expression in Ancient Mesoamerica. *Cambridge Archaeological Journal* 10(2):261–294.

Howell, Mark

2009 Music Syncretism in the Postclassic K'iche' Warrior Dance and the Colonial Period Baile de los Moros y Cristianos. In *Maya Worldviews at Conquest*, edited by Leslie G. Cecil and Timothy W. Pugh, pp. 279–297. University Press of Colorado, Boulder.

Hutcheson, Maury

2009 Memory, Mimesis, and Narrative in the K'iche' Mayan Serpent Dance of Joyabaj, Guatemala. *Comparative Studies in Society and History* 51(4):865–895.

Hutson, Scott R.

2010 *Dwelling, Identity, and the Maya*. AltaMira, Lanham, MD.

Iannone, Gyles

2002 Annales History and the Ancient Maya State: Some Observations on the "Dynamic Model." *American Anthropologist* 104(1):68–78.

Iannone, Gyles, and Samuel V. Connell (editors)

2002 *Perspectives on Ancient Maya Rural Complexity*. Cotsen Institute of Archaeology, University of California, Los Angeles.

Inomata, Takeshi

1995 Archaeological Investigations at the Fortified Center of Aguateca, El Petén, Guatemala. PhD dissertation, Department of Anthropology, Vanderbilt University, Nashville.

2001a Classic Maya Palace as a Political Theater. In *Reconstruyendo la ciudad Maya: El urbanismo en las sociedades antiguas*, edited by Andrés Ciudad Ruiz, María J. Iglesias Ponce de León, and María de Carmen Martínez, pp. 341–362. Sociedad Española de Estudios Mayas, Madrid.

2001b The Power and Ideology of Artistic Creation. *Current Anthropology* 42(3):321–348.

2004 The Spatial Mobility of Non-elite Populations in Classic Maya Society and Its Political Implications. In *Ancient Maya Commoners*, edited by Jon C. Lohse and Fred Valdez Jr., pp. 175–196. University of Texas Press, Austin.

2006a Plazas, Performers, and Spectators: Political Theaters of the Classic Maya. *Current Anthropology* 47:805–842.

2006b Politics and Theatricality in Mayan Society. In *Archaeology of Performance: Theatres of Power, Community, and Politics*, edited by Takeshi Inomata and Lawrence S. Coben, pp. 187–221. AltaMira Press, Lanham, MD.

Inomata, Takeshi, and Stephen D. Houston (editors)

2001 *Royal Courts of the Ancient Maya*. 2 vols. Westview Press, Boulder, CO.

Inomata, Takeshi, and Laura R. Stiver

1998 Floor Assemblages from Burned Structures at Aguateca, Guatemala: A Study of Classic Maya Households. *Journal of Field Archaeology* 25(4):431–452.

Inomata, Takeshi, Daniela Triadan, Erick Ponciano, Estela Pinto, Richard E. Terry, and Markus Eberl

2002 Domestic and Political Lives of Classic Maya Elites: The Excavation of Rapidly Abandoned Structures at Aguateca. *Latin American Antiquity* 13(3):305–330.

Ishihara, Reiko

2007 Bridging the Chasm between Religion and Politics: Archaeological Investigations of the Grietas at the Late Classic Maya Site of Aguateca, Petén, Guatemala. PhD dissertation, Department of Anthropology, University of California, Riverside.

2008 Rising Clouds, Blowing Winds: Late Classic Maya Rain Rituals in the Main Chasm, Aguateca, Guatemala. *World Archaeology* 40(2):169–189.

Ivic de Monterroso, Matilde

1999 Las figurillas de Piedras Negras: Un análisis preliminar. In Proyecto Arqueológico

Piedras Negras: Informe preliminar no. 3, Tercera temporada, 1999, edited by Hector L. Escobedo and Stephen Houston, pp. 359–373. Report submitted to the Instituto de Antropología e Historia, Guatemala City.

2002 Resultados de los análises de las figurillas de Piedras Negras. In *XV Annual Simposio de Investicaciónes Arqueologicas en Guatemala, 2001*, edited by Juan Pedro LaPorte, Héctor Escobedo, and Bárbara Arroyo, pp. 555–568. Museo Nacional de Arqueología y Etnología, Guatemala City.

Jackson, Sarah
2009 Imagining Courtly Communities: An Exploration of Classic Maya Experiences of Status and Identity through Painted Ceramic Vessels. *Ancient Mesoamerica* 20:71–85.

Jackson, Sarah, and David Stuart
2001 Aj K'uhun Title: Deciphering a Classic Maya Term of Rank. *Ancient Mesoamerica* 12(2):217–228.

Janusek, John W.
1999 Craft and Local Power: Embedded Specialization in Tiwanaku Cities. *Latin American Antiquity* 10(2):107–131.

Jennings, Justin
2010 *Globalizations and the Ancient World*. Cambridge University Press, Cambridge.

Johnson, A. W., and Timothy K. Earle
2000 *The Evolution of Human Societies*. 2nd ed. Stanford University Press, Stanford.

Jones, Christopher, and Linton Satterthwaite
1982 *The Monuments and Inscriptions of Tikal: The Carved Monuments*. Tikal Report No. 33. University Museum Publications, University of Pennsylvania, Philadelphia.

Jones, Grant D.
1992 The Canek Manuscript in Ethnohistorical Perspective. *Ancient Mesoamerica* 3:243–268.

1998 *The Conquest of the Last Maya Kingdom*. Stanford University Press, Stanford.

Josserand, J. Kathryn
2002 Women in Classic Maya Hieroglyphic Texts. In *Ancient Maya Women*, edited by Traci Ardren, pp. 114–151. AltaMira Press, Walnut Creek, CA.

Joyce, Arthur A., Laura Arnaud Bustamente, and Marc N. Levine
2001 Commoner Power: A Case Study from the Classic Period Collapse on the Oaxaca Coast. *Journal of Archaeological Method and Theory* 8(4):343–385.

Joyce, Arthur A., and Errin T. Weller
2007 Commoner Rituals, Resistance, and the Classic-to-Postclassic Transition in Ancient Mesoamerica. In *Commoner Ritual and Ideology in Ancient Mesoamerica*, edited by Nancy Gonlin and Jon C. Lohse, pp. 143–184. University Press of Colorado, Boulder.

Joyce, Rosemary A.
1993 Women's Work: Images of Production and Reproduction in Pre-Hispanic Southern Central America. *Current Anthropology* 34(3):255–274.

1996 The Construction of Gender in Classic Maya Monuments. In *Gender in Archaeology*, edited by Rita P. Wright, pp. 167–195. University of Pennsylvania Press, Philadelphia.

1998 Performing the Body in Pre-Hispanic Central America. *RES: Anthropology and Aesthetics* 33:147–165.

2000a *Gender and Power in Prehispanic Mesoamerica*. University of Texas Press, Austin.

2000b Girling the Girl and Boying the Boy: The Production of Adulthood in Ancient Mesoamerica. *World Archaeology* 31:473–483.

2003a Concrete Memories: Fragments of the Past in the Classic Maya Present (500–100 AD). In *Archaeologies of Memory*, edited by Ruth M. Van Dyke and Susan E. Alcock, pp. 104–127. Blackwell, Oxford.

2003b Making Something of Herself: Embodiment in Life and Death at Playa de los Muertos, Honduras. *Cambridge Archaeological Journal* 13(2):248–261.

2004 Embodied Subjectivity: Gender, Femininity, Masculinity, Sexuality. In *A Companion to Social Archaeology*, edited by Lynn Meskell and Robert Preucel, pp. 82–95. Blackwell, Oxford.

Joyce, Rosemary A., and Susan Gillespie (editors)

2000 *Beyond Kinship: Social and Material Reproduction in House Societies.* University of Pennsylvania Press, Philadelphia.

Joyce, T. A.

1933 The Pottery-Whistle Figurines of Lubaantun. *Journal of the Royal Anthropological Institute of Great Britain and Ireland* 63:xv–xxv.

Just, Bryan R.

2009 Mysteries of the Maize God. *Princeton University Art Museum Record* 68:3–16.

Kearney, Michael

1995 The Local and the Global: The Anthropology of Globalization and Transnationalism. *Annual Review of Anthropology* 24:547–565.

Kertzer, David I.

1988 *Ritual, Politics, and Power.* Yale University Press, New Haven.

Kidder, Alfred I., and Samayoa Chinchilla, Carlos

1959 *The Art of the Ancient Maya.* Detroit Institute of Arts, Detroit.

Klein, Cecelia F.

2001 None of the Above: Gender Ambiguity in Nahua Ideology. In *Gender in Pre-Hispanic America*, edited by Cecelia F. Klein, pp. 183–253. Dumbarton Oaks Research Library and Collection, Washington, DC.

Klein, Cecelia F., and Naoli Victoria Lona

2009 Sex in the City: A Comparison of Aztec Ceramic Figurines to Copal Figurines from the Templo Mayor. In *Mesoamerican Figurines: Small-Scale Indices of Large-Scale Phenomena*, edited by Christina T. Halperin, Katherine A. Faust, Rhonda Taube, and Aurora Giguet, pp. 327–377. University Press of Florida, Gainesville.

Koepping, Klaus-Peter

1985 Absurdity and Hidden Truth: Cunning Intelligence and Grotesque Body Images as Manifestations of the Trickster. *History of Religions* 24(3):191–214.

Kristan-Graham, Cynthia

1989 *Art, Rulership, and the Mesoamerican Body Politic at Tula and Chichen Itza.* Department of Art History, University of California, Los Angeles.

Kurbjuhn, Kornelia

1985 Busts in Flowers: A Singular Theme in Jaina Figurines. In *Fourth Palenque Round Table, 1980*, edited by Elizabeth P. Benson, pp. 221–223. Pre-Columbian Art Research Institute, San Francisco.

Kus, Susan, and Victor Raharijaona

1998 Between Earth and Sky There Are Only a Few Boulders: Sovereignty and Monumentality in Central Madagascar. *Journal of Anthropological Archaeology* 17:53–79.

2000 House to Palace, Village to State: Scaling up Architecture and Ideology. *American Anthropologist* 102(1):98.

2001 To Dare to Wear the Cloak of Another before Their Very Eyes: State Co-optation and Local Re-Appropriation in Mortuary Rituals of Central Madagascar. In *Social*

Memory, Identity, and Death: Anthropological Perspectives on Mortuary Rituals, edited by M. Chesson, pp. 114–131. AAA Archaeological Papers, No. 10. American Anthropological Association, Washington, DC.

Lacadena, Alfonso
2008 El título lakam: Evidencia epigráfica sobre la organización tributaria y militar interna de los reinos mayas del Clásico. *Mayab* 20:23–43.

Laporte, Juan Pedro
2008 El embrujo del tecolote y otras historietas: Algunas consideraciones sobre los silbatos del Clásico de Tikal. In *XXII Simposio de Investigaciones Arqueológicas en Guatemala*, edited by Juan Pedro Laporte, Bárbara Arroyo, and Héctor E. Mejía, pp. 949–955. Instituto de Antropología e Historia (IDAEH) y Asociación Tikal, Guatemala City.

Laporte, Juan Pedro, and María Josefa Iglesias Ponce de León
1990 Más allá de Mundo Perdido: Investigación en groupos residenciales de Tikal. *Mayab* 12:32–57.

Laporte, Juan Pedro, Mara A. Reyes, and Jorge E. Chocón
2004 Catálogo de figurillas y silbatos de barro del Atlas Arqueológico de Guatemala. In *Reconocimiento y excavaciones arqueológicas en los municipios de La Libertad y Dolores y Poptun, Petén*, edited by Juan Pedro Laporte and Héctor Mejía, pp. 295–344. Atlas Arqueológico de Guatemala y Área de Arqueología, Guatemala City.

Latour, Bruno
2005 *Reassembling the Social: An Introduction to Actor-Network-Theory*. Oxford University Press, Oxford.

Laughlin, Robert M.
1977 *Of Cabbages and Kings: Tales from Zinacatán*. Smithsonian Contributions to Anthropology, No. 23. Smithsonian Institution Press, Washington, DC.

LeCount, Lisa J.
1996 Pottery and Power: Feasting, Gifting, and Displaying Wealth among Late and Terminal Classic Lowland Maya. PhD dissertation, Department of Anthropology, University of California, Los Angeles.

LeCount, Lisa J., and Jason Yaeger (editors)
2010 *Provincial Politics: Xunantunich and Its Hinterlands*. University of Arizona Press, Tucson.

Lederman, R.
1998 Globalization and the Future of Culture Areas: Melanesianist Anthropology in Transition. *Annual Review of Anthropology* 27:427–449.

Lee, Thomas A.
1969 *The Artifacts of Chiapa de Corzo, Chiapas, Mexico*. Papers of the New World Archaeological Foundation No. 26. Brigham Young University, Provo.

Lesure, Richard G.
1997 Figurines and Social Identities in Early Sedentary Societies of Coastal Chiapas, Mexico, 1550–800 B.C. In *Women in Prehistory: North America and Mesoamerica*, edited by Cheryl Claassen and Rosemary A. Joyce, pp. 227–248. University of Pennsylvania Press, Philadelphia.

2002 The Goddess Diffracted: Thinking about the Figurines of Early Villages. *Current Anthropology* 43(4):587–610.

2011 *Interpreting Ancient Figurines: Context, Comparison, and Prehistoric Art*. Cambridge University Press, Cambridge.

Lévi-Strauss, Claude
1955 The Structural Study of Myth. *Journal of American Folklore* 68(270):428–444.

Lightfoot, K. G., and A. Martinez
1995 Frontiers and Boundaries in Archaeological Perspective. *Annual Review of Anthropology* 24(1):471–492.

Linné, S.
1942 *Mexican Highland Cultures: Archaeological Researches at Teotihuacan, Calpulalpan and Chalchicomula in 1934/35.* Publication No. 7. Ethnographical Museum of Sweden, Stockholm.

Longyear, John K.
1952 *Copan Ceramics: A Study of Southeastern Maya Pottery.* Carnegie Institution of Washington, Publication 597. Carnegie Institution, Washington, DC.

Looper, Matthew G.
2009 *To Be Like Gods: Dance in Ancient Maya Civilization.* University of Texas Press, Austin.

Lopes, Luis
2005 On the Text and Iconography of a Vessel in the Popol Vuh Museum. *Mesoweb,* www.mesoweb.com/articles/lopes/PopolVuh.pdf (accessed March 12, 2010).

López Bravo, Roberto
2000 La veneración de los ancestros en Palenque. *Arqueología Mexicana* 8(45):38–43.
2004 State and Domestic Cult in Palenque Censer Stands. In *Courtly Art of the Ancient Maya,* edited by Mary Ellen Miller and Simon Martin, pp. 256–258. Thames and Hudson, New York.

Lopiparo, Jeanne Lynn
2003 Household Ceramic Production and the Crafting of Society in the Terminal Classic Ulúa Valley, Honduras. PhD dissertation, Department of Anthropology, University of California, Berkeley.
2006 Crafting Children: Materiality, Social Memory, and Reproduction of Terminal Classic House Societies in the Ulúa Valley, Honduras. In *The Social Experience of Childhood in Ancient Mesoamerica,* edited by Traci Ardren and Scott R. Hutson, pp. 133–168. University Press of Colorado, Boulder.

Lopiparo, Jeanne Lynn, and Julia Hendon
2009 Honduras Figurines and Whistles in Social Context: Production, Use, and Meaning in the Úlua Valley. In *Mesoamerican Figurines: Small-Scale Indices of Large-Scale Social Phenomena,* edited by Christina T. Halperin, Katherine A. Faust, Rhonda Taube, and Aurora Giguet, pp. 81–74. University Press of Florida, Gainesville.

Low, Setha M.
2000 *On the Plaza: The Politics of Public Space and Culture.* University of Texas Press, Austin.

Lucero, Lisa J.
1999 Classic Lowland Maya Political Organization: A Review. *Journal of World Prehistory* 13(2):211–263.
2003 The Emergence of Classic Maya Rulers. *Current Anthropology* 44(4):523–558.
2008 Memorializing Place among Classic Maya Commoners. In *Memory Work: Archaeologies of Material Practices,* edited by Barbara J. Mills and William H. Walker, pp. 187–206. School for Advanced Research, Santa Fe.

Lukach, Katharine, and Jose Luis Garrido
2009 Análisis descriptivo de las figurillas de El Zotz. In Proyecto Arqueológico "El Zotz" Informe no. 4: Temporada 2009, edited by Pérez Robles, Edwin Román, and Stephen Houston, pp. 335–450. Report submitted to the Guatemalan Institute of Archaeology and History (IDAEH), Guatemala City.

MacAloon, John J.
1984 Olympic Games and the Theory of Spectacle. In *Rite, Drama, Festival, Spectacle:*

Rehearsals toward a Theory of Cultural Performance, edited by John J. MacAloon, pp. 241–280. Institute for the Study of Human Issues, Philadelphia.

Mace, Carroll E.

1999 Danza y teatro prehispánicos. In *Historia general de Guatemala*, edited by Jorge Luján Muñoz, pp. 619–632. Asociación de Amigos del País, Fundación para la Cultura y el Desarrollo, Ciudad de Guatemala.

Manzanilla, Linda

1996 Corporate Groups and Domestic Activities at Teotihuacan. *Latin American Antiquity* 7(3):228–246.

Marcus, Joyce

1976 *Emblem and State in the Classic Maya Lowlands: An Epigraphic Approach to Territorial Organization.* Dumbarton Oaks Research Library and Collections, Washington, DC.

1983 Lowland Maya Archaeology at the Crossroads. *American Antiquity* 48:454–488.

1993 Ancient Maya Political Organization. In *Lowland Maya Civilization in the Eighth Century*, edited by Jeremy A. Sabloff and John S. Henderson, pp. 111–183. Dumbarton Oaks Research Library and Collection, Washington, DC.

1996 The Importance of Context in Interpreting Figurines. *Cambridge Archaeological Journal*: 285–291.

1998a The Peaks and Valleys of Ancient States: An Extension of the Dynamic Model. In *Archaic States*, edited by Gary M. Feinman and Joyce Marcus, pp. 59–94. School of American Research, Santa Fe.

1998b *Women's Ritual in Formative Oaxaca: Figurine-Making, Divination, Death and the Ancestors.* Memoir 33. University of Michigan, Museum of Anthropology, Ann Arbor.

2000 Toward an Archaeology of Communities. In *The Archaeology of Communities: A New World Perspective*, edited by Marcello A. Canuto and Jason Yaeger, pp. 231–242. Routledge, New York.

2009 Rethinking Figurines. In *Mesoamerican Figurines: Small-Scale Indices of Large-Scale Social Phenomena*, edited by Christina T. Halperin, Katherine A. Faust, Rhonda Taube, and Aurora Giguet, pp. 25–50. University Press of Florida, Gainesville, FL.

Marcus, Joyce, and Gary M. Feinman

1998 Introduction. In *Archaic States*, edited by Gary M. Feinman and Joyce Marcus, pp. 3–13. School of American Research, Santa Fe.

Marcuse, Herbert

1964 *One-Dimensional Man: Studies in the Ideology of Advanced Industrial Society.* Bacon Press, Boston.

Martin, Simon, and Nikolai Grube

2000 *Chronicle of the Maya Kings and Queens: Deciphering the Dynasties of the Ancient Maya.* Thames and Hudson, London.

Martínez López, Cira, and Marcus Winter

1994 *Figurillas y silbatos de cerámica de Monte Albán.* Contribución No. 5 del Proyecto Especial Monte Albán 1991–1994. INAH, Oaxaca City.

Marx, Karl

1973 *Grundrisse: Foundations to the Critique of Political Economy.* Vintage Books, New York.

1990 *Capital, Volume I.* Penguin Classics, London.

Marx, Karl, and Friedrich Engels

1970 *The German Ideology.* Lawrence and Wishart, London.

Masson, Marilyn A.

2002 Introduction. In *Ancient Maya Political Economies*, edited by Marilyn A. Masson and David A. Freidel, pp. 1–30. AltaMira Press, Walnut Creek, CA.

Masson, Marilyn A., and Carlos Peraza Lope

2010 Evidence for Maya-Mexican Interaction in the Archaeological Record of May-apán. In *Astronomers, Scribes, and Priests: Intellectual Interchange between the Northern Lowlands and Highland Mexico in the Late Postclassic Period*, edited by Gabrielle Vail and Christine Hernández, pp. 77–114. Dumbarton Oaks, Washington, DC.

Mathews, Peter

1980 Notes on the Dynastic Sequence of Bonampak, Part 1. In *Third Palenque Round Table, 1978*, edited by Merle Greene Robertson, pp. 60–73. University of Texas Press, Austin.

Mauss, Marcel

1990 *The Gift: The Form of Reason for Exchange in Archaic Societies.* W. W. Norton, New York.

McAnany, Patricia A.

1989 Economic Foundations of Prehistoric Maya Society: Paradigms and Concepts. In *Research in Economic Anthropology, Supplement 4: Prehistoric Maya Economies of Belize*, edited by Patricia A. McAnany and B. Isaac, pp. 347–372. JAI Press, Greenwich.

1993 The Economics of Social Power and Wealth among Eighth-Century Maya Households. In *Lowland Maya Civilization in the Eighth Century A.D.*, edited by Jeremy A. Sabloff and John S. Henderson, pp. 65–89. Dumbarton Oaks Research Library and Collection, Washington, DC.

1995 *Living with the Ancestors: Kinship and Kingship in Ancient Maya Society.* University of Austin Press, Austin.

2002 Rethinking the Great and Little Tradition Paradigm from the Perspective of Domestic Ritual. In *The Cotsen Institute of Archaeology*, edited by Patricia Plunket, pp. 115–119. Cotsen Institute of Archaeology, University of California, Los Angeles.

2008 Shaping Social Difference: Political and Ritual Economy of Classic Maya Royal Courts. In *Dimensions of Ritual Economy: Research in Economic Anthropology, Volume 27*, edited by E. Christian Wells and Patricia A. McAnany, pp. 219–247. Emerald Group Publishing, Bingley, UK.

2010 *Ancestral Maya Economies in Archaeological Perspective.* Cambridge University Press, Cambridge.

McCafferty, Geoffrey G.

2007 Altar Egos: Domestic Ritual and Social Identity in Postclassic Cholula, Mexico. In *Commoner Ritual and Ideology in Ancient Mesoamerica*, edited by Nancy Gonlin and Jon C. Lohse, pp. 213–250. University Press of Colorado, Boulder.

McCafferty, Geoffrey G., and Sharisse D. McCafferty

2009 Crafting the Body Beautiful: Performing Social Identity at Santa Isabel, Nicaragua. In *Mesoamerican Figurines: Small-Scale Indices of Large-Scale Phenomena*, edited by Christina T. Halperin, Katherine A. Faust, Rhonda Taube, and Aurora Giguet, pp. 183–204. University Press of Florida, Gainesville.

McInnis Thompson, Lauri, and Fred Valdez Jr.

2008 Potbelly Sculpture: An Inventory and Analysis. *Ancient Mesoamerica* 19:13–27.

Medellín Zenil, Alfonso

1987 *Nopiloa: Exploraciones arqueológicas.* Universidad Veracruzana, Xalapa.

Meneses López, M.

1986 *K'uk Witz, Cerro de los Quetzales: Tradición oral chol del municipio de Tumbalá.* Dirección de Fortalecimiento y Formento a las Culturas de la Sub-Secretaría de Asuntos Indígenas, Secretaría de Desarrollo Rural. Gobierno del Estado de Chiapas, Tuxtla Gutiérrez.

Meskell, Lynn
1995 Goddesses, Gimbutas and "New Age" Archaeology. *Antiquity* 69:74–86.
2005 *Archaeologies of Materiality.* Blackwell, Malden, MA.
2008 The Nature of the Beast: Curating Animals and Ancestors at Çatalhöyük. *World Archaeology* 40(3):373–389.
Meskell, Lynn, Carolyn Nakamura, Rachel King, and Shahina Farid
2008 Figured Lifeworlds and Depositional Practices at Çatalhöyük. *Cambridge Archaeological Journal* 18(2):139–161.
Miller, Daniel (editor)
1998 *Material Cultures: Why Some Things Matter.* University of Chicago Press, Chicago.
2005 *Materiality: Politics, History, Culture.* Duke University Press, Durham, NC.
Miller, Mary Ellen
1975 *Jaina Figurines: A Study of Maya Iconography.* Art Museum, Princeton University, Princeton.
1985 The Dwarf Motif in Classic Maya Art. In *Fourth Palenque Round Table, 1980,* edited by Elizabeth P. Benson, pp. 141–153. Pre-Columbian Art Research Institute, San Francisco.
1986 *The Murals of Bonampak.* Princeton University Press, Princeton.
1988 The Boys in the Bonampak Band. In *Maya Iconography,* edited by Elizabeth P. Benson and Gillett G. Griffin, pp. 318–330. Princeton University Press, Princeton.
2002 Reconstrucción de los murales de Bonampak. *Arqueología Mexicana* 10(55):44–54.
Miller, Mary Ellen, and Simon Martin
2004 *Courtly Art of the Ancient Maya.* Thames and Hudson, New York.
Miller, Mary Ellen, and Karl Taube
1993 *An Illustrated Dictionary of the Gods and Symbols of Ancient Mexico and the Maya.* Thames and Hudson, London.
Millian, Alva Clarke
1981 The Iconography of Aztec Ceramic Figurines. MA thesis, Department of Art History, Columbia University, New York.
Mills, Barbara J.
2004 The Establishment and Defeat of Hierarchy: Inalienable Possessions and the History of Collective Prestige Structures in the Pueblo Southwest. *American Anthropologist* 106(2):238–251.
Mills, Barbara J., and William H. Walker (editors)
2008 *Memory Work: Archaeologies of Material Practices.* School for Advanced Research, Santa Fe.
Minc, Leah D.
2006 Monitoring Regional Market Systems in Prehistory: Models, Methods, and Metrics. *Journal of Anthropological Archaeology* 25(1):82–116.
Ming Dong, Gu
2005 Is Mimetic Theory in Literature and Art Universal? *Poetics Today* 26(3):459–498.
Mintz, Sidney W.
1953 The Folk-Urban Continuum and the Rural Proletarian Community. *American Journal of Sociology* 59(2):136–143.
Mitchell, Timothy
2006 [1999] Society, Economy, and the State Effect. In *The Anthropology of the State: A Reader,* edited by Aradhana Sharma and Akhil Gupta, pp. 169–186. Blackwell, Malden, MA.
Mock, Shirley Boteler
2003 A Macabre Sense of Humor: Dramas of Conflict and War in Mesoamerica.

In *Ancient Mesoamerican Warfare*, edited by M. Kathryn Brown and Travis W. Stanton, pp. 245–261. AltaMira Press, Walnut Creek, CA.

Mock, Shirley Boteler (editor)

1998　*The Sowing and the Dawning: Termination, Dedication, and Transformation in the Archaeological and Ethnographic Record of Mesoamerica*. University of New Mexico, Albuquerque.

Moholy-Nagy, Hattula

2003　Beyond the Catalog: The Chronology and Contexts of Tikal Artifacts. In *Tikal: Dynasties, Foreigners, and Affairs of State*, edited by Jeremy A. Sabloff, pp. 83–110. School of American Research Advanced Seminar Series, Santa Fe.

Mongelluzzo, Ryan W.

2011　*Experiencing Maya Palaces: Royal Power, Space, and Architecture at Holmul, Guatemala*. Department of Anthropology, University of California, Riverside.

Morehart, Christopher T., and Dan T. A. Eisenberg

2010　Prosperity, Power, and Change: Modeling Maize at Postclassic Xaltocan, Mexico. *Journal of Anthropological Archaeology* 29(1):94–112.

Moriarty, Matthew D.

2004　Settlement Archaeology at Motul de San José, Petén, Guatemala. Preliminary Results from the 1998–2003 Field Seasons. *Mayab* 17:21–44.

2012　History, Politics, and Ceramics: The Ceramic Sequence of Trinidad de Nosotros, El Petén, Guatemala. In *Motul de San José: Politics, History, and Economy in a Classic Maya Polity*, edited by Antonia E. Foias and Kitty F. Emery, pp. 194–228. University Press of Florida, Gainesville.

Moriarty, Matthew D., and Antonia E. Foias

2006　El juego de poder en el centro del Petén: Evidencia cerámica sobre festejos asociados al juego de pelota en La Trinidad de Nosotros. Paper presented at the XX Simposio de Investigaciones Arqueológicas en Guatemala, Guatemala City.

Moriarty, Matthew D., Ingrid Seyb, Ellen Spensley, and Jorge Guzmán

2007　Investigaciones en el Grupo F: Los Pozos de Sondeo (Operaciones 1F2 y 1F3) y la Prospección de Basureros (Operación 10). In Proyecto Arqueológico Motul de San José, Informe #7: Temporada de campo 2005–2006, edited by Matthew D. Moriarty, Ellen Spensley, Jeannette E. Castellanos C., and Antonia E. Foias, pp. 141–166. Report submitted to the Guatemalan Institute of Anthropology and History (IDAEH), Guatemala City, and Williams College, Williamstown.

Morinis, Alan (editor)

1992　*Sacred Journeys: The Anthropology of Pilgrimage*. Greenwood Press, Westport.

Moser, Christopher L.

1973　*Human Decapitation in Ancient Mesoamerica*. Studies in Pre-Columbian Art and Archaeology, No. 11. Dumbarton Oaks, Washington, DC.

Mukerji, Chandra

1983　*From Graven Images: Patterns of Modern Materialism*. Columbia University Press, New York.

Mukerji, Chandra, and Michael Schudson

1986　Popular Culture. *Annual Review of Sociology* 12:47–66.

Nagel, Alexander, and Christopher Wood

2010　*Anachronic Renaissance*. Zone Books, New York.

Nash, June

1981　Ethnographic Aspects of the World Capitalist System. *Annual Review of Anthropology* 10:393–423.

Nelson, Zachery
2003 The Growth of Piedras Negras, Guatemala. Report submitted to the Foundation for the Advancement of Mesoamerican Studies, Inc. (FAMSI). Crystal River, FL.

Nichols, Deborah L., Elizabeth M. Brumfiel, Hector Neff, Mary Hodge, Thomas H. Charlton, and Michael D. Glascock
2002 Neutrons, Markets, Cities, and Empires: A 1000-Year Perspective on Ceramic Production and Distribution in the Postclassic Basin of Mexico. *Journal of Anthropological Archaeology* 21:25–82.

Niederberger, Christine
2000 Ranked Societies, Iconographic Complexity, and Economic Wealth in the Basin of Mexico toward 1200 B.C. In *Olmec Art and Iconography*, edited by John E. Clark and Mary E. Pye, pp. 169–191. Studies in the History of Art, 58. National Gallery of Art, Washington, DC.

Nonini, Donald M., and Aihwa Ong
1997 Chinese Transnationalism as an Alternative Modernity. In *Underground Empires: The Cultural Politics of Modern Chinese Transnationalism*, edited by Aihwa Ong and Donald N. Nonini, pp. 3–33. Routledge, New York.

Olson, Jan
2007 A Socioeconomic Interpretation of Figurine Assemblages from Late Postclassic Morelos, Mexico. In *Commoner Ritual and Ideology in Ancient Mesoamerica*, edited by Nancy Gonlin and Jon C. Lohse, pp. 251–279. University Press of Colorado, Boulder.

O'Mack, Scott
1991 Yacateuctli and Ehecatl-Quetzalcoatl: Earth Divers in Aztec Central Mexico. *Ethnohistory* 38(1):1–33.

Ong, Aihwa
1987 *Spirits of Resistance and Capitalist Discipline: Factory Women in Malaysia*. State University of New York, Albany.

Orr, Healther S.
1997 Power Games in the Late Formative Valley of Oaxaca: The Ballplayer Carvings at Dainzu. Master's thesis, Department of Art History, University of Texas, Austin.

Ortner, Sherry B.
1974 Is Female to Male as Nature Is to Culture? In *Women, Culture, and Society*, edited by Michelle Rosaldo and Louise Lamphere, pp. 67–87. Stanford University Press, Stanford.

Otis Charlton, Cynthia
1994 Plebeians and Patricians: Contrasting Patterns of Production and Distribution in the Aztec Figurine and Lapidary Industries. In *Economies and Polities in the Aztec Realm*, edited by Mary G. Hodge and Michael E. Smith, pp. 195–220. Institute for Mesoamerican Studies, University at Albany, State University of New York, Albany.

Palka, Joel W.
1997 Reconstructing Classic Maya Socioeconomic Differentiation and the Collapse at Dos Pilas, Petén, Guatemala. *Ancient Mesoamerica* 8:293–306.

Palma, Adriana Linares
2008 Animales en espacios ceremoniales: Estudio de figurillas zoomorfas en Naranjo, Guatemala. In *XXII Simposio de Investigaciones Arqueológicas en Guatemala*, edited by Juan Pedro Laporte, Bárbara Arroyo, and Héctor E. Mejía, pp. 913–919. Instituto de Antropología e Historia (IDAEH) y Asociación Tikal, Guatemala City.

Parkinson, William A., and Michael L. Galaty (editors)

2009 *Archaic State Interaction: The Eastern Mediterranean in the Bronze Age.* School for Advanced Research Press, Santa Fe.

Parsons, Lee A.

1986 *The Origins of Maya Art: Monumental Stone Sculpture of Kaminalijuyu, Guatemala, and the Southern Pacific Coast.* Studies in Pre-Columbian Art and Archaeology 28. Dumbarton Oaks Research Library, Washington, DC.

Parsons, Lee A., John B. Carlson, and Peter David Joralemon

1989 *The Faces of Ancient America: The Wally and Brenda Zollman Collection of Precolumbian Art.* Indianapolis Museum of Art, Indianapolis.

Parsons, Mary H.

1972 Aztec Figurines from the Teotihuacán Valley, Mexico. In *Miscellaneous Studies in Mexican Prehistory,* edited by Michael W. Spence, Jeffrey R. Parsons, and Mary H. Parsons, pp. 81–117. Anthropological Papers, Museum of Anthropology, University of Michigan, No. 45. University of Michigan, Ann Arbor.

Patel, Shakari

2005 Pilgrimage and Caves on Cozumel. In *Stone Houses and Earth Lords: Maya Religion in the Cave Context,* edited by Keith M. Prufer and James E. Brady, pp. 91–115. University Press of Colorado, Boulder.

Patterson, Thomas C.

1985 Exploitation and Class Formation in the Inca State. *Culture* 5(1):35–42.

1986 Ideology, Class Formation, and Resistance in the Inca State. *Critique of Anthropology* 6(1):75–85.

1991 *The Inca Empire: Formation and Dissolution of a Precapitalist State.* Berg Publishers, Oxford.

1995 Gender, Class, and State Formation in Ancient Japan. In *Alternative Pathways to Early State,* edited by Nikolay N. Kradin and Valeri A. Lynsha, pp. 128–135. Dal'nauka, Vladivostok, Russia.

1999a *Change and Development in the Twentieth Century.* Berg, Oxford.

1999b The Development of Agriculture and the Emergence of Formative Civilization in the Central Andes. In *The Evolution of Archaic and Formative Cultures,* edited by Michael Blake, pp. 181–188. Washington State University Press, Pullman.

2003 *Marx's Ghost: Conversations with Archaeologists.* Berg, Oxford.

2004 Class Conflict, State Formation, and Archaism. *Journal of Social Archaeology* (4):288–306.

2009 *Karl Marx, Anthropologist.* Berg, New York.

Patterson, Thomas C., and Christine W. Gailey (editors)

1987 *Power Relations and State Formation.* American Anthropological Association, Washington, DC.

Pauketat, Timothy R.

2000a Politicization and Community in the Pre-Columbian Mississippi Valley. In *The Archaeology of Communities: A New World Perspective,* edited by Marcello A. Canuto and Jason Yaeger, pp. 16–43. Routledge, London.

2000b The Tragedy of the Commoners. In *Agency in Archaeology,* edited by Marcia-Anne Dobres and John Robb, pp. 113–129. Routledge, London.

2001 Practice and History in Archaeology: An Emerging Paradigm. *Anthropological Theory* 1(1):73–98.

2003 Resettled Farmers and the Making of a Mississippian Polity. *American Antiquity* 68(1):39–66.

2007 *Chiefdoms and Other Archaeological Delusions.* Altamira Press, Lanham, MD.

Paynter, Robert, and Randall H. McGuire
1991 The Archaeology of Inequality: Material Culture, Domination, and Resistance. In *The Archaeology of Inequality*, edited by Randall H. McGuire and Robert Paynter, pp. 1–27. Blackwell, Oxford.

Peirce, Charles S.
1958 *Charles S. Peirce: Selected Writings (Values in a Universe of Chance).* Dover Publications, New York.

Pendergast, David M.
1971 *Excavations at Eduardo Quiroz Cave, British Honduras (Belize).* Art and Archaeology Occasional Paper No. 21. Royal Ontario Museum, Toronto.

Pérez Chacón, José L.
1988 *Los choles de Tila y su mundo: Tradición oral.* Dirección de Fortalecimiento y Formento a las Culturas de la Sub-Secretaría de Asuntos Indígenas, Secretaría de Desarrollo Rural, Gobierno del Estado de Chiapas, San Cristóbal de Las Casas.

Peterson, Polly Ann
2006 Ancient Maya Ritual Cave Use in the Sibun Valley, Belize. PhD dissertation, Department of Archaeology, Boston University, Boston.

Piehl, Jennifer C.
2006 *Performing Identity in an Ancient Maya City: The Archaeology of Houses, Health, and Social Differentiation at the Site of Baking Pot, Belize.* Department of Anthropology, Tulane University, New Orleans.

Piña Chán, Román
1968 *Jaina: La Casa en el Agua.* INAH, Mexico City.
1996 Las figurillas de Jaina. *Arqueología Mexicana* 3(18):52–59.
2001 [1948] *Breve estudio sobre la funeraria de Jaina, Campeche.* Gobierno del Estado de Campeche, INAH, Campeche, Mexico.

Piña Chán, Román, and Carlos Navarrete
1967 *Archaeological Research in the Lower Grijalva River Region, Tabasco and Chiapas.* Papers of the New World Archaeological Foundation, No. 22. Brigham Young University, Provo.

Pohl, John M. D., John Monaghan, and Laura R. Stiver
1997 Religion, Economy, and Factionalism in Mixtec Boundary Zones. In *Códices y documentos sobre México*, edited by Salvador Rueda Smithers, Constanza Vega Sosa, and Rodrigo Martínez Baracs, pp. 205–232. Vol. 1. Instituto Nacional de Antropología e Historia y Consejo Nacional para la Cultura y las Artes Dirección General de Publicaciones, Mexico City.

Pohl, Mary D.
1991 Women, Animal Rearing, and Social Status: The Case of the Formative Period Maya of Central America. In *Proceedings of the 22nd Annual Chacmool Conference, the Archaeology of Gender*, edited by Dale Walde and Noreen D. Willows, pp. 392–399. Archaeological Association of the University of Calgary, Calgary.

Pohl, Mary D., and John D. Pohl
1994 Cycles of Conflict: Political Factionalism in the Maya Lowlands. In *Political Factionalism in the New World*, edited by Elizabeth Brumfiel and John Fox, pp. 138–157. Cambridge University Press, Cambridge.

Potolsky, Matthew
2006 *Mimesis: The New Critical Idiom.* Routledge, New York/London.

Potter, Daniel R., and Eleanor M. King

1995 A Heterarchical Approach to Lowland Maya Socioeconomies. In *Heterarchy and the Analysis of Complex Societies*, edited by Robert M. Ehrenreich, Carole L. Crumley, and Janet L. Levy, pp. 17–32. American Anthropological Association, Arlington.

Preucel, Robert W.

2006 *Archaeological Semiotics*. Blackwell Publishing, Malden, MA.

Proskouriakoff, Tatiana

1950 *A Study of Classic Maya Sculpture*. Publication 593. Carnegie Institution of Washington, Washington, DC.

1960 Historical Implications of a Pattern of Dates at Piedras Negras. *American Antiquity* 25(4):454–475.

1961 Portraits of Women in Maya Art. In *Essays in Pre-Columbian Art and Archaeology*, edited by Samuel K. Lothrop, pp. 81–99. Harvard University Press, Cambridge, MA.

Prufer, Keith M.

2002 Communities, Caves, and Ritual Specialists: A Study of Sacred Space in the Maya Mountains of Southern Belize. PhD dissertation, Department of Anthropology, Southern Illinois University, Carbondale.

Prufer, Keith M., Phil Wanyerka, and Monica Shah

2003 Wooden Figurines, Scepters, and Religious Specialists in Pre-Columbian Maya Society. *Ancient Mesoamerica* 14:219–236.

Quenon, Michel, and Genevieve Le Fort

1997 Rebirth and Resurrection in Maize God Iconography. In *The Maya Vase Book, 5*, edited by Barbara Kerr and Justin Kerr, pp. 884–902. Kerr Associates, New York.

Quirarte, Jacinto

1979 The Representation of Underworld Processions in Maya Vase Painting: An Iconographic Study. In *Maya Archaeology and Ethnohistory*, edited by Norman Hammond and Gordon R. Willey, pp. 116–148. University of Texas Press, Austin.

Ramos, Carmen E., Paulino I. Morales, and Zoila Rodríguez Girón

2002 Contribuciones para la historia del municipio de Santa María de Jesús, Departamento de Sacatepéquez. In *XV Annual Simposio de Investigaciónes Arqueológicas en Guatemala, 2001*, edited by Juan Pedro LaPorte, Héctor Escobedo, and Bárbara Arroyo, pp. 735–751. Museo Nacional de Arqueología y Etnología, Guatemala City.

Rands, Robert L.

1967 Ceramic Technology and Trade in the Palenque Region, Mexico. In *American Historical Anthropology*, edited by C. L. Riley and W. W. Taylor, pp. 137–151. Southern Illinois University Press, Carbondale.

Rands, Robert L., Ronald L. Bishop, and Garman Harbottle

1978 Thematic and Compositional Variation in Palenque-Region Incensarios. In *Tercera Mesa Redonda de Palenque, Vol. 4*, edited by Merle Greene Robertson and Donnan C. Jeffers, pp. 19–30. Herald Peters, Monterey.

Rands, Robert L., and Barbara C. Rands

1959 The Incensario Complex of Palenque, Chiapas. *American Antiquity* 25(2):225–236.

1965 Pottery Figurines of the Maya Lowlands. In *The Handbook of Middle American Indians*, edited by Robert Wauchope, pp. 535–560. Middle American Research Institute, Tulane University, New Orleans.

Rappaport, Roy A.

1984 *Pigs for the Ancestors*. Yale University Press, New Haven.

Redfield, Robert

1952 The Natural History of Folk Society. *Social Forces* 31:224–228.

1956 *Peasant Society and Culture: An Anthropological Approach to Civilization.* University of Chicago Press, Chicago.

1962 *Chan Kom: A Maya Village.* University of Chicago Press, Chicago.

Reents-Budet, Dorie

2001 Classic Maya Concepts of the Royal Court: An Analysis of Renderings on Pictorial Ceramics. In *Royal Courts of the Ancient Maya, Volume One: Theory, Comparison, and Synthesis,* edited by Takeshi Inomata and Stephen D. Houston, pp. 195–236. Westview, Boulder.

Reents-Budet, Dorie (editor)

1994 *Painting the Maya Universe: Royal Ceramics of the Classic Period.* Duke University Press, Durham.

Reents-Budet, Dorie, and Ronald L. Bishop

2012 History and Politics: The Polychrome Pottery of Yajaw Te' Kihnich, Divine Lord of the Ik' Polity. In *Motul de San José: Politics, History, and Economy in a Classic Maya Polity,* edited by Antonia E. Foias and Kitty F. Emery, pp. 67–93. University Press of Florida, Gainesville.

Reents-Budet, Dorie, Ronald L. Bishop, and Barbara MacLeod

1994 Painting Styles, Workshop Locations and Pottery Production. In *Painting the Maya Universe: Royal Ceramics of the Classic Period,* edited by Dorie Reents-Budet, pp. 164–233. Duke University Press, Durham.

Reents-Budet, Dorie, Antonia Foias, Ronald L. Bishop, M. James Blackman, and Stanley Guenter

2007 Interacciones políticas y el sitio Ik' (Motul de San José): Datos de la cerámica. In *XX Simposios de Investigaciones Arqueológicas en Guatemala,* edited by Juan Pedro Laporte, Bárbara Arroyo, and Héctor E. Mejía, pp. 1141–1160. Ministerio de Cultura y Deportes, IDAEH, Asociación Tikal, Guatemala City.

Reese-Taylor, Kathryn, Peter Mathews, Julia Guernsey, and Marlene Fritzler

2009 Warrior Queens among the Classic Maya. In *Blood and Beauty: Organized Violence in the Art and Archaeology of Mesoamerican and Central America,* edited by Heather Orr and Rex Koontz, pp. 39–72. Cotsen Institute of Archaeology Press, University of California, Los Angeles.

Reyna Robles, Rosa Ma.

1971 *Las figurillas Preclásicas.* Thesis, Escuela Nacional de Antropología e Historia, Universidad Nacional Autónoma de México, Mexico City.

Rice, Prudence M.

1986 The Peten Postclassic: Perspectives from the Central Peten Lakes. In *Late Lowland Maya Civilization,* edited by Jeremy A. Sabloff and E. Wyllys Andrews V, pp. 251–299. School of American Research, Santa Fe.

1987 Economic Change in the Lowland Maya Late Classic Period. In *Specialization, Exchange, and Complex Societies,* edited by Elizabeth M. Brumfiel and Timothy K. Earle, pp. 76–85. Cambridge University Press, Cambridge.

1999 Rethinking Classic Lowland Maya Pottery Censers. *Ancient Mesoamerica* 10:25–50.

2004 *Maya Political Science: Time, Astronomy, and the Cosmos.* University of Texas Press, Austin.

Rice, Prudence M., and Don S. Rice

2004 Late Classic to Postclassic Transformations in the Petén Lakes Region, Guatemala. In *The Terminal Classic in the Maya Lowlands: Collapse, Transition, and*

Transformation, edited by Arthur A. Demarest, Prudence M. Rice, and Don S. Rice, pp. 125–139. University Press of Colorado, Boulder.

Rice, Prudence M., and Don S. Rice (editors)

2009 *The Kowoj: Identity, Migration, and Geopolitics in Late Postclassic Petén, Guatemala.* University Press of Colorado, Boulder.

Ricketson, Edith Bayles

1937 In *Uaxactun, Guatemala. Group E-1926–1931: Part II: The Artifacts.* Carnegie Institution of Washington, Washington, DC.

Ricoeur, Paul

1998 *Time and Narrative.* University of Chicago Press, Chicago.

2004 *Memory, History, Forgetting.* Translated by Kathleen Blamey and David Pellauer. University of Chicago Press, Chicago.

Rivero Torres, Sonia

2002 *Figurillas antropomorfas y zoomorfas del juego de pelota de Lagartero, Chiapas.* Universidad de Ciencias y Artes de Chiapas, Tuxtla Gutiérrez.

Robb, John E.

1999 *Material Symbols: Culture and Economy in Prehistory.* Southern Illinois University, Carbondale.

2008 Tradition and Agency: Human Body Representations in Later Prehistoric Europe. *World Archaeology* 40(3):332–353.

Robertson, Merle Greene

1985 "57 Varieties": The Palenque Beauty Salon. In *Fourth Palenque Round Table, 1980, Vol. VI,* edited by Merle Greene Robertson and Elizabeth P. Benson, pp. 29–44. Pre-Columbian Art Research Institute, San Francisco.

Robin, Cynthia

1989 *Preclassic Maya Burials at Cuello, Belize.* BAR International Series 480. BAR, Oxford.

1999 Towards an Archaeology of Everyday Life: Maya Farmers of Chan Nòohol and Dos Chombitos Cik'in, Belize. PhD dissertation, Department of Anthropology, University of Pennsylvania, Philadelphia.

2002 Outside of Houses: The Practices of Everyday Life at Chan Noohol, Belize. *Journal of Social Archaeology* 2:245–268.

2003 New Directions in Classic Maya Household Archaeology. *Journal of Archaeological Research* 11(4):307–356.

Rodens, Vanessa

2008 Estudio arqueoorganológico de objetos sonoros excavados en los asentamientos mayas de Motul de San José y Piedras Negras, Petén, Guatemala. Report submitted to the Departamento de Monumentos Prehispánicos y Coloniales, Instituto der Antropología e Historia, Guatemala.

Roseberry, William

1988 Political Economy. *Annual Review of Anthropology* 17:161–185.

Rousseau, Jean-Jacques

2006 *A Discourse on the Origin of Inequality and A Discourse on Political Economy.* Translated by G. D. H. Cole. Digireads, Stilwell, KS.

Roys, Ralph L.

1972 *The Indian Background of Colonial Yucatan.* University of Oklahoma Press, Norman.

Ruiz Guzmán, Roberto, Ronald L. Bishop, and William J. Folan

1999 Las figurillas de Calakmul, Campeche: Su uso funcional y clasificación sociocultural y química. *Los Investigadores de la Cultura Maya* 7(1):37–49.

Ruscheinsky, Lynn Marie
2003 The Social Reproduction of Gender Identity through the Production and Reception of Lowland Maya Figurines. PhD dissertation, Department of Art History, Visual Art and Theory, University of British Columbia, Vancouver.

Sackett, James R.
1982 Approaches to Style in Lithic Archaeology. *Journal of Anthropological Archaeology* 1(59):154–159.

Sahagún, Fray Bernardino de
1959 *Florentine Codex: General History of the Things of New Spain: Book 9—The Merchants.* School of American Research and the University of Utah, Santa Fe.
1961 *Florentine Codex: General History of the Things of New Spain: Book 10—The People.* Translated by Charles E. Dibble and Arthur J. O. Anderson. School of American Research and the University of Utah, Santa Fe.
1970 *Florentine Codex: General History of the Things of New Spain: Book 1—The Gods.* Translated by Arthur J. O. Anderson and Charles E. Dibble. School of American Research and the University of Utah, Santa Fe.

Salas, Miriam E.
2006 La contribución arqueológica en la recuperación de los valores culturales, Programa de Rescate en Sitios y Comunidades: El ejemplo de San Clemente, Petén, Guatemala. In *Actas del II Congreso Internacional de Patrimonio Cultural y Cooperación al Desarrollo*, edited by Gaspar Muñoz Cosme and Cristina Vidal Lorenzo, pp. 113–124. Universidad Politécnica de Valencia, Valencia.

Saler, Benson
1964 *Nagual*, Witch, and Sorcerer in a Quiché Village. *Ethnology* 3(3):305–328.

Salvador, Mari Lyn (editor)
1997 *The Art of Being Kuna: Layers of Meaning among the Kuna of Panama.* UCLA Fowler Museum of Cultural History, Los Angeles.

Sandstrom, Alan R.
2009 The Weeping Baby and the Nahua Corn Spirit: The Human Body as Key Symbol in the Huasteca Veracruzana, Mexico. In *Mesoamerican Figurines: Small-Scale Indices of Large-Scale Social Phenomena*, edited by Christina T. Halperin, Katherine Faust, Rhonda Taube, and Aurora Giguet, pp. 261–296. University Press of Florida, Gainesville.

Satterthwaite, Linton
1961 Tikal Report No. 9: The Mounds and Monuments of Xutilha, Peten, Guatemala. In *Tikal Reports Numbers 5–10*, pp. 171–212. University Museum, University of Pennsylvania, Philadelphia.

Scarborough, Vernon L., and Fred Valdez
2009 An Alternative Order: The Dualistic Economies of the Ancient Maya. *Latin American Antiquity* 20(1):207–227.

Scarborough, Vernon L., Fred Valdez Jr., and Nicholas P. Dunning (editors)
2003 *Heterarchy, Political Economy, and the Ancient Maya: The Three Rivers Region of the East-Central Yucatán Peninsula.* University of Arizona Press, Tucson.

Scarborough, Vernon L., and David R. Wilcox (editors)
1991 *The Mesoamerican Ballgame.* University of Arizona Press, Tucson.

Schackel, P.
2000 Craft to Wage Labor: Agency and Resistance in American Historical Archaeology. In *Agency in Archaeology*, edited by Marcia-Anne Dobres and John Robb, pp. 232–246. Routledge, London.

Schechner, Richard
1988 [1977] *Performance Theory*. Routledge, New York.
Schele, Linda
1997 *Hidden Faces of the Maya*. ALTI Publishing, San Diego.
Schele, Linda, and David Freidel
1990 *A Forest of Kings: The Untold Story of the Ancient Maya*. William Morrow and Co., New York.
Schele, Linda, and Peter Mathews
1979 *The Bodega of Palenque, Chiapas, Mexico*. Dumbarton Oaks, Washington, DC.
Schele, Linda, and Mary E. Miller
1986 *The Blood of Kings: Dynastic Ritual in Maya Art*. Kimbell Art Museum, Fort Worth/ George Braziller, New York.
Schellhas, Paul
1904 *Representation of Deities of the Maya Manuscripts*. Translated by Miss Selma Wesselfoeft and Miss A. M. Parker. Papers of the Peabody Museum of American Archaeology and Ethnology, No. 4. Harvard University, Cambridge, MA.
Schlosser, Ann L.
1978 Ceramic Maya Lowland Figurine Development with Special Reference to Piedras Negras, Guatemala. PhD dissertation, Department of Anthropology, Southern Illinois University, Carbondale.
Schmidt, Peter, Mercedes de la Garza, and Enrique Nalda (editors)
1988 *Maya*. Rizzoli International Publications, New York.
Schortman, Edward M., and Patricia A. Urban
1994 Living on the Edge: Core/Periphery Relations in Ancient Southeastern Mesoamerica. *Current Anthropology* 35(4):401–403.
Schortman, Edward M., Patricia A. Urban, and Marne Ausec
2001 Politics with Style: Identity Formation in Prehispanic Southeastern Mesoamerica. *American Anthropologist* 103(2):312–330.
Scott, James C.
1976 *The Moral Economy of the Peasant: Rebellion and Subsistence in Southeast Asia*. Yale University Press, New Haven.
1985 *Weapons of the Weak: Everyday Forms of Peasant Resistance*. Yale University Press, New Haven.
1990 *Domination and the Arts of Resistance: Hidden Transcripts*. Yale University Press, New Haven.
Sears, Erin L.
2007 Along the Rivers and through the Woods: Cancuén's Figural Contacts. Paper presented at the 2nd Annual Braunstein Symposium, University of Nevada, Las Vegas.
Sears, Erin L., Ronald L. Bishop, and M. James Blackman
2004 Las figurillas de Cancuen: El surgimiento de una perspectiva regional. Paper presented at the XVIII Simposio de Investigaciones Arqueológicas en Guatemala, Guatemala City.
Seler, Eduard E.
1966 *Collected Works in Mesoamerican Linguistics and Archaeology*. Labyrinthos, Lancaster, CA.
1961 *Gesammelte Abhandlungen zur Amerikanischen Sprach- und Alterthumskunde*. Akademische Druck- u. Verlagsanstalt, Graz, Austria.
Service, Elman R.
1975 *Origins of the State and Civilization*. Norton, New York.

Sharma, Aradhana, and Akhil Gupta

2006 Introduction: Rethinking Theories of the State in the Age of Globalization. In *The Anthropology of the State: A Reader*, edited by Aradhana Sharma and Akhil Gupta, pp. 1–41. Blackwell, Malden, MA.

Shaw, Mary (editor)

1971 *According to Our Ancestors: Folk Texts from Guatemala and Honduras*. Summer Institute of Linguistics, University of Oklahoma, Norman.

Sheets, Payson D.

2000 Provisioning the Cerén Household: The Vertical Economy, Village Economy, and Household Economy in the Southeast Maya Periphery. *Ancient Mesoamerica* 11:217–230.

2002 *Before the Volcano Erupted: The Ancient Cerén Village in Central America*. University of Texas Press, Austin.

2006 *The Cerén Site: An Ancient Village Buried by Volcanic Ash in Central America*. 2nd ed. Thomson Wadsworth, Belmont.

Silliman, Stephen

2001 Agency, Practical Politics, and the Archaeology of Culture Contact. *Journal of Social Archaeology* 1:190–209.

Sinopoli, Carla M.

1988 The Organization of Craft Production at Vijayanagara, South India. *American Anthropologist* 90(3):580–597.

Smith, Adam T.

2003 *The Political Landscape: Constellations of Authority in Early Complex Polities*. University of California Press, Berkeley.

Smith, A. Ledyard

1971 *The Pottery of Mayapan: Including Studies of Ceramic Material from Uxmal, Kabah, and Chichen Itza* 66. Part II. Papers of the Peabody Museum of Archaeology and Ethnology, Harvard University, Cambridge, MA.

Smith, Anthony D.

1994 The Politics of Culture: Ethnicity and Nationalism. In *Companion Encyclopedia of Anthropology*, edited by Tim Ingold, pp. 706–733. Routledge, New York.

Smith, Cameron McPherson

2006 Rise of American Mind. *Scientific American Mind* 17(4):70–77.

Smith, Michael E.

2002 Domestic Ritual at Aztec Provincial Sites in Morelos. In *Domestic Ritual in Ancient Mesoamerica*, edited by Patricia Plunket, pp. 93–114. Costen Institute of Archaeology, Los Angeles.

2003 Economic Change in Morelos Households. In *The Postclassic Mesoamerican World*, edited by Michael E. Smith and Frances F. Berdan, pp. 249–258. University of Utah Press, Salt Lake City.

2004 The Archaeology of Ancient State Economies. *Annual Review of Anthropology* 33:73–102.

Smith, Michael E., and Frances F. Berdan (editors)

2003 *The Postclassic Mesoamerican World*. University of Utah Press, Salt Lake City.

Smith, Monica L.

2005 Networks, Territories, and the Cartography of Ancient States. *Annals of the Association of American Geographers* 95(4):832–849.

Sosa, John R.

1985 The Maya Sky, the Maya World: A Symbolic Analysis of Yucatec Maya

Cosmology. PhD dissertation, Anthropology, State University of New York at Albany.

Spence, Michael W.

2002 Domestic Ritual in Tlailotlacan, Teotihuacan. In *Domestic Ritual in Ancient Meso-america*, edited by Patricia Plunket, pp. 53–66. Costen Institute of Archaeology at University of California, Los Angeles.

Spencer, Charles S., and Elsa M. Redmond

2006 Resistance Strategies and Early State Formation in Oaxaca, Mexico. In *Intermedi-ate Elites in Precolumbian States and Empires*, edited by Christina M. Elson and R. Alan Covey, pp. 21–43. University of Arizona Press, Tucson.

Spensley, Ellen

2007 Investigaciones en la sabana Chächäklu'um, 2005: Operación 1. In Proyecto Arqueologico Motul de San José, Informe #7: Temporada de campo 2005–2006, edited by Matthew D. Moriarty, Ellen Spensley, Jeannette E. Castellanos C., and Antonia E. Foias, pp. 219–226. Report submitted to the Institute of Anthropology and History (IDAEH), Guatemala City, and Williams College, Williamstown.

Spero, Joanne M., and Justin Kerr

1994 Glyphic Names of Animals on Codex-Style Vases. In *Seventh Palenque Round Table, 1989*, edited by Merle Greene Robertson and Virginia M. Fields, pp. 145–155. Pre-Columbian Art Research Institute, San Francisco.

Spielmann, Katherine A.

2002 Feasting, Craft Specialization, and the Ritual Mode of Production in Small-Scale Societies. *American Anthropologist* 104(1):195–207.

Stark, Barbara L.

1985 Archaeological Identification of Pottery Production Locations: Ethnoarchaeo-logical and Archaeological Data in Mesoamerica. In *Decoding Prehistoric Ceram-ics*, edited by Ben A. Nelson, pp. 157–194. Southern Illinois University Press, Carbondale.

2001 Figurines and Other Artifacts. In *Classic Period Mixtequilla, Veracruz, Mexico*, edited by Barbara L. Stark, pp. 179–220. Institute for Mesoamerican Studies, SUNY, Albany/University of Texas Press, Austin.

Stein, Gil J.

1999 *Rethinking World Systems: Diasporas, Colonies, and Interaction in Uruk Mesopotamia*. University of Arizona Press, Tucson.

Stockett, Miranda K.

2007 Performing Power: Identity, Ritual, and Materiality in a Late Classic Southeast Mesoamerican Crafting Community. *Ancient Mesoamerica* 18(1):91–105.

Stoller, Paul

1995 *Embodying Colonial Memories: Spirit Possession, Power, and the Hauka in West Africa*. Routledge, New York.

Stone, Andrea

1989 Disconnection, Foreign Insignia, and Political Expansion: Teotihuacan and the Warrior Stelae of Piedras Negras. In *Mesoamerica after the Decline of Teotihuacan, A.D. 700–900*, edited by Richard A. Diehl and Janet Catherine Berlo, pp. 153–172. Dumbarton Oaks Research Library and Collections, Washington, DC.

1995 *Images from the Underworld: Naj Tunich and the Tradition of Maya Cave Painting*. Univer-sity of Texas Press, Austin.

n.d. Spiritual Journeys, Secular Guises: Rock Art and Elite Pilgrimage at Naj Tunich Cave, Manuscript on file with the author.

Stone, Andrea, and Marc Zender
2011 *Reading Maya Art: A Hieroglyphic Guide to Ancient Maya Painting and Sculpture.* Thames and Hudson, London.

Storey, John
2003 *Inventing Popular Culture: From Folklore to Globalization.* Blackwell, Malden, MA.

Strathern, Marilyn
1988 *The Gender of the Gift.* University of California Press, Berkeley.

Stross, Brian
1978 *Tzeltal Tales of Demons and Monsters.* Museum Brief 24. University of Missouri, Columbia.
1998 Seven Ingredients in Mesoamerican Ensoulment: Dedication and Termination in Tenejapa. In *The Sowing and the Dawning: Termination, Dedication, and Transformation in the Archaeological Record of Mesoamerica*, edited by Shirley Boteler Mock, pp. 31–39. University of New Mexico, Albuquerque.

Stuart, David
1993 Historical Inscriptions and the Maya Collapse. In *Lowland Maya Civilization in the Eighth Century A.D.*, edited by Jeremy A. Sabloff and John S. Henderson, pp. 321–349. Dumbarton Oaks, Washington, DC.
2005 *The Inscriptions from Temple XIX at Palenque.* Pre-Columbian Art Research Institute, San Francisco.

Sugiyama, Saburo
1989 Burials Dedicated to the Old Temple of Quetzalcoatl at Teotihuacan, Mexico. *American Antiquity* 54(1):85–106.
1993 Worldview Materialized in Teotihuacan, Mexico. *Latin American Antiquity* 4(2):103–129.
2000 Teotihuacan as an Origin for Postclassic Feathered Serpent Symbolism. In *Mesoamerica's Classic Heritage: From Teotihuacan to the Aztecs*, edited by David Carrasco, Lindsay Jones, and Scott Sessions, pp. 117–143. University Press of Colorado, Boulder.

Sugiyama, Saburo, and Leonardo López Luján
2007 Dedicatory Burial/Offering Complexes at the Moon Pyramid, Teotihuacan. *Ancient Mesoamerica* 18:127–146.

Sullivan, Kristin S.
2007 Commercialization in Early State Economies: Craft Production and Market Exchange in Classic Period Teotihuacan. PhD dissertation, Department of Anthropology, Arizona State University, Phoenix.

Taschek, Jennifer T.
1994 *The Artifacts of Dzibilchaltun, Yucatan, Mexico: Shell, Polished Stone, Bone, Wood, and Ceramics.* Middle American Research Institute, Tulane University, New Orleans.

Taube, Karl A.
1985 Classic Maya Maize God: A Reappraisal. In *Fifth Palenque Round Table, 1983*, edited by Virginia M. Fields, pp. 171–182. Pre-Columbian Art Research Institute, San Francisco.
1988 A Study of Classic Maya Scaffold Sacrifice. In *Maya Iconography*, edited by Elizabeth P. Benson and Gillett G. Griffin, pp. 331–351. Princeton University Press, Princeton.
1989 Ritual Humor in Classic Maya Religion. In *Word and Image in Maya Culture: Explorations in Language, Writing, and Representation*, edited by William F. Hanks and Don S. Rice, pp. 351–382. University of Utah Press, Salt Lake City.

1992a *The Major Gods of Ancient Yucatán*. Dumbarton Oaks Research Library and Collections, Washington, DC.

1992b The Temple of Quetzalcoatl and the Cult of the Sacred War at Teotihuacan. *RES: Anthropology and Aesthetics* 21:53–87.

1994 The Birth Vase: Natal Imagery in Ancient Maya Myth and Ritual. In *The Maya Vase Database: A Corpus of Rollout Photographs of Maya Vases, Volume 4*, edited by Justin Kerr, pp. 652–675. Kerr Associates, New York.

1996 The Olmec Maize God: The Face of Corn in Formative Mesoamerica. *RES: Anthropology and Aesthetics* 29–30:39–81.

1998 Enemas rituales en Mesoamérica. *Arqueología Mexicana* 6(34):38–45.

2000a The Breath of Life: The Symbolism of Wind in Mesoamerica and the American Southwest. In *The Road to Aztlan: Art from a Mythic Homeland*, edited by Virginia M. Fields and V. Zamudio-Taylor, pp. 102–123. Los Angeles County Museum of Art, Los Angeles.

2000b The Turquoise Hearth: Fire, Self Sacrifice, and the Central Mexican Cult of War. In *Mesoamerica's Classic Heritage: From Teotihuacan to the Aztecs*, edited by David Carrasco, Lindsay Jones, and Scott Sessions, pp. 269–340. University Press of Colorado, Boulder.

2003a Ancient and Contemporary Maya Conceptions about Field and Forest. In *The Lowland Maya Area: Three Millennia at the Human-Wildland Interface*, edited by Arturo Gómez-Pompa, Michael Allen, Scott Fedick, and Juan Jiménez-Osornio, pp. 461–492. Haworth Press, New York.

2003b Tetitla and the Maya Presence at Teotihuacan. In *The Maya and Teotihuacan: Reinterpreting Early Classic Interaction*, edited by Geoffrey E. Braswell, pp. 273–314. University of Texas Press, Austin.

2004a Flower Mountain: Concepts of Life, Beauty, and Paradise among the Classic Maya. *RES: Anthropology and Aesthetics* 45:69–98.

2004b *Olmec Art at Dumbarton Oaks*. Dumbarton Oaks Research Library and Collection, Washington, DC.

Taube, Karl A., William A. Saturno, David Stuart, and Heather Hurst

2010 *The Murals of San Bartolo, El Petén, Guatemala Part 2: The West Wall*. Boundary End Archaeological Research Center, Barnardsville, NC.

Taube, Karl A., and Marc Zender

2009 American Gladiators: Ritual Boxing in Ancient Mesoamerica. In *Blood and Beauty: Organized Violence in the Art and Archaeology of Mesoamerican and Central America*, edited by Heather Orr and Rex Koontz, pp. 161–220. Cotsen Institute of Archaeology Press, University of California, Los Angeles.

Taube, Rhonda

2006 The Figurines of Piedras Negras: An Iconographic Analysis. Paper presented at the 71st Annual Meeting of the Society for American Archaeology, San Juan, Puerto Rico.

Taube, Rhonda, and Karl A. Taube

2009 The Beautiful, the Bad, and the Ugly: Aesthetics and Morality in Maya Figurines. In *Mesoamerican Figurines: Small-Scale Indices of Large-Scale Phenomena*, edited by Christina T. Halperin, Katherine A. Faust, Rhonda Taube, and Aurora Giguet, pp. 236–258. University Press of Florida, Gainesville.

Taussig, Michael

1993 *Mimesis and Alterity: A Particular History of the Senses*. Routledge, New York.

Tedlock, Barbara
1975 The Clown's Way. In *Teachings from the American Earth: Indian Religion and Philosophy*, edited by Dennis Tedlock and Barbara Tedlock, pp. 105–120. Liveright, New York.
1982 *Time and the Highland Maya.* University of New Mexico Press, Albuquerque.
Tedlock, Dennis
1996 *Popol Vuh: The Maya Book of the Dawn of Life.* Touchstone, New York.
Teiwes, Helga
1991 *Kachina Dolls: The Art of Hopi Carvers.* University of Arizona Press, Tucson.
Termer, Franz
1930 Los bailes de culebra entre los indios quiches en Guatemala, pp. 661–667. Proceedings of the 23rd International Congress of Americanists, 1928, New York.
Thompson, J. Eric S.
1930 *Ethnology of the Mayas of Southern and Central British Honduras.* Field Museum of Natural History, Chicago.
1939a *Excavations at San Jose, British Honduras.* Carnegie Institution of Washington, Washington, DC.
1939b *The Moon Goddess in Middle America with Notes on Related Deities.* Carnegie Institution of Washington, Washington, DC.
1950 *Maya Hieroglyphic Writing: An Introduction.* Carnegie Institution, Washington, DC.
Tokovinine, Alexander, and Marc Zender
2012 Lords of Windy Water: The Royal Court of Motul de San José in Classic Maya Inscriptions. In *Motul de San José: Politics, History, and Economy in a Classic Maya Polity*, edited by Antonia E. Foias and Kitty F. Emery, pp. 30–66. University Press of Florida, Gainesville.
Tozzer, Alfred M.
1941 *Landa's Relación de las Cosas de Yucatán: A Translation.* Peabody Museum of American Archaeology and Ethnology, Harvard University, Cambridge, MA.
Triadan, Daniela
2005 Las figurillas de Aguateca y su significado sociopolítico. *Anales de la Academia de Geografía e Historia de Guatemala* 80:25–54.
2007 Warriors, Nobles, Commoners and Beasts: Figurines from Elite Buildings at Aguateca, Guatemala. *Latin American Antiquity* 18(3):269–293.
Trigger, Bruce G.
2003 *Understanding Early Civilizations: A Comparative Study.* Cambridge University Press, Cambridge.
Trik, Helen, and Michael E. Kampen
1983 *The Graffiti of Tikal.* Tikal Report No. 31, University Museum Monograph 57. University of Pennsylvania, Philadelphia.
Trouillot, Michel-Rolph
2001 The Anthropology of the State in the Age of Globalization. *Current Anthropology* 42(1):125–138.
Turner, Victor
1969 *The Ritual Process: Structure and Anti-Structure.* Cornell University Press, Ithaca.
1982 *From Ritual to Theatre: The Human Seriousness of Play.* PAJ Publications, New York.
Tylor, Edward B.
1958 *Primitive Culture.* Harper, New York.
Urban, Patricia A., E. Christian Wells, and Marne T. Ausec
1997 The Fires Without and the Fires Within: Evidence for Ceramic Production

Facilities at the Late Classic Site of La Sierra, Naco Valley, Northwestern Honduras, and in Its Environs. In *The Prehistory and History of Ceramic Kilns*, edited by Prudence M. Rice, pp. 173–194. Vol. 7. American Ceramic Society, Westerville, OH.

Vail, Gabrielle
2000 Ancient Maya Religion. *Ancient Mesoamerica* 11:123–147.

Vail, Gabrielle, and Andrea Stone
2002 Representations of Women in Postclassic and Colonial Literature and Art. In *Ancient Maya Women*, edited by Traci Ardren, pp. 203–228. Altamira Press, Walnut Creek, CA.

Vaillant, George C.
1930 *Excavations at Zacatenco.* American Museum of Natural History, New York.
1935 *Excavations at El Arbolillo.* American Museum of Natural History, New York.

Valdés, Juan Antonio, Monica Urquizú, Horacio Martínez Paiz, and Carolina Díaz-Samayoa
2001 Lo que expresan las figurillas de Aguateca acerca del hombre y los animales. In *XIV Simposio de Investigaciones Arqueológicas en Guatemala, 2000*, edited by J. P. Laporte, A. C. d. Suasnávar, and B. Arroyo, pp. 761–786. Museo Nacional de Arqueología y Etnología, Guatemala City.

Valverde, Mariana
2007 Genealogies of European States: Foucauldian Reflections. *Economy and Society* 36(1):159–178.

Van Stone, Mark
1996 *Headdresses and Hieroglyphs: The Iconography of Headdresses on Royal Monuments of the Southern Lowland Classic Maya.* University of Texas, Austin.

Vaughn, Kevin J.
2004 Households, Crafts, and Feasting in the Ancient Andes: The Village Context of Early Nasca Craft Consumption. *Latin American Antiquity* 15(1):61–88.
2005 Crafts and the Materialization of Chiefly Power in Nasca. In *Foundation of Power in the Prehispanic Andes*, edited by Kevin J. Vaughn, Dennis Ogburn, and Christina A. Conlee, pp. 113–130. Archaeological Papers, No. 14. American Anthropological Association, Arlington, VA.

Vélez-Ibáñez, Carlos G.
2004 Malinowski Award Lecture, 2003: Regions of Refuge in the United States: Issues, Problems, and Concerns for the Future of Mexican-Origin Populations in the United States. *Human Organization* 63(1):1–20.

von Wuthenau, Alexander
1969 *Pre-Columbian Terracottas.* Translated by Irene Nicholson. Methuen and Co., London.

Wailes, Bernard (editor)
1996 *Craft Specialization and Social Evolution: In Memory of V. Gordon Childe.* University Museum of Archaeology and Anthropology, University of Pennsylvania, Philadelphia.

Watanabe, John M.
2004 Some Models in a Muddle: Lineage and House in Classic Maya Social Organization. *Ancient Mesoamerica* 15:159–166.

Waterson, Roxana
2000 House, Place, and Memory in Tana Toraja (Indonesia). In *Beyond Kinship: Social and Material Reproduction in House Societies*, edited by Rosemary A. Joyce and Susan D. Gillespie, pp. 177–188. University of Pennsylvania Press, Philadelphia.

Wattenmaker, Patricia
1998 *Household and the State in Upper Mesopotamia: Specialized Economy and the Social Uses of Goods in an Early Complex Society.* Smithsonian Institution Press, Washington, DC.

Weber, Max
1964 *The Theory of Social and Economic Organization.* Free Press, New York.

Wegars, Priscilla
1977 A Typological Study of Some Mayan Figurines from Lubaantun, Belize. Master's thesis, Department of Anthropology, University of Bradford, Bradford, UK.

Weiner, Annette B.
1985 Inalienable Wealth. *American Ethnologist* 12(2):210–227.
1992 *Inalienable Possessions: The Paradox of Keeping-While-Giving.* University of California Press, Berkeley.

Weissleder, Wolfgang
1978 Aristotle's Concept of Political Structure and the State. In *Origins of the State: The Anthropology of Political Evolution,* edited by Ronald Cohen and Elman R. Service, pp. 187–203. Institute for the Study of Human Issues, Philadelphia.

Wells, E. Christian, and Ben A. Nelson
2007 Ritual Pilgrimage and Material Transfers in Prehispanic Northwest Mexico. In *Mesoamerican Ritual Economy: Archaeological and Ethnological Perspectives,* edited by E. Christian Wells and Karla L. Davis-Salazar, pp. 137–166. University Press of Colorado, Boulder.

Welsh, W. B. M.
1988 *An Analysis of Classic Lowland Maya Burials.* BAR International Series 409. BAR, Oxford.

Wilk, Richard R. (editor)
1989 *The Household Economy: Reconsidering the Domestic Mode of Production.* Westview Press, Boulder, CO.

Wilk, Richard R., and Lisa Cliggett
2007 *Economies and Cultures: Foundations of Economic Anthropology.* Westview Press, Boulder, CO.

Wilk, Richard R., and William L. Rathje
1982 Household Archaeology. *American Behavioral Scientist* 25(6):617–639.

Willey, Gordon R.
1972 *The Artifacts of Altar de Sacrificios.* Papers of the Peabody Museum of Archaeology and Ethnology 64. Harvard University, Cambridge, MA.
1978 Artifacts. In *Excavations at Seibal, Department of Peten, Guatemala,* edited by Gordon R. Willey, pp. 1–189. Peabody Museum of Archaeology and Ethnology, Harvard University, Cambridge, MA.

Willey, Gordon R., Jr. William R. Bullard, John B. Glass, and James C. Gifford
1965 *Prehistoric Maya Settlements in the Belize Valley.* Peabody Museum of Archaeology and Ethnology, Harvard University, Cambridge, MA.

Winter, Marcus
2002 Monte Albán: Mortuary Practices as Domestic Ritual and Their Relation to Community Religion. In *Domestic Ritual in Ancient Mesoamerica,* edited by Patricia Plunket, pp. 67–82. Costen Institute of Archaeology at University of California, Los Angeles.

Wolf, Eric R.
1982 *Europe and the People without History.* University of California Press, Berkeley.

Wright, Barton
1977 *Hopi Kachinas: The Complete Guide to Collecting Kachina Dolls.* Northland Press, Flagstaff.

Wright, Henry T.
1977 Recent Research on the Origin of the State. *Annual Review of Anthropology* 6:379–397.

Wyllie, Cherra
2010 The Mural Paintings of El Zapotal, Veracruz, Mexico. *Ancient Mesoamerica* 21:209–227.

Yaeger, Jason
2000 Changing Patterns of Social Organization: The Late and Terminal Classic Communities at San Lorenzo, Cayo District, Belize. PhD dissertation, Department of Anthropology, University of Pennsylvania, Philadelphia.

Yaeger, Jason, and Marcello A. Canuto
2000 Introducing an Archaeology of Communities. In *The Archaeology of Communities: A New World Perspective*, edited by Marcello A. Canuto and Jason Yaeger, pp. 1–13. Routledge, New York.

Yorgey, Suzanna C.
2005 Rural Complexity in the Central Petén: A View from Akte, El Petén, Guatemala. MA thesis, Department of Anthropology, Tulane University, New Orleans.

Zender, Marc
2004 A Study of Classic Maya Priesthood. PhD dissertation, Department of Anthropology, University of Calgary, Calgary.

INDEX